NEW BRUNSWICK,
NEW JERSEY

RIVERGATE REGIONALS

Rivergate Regionals is a collection of books published by Rutgers University Press focusing on New Jersey and the surrounding area. Since its founding in 1936, Rutgers University Press has been devoted to serving the people of New Jersey and this collection solidifies that tradition. The books in the Rivergate Regionals Collection explore history, politics, nature and the environment, recreation, sports, health and medicine, and the arts. By incorporating the collection within the larger Rutgers University Press editorial program, the Rivergate Regionals Collection enhances our commitment to publishing the best books about our great state and the surrounding region.

★ **NEW BRUNSWICK, NEW JERSEY**

The Decline
and Revitalization
of Urban America

David Listokin,
Dorothea Berkhout,
and James W. Hughes

Rutgers University Press
New Brunswick, New Jersey, and London

Library of Congress Cataloging-in-Publication Data
Names: Listokin, David, author. | Berkhout, Dorothea, author. | Hughes, James W., author.
Title: New Brunswick, New Jersey : the decline and revitalization of urban America /
David Listokin, Dorothea Berkhout, James W. Hughes.
Description: New Brunswick : Rutgers University Press, 2016. | Series: Rivergate regionals
collection | Includes bibliographical references and index.
Identifiers: LCCN 2015032493| ISBN 9780813575148 (hardback) | ISBN 9780813575575
(e-book (epub)) | ISBN 9780813575582 (e-book (web pdf))
Subjects: LCSH: City planning—New Jersey—New Brunswick. | Cities and towns—
Growth. | New Brunswick (N.J.)—History—21st century. | BISAC: HISTORY / United
States / State & Local / Middle Atlantic (DC, DE, MD, NJ, NY, PA). | POLITICAL
SCIENCE / Public Policy / City Planning & Urban Development. | BUSINESS &
ECONOMICS / Urban & Regional. | SOCIAL SCIENCE / Sociology / Urban. | TRAVEL /
United States / Northeast / Middle Atlantic (NJ, NY, PA). | PHOTOGRAPHY / Subjects &
Themes / Regional (see also TRAVEL / Pictorials).
Classification: LCC HT168.N3457 L57 2016 | DDC 307.7609749/42—dc23
LC record available at http://lccn.loc.gov/2015032493

A British Cataloging-in Publication record for this book is available from the
British Library.

Visit our website: http://rutgerspress.rutgers.edu

Manufactured in the United States of America

CONTENTS

PREFACE AND
ACKNOWLEDGMENTS

THIS BOOK has its origins in two different projects. One was a set of oral histories conducted by Dorothea Berkhout and David Listokin with twenty-four individuals who were involved in or present during the major phases of the redevelopment of New Brunswick. The other was a Rutgers University first-year Byrne seminar on cities, at which James Hughes presented a pictorial history of the transformation of New Brunswick. Marlie Wasserman, director of Rutgers University Press, encouraged the authors to consider using this material in a book that also would set the redevelopment of New Brunswick in a national context of transformation of cities.

We are greatly indebted to a number of individuals who assisted us in the research and writing of this book. First and foremost are the twenty-four people who agreed to be interviewed, resulting in the many hours of oral histories that provided the basis for this book. The names and biographies of these individuals are included in an appendix, but we would like to mention in particular John Heldrich and Ralph Voorhees, who have since passed away; both were instrumental in revitalizing New Brunswick over several decades.

Others who provided a great deal of assistance with the history of New Brunswick and photographs of the city include Thomas Frusciano and Erica Gorder of the Rutgers University Libraries Special Collections Department; Robert Belvin, Kim Adams, Kim Kirkley, Jackie Oshman, and Hsienmin Chen of the New Brunswick Free Public Library; Margaret Gurowitz of Johnson & Johnson; Peter Haigney of the Robert Wood Johnson University Hospital and Tabiri Chukunta of Saint Peter's University Hospital; Glenn Patterson of the City of New Brunswick; Omar, Sam, and Wasseem Boraie of Boraie Development; and Christopher Paladino and Jean Holtz of the New Brunswick

Development Corporation. In addition, we thank George "Red" Ellis and Jacqueline "Jacque" Rubel, who provided us with their family photographs.

At the Edward J. Bloustein School of Planning and Public Policy at Rutgers, The State University of New Jersey, we would like to thank Tamara Swedberg and Martin O'Reilly for their technical support with the oral history voice and video recordings; Karyn Olsen for her design and production skills working with photographs, figures, tables, and maps; Jennifer Whytlaw for her GIS mapmaking skills; Will Irving for providing important employment information for chapter 2; and Frances Loeser for keeping track of our grant expenditures. Also deserving special mention are Marc Weiner and Orin Puniello, who provided quantitative analysis and interpretation of data from the Rutgers University Eagleton Institute of Politics' periodic survey of New Brunswick residents in chapter 6.

Many outstanding Rutgers University students who assisted the undertaking deserve our special thanks. Author of an honors undergraduate thesis on New Brunswick, Eric Schkrutz undertook multifaceted research for us and wrote portions of chapter 2, including those on Native Americans, immigrant, racial, and ethnic groups; portions of chapter 6; and the appendix descriptions of the interviewees of oral histories conducted by Dorothea Berkhout and David Listokin. Gabriel Sherman gathered extensive socioeconomic data and wrote portions of chapter 2, especially those on quantitative national, New Jersey, and New Brunswick immigration, racial, and ethnic trends; he also contributed significantly to chapter 6. Katie Brennan wrote on school construction in New Brunswick in chapter 5. Other exemplary assistance was provided by Rutgers University students Kate Davidoff, Jena Fagan, Leigh Hindenlang, Steven Malick, Prutha Patel, Swetha Ramkumar, and Loveleen Saran.

The entire project would not have been possible without support from our funders, including the Rutgers University Office of Academic Affairs, which supplied the seed money for the oral histories, as did several developers involved in projects in New Brunswick: Foglio & Associates; Garfield Foundation c/o Baldwin Brothers Inc.; Keating Building Corporation; New Brunswick Development Corporation; and Pennrose Development LLC. Their contributions enabled us to conduct, record, videotape, transcribe, and summarize the oral history interviews.

Finally, we thank Marlie Wasserman, director of Rutgers University Press, whose guidance and patience are greatly appreciated, and Gretchen Oberfranc for her substantive editing of the early drafts of our manuscript.

ABBREVIATIONS

ACC	American City Corporation
ACHP	Advisory Council on Historic Preservation
ARRA	American Recovery and Reinvestment Act
BMIR	below-market interest rate
CBD	central business district
CDBG	Community Development Block Grants
CDC	community development corporation
CDE	Community Development Entity
CDFI	Community Development Financial Institution
CRA	Community Reinvestment Act
CRDA	Casino Reinvestment Development Authority
DCA	Department of Community Affairs
DEVCO	New Brunswick Development Corporation
EDA	Economic Development Authority
EDI	Economic Development Initiative
EPTR	equalized property tax rate
EZ, UEZ	enterprise zone, urban enterprise zone
FHA	Federal Housing Administration
GSE	government-sponsored enterprise
HHMPA	Historic Hiram Market Preservation Association
HUD	Department of Housing and Urban Development
LIC	low-income community

LIHTC	low-income housing tax credit
LISC	Local Initiatives Support Corporation
LMI	low- and moderate-income
LPC	local preservation commission
MCIA	Middlesex County Improvement Authority
MRI	municipal revitalization index
NBCC	New Brunswick Cultural Center
NBHA	New Brunswick Housing Authority
NBPA	New Brunswick Parking Authority
NBT	New Brunswick Tomorrow
NEPA	National Environmental Policy Act
NHPA	National Historic Preservation Act
NHTF	National Housing Trust Fund
NJRA	New Jersey Redevelopment Authority
NMTC	New Markets Tax Credit
PILOT	payment in lieu of taxes
PPP	public-private partnership
PWA	Public Works Administration
QLICI	qualified low-income community investment
RC	Renewal Community
RCA	Regional Contribution Agreement (New Jersey)
RFC	Reconstruction Finance Corporation
RTC	rehabilitation tax credit
SHPO	State Historic Preservation Office
TBS	tax base sharing
TIF	tax increment financing
TOD	transit-oriented development
UDAG	Urban Development Action Grant
UDC	Urban Development Corporation
UMDNJ	University of Medicine and Dentistry of New Jersey (Rutgers)
UTHTC	Urban Transit Hub Tax Credit
VA	Veterans Administration

NEW BRUNSWICK,
NEW JERSEY

★ INTRODUCTION

THE AREA that was to become the city of New Brunswick in central New Jersey had a bucolic start. In the 1600s, the Lenni Lenape Indians seasonally planted crops, hunted, and traded with the few local farmers. Although, sadly, the Lenape suffered the fate of other Native American tribes as many perished and the remainder were driven out from their ancestral lands, New Brunswick attracted a growing population of European settlers from many countries. In time, the city became a trading, manufacturing, and retail dynamo, with a seemingly limitless future. By the 1960s, however, New Brunswick was an aging industrial urban center of about 40,000 persons with a growing minority population. When the summer of 1967 "again brought racial disorders to American cities, and with them shock, fear, and bewilderment to the nation," devastating riots occurred in Newark, Elizabeth, Jersey City, Paterson, Plainfield, and other New Jersey cities (Kerner Commission 1988, 1, 69–70). Yet a New Brunswick riot "failed to materialize" (ibid., 84). Why? (Rasmussen 2014, 137). And why, in 2015, is the economic condition of New Brunswick so much stronger than that of many of the other cities chronicled by the Kerner Commission, such as Detroit on the national scene and Newark, Elizabeth, and Plainfield in New Jersey?

Academic analyses of urban revitalization efforts in the United States have described how projects aimed to transition older cities from their historical but challenged industrial economic past to a postindustrial future. That transition from factory to an information age economy has been emphasized in New Brunswick in a multi-decade effort at redevelopment. The city's skyline has been dramatically altered by new office buildings, residential towers, medical complexes, and popular cultural centers. To be sure, New Brunswick's "development priorities have not been without their critics, and many lament the loss of historical and cultural landmarks. They also charge that these development efforts have overemphasized [the] downtown and are aimed at meeting the needs of those who

live outside the city [and visit] rather [than] the city's own residents" (Abt Associates 2003, 75).

Other observers have a more positive perspective on the "new" New Brunswick, popularly referred to as Hub City or Health Care City. New Jersey's leading business journal described the city as a phoenix risen from the ashes of urban decay (Prior 1988, 1), and a state commission appointed to examine strategies to jump-start Atlantic City's stalled revitalization pointed to New Brunswick as a model to emulate (Lei and Seidman 2014). There is even some empirical evidence for that positive view. Since 1978, a biennial survey has asked city residents, "How would you rate New Brunswick as a place to live?" In 1978, when the city's revitalization process was just beginning, only 32 percent rated the city as a good or excellent place to live; thirty years later, 62 percent said that New Brunswick is a good or excellent community (Rutgers University, Eagleton Institute 2000 and 2008).

New Brunswick deserves our attention both as a mirror of the challenges facing urban America and as a specific case study of a city's quest to raise its economic fortunes and retool its economy to fit changing needs. Whether the results in New Brunswick can be termed a success and whether the strategies employed to achieve them can serve as a blueprint for cities elsewhere are questions that will be raised throughout this book.

The tale of the dynamic interplay between New Brunswick and larger urban revitalization policy in America follows in six chapters. Chapters 1 and 2 lay the foundation of the case study community. Both chapters discuss the city's historical evolution, with chapter 1 focusing on the economy of the community and chapter 2 presenting the changing demographics of the city. The economy and people experienced cataclysmic changes in the post–World War II era, and in response New Brunswick embarked on redevelopment. To set that effort in context, chapter 3 presents the national record of changing city conditions and multifaceted (government, private, and nonprofit sector) housing and economic development programs aimed at revitalizing urban centers. The book then segues back to New Brunswick's redevelopment, first in chapter 4, which describes the redevelopment's origins, actors, and early actions, and then chapter 5, which details the community's most prominent and sometimes most controversial redevelopment projects (many using the national programs presented in chapter 3). The final chapter connects the dual lenses of the national and New Brunswick threads of urban revitalization, then assesses whether the outcomes in New Brunswick can be deemed successful and serve as a model for other cities.

The chapters are followed by three appendices: Appendix A provides biographical information about the twenty-four individuals interviewed from 2009 to 2015 by authors Dorothea Berkhout and David Listokin. Appendix B is a chronology of New Brunswick's redevelopment from 1968 through 2015. Appendix C includes nine maps of New Brunswick, nearby communities, and the larger region. This appendix provides a spatial orientation to the many streets, highways, and other places referred to in this book.

★ THE ECONOMY OF NEW BRUNSWICK
A City Reinventing Itself from Inian's Ferry to the Information Age

LEAVING THE NEW JERSEY TURNPIKE today at Exit 9 and proceeding on Route 18 North toward New Brunswick (which is actually moving in a westward direction at this point), one passes over Route 1 and then skirts the northern edge of the Douglass campus of Rutgers University. There, the full panorama of twenty-first-century downtown New Brunswick unfolds on the left, while the newly renovated Boyd Park, which stretches along the Raritan River, stands out on the right. All the characteristics of a postindustrial metropolis and knowledge-based economy are evident on the city's impressive, burgeoning skyline. Continuing farther north through New Brunswick, one passes the I. M. Pei–designed global headquarters of Johnson & Johnson—the crown jewel of the city's private sector—and then goes under Amtrak's Northeast Corridor rail bridge and the Deiner Park deck of the College Avenue campus of Rutgers. Finally, the John A. Lynch Sr. Memorial Bridge takes Route 18 across the Raritan River into Piscataway.

What is not seen anywhere along this short stretch of present-day Route 18 is physical evidence of what had been a very significant eighteenth-century shipping port and trading settlement, an important nineteenth-century industrial city, and a potent twentieth-century manufacturing center. All of the structures, save one, that sheltered commercial and industrial activities along the waterfront for more than 150 years have been removed.[1] The very economic reasons for the emergence of New Brunswick have been erased from the landscape.

Across the Raritan River, Route 18 cuts through Johnson Park and approaches River Road in Piscataway. After exiting onto River Road heading west, the first intersection is Landing Lane, a short road that also links New Brunswick and Piscataway via the Landing Lane Bridge. The name of this road originated with Raritan Landing, a thriving colonial port and commerce center that spanned both sides of the Raritan about a mile and a half upriver from what is today the heart of New Brunswick. It has also largely disappeared from the landscape (Yamin

2011). The most prominent remaining structure, the Cornelius Low House (Ivy Hall), sits on a bluff overlooking the intersection of River Road and Landing Lane. To provide context for New Brunswick's latest economic transformation, this chapter examines how and why these communities and their economies grew, expanded, and declined.

Raritan Landing and the Emergence of New Brunswick

Most cities in the United States evolved from changes in both transportation and economic technology. From the mid-1600s, Raritan Landing was the earliest center of the Raritan Valley's preindustrial economy. Its specific location on the Raritan River was the result of almost complete dependence on water-borne shipping and movement. Land-based transportation at the time of this settlement's inception depended mainly on Lenni Lenape trails and the most rudimentary of roads. Distinct from port settlements situated directly on natural harbors, inland settlements in America were located at the navigable limits of rivers, that is, the farthest point into the interior that small flatboats and other simple craft could travel at high tide. At those places, agricultural and natural resources products could be loaded and shipped to coastal ports for transfer onto larger vessels headed to European or colonial coastal markets. The return trip brought products from Europe to colonists in interior areas. Thus, navigable rivers functioned as highways linking the continent's interiors to the sea.

From Raritan Landing, situated at the navigable high-tide limit of the river, small craft carried agricultural commodities from surrounding farms to Perth Amboy, the coastal port located on Raritan Bay. At its peak in the mid-eighteenth century, Raritan Landing encompassed more than seventy structures, including warehouses and wharves, storehouses and shops, barns and liveries, mills, estate houses, and dwellings (Yamin 2011). Among its approximately one hundred inhabitants were traders, merchants, and gentlemen, farmers and millers, storekeepers and artisans, and indentured servants and black slaves.

However, general transportation improvements in the late seventeenth and early eighteenth centuries provided new means of overland accessibility and bolstered the fortunes of another trading center, Inian's Ferry (later New Brunswick), located 1.5 miles downstream. At that point, the Raritan River is navigable at both high and low tides, which provided a distinct shipping advantage over Raritan Landing. The rise of the new trading center also weakened the economic base of Perth Amboy because merchants realized they could send small ships to and from New Brunswick without having to offload there (De Angelo 2007).

After John Inian established ferry service across the Raritan River to Highland Park in 1686 at the current site of the Albany Street Bridge (the northern edge of today's downtown New Brunswick), subsequent road improvements connected directly to this crossing. The Upper Road, incorporating Indian trails that went from present-day Elizabeth to New Brunswick and then to the Delaware River near present-day Trenton, was established by the early 1700s. This road (now Route 27) became part of the intercolonial post road known as the

King's Highway, which linked New York City and Philadelphia. With what would become one of the most heavily traveled stagecoach routes in the American colonies passing through New Brunswick, the early economy based on commercial trade broadened to include communications functions. The postal activities and overland travel spurred the construction of numerous taverns, inns, and hotels. Significantly, the transportation efficiencies represented by the King's Highway influenced the decision of the British military to build barracks in New Brunswick rather than at Raritan Landing in 1759 during the French and Indian War.[2]

By the time it was formally chartered in 1730, New Brunswick was emerging from its origins as a market trading center to become a nascent commercial center, the nexus of communications, military activities, government, and education. In 1766, Queens College, later Rutgers, was chartered. What is now Rutgers Preparatory School also began in 1766, serving as a grammar school to prepare boys for entry into the colonial colleges.

The city's principal economic function through the 1700s, however, was as an agricultural and commercial depot for a broad geographic region. Warehousing and wholesaling functions expanded to include agricultural processing with the establishment of mills and tanneries. As the middleman between the agricultural producers and the final markets for their products, New Brunswick began to outpace Raritan Landing.[3] After the American Revolution, New Brunswick's position was further enhanced by the replacement of Inian's Ferry at the foot of Albany Street in 1794–95 by a toll bridge. Though only a short distance away, Raritan Landing could not take advantage of transportation technologies that developed rapidly in the early nineteenth century.

Turnpikes, a Canal, and Railroads

The beginning of the nineteenth century in America is known as the Turnpike Era for the proliferation of toll roads, sometimes called straight roads, which were generally financed by private companies under state charters. One major route that was part of the connection between Philadelphia and New York during the first quarter of the nineteenth century was the Trenton and New Brunswick Straight Line Turnpike, which was chartered in 1803 for one hundred years. Livingston Avenue in New Brunswick and North Brunswick was its northernmost section, which ended at the foot of Livingston Avenue at George Street. Route 1 as it exists now between North Brunswick and the traffic circle in Trenton comprises the balance of the roadway. Two other nineteenth-century turnpikes also had New Brunswick as one of their terminal points. The Essex and Middlesex Turnpike, chartered in 1806, connected New Brunswick and Newark (roughly today's Route 27 north from New Brunswick). The Georgetown and Franklin Turnpike, chartered in 1815, traveled between Lambertville and New Brunswick (today's Route 27 south to Kendall Park and then County Route 518 to Lambertville). Thus, the city was a terminal point for a number of key transportation routes.

Unlike the winding King's Highway, which passed through town centers and settlements like Princeton, the Straight Line Turnpike was indeed an unwavering point-to-point artery. It thus provided the fastest, most direct carriage route to Trenton, greatly improving communication as well as the movement of passengers and goods. But the construction of canals and railroads caused the demise of stagecoach companies by midcentury, and the turnpike companies disbanded.[4]

The New Jersey Delaware and Raritan Canal Company received its charter from the state legislature in 1820, and construction started in 1830. When it was completed in 1834, the Delaware and Raritan Canal linked Bordentown, a transportation nexus on the Delaware River for travel to Philadelphia, with New Brunswick, where it connected with the Raritan River. Originally, the canal carried agricultural products on mule-drawn barges; later, steam-powered vessels brought Pennsylvania coal to New Brunswick and to New York. This source of power would prove instrumental to New Brunswick when the Industrial Revolution transformed the city.

Because the canal ran along the south bank of the Raritan River through Middlesex County, it bypassed Raritan Landing's principal commercial businesses, which were on the north side of the river. The same was true downstream in Highland Park. All of the early economic activities based on the canal took place in New Brunswick.

However, the canal also had negative effects on two of the older economic foundations of New Brunswick: shipping and wholesaling. Agricultural and other products formerly transported by land and warehoused in New Brunswick before transfer to river vessels could now sail through the city directly to other markets.[5] The arrival of railroads also contributed to the decline of the city's wholesaling function and its shipping industry.

Rail service came to the edge of New Brunswick just a year after completion of the canal. The New Jersey Railroad and Transportation Company was chartered by the state in 1832 and began operating a direct line from Jersey City and Newark to the northern shore of the Raritan River in 1835. To continue south, passengers had to take a stagecoach across the Albany Street Bridge and then proceed by other means. The first railroad bridge across the Raritan was erected at New Brunswick in 1838. The double-decker wooden structure, built on stone foundations and pillars, accommodated pedestrian, horse, and wagon travel on the lower level, with the railroad tracks and trains on the upper level. At the same time, a rail depot was erected on George Street. The railroad tracks cut across the city at ground level, intersecting main streets at odd angles, a feature still evident today. In 1839, New Brunswick and Trenton were connected by rail, and full service between Philadelphia, Trenton, New Brunswick, Newark, and Jersey City was established by 1841. The new transportation connectivity brought by canal and railroads, along with its advantageous geographic location between New York City and Philadelphia, ensured that New Brunswick was well positioned as the Industrial Revolution unfolded.

New Brunswick in the Industrial Revolution

The Industrial Revolution in America encompassed a complex set of technologi-cal and societal changes that spanned the entire nineteenth century. It is generally divided into two periods. The first Industrial Revolution began in the early 1800s and continued until the Civil War. Broadly, it represented the transformation from hand and home production—products crafted manually in home businesses by artisans and craftspeople—to machine and factory production. The techno-logical advances that facilitated this transformation were the steam engine—the shift from water power to steam power—the telegraph, and the sewing machine. Industrialization accelerated greatly just before, during, and following the Civil War. This second Industrial Revolution was spurred by further technological ad-vances, such as steam-powered ships, more comprehensive railroad networks, electrical power, typewriters, and eventually the telephone and the internal com-bustion engine. New Brunswick was a prototypical example of the rise of indus-trialization and the emergence of the manufacturing city during the first and second Industrial Revolutions.

The first industrial activities developed approximately at the intersection of the canal and the railroad and along the canal and the Raritan River toward what is today the Douglass campus of Rutgers University. Firms produced, sequentially, horse carriages; wallpaper; rubber and rubber products; iron products; textiles and cotton cloth; machinery for wallpaper making, box making, and floor cover-ings; hosiery and underwear; knitting and hosiery machines; fruit jars; sterile sur-gical dressings; and horseshoes and related tools (Jenkins et al. 2007).[6]

Manufacturing's Evolution and Decentralization into the Twentieth Century

At the end of the nineteenth century, the entire canal front in New Brunswick—from what today is Seminary Place (northwestern edge) to the canal's southern terminus below Sonomon's Hill (now Antilles Field of Douglass College)—was a dense concentration of industrial, manufacturing, and warehouse structures. Land constraints, as well as the initial dependence on steam power and its trans-mission by belt-and-pulley systems, led to multistory industrial structures and increasing congestion in the oldest part of the city.[7] As newer production tech-nologies began to require larger floor plans, manufacturing moved away from the waterfront, shifting toward the southern portions of the city and then to the adjacent towns of North Brunswick and Milltown. With the sole exception of Johnson & Johnson, nothing of this dense urban manufacturing complex re-mains today.

Farther south, along Jersey Avenue, what would become the city's major in-dustrial zone throughout the twentieth century emerged, serviced by sidings from the Pennsylvania Railroad. A second cluster developed in the Remsen Avenue–Sanford Street area in southeastern New Brunswick. This area was serviced by the Raritan River Railroad.[8] One of the new facilities was a clothing factory for

1. Raritan River, New Brunswick, N.J.

Postcard, William & Reed, New Brunswick, NJ. Special Collections and University Archives, Rutgers University Libraries.

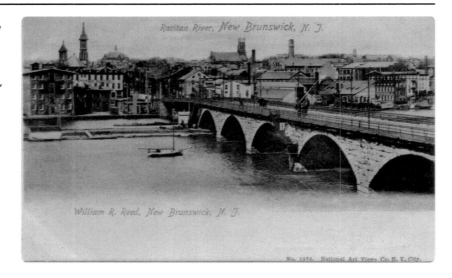

2. U.S. Rubber Company, New Brunswick, N.J.

Postcard, Hammell Bros., New Brunswick, NJ. Special Collections and University Archives, Rutgers University Libraries.

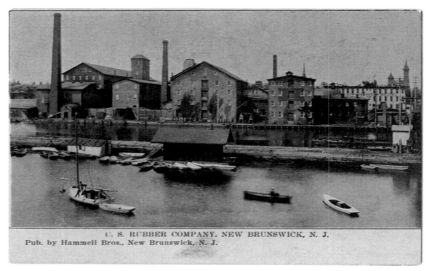

Bond Stores on Remsen Avenue at the intersection with Howard Street. By the 1920s, Bond Stores became the largest men's clothing retailer in America (Jenkins et al. 2007).[9]

Electric power and the internal combustion engine were key technologies that transformed manufacturing and spurred further decentralization. The Jersey Avenue industrial district attracted automobile and aircraft-related production. The Simplex Automobile Company began producing cars in 1908. Its facility was subsequently purchased by the newly formed Wright-Martin Aircraft Corporation in 1915 to produce aircraft engines for France and the United States during World War I. This plant employed between 2,500 and 3,000 workers; at its peak, it was New Brunswick's largest employer. After the war, in 1919, the International Motor Company, subsequently Mack Truck, purchased the Simplex complex in

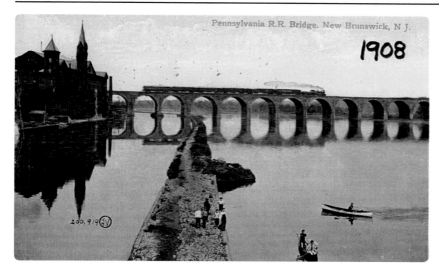

3. Pennsylvania R.R. Bridge

1908 postcard, The Valentine & Son's Publishing Co., Ltd., New York, Printed in Great Britain. Courtesy of New Brunswick Free Public Library.

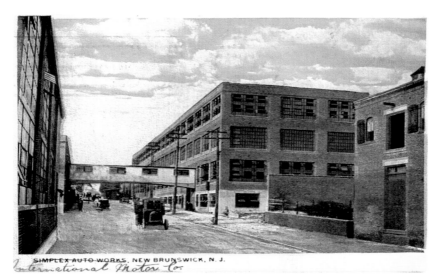

4. Simplex Auto Works, International Motors, Wright Martin

Postcard, No attribution. Courtesy of New Brunswick Free Public Library.

order to produce truck and bus engine parts, and it employed 1,500 workers (Zeitz 1998, 7). The Jersey Avenue manufacturing zone continued to develop through the 1920s until the Great Depression. Still, the city's older manufacturing infrastructure close to the canal soldiered on, particularly during World War I. Johnson & Johnson, for example, was running its manufacturing facilities around the clock seven days a week to meet the wartime demand for surgical dressings (Gurowitz 2006, chap. 194).

Two Companies, Two Outcomes

In the early decades of the twentieth century, two companies represented the maturation and advancement of New Brunswick's manufacturing base. Both had their headquarters in New Brunswick, but only one survives today.

**5. Johnson &
Johnson Plant**

Artist's rendering.
Courtesy of New Brunswick
Free Public Library.

**6. Original
cotton mill,
1901**

Courtesy of
Johnson & Johnson.

In 1886, James Wood Johnson, one of the founding brothers of Johnson & Johnson, was traveling by train from New York City to Philadelphia and thinking about where to locate a facility to produce sterile surgical dressings and sterile sutures.[10] Midway through the journey, the train stopped in New Brunswick. Johnson "noticed a small, four-story building about 150 feet back from the railroad depot" (Gurowitz 2006, chap. 129). Once home to the Janeway & Carpender wallpaper factory, the building was for rent. He immediately got off the train and rented the fourth floor. By the end of 1894, "the [Johnson's] company employed four hundred, and manufacturing and office space occupied fourteen buildings" (ibid., chap. 6).

Into the twentieth century, the manufacturing complex kept increasing its real estate footprint, virtually covering the area bounded by Hamilton Street, the

canal (since overlaid by today's Route 18), and George Street. The largest structure was the Cotton Mill, erected in 1901, a four-story behemoth that housed the company's surgical dressings, cotton, and gauze business (Gurowitz 2006, chap. 56). The location of today's parking deck at the northeast corner of George Street and Hamilton Street was the site of a multitrack railroad siding where raw materials for the Cotton Mill were delivered and finished products shipped. Business was so strong that a huge addition was added to the Cotton Mill in 1908, virtually doubling its size (ibid., chap. 57). Approximately seven hundred feet long, it stretched along George Street (still a dirt road) from Hamilton Street almost to Seminary Place. The mill loomed over the Rutgers campus, which was then expanding northward from the Old Queens campus into what is today's Voorhees Mall.

Johnson & Johnson was not the only national economic powerhouse that blossomed in the early 1900s in New Brunswick. The Interwoven Stocking Company, founded in 1905 by John Wyckoff Mettler, ultimately had a very different fate. Interwoven was an outgrowth of the city's nineteenth-century Kilbourne Knitting Machine Company, which produced knitting machines and needles. Its

7. 1908 Johnson & Johnson footprint

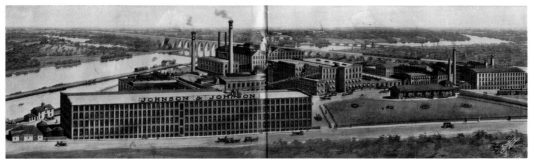

Courtesy of Johnson & Johnson.

8. Factories on New Brunswick waterfront, 1950s

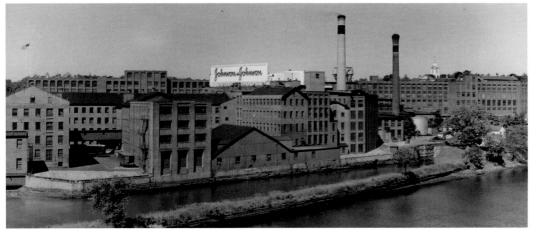

Photograph by Harry Rubel. Courtesy of Jacque Rubel.

major factory in New Brunswick, built in 1887, was located on the corner of Somerset Street and Bethany Street (Jenkins et al. 2007). Today the building houses the American Hungarian Foundation, a public museum and library.

By the end of the 1920s, Interwoven had evolved into a national and international leader in the men's hosiery field, manufacturing more types of men's socks than any other company in America. Its unique manufacturing process secured it numerous military contracts during World War I (and subsequently in World War II). The company operated five factories: two in West Virginia and one each in Pennsylvania, Maryland, and Tennessee. However, New Brunswick remained the site of the corporate headquarters. Mettler, who graduated from Rutgers College in 1899 and eventually became a trustee of the college, serving from 1916 through 1952, built a three-story headquarters building at 123 Church Street in 1929. It was connected to the adjacent National Bank of New Jersey, and Interwoven occupied the seventh and eighth floors of that building. Both the headquarters and bank buildings still exist.[11]

An Interwoven advertisement in the June 4, 1945, issue of *Life* magazine proclaimed it to be the largest manufacturer of men's hosiery in the world. But it did not survive the postwar era of corporate mergers. After John Wycoff Mettler passed away in 1952, his son eventually sold the company to Roth and Co. The subsequent business went under by 1971. Johnson & Johnson was left as the only global headquarters of a leading private-sector enterprise in New Brunswick.

The Emerging Twentieth-Century Business and Cultural Center

The geographic shift of the city's business, commerce, and finance centers continued after World War I. Most of these activities had been clustered along the streets close to the canal and the manufacturing operations that lined it. This dis-

9. Old Market

Photograph by Van Derveer Studio/New Brunswick Savings Bank. Courtesy of New Brunswick Free Public Library.

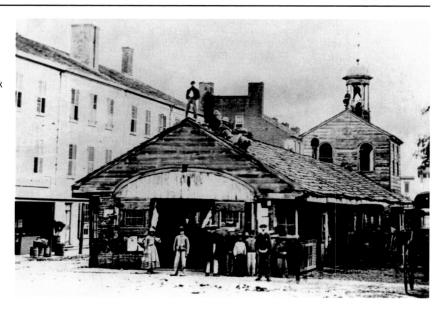

trict, usually referred to as Hiram Market, is now marked by Hiram Street and Hiram Square, which run perpendicular to the canal. Burnet Street, between to-day's Hyatt Regency hotel and Route 18, is one of this commercial district's last remaining road fragments paralleling the canal.[12] Today's Neilson Street, parallel to and south of Burnet Street, evolved into the "main street" of the city.[13] South-westward migration to the George Street area intensified as the post–Civil War manufacturing economy grew, and the area, formerly residential in character, had many dwellings that were subsequently displaced by commercial activities and churches, and the older Hiram Market commercial heart between Burnet Street and Neilson Street began to fade.

One reason for this shift was the continuing importance of the railroad and the decreasing importance of the canal and river.[14] As in many other American

10. Hiram Street west from Burnet Street, 1870

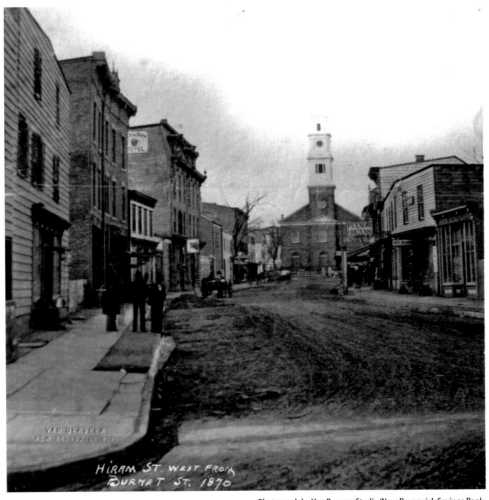

Photograph by Van Derveer Studio/New Brunswick Savings Bank.
Courtesy of New Brunswick Free Public Library.

cities at the same time, the original port-centric business and commercial districts (downtown) shifted to their more inland rail hubs (uptown) as rail systems advanced. After New Brunswick's innovative double-deck wooden railroad bridge was destroyed in a major fire in 1878, it was replaced by a steel-girder bridge with a swing draw. The railroad tracks through the city remained at street level, however, even as growing rail traffic and congestion led to safety concerns. As a result, by 1904 the tracks were elevated through the city, and a new four-track masonry bridge crossed the river. A new station, still in use today, was constructed by the Pennsylvania Railroad at the intersection of Easton Avenue and Albany Street. In addition, the city's streetcar transit system, which was initially constructed in the late nineteenth century, had all of its lines converge at the intersection of George Street and Albany Street. This meeting place became the prime commercial corner in the city because it was the most accessible point in all of New Brunswick. At its peak, the streetcar system tied this intersection and the George Street corridor not only to the rest of the city but also to Milltown, parts of North Brunswick, Highland Park, Piscataway, and Bound Brook.[15]

A signature event in New Brunswick's geographic shift was the erection in 1909 of the eight-story National Bank of New Jersey building on the northwestern corner of George and Church Streets, which moved up from the northwestern corner of Church and Neilsen Streets.[16] For the next seven decades, it was the most prominent commercial structure in the city. It joined two other financial institutions already located at that intersection. On the southwestern corner was the New Brunswick Savings Institution. On the southeastern corner stood the Peoples National Bank of New Brunswick building (1905). Farther south on George Street stood the Citizens National Bank, making this area a financial nerve center—central New Jersey's Wall Street.

11. Pennsylvania Railroad Station, New Brunswick, N.J.

Postcard, Leighton & Valentine Co., N.Y. City. James W. Hughes Collection.

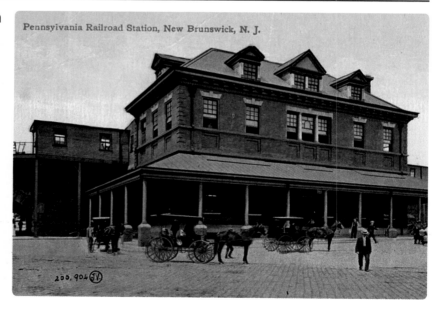

Pennsylvania Railroad Station, New Brunswick, N. J.

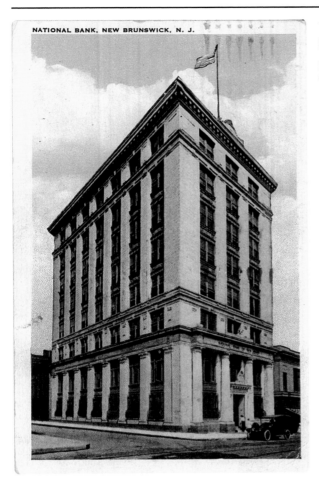

12. National Bank, New Brunswick, N.J.

Postcard, Schneider Bros., New Brunswick, NJ.
Courtesy of New Brunswick Free Public Library.

13. The Citizens National Bank, New Brunswick, N.J.

Postcard, Meiner & Boardman News Dealers, New Brunswick, NJ. Special Collections and University Archives, Rutgers University Libraries.

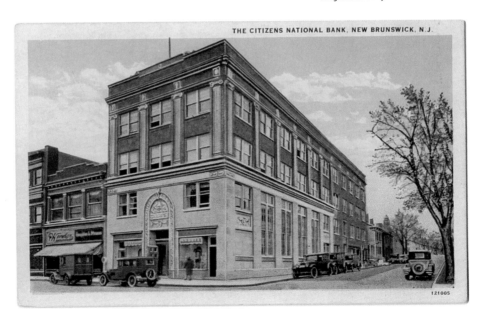

Even before this new financial concentration began, the intersection of George Street and Albany Street had been a prominent location. New Brunswick's most elaborate nineteenth-century structure, Masonic Hall, was erected in 1871 on the southeast corner. It marked the emergence of New Brunswick as the cultural center of the region. As detailed in the photo essay following this chapter, this five-story edifice contained an opera house, retailing, the Masonic Lodge, the city post office, and other activities. After it burned down in 1896, it was replaced by a new post office in 1901.

That government building was joined by a number of theaters early in the twentieth century: the Strand Theater (1905) at the northwest corner of Albany and George Streets, currently the site of the Golden Triangle office building; the Bijou Theater (1906) on George Street close to Albany, currently part of today's Johnson & Johnson campus; and the State Theatre (1920), the city's largest venue, at the foot of Livingston Avenue, close to George Street. In 1929, the nine-story Woodrow Wilson Hotel opened on Livingston Avenue and Schureman Street (today's Monument Square). It was the pride of the city.[17]

As part of its development as the nexus of financial and cultural activities in Middlesex County, New Brunswick also became a health care center. Earlier nineteenth-century hospitals grew into full-fledged institutions. New Brunswick City Hospital (1884) became the John Wells Memorial Hospital in a new building on Somerset Street in 1889. In 1916 its name was changed to Middlesex General Hospital. In 1986 it became the Robert Wood Johnson University Hospital, still headquartered at the same location. Saint Peter's Hospital was created in 1872 but closed in 1874. It reopened in 1907 at the intersection of Somerset and Hardenberg Streets. It eventually moved to Easton Avenue in 1907, diagonally across from Buccleuch Park, its current site.

14. Woodrow Wilson Hotel, New Brunswick, N.J.

Postcard, Meiner & Boardman, New Brunswick, NJ. Courtesy of New Brunswick Free Public Library.

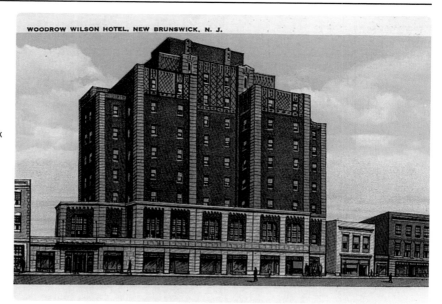

WOODROW WILSON HOTEL, NEW BRUNSWICK, N. J.

The creation of seventy-eight-acre Buccleuch Park itself was another land-mark event in the maturation of New Brunswick. The land and present-day Buccleuch Mansion were donated to the city in 1911 as a memorial to former owner Colonel Joseph Warren Scott (1778–1871). As a city-owned park, it is second in size in New Jersey only to Trenton's Cadwalader Park (approximately one hundred acres).

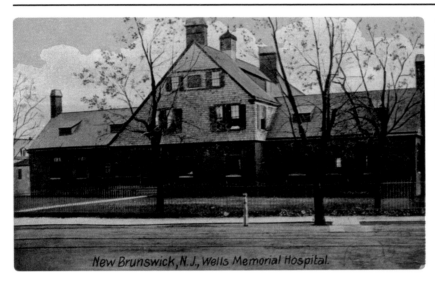

15. Wells Memorial Hospital, 1911

Postcard, Rudon Collection. Courtesy of New Brunswick Free Public Library.

New Brunswick, N.J., Wells Memorial Hospital.

16. St. Peter's Hospital, New Brunswick, N.J.

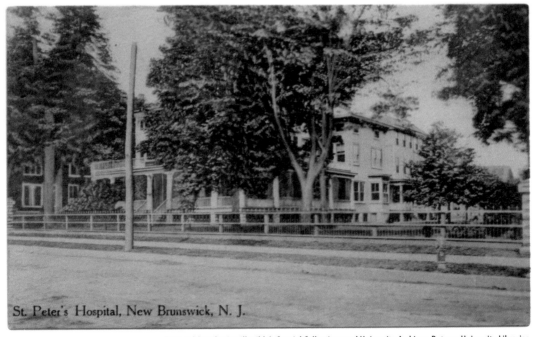

St. Peter's Hospital, New Brunswick, N. J.

Postcard (attribution illegible). Special Collections and University Archives, Rutgers University Libraries.

Residential Development Patterns

The second half of the nineteenth century—and the second Industrial Revolution—brought an expansion of both working-class and upper-class populations in New Brunswick, as well as the housing to shelter them. After the Civil War, particularly during America's Gilded Age (1880–1910), large houses on large lots were constructed for the captains of the new industries along Livingston Avenue, which was typical of the wide, leafy streets that dignified many American cities during this era. Impressive Victorian houses were also constructed on Hassart Street close to George Street. Union Street, which parallels College Avenue and was within walking distance of Johnson & Johnson, had a number of very large, impressive dwellings, one of which was owned by James Wood Johnson. Nearby, on the corner of College Avenue and Hamilton Street, stood Grey Terrace, a true Victorian "wedding cake" structure, which was the home of Robert Wood Johnson (Gurowitz 2006, chap. 116). Eventually acquired by Rutgers, the house was demolished in favor of a parking lot in the early 1960s; today, it is the site of a new Rutgers residential complex due to be completed in 2016. Many of the houses on Union Street eventually became fraternity houses or parking lots. In addition, a number of large estates grew up on the outskirts of the city, including the Charles Carpender House just off George Street on what is now Rutgers's Douglass campus.[18]

17. Grey Terrace, Johnson home

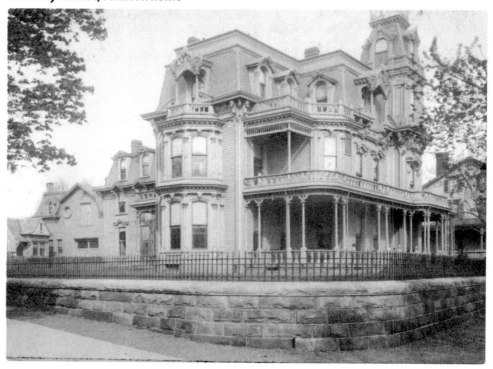

Courtesy of Johnson & Johnson.

18. Morell Street houses

Courtesy of Johnson & Johnson.

Housing for factory workers also proliferated within walking distance of the new production facilities during and after the Civil War. Much of it was privately built and owned, but Johnson & Johnson erected subsidized row housing for its employees along Morell Street south of College Avenue (Gurowitz 2006, chap. 116). In the early part of the twentieth century, more worker housing—mostly two-family wood-frame dwellings—was constructed near the newly decentralized industries. During World War I, the federal government recognized the importance of workers at Wright-Martin and other wartime industries and built a housing development for them that stretched between Jersey Avenue and Somerset Street; it was named Lincoln Gardens.[19]

The most significant additions to the housing stock in the early twentieth century were for a newly emerging middle-class population. Neighborhoods of single-family dwellings and mid-rise apartments developed on side streets off Livingston Avenue (Stratford Place, Lewellyn Place, Edgeworth Place, and Wellington Place) and along Easton Avenue across from Buccleuch Park (New York Avenue and Jefferson Avenue). Similar patterns of development also took place in most of New Jersey's cities, since they still had vacant land on their peripheries. Notably, rental housing for the middle class was much more substantial than the earlier modest wood-frame structures. In New Brunswick, on two sites close to downtown, two masonry six-story rental buildings were erected, facing each other across Livingston Avenue at the intersection of Townsend Street (Hughes and Seneca 2012). They still stand today as landmarks of the pre-Depression wave of middle-class rental housing that swept through New Jersey.[20]

From Great Depression to Postwar Suburbanization

Even though the Depression stalled the city's manufacturing growth, New Brunswick was described in the late 1930s as a city that "combines the attributes of a

manufacturing center, a college town, a market place and a county seat. . . . George Street, the main thoroughfare, is lined with modern shops. Glass-fronted first stories are topped with beauty parlors and offices of lawyers and dentists. Above the low skyline of two- and three-story brick and frame buildings rise the eight-story, white stone building of the First National Bank; the nine-story, red brick Hotel Woodrow Wilson; and the delicate white spire of the chapel at the New Jersey College for Women" (Federal Writers' Project 1939, 298–299).

Until the beginning of the 1930s, successive transportation improvements tended to enhance the economic position of New Brunswick: Inian's Ferry, the King's Highway, the turnpikes, the Delaware and Raritan Canal, the railroads, and the early state highway system (Route 27: Albany Street/French Street; and Route 26: Livingston Avenue and the balance of the former Straight Line Turnpike).[21] New Jersey established one of the first state highway departments in the country. The state senate authorized the creation of the state highway commission in 1909, and the highway department and an initial system of thirteen highways were approved in 1917. However, in the late 1920s and 1930s, the advancing state highway system began bypassing city centers. The new Route 25 (today's Route 1) was routed through the undeveloped eastern edge of New Brunswick, bisecting Rutgers's sprawling College Farm and crossing the Raritan River on a new span (College Bridge). Its construction was immediately instrumental in the siting of Johnson & Johnson's Permacel Tape facility along the new "super-highway" near the Raritan River Railroad in North Brunswick.[22] Surrounded by lawns and trees, it was the first part of what would later become a vast Johnson & Johnson campus stretching from the Raritan River Railroad to Milltown Road on both sides of Route 1. This suburban model would be followed by other Johnson & Johnson divisions in the post–World War II decades.

19. Permacel exterior, 1970s

Courtesy of Johnson & Johnson.

New Brunswick's manufacturing industries were full participants in America's "arsenal of democracy" during World War II. The city remained the county's major business, financial, and retail center, bolstered by the erection of Camp Kilmer, a major processing center for soldiers heading to Europe, across the Raritan River in Edison (today Rutgers University's Livingston campus). New Brunswick was the closest major commercial center and offered many attractions to servicemen in their off hours. In addition to other entertainments, the RKO Theatre had opened in 1936 at the foot of Albany Street near Neilson Street. But the city's manufacturing infrastructure did not get a major boost from the nation's war efforts, as it did during World War I. The national preference was to decentralize large new facilities away from dense urban areas so they would be "harder to target" by potential enemies. The former Hyatt Bearings plant in Clark (Union County), now a golf course, was a model of the new locational preference that would determine manufacturing's post–World War II future around New Brunswick.

The nation, New Jersey, and New Brunswick were dramatically transformed by the end of the war and the release from the extended period of deferred household formation, housing investment, and consumer spending that had started with the Great Depression. Returning veterans were desperate to embrace a normal life, and single-family housing emerged as the key symbol of the American Dream. The G.I. Bill of Rights, formally called the Servicemen's Readjustment Act of 1944, provided help to veterans readjusting to civilian life, including guaranteed low-cost mortgages for home purchases. But there was a severe and widespread housing shortage; at the same time, there was enormous pent-up consumer demand as a result of wartime rationing. Consequently, jobs and incomes generated by extensive wartime industrial production created a large reservoir of savings ready to be spent when consumer goods became available.

Accompanying the returning veterans was a cadre of individuals armed with new construction techniques and expertise gained through the mass production of military housing. Such building systems required very large tracts of vacant land to accommodate standardized, efficient, high-volume construction. In most cases, New Jersey cities had minimal undeveloped land within their boundaries. The surrounding suburbs offered it in abundance. Government mortgage policies also favored suburbs as opposed to urban housing.

The convergence of all of these forces led to unfettered residential suburbanization and the parallel development of a robust consumer economy. Automobile-dependent tract-house suburbia relentlessly spread across New Jersey. Housing production soared from 4,857 units in 1944 to 36,471 units in 1947 and to a peak of 72,657 units in 1950.[23] Between 1950 and 1970, the state added more than one million housing units, a record level of production, along with the requisite strip shopping malls and attendant residential and household services businesses. The state's population geography was redrawn. New Brunswick participated somewhat in the surge, with small parcels of vacant land on the city's edge quickly covered with single-family units and garden apartments. However, their scale fell far

below that of the development taking place in the surrounding townships of East Brunswick, North Brunswick, Franklin, Piscataway, and Edison.

At the same time, unprecedented consumer demand led to the erection of sprawling suburban manufacturing complexes. Production of automobiles, tube televisions, washing machines, and other household goods soared. In New Jersey, the expanding industrial infrastructure largely took place along the state highway system constructed in the 1920s and 1930s. A typical example was the 1.3-million-square-foot Ford assembly plant that opened in 1948 along Route 1 in Edison Township, approximately three miles north of New Brunswick. A second example was the massive Johnson & Johnson Consumer Products Company plant in North Brunswick Township, also along Route 1, about two miles south of New Brunswick.

Postwar America epitomized the era of pastoral capitalism (Monzingo 2011). Auto-dependent suburban campuses and office parks surrounded by broad lawns and leafy trees became the predominant corporate landscape. Johnson & Johnson, an early proponent of this movement, erected its Ethicon building on the same suburban campus on Route 1 where the prewar Permacel Tape building was located. It was both a manufacturing plant and a laboratory. "Part of General Johnson's 'Factories Can Be Beautiful' campaign, the building was faced with white marble and had distinctive imported blue glass windows, complemented by apple trees on its expansive lawn" (Gurowitz 2006, chap. 199). It was an extraordinary vista at a time when postwar suburbia had not reached its development-intensive phase.

20. George Street, New Brunswick, N.J.

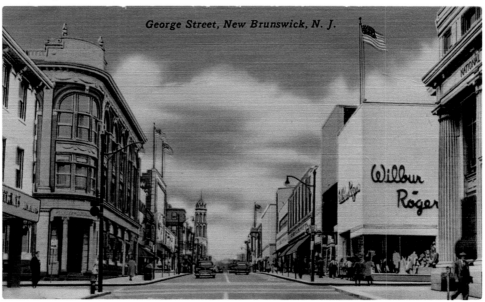

Postcard, Coronet Greeting Card Co., Elizabeth, NJ. Courtesy of New Brunswick Free Public Library.

21. P. J. Young's department store

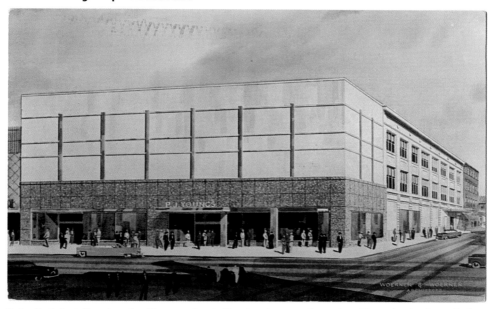

Postcard Invitation to "formal opening of the new and greater Young's marks a great milestone in our history of serving the people of central Jersey for over seventy-five years. It brings to reality our desire to make Young's one of the most modern and beautiful stores in this area. It answers your need for better shopping facilities and services. It demonstrates our faith in New Brunswick's future." Special Collections and University Archives, Rutgers University Libraries.

In these immediate postwar years, New Brunswick remained a vibrant commercial center. Retailing and entertainment flourished. The period's optimism is perhaps best symbolized by the construction of the Arnold Constable department store in 1956 at Livingston and New Streets, the site of today's Civic Square Building (1995), home of Rutgers's Edward J. Bloustein School of Planning and Public Policy and Mason Gross School of the Arts.[24]

However, the older commercial and industrial waterfront—the Burnet Street corridor—had deteriorated badly. In the early 1950s, the city and state conceived the Burnet Street Parkway (today's Route 18) project. As explained in an undated *Home News* article, the overall plan consisted of eliminating blighted structures along the canal, transforming the cleared land into a park (today's Boyd Park), converting Burnet Street into a modern divided highway, and rehabilitating the area south of Burnet Street, up toward Neilson Street. The new highway that opened in 1955 as Memorial Parkway, ending at Albany Street, did have the appearance of a parkway, with trees in the grassy median center island and new parkland to its east along the Raritan River. However, the city was cut off from the river, a fateful decision from today's perspective, and a majority of the historic industrial structures disappeared from the landscape.

The cleared properties south of Memorial Parkway became the site of a public housing project called Memorial Homes. Completed in 1958, it consisted of four nine-story towers on a parcel of land located directly on the parkway. Many of the

rest of the cleared properties remained vacant for decades; there simply was no demand for urban land in an era of rampant suburbanization. Even a new overpass constructed across Memorial Parkway in 1964, which provided direct highway access to the vacant urban renewal site along New Street, could not attract development to the city's central business district.[25]

Retail Suburbanization and Transportation Realignment

The second-generation state highway system, which largely bypassed city and town centers, provided the initial framework for development in the post–World War II decades. In central New Jersey, Route 1 and Route 22 were key arteries in this system. Initially, highway-oriented strip malls emerged to serve the day-to-day needs of the households in the newly burgeoning suburbs. But in the 1960s, the true retail future for the balance of the twentieth century started to come into focus: the suburban regional mall, which replicated all of the retail functions of traditional downtowns in a clean, safe, pedestrian-oriented environment surrounded by free and easy parking. As it evolved, its most sophisticated format was the fully enclosed, climate-controlled, multi-department-store super-regional mall.[26] As early as the 1970s, traditional downtowns throughout New Jersey and the nation quickly succumbed, as their premier shopping facilities migrated to the super-regional mall. Local department stores in downtowns, such as P. J. Young's in New Brunswick, simply were driven out of business.

The Menlo Park Shopping Center (later Menlo Park Mall), located on Route 1 in Edison, approximately seven miles north of New Brunswick, was the first of many malls that would surround the city and undercut its regional retailing and entertainment dominance. Opened in 1959 as an open-air, single-story complex, it eventually upgraded to a multistory, fully enclosed super-regional mall. It was anchored by a Bamberger's department store, which immediately challenged the still-new Arnold Constable store in New Brunswick.[27] On the corner of Parsonage Road and Route 1, adjacent to the mall, the 1,800-seat Menlo Park Cinema was erected in 1961; it quickly surpassed the aging State Theatre in New Brunswick as the premier movie venue in Middlesex County.

The pace of mallification quickened in the next decade. The Brunswick Square Mall, less than four miles south of New Brunswick on Route 18, opened in 1970. One year later, Woodbridge Center Mall opened on Route 1 at a location less than a mile north of Menlo Park Mall. In 1975, Quaker Bridge Mall entered the regional mall roster. It was also located on Route 1, approximately thirteen miles southwest of New Brunswick in Lawrence Township. By this time, even before the extensive expansions of all of these malls, New Brunswick had lost the regional retailing wars.[28]

The defeat had been facilitated by the development of New Jersey's third- and fourth-generation highway systems in the post-1950 period. The New Jersey Turnpike, envisioned as a superhighway in recognition that Route 1 would soon be overburdened, opened in 1952. Thus, Route 27, which provided accessibility to the heart of New Brunswick, had been supplanted as the principal highway artery

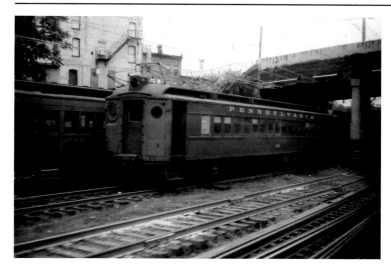

22. A Pennsylvania Railroad MP 54 car in New Jersey, 1967

Photograph from David Wilson, Oak Park, Illinois. From Wikimedia Commons repository.

by Route 1, which bypassed the city center in the 1930s. In turn, Route 1 was sup-planted by the Turnpike, which bypassed the city entirely. The Turnpike traversed the western edge of East Brunswick, near the New Brunswick border defined by Lawrence Brook. Even though Exit 9 provided direct access to New Brunswick via Route 18, the city became far less central to the region's highway grid at a time when the automobile was achieving complete dominance.[29]

The fourth-generation highway advance was the Interstate Highway System. The first stretch of I-287, between Route 1 in Edison and Route 22 in Bridgewater, opened in the early 1960s. Traversing mostly vacant land at the time, it provided easy access to large developable parcels throughout Edison, South Plainfield, Pis-cataway, and Somerset (Franklin Township), which were quickly transformed. Suburban office buildings and other commercial structures proliferated.

Thus, a fully interconnected highway, toll road, and freeway network com-pletely surrounded New Brunswick by the late 1960s, providing the opportunity for the suburbanization of all types of economic activity. Similar developments nationwide, which facilitated the growth of the trucking industry, weakened the nation's railroads and reduced the advantages of major rail hubs. In 1968, two struggling lines, the Pennsylvania Railroad and the New York Central Railroad, merged to form what was popularly labeled the Penn Central Railroad.[30] By 1970, it had filed for bankruptcy. Although the railroad maintained commuter service on the Northeast Corridor line through New Brunswick, the system's quality con-tinued to deteriorate markedly; state subsidies could not alleviate decades of ne-glect and disinvestment. The decade of the 1970s was the dark age of public transit in New Jersey.[31]

The Challenge of the Postindustrial Economy

In the 1970s, New Jersey's badly aging manufacturing economy was hemorrhag-ing obsolete industrial-age jobs and factory inventory. Like many other cities in

the United States and New Jersey, New Brunswick experienced the decade's severe urban decline, white flight, and disinvestment. Crime and broader physical deterioration spurred middle-class flight to suburbia, which had a major negative impact on the city's economic base. The once-proud George Street corridor fell into total despair, as the city's role as a regional hub was reduced to reliance on the government and higher education sectors.

But in the 1980s, New Jersey was remarkably transforming itself into a leading-edge, postindustrial, information-age economy, even as deindustrialization was gaining momentum. This new economy was accommodated by the great 1980s office building boom, which completely reinvented the state's fundamental economic geography. So strong was the boom that 80 percent of all the commercial office space ever built in the history of New Jersey was erected in the 1980–1990 decade. White-collar corporations were the state's growth locomotive, producing vast numbers of knowledge-based jobs. Unfortunately for the state's cities, including New Brunswick, most of these jobs were located along freeway- and highway-oriented growth corridors, the nation's development model at the time. Johnson & Johnson's decision in the late 1970s to rebuild in New Brunswick, detailed in chapter 4, could not have been more counter to the dominant trend.

New Brunswick faced the task of reinventing itself once again if it were to survive and become relevant in the new global economy. In the past, it had successfully made the transition from a totally agriculture- and natural resources–based economy to a colonial hub for trade, shipping, and commerce. During the nineteenth century and the Industrial Revolution, it took advantage of transportation innovations to reinvent itself as a manufacturing city. This economic position was maintained and strengthened through two world wars. However, the powerful economic and demographic dimensions of postwar suburbanization encouraged disinvestment and retreat from the city. By the mid-1970s, it appeared that nothing less than an economic miracle could reverse New Brunswick's inevitable decline.

The Corner of Albany and George Streets

The Remarkable Transformation
of New Brunswick's Commercial Crossroads

THE INTERSECTION of Albany Street and George Street in the heart of New Brunswick is the classic American downtown crossroads. In real estate terms, it was once considered the "100 percent location," that is, the busiest intersection with the greatest degree of accessibility in the market area.[1]

Albany Street was originally the King's Highway in the 1700s, connecting New York City and Philadelphia, while George Street emerged as the second major commercial thoroughfare by the late 1800s. The structural changes at this site illustrate the transformation of a city—its rise, fall, and rebirth. Today, Albany Street Plaza, the eight-story, reddish-brown building in the middle of photo 23, occupies the southeast corner of this intersection.

In the post–Civil War years, Masonic Hall—the city's most prestigious and sophisticated edifice—was erected on this site. Also known as the New Brunswick Opera House, it stood as a cultural symbol of the rise of a successful manufacturing and commercial city. Completed and formally opened in 1871, this five-story building (photo 24) had a mansard roof modeled on Philadelphia's City Hall. It contained the opera house itself, the Masonic Lodge, the Opera House Drug Store (photo 25), offices, various businesses, and the post office. The drugstore was owned in the early 1880s by Fred Kilmer, an early believer in sanitation and public health who was instrumental in organizing a board of health in New Brunswick in the early 1880s (Gurowitz 2006, chap. 152). (He was also the father of poet Joyce Kilmer.) According to Margaret Gurowitz, Johnson & Johnson's resident historian,

23. Aerial view of New Brunswick, ca. 2000

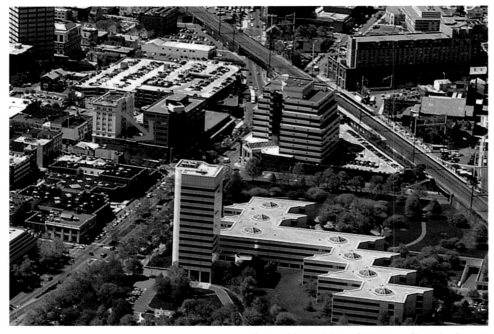

Photograph by Aerial Photos of NJ. Courtesy of Boraie Development.

24. Masonic Lodge and Opera Drug Store

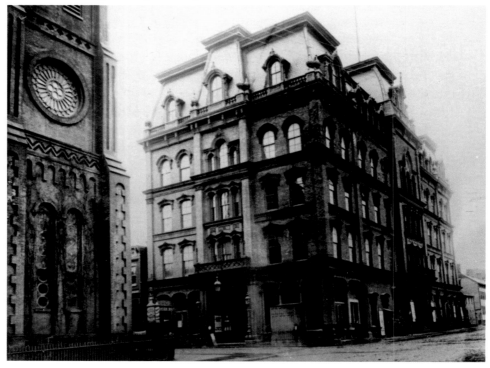

Courtesy of Special Collections and University Archives, Rutgers University Libraries.

the Johnson brothers often had lunch at this location, occasionally joined by Thomas Alva Edison, the famed inventor, who was a friend of Fred Kilmer. Edison's Menlo Park laboratories were located several miles north of New Brunswick in what is now Edison Township. Fred Kilmer ultimately sold the drugstore and in 1889 became Johnson & Johnson's director of scientific affairs (Gurowitz 2006, chap. 132).

25. Fred Kilmer's Opera House Pharmacy

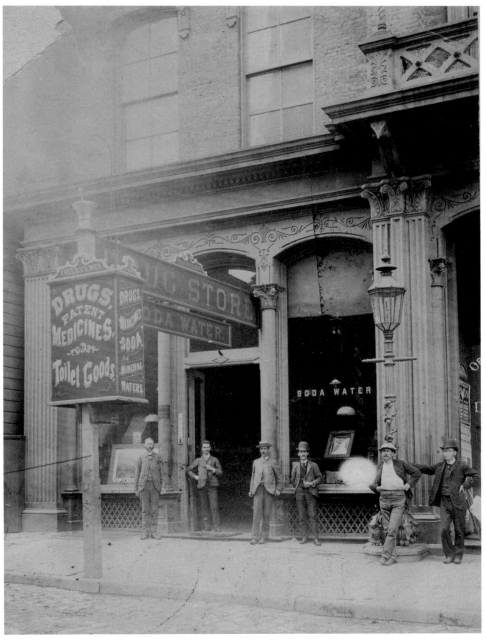

Courtesy of Special Collections and University Archives, Rutgers University Libraries.

After Masonic Hall was destroyed by fire in 1896, the site became the location of a new post office in 1901 (photos 26 and 27). Although it was a very substantial and prominent building, built in the style of a Renaissance palazzo and set back from George Street by a generous courtyard, the two-story structure could hardly be said to replace the grand five-story Masonic Hall. An asymmetrical addition was erected in the early twentieth century, and part of the courtyard was eventually lost to parking. This unfortunate loss of public space to the automobile would be repeated many times throughout the twentieth century in New Brunswick.

Nonetheless, the turn of the twentieth century was an era during which cities took great care and pride in basic urban infrastructure and public buildings. As can be seen in photo 27, parked automobiles and trolley tracks were located on an Albany Street elegantly paved with yellow bricks. Following the harsh winter of 2010, the emergence of a pothole revealed a surprising reminder of this "yellow brick road" heritage (photo 28).

Ultimately, a new main post office, designed in the neo-Georgian style, was built in 1934 next to City Hall on Bayard Street, where the city's (and Middlesex County's) civic/governmental functions became concentrated. A one-story utilitarian commercial structure erected as a replacement on the George and Albany site revived the area's drugstore heritage, with first a national chain (Whelan Drugs) occupying the prime corner space, then Mandell's Drugs (photo 29).

Throughout the 1950s and 1960s, New Brunswick remained the regional retail center for Middlesex County. The 1970s brought a sharp decline in commercial viability. Photo 29 shows the scale of urban and retail decline that descended on the corner of George and Albany Streets. The city had truly reached bottom. However, it still was managing to hold on to its drugstore roots nearly a hundred years after Fred Kilmer.

26. Masonic Lodge destroyed by fire, 1896

Courtesy of Special Collections and University Archives, Rutgers University Libraries.

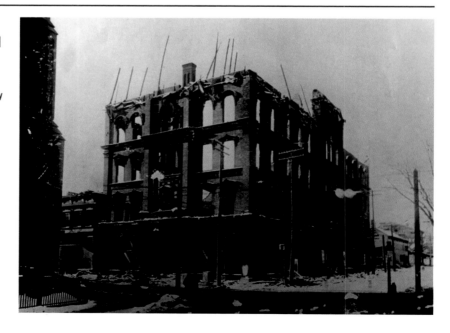

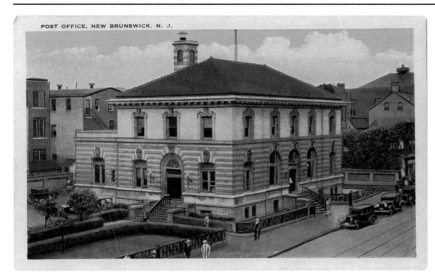

27. Post Office, New Brunswick, N.J.

Postcard, Meiner & Boardman, New Brunswick, NJ. Special Collections and University Archives, Rutgers University Libraries.

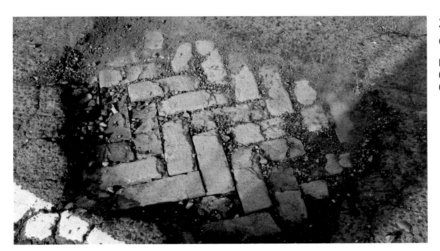

28. Yellow brick on Albany Street

Photograph by Karyn Olsen. Courtesy of Karyn Olsen/Bloustein School.

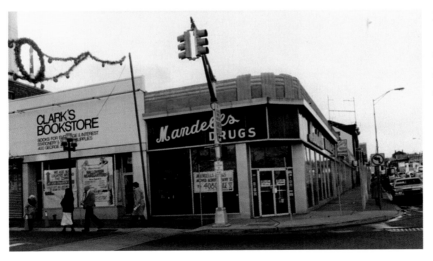

29. Mandell's Drugs, Albany and George Streets, ca. 1980

Courtesy of Boriae Development.

The 1980s brought a new knowledge-based economy to New Brunswick, which then required expanded office infrastructure. This transformation brought the city's 100 percent location back to prominence when Albany Street Plaza opened in 1988. The early construction (photo 30) still shows the remnants of urban decline, but by 2010 (photos 31 and 32), the entire crossroads had been fully reinvented. The evolution of this corner stands as testimony to urban glory, urban despair, and, finally, urban renaissance.

30. Omar Boraie on construction site of Albany Street Plaza

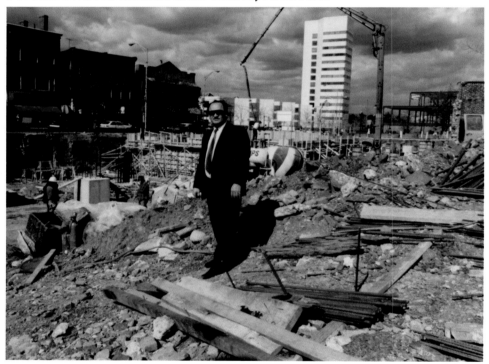

Courtesy of Boraie Development.

31. Albany Street Plaza with both towers

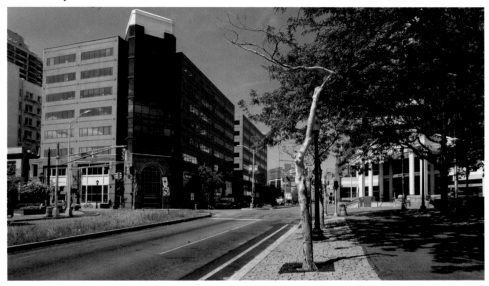

Photograph by Larry Levanti. Courtesy of Larry Levanti.

32. Albany Street Plaza

Photograph by
Larry Levanti.
Courtesy of Larry Levanti.

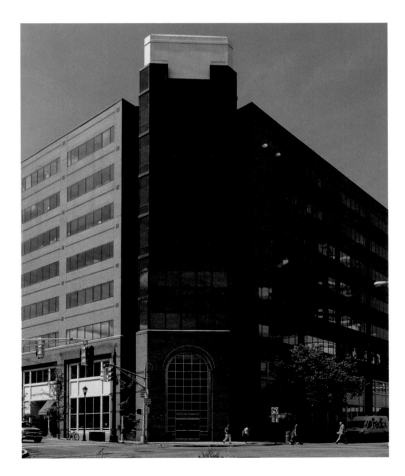

★ THE PEOPLE OF NEW BRUNSWICK
Population and Resident Profile over Time

THE HISTORICAL AND ECONOMIC FORCES detailed in chapter 1 contributed to the size and composition of New Brunswick's population over time. This chapter first charts the number of persons calling New Brunswick home from 1800 until today and sets this population in the larger context of national, state, and regional (Middlesex County) demographic trends. Individual sections then describe the many groups that have been drawn to New Brunswick over time, including waves of immigrants and varying racial and ethnic groups. The chapter concludes by linking New Brunswick's changing economy and population, a transformation that by the 1970s and 1980s challenged many other American cities. How the nation and especially New Brunswick responded to these challenges is detailed in chapters 3 through 6.

A contemporary theater in New Brunswick is named Crossroads, and this city represents a literal "crossroads" of many diverse populations over centuries.[1] They have been the human catalyst powering the city's economic engine. A former president of the New Brunswick Chamber of Commerce observed: "The town became a true melting pot, which caused and supported the industries we used to know and know today. Each new wave of citizens has been a factor in the city's industrial growth [which is] largely responsible for giving the city an important place in history."[2] Beyond their economic importance, the people who have converged on and lived in New Brunswick over the centuries have defined the human character of this community by the Raritan.

New Brunswick's People and the Larger Population Context, 1800–2010

At the beginning of the nineteenth century, the population of the United States was mostly rural and made a living from agriculture and natural resources. The nation's 5.3 million people were largely concentrated on the East Coast in what

had been the original thirteen colonies. At the time, New Jersey accounted for ap-proximately 4 percent of this population, or 211,000 people, a number that includes 12,422 slaves. Middlesex County, with a population of almost 18,000, claimed more than one out of twelve (8.5 percent) of the state's residents. In turn, New Brunswick, while still a small settlement, accounted for one in nine (11.3 percent) of Middlesex County's residents, or 2,025 people (see tables 2.1 and 2.2).

During the next sixty-five years, three dynamics influenced the growth and distribution of America's population. The first was a major wave of immigration from northern and western Europe starting around 1815. (Immigration will be discussed in detail later in this chapter.) This influx was linked to the second dy-namic, the first Industrial Revolution. The third was the westward expansion of the United States, starting with the Louisiana Purchase in 1803.[3] By the 1840s, four in ten Americans lived west of the Appalachians.

Between 1800 and 1860, the population of the nation increased by almost 500 percent, from 5.3 million people to 31.4 million. However, New Jersey's popula-tion barely tripled (just over 200 percent), from approximately 211,000 people to 672,000, and its share of the nation's total population dropped by nearly one-half (from approximately 4 percent to just over 2 percent). These changes reflected the sustained migration westward. Likewise, Middlesex County's population only doubled (approximately 100 percent), from about 18,000 people in 1800 to 35,000 in 1860. New Brunswick, on the other hand, was the epicenter of the Industrial Revolution in Middlesex County and thus was a primary destination for European immigrants. Its population growth rate (450 percent) almost matched that of the nation (500 percent): between 1800 and 1860, the city's population jumped from 2,025 people to 11,287. Moreover, its share of Middlesex County's population nearly tripled, from 11.3 percent to 32.4 percent, meaning that almost one out of three people in Middlesex County resided in New Brunswick by the mid-nineteenth century. The city's lofty share of the county's residents would stay above 30 percent until 1900, when it fell to 25 percent. It would ultimately drop into single digits by 1960 and not begin to recover until 2010 (see tables 2.1 and 2.2).

Following an immigration slowdown during the 1870s because of depressed economic conditions in the United States, the second Industrial Revolution brought a new wave of immigrants, which peaked during the period 1880–1920. The majority of these immigrants came from central, eastern, and southern Eu-rope. Despite the slowdown in immigration caused by World War I (1914–1918), the nation's population had soared to above 106 million people by 1920—a 237 percent increase (nearly 75 million people) from the population of 31.4 million in 1860. This strong growth continued through the 1920s; by 1930, more than 123 million people lived in the United States.

The shrinking of New Jersey's share of the nation's population was halted in the post–Civil War era, as it became a major industrial state and immigration destination. Between 1860 and 1920, New Jersey's population grew by nearly 2.5 million people (370 percent), from about 670,000 people to nearly 3.2 million. As a result, its share of the national population increased from 2.1 percent to 3.0

percent. This rebound continued during the 1920s. By 1930, when the state's total population topped 4.0 million people, its share of the nation's population reached 3.3 percent.

Between 1860 and 1920, Middlesex County's population growth rate (366 percent) nearly matched that of New Jersey (370 percent). The county gained nearly 128,000 people, and its total population surpassed 162,000 in 1920. This pattern of growth continued during the decade of the 1920s. By 1930, the county's population topped 212,000, and its state share reached 5.3 percent. As in New Jersey overall, immigration and industrialization fueled the county's population growth.

Table 2.1 Comparative Populations of the United States, New Jersey, Middlesex County, and the City of New Brunswick, 1800–2010

	DECENNIAL POPULATION			
YEAR	U.S.	New Jersey (population rank among states)	Middlesex County	New Brunswick
1800	5,308,483	211,149 (10)	17,890	2,025
1810	7,239,881	245,562 (12)	20,381	3,042
1820	9,638,453	277,575 (13)	21,470	3,814
1830	12,866,020	320,823 (14)	23,157	4,993
1840	17,069,453	373,306 (18)	21,893	5,866
1850	23,191,876	489,555 (19)	28,635	10,019
1860	31,443,321	672,035 (21)	34,812	11,287
1870	38,558,371	906,096 (17)	45,029	15,058
1880	50,189,209	1,131,116 (19)	52,286	17,166
1890	62,979,766	1,444,933 (18)	61,754	18,603
1900	76,212,168	1,883,669 (16)	79,762	20,006
1910	92,228,496	2,537,167 (11)	114,426	23,388
1920	106,021,537	3,155,900 (10)	162,334	32,779
1930	123,202,624	4,041,334 (9)	212,208	34,555
1940	132,164,569	4,160,165 (9)	217,077	33,180
1950	151,325,798	4,835,329 (8)	264,872	38,811
1960	179,323,175	6,066,782 (8)	433,856	40,139
1970	203,302,031	7,171,112 (8)	583,813	41,885
1980	226,545,805	7,365,011 (9)	595,893	41,442
1990	248,709,873	7,730,188 (9)	671,780	41,711
2000	281,421,906	8,414,350 (9)	750,162	48,573
2010	308,745,538	8,791,894 (11)	809,858	55,181

SOURCE: Decennial census for indicated years. The New Brunswick population for 1800 is an estimate from Wall 1931, 439.
NOTE: The Middlesex County and New Brunswick boundaries changed over time.

New Brunswick's population nearly tripled between 1860 and 1920, from just over 11,000 people to nearly 33,000. However, the city's rate of increase during that period (190 percent) failed to match those of New Jersey (370 percent) and Middlesex County (366 percent). An expanded railroad network and the diminishing importance of waterborne shipping made other areas of the county more competitive as sites for manufacturing and, in turn, population growth. New Brunswick's share of Middlesex County's population fell from 32.4 percent in 1860 to 20.2 percent in 1920, and to 16.3 percent in 1930. But its population was still growing and approached 35,000 by 1930.

Table 2.2 Population Context for New Jersey, Middlesex County, and New Brunswick, 1800–2010

YEAR	POPULATION PERCENTAGE COMPARISONS		
	New Jersey's population as a percentage of the U.S. population	Middlesex County's population as a percentage of New Jersey's population	New Brunswick's population as a percentage of Middlesex County's population
1800	3.98	8.47	11.32
1810	3.39	8.30	14.93
1820	2.88	7.73	17.76
1830	2.49	7.22	21.56
1840	2.19	5.86	26.79
1850	2.11	5.85	34.99
1860	2.14	5.18	32.42
1870	2.35	4.97	33.44
1880	2.25	4.62	32.83
1890	2.29	4.27	30.12
1900	2.47	4.23	25.08
1910	2.75	4.51	20.44
1920	2.98	5.14	20.19
1930	3.28	5.25	16.28
1940	3.15	5.22	15.28
1950	3.20	5.48	14.65
1960	3.38	7.15	9.25
1970	3.53	8.14	7.17
1980	3.25	8.09	6.95
1990	3.11	8.69	6.21
2000	2.99	8.92	6.48
2010	2.85	9.21	6.81

SOURCE: Decennial census for indicated years. The New Brunswick population for 1800 is an estimate from Wall 1931, 439.

During the Great Depression of the 1930s, immigration was reduced to a trickle, and the nation's birthrate declined, leading to what demographers call the Depression-era birth dearth. Consequently, population growth slowed dramatically in the nation, state, and county. New Brunswick experienced an absolute population decline. Following World War II, birthrates soared, producing the now fabled baby boom generation, the huge population cohort born between 1946 and 1964. This demographic force was one of the factors influencing the period of intense highway-dependent residential suburbanization that unfolded in America and New Jersey. The largest generation ever produced in the nation's history, the baby boomers were mostly born and reared in new postwar suburban housing developments.

Between 1950 and 1970, the nation's population increased by more than one-third (34.3 percent), from 151.3 million people to 203.3 million. New Jersey, being a vast bedroom community for New York City and Philadelphia, saw its population grow by nearly one-half (48.3 percent), from 4.8 million people in 1950 to 7.2 million in 1970, as its share of the nation's population increased from 3.2 percent to 3.5 percent. This was the state's highest share since 1800 (when it had been 4.0 percent).

Middlesex County was one of New Jersey's most intense zones of residential development because of its extensive road networks and regional connectivity. The county's population more than doubled (120.4 percent) during this period, increasing from 264,872 people in 1950 to 583,813 in 1970, mostly in its new automobile-centric suburban developments. As a result, its share of the state's population jumped from 5.5 percent to 8.1 percent. In contrast, New Brunswick's population, although still growing, increased by only 7.9 percent in the same period, with most of this growth occurring in the 1950s, when the last of its vacant tracts of residentially zoned land were finally developed. The city's population grew from 38,811 persons in 1950 to 40,139 in 1960 and to just 41,885 in 1970. Its share of Middlesex County's population steadily declined—from 14.7 percent (1950) to 9.3 percent (1960) and to 7.2 percent (1970)—as the city was overshadowed by the burgeoning suburban communities surrounding it. To put its diminished scale in perspective, one hundred years earlier (1870), New Brunswick had dominated the county, accounting for more than one-third (33.4 percent) of Middlesex's population. By 1970, outside its county government functions, it was becoming an afterthought.

Over the next four decades (1970–2010), New Jersey lagged behind the population growth metrics of the United States. Its share of the nation's total population steadily fell from 3.5 percent (1970) to 2.9 percent (2010). This decline was pervasive throughout the Northeast starting in the 1970s, when the rise of the Sunbelt—the vast region stretching across the Southeast and Southwest—dominated demographic and economic headlines. However, within New Jersey, Middlesex County continually outpaced the state's growth rate, increasing its share of the state's population from 8.1 percent in 1970 to 9.2 percent in 2010. In fact, after 1980, the county's population growth rate nearly matched that of the nation.

In this broader state and county context, New Brunswick's population numbers were almost completely unchanged in the period 1970–1990: 41,885 people in 1970, 41,442 in 1980, and 41,711 in 1990. But starting in the 1990s, the city again became a destination for international immigration, mirroring the second half of the nineteenth century.[4] Its population increased to 48,573 people in 2000 and to 55,181 in 2010. And in the decades 1990–2000 and 2000–2010, New Brunswick's population growth rates exceeded those of the United States, New Jersey, and Middlesex County. As a result, its share of the county's population began to increase, from 6.2 percent in 1990 to 6.8 percent in 2010. Thus, New Brunswick's strong population growth in the first decade of the twenty-first century mirrored the first decade of the twentieth century.

The Composition of New Brunswick's Population: Who Were and Are New Brunswick's People?

The numbers presented in the previous section do not reveal much about who actually lived in New Brunswick. This section profiles New Brunswick's residents, starting with the original Native American inhabitants, and then considers major immigrant populations from Ireland, Germany, Hungary, Italy, Mexico, and other countries. Following is a summary of the city as a social crossroads, a story that reflects its changing racial and ethnic groups.

Native Americans

In 1524, Giovanni da Verrazano explored the mouth of the Raritan River for France (De Angelo 2007, 15). He was the first European to report contact with the native Lenape inhabitants. In 1609, Henry Hudson sailed into the Raritan River under contract to the Dutch East India Company, looking for a northwest passage to Asia. His reports of fertile land and amicable natives encouraged the Dutch government and other trading companies to explore and chart the area. Settlers followed in the 1600s and established the beginnings of a European-based community at New Brunswick. These early European explorers "encountered a coastline littered with large oyster shells and a handsome and fertile countryside marked by salt marshes, meadows, and forests of pine, oak, chestnut, and hickory" (Slesinski 2014, 9). Such a bucolic landscape was of course already occupied by the Lenape, the first known human inhabitants of Middlesex County (Nelson 2013).

The ancestors of the Lenape are believed to have migrated from Asia about fifteen thousand years ago across a then-existing land bridge to North America, and they migrated to the current Middle Atlantic region more than ten thousand years ago (Cohen 2006, 1; Nanticoke Lenni-Lenape 2007). The Lenape territory stretched from the Delaware Bay in the south through all of present-day New Jersey, western Long Island, New York Bay, and the Lower Hudson Valley in New York. "Lenape," from the Algonquin language, can be translated to mean "Original People." Among the Algonquian-speaking tribes on the East Coast, the Lenape were considered the "grandfathers" from whom other groups originated.

The tribe was divided into three clans: the Minci (Wolf), Unami (Turtle), and Unilachtigo (Turkey). Present-day Middlesex County would fall into Unami territory, although some archaeologists place the boundary between the Unami and the Minci along the Raritan River. The Lenape society was matriarchal: the men hunted, cleared the fields, and built homes, while the women cultivated the fields, raised crops, and controlled domestic life. The Lenape practiced exogamy, the custom of marrying specifically outside of the tribe (De Angelo 2007, 12–13).

Present-day New Brunswick stands near the former site of the Lenape village of Ahandewamock along the Raritan River. Such a village could be considered semipermanent. The Lenape moved with the seasons, retreating to the cooler shore areas in the heat of the summer, much like the annual tradition of many New Jersey residents today. In the autumn, the Lenape would return to their villages and harvest their crops (De Angelo 2007, 14–15). At the time of European contact, the Lenape practiced agriculture alongside hunting and fishing. The primary subsistence crops were corn, squash, and beans. Lenape men hunted deer, elk, bear, beaver, otter, muskrat, raccoon, mink, wild cats, and various fish and birds (Corté 2013, 3:1348). It is said that the Lenape would annually "feast on succulent oysters at the present site of . . . busy Newark Airport" (Cummings 2004, 1).

Prior to the arrival of European colonists, the Lenape contributed to a vast network of footpaths used by Algonquian- and Iroquoian-speaking tribes. Known as the Great Trail, these routes connected New England, eastern Canada, the mid-Atlantic region, and the Great Lakes region. Although these trails started out as single-file footpaths, they were eventually expanded and widened, later becoming the framework for major highways in the northeastern United States (De Angelo 2007, 15). One Native American trail, the Allamatunk, extended from the Delaware Water Gap to New Brunswick (Cross 1965, 47; Dowd 1992), and other Native American trails near New Brunswick were taken over by the colonial-era Upper and Lower Roads, which were later called the King's Highway, as discussed in chapter 1. Such a transportation network helps to dispel the notion that early explorers were walking upon "untouched wilderness"; indeed, in many ways, America was already a "humanized landscape," and Native Americans offered "much valuable information about its contents" (Zelinsky 1973, 16).

In 1651, Cornelis van Werckhoven, a Dutchman from Utrecht, was granted title to a large tract of land that stretched from the Arthur Kill in the east to the Raritan River in the south and the Passaic River in the north. The territory encompassed all of present-day Middlesex County north of the Raritan River (De Angelo 2007, 16). In 1661, the Dutch government, looking to encourage prospective settlers to colonize New Jersey, described the area as having "the best climate in the whole world" and emphasized the "great profit to be derived from traffique with the natives" (ibid., 17). Land in the New Brunswick area officially changed hands in 1678 with the first purchase by Europeans from the local Native American inhabitants. From this point forward, numerous Dutch homesteads were

established on the north bank of the Raritan River, eventually forming Dutch Village, across the river from present-day New Brunswick.

The fate of the Lenape was not much different from that of other Native American tribes: a sequence of disease, death, disenfranchisement, and eventually displacement farther west. "The American Indian population of New Jersey, it is estimated, quickly dwindled to between twenty-four hundred and three thousand in 1700, to less than one thousand in 1763, and to fewer than two hundred by 1800" (Lurie 2010, 3).

As the Lenape largely disappeared, European settlement continued apace. By the late seventeenth century, John Inian had established a ferry across the Raritan River approximately where the bridge connecting Highland Park to New Brunswick stands today. Inian's Ferry became one of the early names for the area. A less inviting one was Prigmore's Swamp (*City of New Brunswick* 1979, 3). By the late 1720s, the town was home to English people, Dutch settlers from Albany (thus the name Albany Street), Scots, Irish, Germans, French Huguenots, and a sizable enslaved black population, estimated to be perhaps 10 percent of the total. In 1730, New Brunswick was incorporated as a city (ibid., 26); Elizabeth, Newark, and Piscataway had been chartered in 1664, 1666, and 1667, respectively. It was natural that a trade town at the crossroads of the region would attract a diverse population. Some of the city's major immigrant groups will be described after first considering larger immigration trends.

National, New Jersey, and New Brunswick Immigration Trends

Broadly speaking, since 1850 the United States has undergone two major waves of immigration, which are reflected in the foreign-born proportion of the total population over the past 160 years (figure 2.1). From 1850 to 1910, the total foreign-born population in the United States grew, and its percentage of the total population generally rose as well, from 9.7 percent in 1850 to 14.7 percent in 1910. Immigration restrictions in the 1910s and 1920s resulted in a decline of the country's foreign-born population in absolute terms and as a percentage of the total population, which reached a low of 4.7 percent in 1970. Immigration reforms in the 1960s removed many barriers to legal immigration, and the foreign-born population has climbed every decade since 1970, reaching 12.9 percent of the total national population in 2010 (figure 2.1).

Despite a return to foreign-born levels not seen since the late 1800s and early 1900s, the national composition of the foreign-born population has changed dramatically.[5] From 1850 to 1960, 75 percent or more of the foreign-born population came from Europe. With a loosening of immigration laws, the foreign-born population in the United States from 1960 to 2010 has been dominated by immigrants born in Latin America, a cohort that has grown from 9.4 percent in 1960 to more than 53 percent by 2010. Immigrants born in Asia have been the other major component of the foreign-born population during this period, increasing from about 5 percent in 1960 to about 28 percent in 2010. The

Fig 2.1 Percentage of the Foreign-Born Population in the United States, State of New Jersey, and New Brunswick, 1850–2010

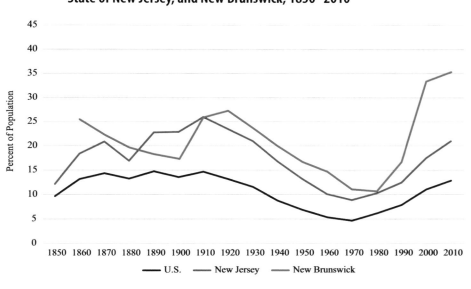

SOURCES: Grieco, Acosta et al. 2012; Gibson n.d.; United States Decennial Census.
NOTE: The percentage foreign-born population is not available for New Brunswick for 1850.

last few decades have also seen modest growth in the number of immigrants from Africa, but this group made up only about 4 percent of the total foreign-born population in 2010.

The leading countries of origin for the U.S. foreign-born population have also shifted dramatically over the last century and a half. From 1850 to 1870, Ireland supplied the largest number of immigrants, followed by Germany from 1880 to 1920, and by Italy from 1930 to 1970. Since 1980, Mexico has remained the leading country of origin, and the number of Mexican-born immigrants is by far the largest single foreign-born population in the history of the United States. In 2010, the Mexican-born population in the United States reached 11,711,000 (out of a total national population of about 309 million in 2010), compared to the 2,167,000 immigrants born in China, the second leading country of origin. Prior to 1980, the 1890 German-born population of 2,785,000 was the largest single foreign-born population for any year.

In New Jersey, overall foreign-born trends have followed national trends, though accounting for a higher proportion of the population (Shaw 1994). The share of New Jersey's population that is foreign-born (figure 2.1) has been roughly 1.5 to 2.0 times greater than the national share from 1850 to 2010. For instance, in 2010, New Jersey's foreign-born population made up 21 percent of its total population, compared to 12.9 percent nationally. New Jersey's proximity to the major immigrant gateway of New York City has always been a primary contributor to the state's large foreign-born population. As in the United States as a whole,

the New Jersey foreign-born population increased from 1850 to 1910, declined from 1910 to 1970, and has grown every decade since (figure 2.1).

The composition of New Jersey's foreign-born population has also been similar to that of the United States as a whole. In 1860, more than a third of the state's foreign-born population had come from Ireland. British and German immigrants also made up large portions of the total population. From 1880 to 1920, Italians overtook the Irish and Germans as the largest immigrant group in New Jersey. After immigration quotas were removed in the 1960s, Latin American and Asian immigrants began to account for New Jersey's major foreign-born populations, a trend that has continued until today. Within New Jersey's Asian foreign-born population, India is the most frequent country of origin, compared to China (including Hong Kong and Taiwan) for the United States as a whole. Mexico is the country of origin for the largest portion of New Jersey's Latin American population.

Just as the state of New Jersey has a higher foreign-born population share relative to the nation, New Brunswick's share has generally exceeded the state's from 1850 to 2010 (fig. 2.1). Between 1860 and 1920, the foreign-born made up around a quarter of New Brunswick's total population, a share that declined from 1920 (27.3 percent) to 1980 (10.7 percent). Since 1980, New Brunswick's foreign-born proportion has risen steadily to 16.7 percent in 1990, 33.4 percent in 2000, and 38.3 percent in 2010, almost double the 2010 foreign-born rate for New Jersey as a whole (figure 2.1).

As in New Jersey, New Brunswick's foreign-born population in 1860 was overwhelmingly Irish (70 percent), with the remainder mostly German (15.2 percent). However, by the early twentieth century, New Brunswick's sizable Hungarian-born population distinguished the city's foreign-born profile from New Jersey's. By 1910, about 41 percent of New Brunswick's foreign-born population was from Hungary, whereas Hungarian immigrants made up less than 8 percent of the state's foreign-born population. Since 1910, however, New Brunswick's foreign-born Hungarian population has declined each decade and made up only 0.2 percent of the city's foreign-born population in 2010. In that same year, immigrants from Asia accounted for only 9.9 percent of New Brunswick's total foreign-born population, compared to 31 percent for New Jersey as a whole.

The other major immigration trend separating New Brunswick from New Jersey is its Mexican foreign-born population. Statewide in 2010, immigrants from Mexico constituted about 7 percent of all foreign-born persons; in New Brunswick, this group made up 47.5 percent of the foreign-born population. The growth of the city's Mexican foreign-born population is a fairly recent phenomenon. In 1980, only 23 New Brunswick residents had been born in Mexico (0.5 percent of the city's foreign-born population). This number has grown steadily: 332 in 1990 (4.8 percent of the city's foreign-born population); 6,134 in 2000 (37.8 percent); and 9,273 in 2010 (47.5 percent).

With this overview in mind, the sections that follow provide some background on New Brunswick's major immigrant groups.[6]

The Irish Community

Irish immigrants arrived in New Brunswick in the early eighteenth century (Byrne 1982, 6). Some came as indentured servants who agreed to work for a specified number of years in exchange for passage to the New World. However, most Irish immigrants in this first wave had owned land and were educated. They left from Northern Ireland and were mostly Presbyterian.

Notable Irish citizens who passed through early New Brunswick included William Paterson (County Antrim, Northern Ireland), who served as a delegate to the U.S. Constitutional Convention, a U.S. senator, the second governor of New Jersey, and an associate justice of the U.S. Supreme Court. His law office was in New Brunswick. John Neilson Jr. (1745–1833) was born in Raritan Landing, the son of an immigrant from Belfast. As a shipping merchant in New Brunswick, Neilson became a well-known Revolutionary sympathizer, and he gave one of the earliest readings of the Declaration of Independence before a crowd at the corner of present-day Neilson and Albany Streets. His son James Neilson (1784–1862) was also a prominent New Brunswick businessman and in 1830 built Wood Lawn mansion, which is now the home of Rutgers University's Eagleton Institute of Politics (Rutgers University, Eagleton Institute of Politics n.d.).

Between 1820 and 1870, 7.5 million Irish immigrants arrived in America, nearly 2 million of them during the decade 1845–1855, owing to the Great Famine of 1846–1849 (Donnelly 2011; Foster 1989, 318).[7] This wave was felt by almost all American cities, including New Brunswick. The period when many Irish came to New Brunswick serendipitously coincided with the city's rise as a yet more important industrial powerhouse with the establishment of such factories as Howell Wallpaper (1836), New Jersey Rubber Shoe (1839), Letson Rubber (1842), and McCrellis Carriage (1851) (Byrne 1982, 62–63).

In 1831, a Roman Catholic church was constructed on Bayard Street (Byrne 1982, 63). By the 1850s, the expanding Irish Catholic population required a new church, Saint Peter's on Somerset Street. With the growing Catholic community came accompanying social services, including a hospital, an orphanage, and a cemetery. Four years before the first free public school opened, the church had already established a grammar school.

In addition to industry-related jobs, the Irish were attracted to New Brunswick for its large-scale construction projects. Major enterprises included a new railroad bridge across the Raritan River and, in 1830, the digging of the Delaware and Raritan Canal. The Irish worked from dawn to dusk on the canal for a dollar a day, six days per week; unfortunately, many died in an 1832 cholera outbreak (Lawlor 2010). Almost every waterway built in New Jersey between 1825 and 1850 had a largely Irish workforce (Quinn 2004, 65). Later construction projects that employed significant numbers of Irish workers included the trolley car tracks, the Albany Street Bridge (along with Italians and Chinese; Serrill 1980), and, in 1877, the local sewer system. Like other groups, the Irish experienced anti-immigrant sentiments at times: New Brunswick's Children's Industrial

Home rejected Irish-Catholic orphans, and more generally in the United States employers would sometimes specify "No Irish Need Apply" (Duffy 2014, 148). But through employment and other means, the community was able to enter and assimilate into mainstream American society. In time, the wave of Irish immigration to New Brunswick dissipated. The city's Irish-born population declined from 2,010 in 1860 (70 percent of the foreign-born population) to 919 by 1910 (15.2 percent), 618 by 1920 (6.9 percent), 238 by 1940 (3.6 percent), and was under 100 in subsequent decennial counts. It was at a nadir of 4 in 2000 (0.2 percent) as the number and share of other foreign-born populations became more significant in the city.

The German Community

The German community in New Brunswick was associated primarily with the first period of immigration to the United States, from 1830 to 1880, called the "old" immigration. In these decades almost all immigrants came from Ireland, Germany, and Great Britain. However, a German presence is known in New Brunswick even earlier. The First Reformed Church in New Brunswick, also known as the Dutch Reformed Church, a congregation organized in 1717, recorded baptisms of German children as early as 1731 (Maugham 1982, 50). It is possible that Germans found their way to New Brunswick while traveling on the King's Highway. German immigrants who arrived in America through New York would often journey south to Pennsylvania, which had somewhere between 65,000 and 100,000 ethnically German residents by the time of the American Revolution. Perhaps the available fertile land enticed the new settlers to join the Dutch and English then living in New Brunswick (ibid., 51).

Some Germans participated in New Brunswick's shipping and factory businesses, while others cultivated the surrounding lands as farmers. A ship owner, James Bishop, imported raw rubber from South America, which was used by Horace Dey and other Germans operating rubber factories in New Brunswick (Maugham 1982). Christopher Meyer of Hanover, Germany, found his way to New Brunswick in 1838 (Garmm 1938), worked for Dey, and went on to invent "most of the machinery and processes used for the manufacture of rubber goods" (Maugham 1982, 53). In 1853, together with a partner, Meyer formed the Novelty Rubber Company, which recruited workers from Germany. At this time, following the Revolution of 1848, almost a million German immigrants arrived in America, many fleeing political persecution.

Other Germans settling in New Brunswick found employment in the carriage factory, James Neilson's cotton mill, and the New Brunswick Hosiery factory; leather workers were attracted to the prominent local shoe factories. Still others became store owners in the New Brunswick shopping district or took up professional occupations in law, medicine, education, and engineering (Maugham 1982, 53). Cecilia Clafen's grandfather emigrated from Germany at the age of fourteen, learned English, and became an astute businessman, ultimately owning an apartment building (with ground-floor stores) at 410 George Street.[8] Germans in time

became involved in local government, serving as aldermen and members of the city council and board of education (Maugham 1982, 53).

In 1851, the Third Reformed Church was established to accommodate the large German population, many of whom wished to hear services in the mother tongue (Maugham 1982, 53). Ten years later, Saint John's German Reformed Church was organized, and the two churches soon merged, with a total membership of sixty. The congregation constructed a new edifice capable of seating 500 parishioners at the corner of Livingston Avenue and Suydam Street. The name was then changed to Livingston Avenue Reformed Church (Maugham 1982, 54). Saint John the Baptist (1867) and the German Evangelisch Emanuels Lutheran Church (1878) were established to accommodate German Catholics and Lutherans, respectively. Not all social activity was ecclesiastical; there were nine German lodges with singing societies and fraternal organizations in New Brunswick (Serrill 1980).

The number of German immigrants in New Brunswick rose from 439 in 1860 (15.2 percent of the city's foreign-born population) to 818 in 1910 (13.5 percent) and then declined to 637 in 1920 (7.1 percent), 430 in 1940, 345 in 1950, and fell to about 200 or fewer (about 0.2 percent) in succeeding decades. It reached a nadir of 20 in 2010. The German share of New Brunswick's foreign-born population was thus never as significant as that of the Irish or the Hungarians.

The Hungarian Community

As late as the 1860 census, only one foreign-born Hungarian was counted in New Brunswick out of a total city population of 11,287 and a total foreign-born population of 2,880. But underrepresentation would soon end both nationally and in New Brunswick. Large-scale Hungarian immigration to the United States began in 1880 (Molnar 1982, 84). People left for many reasons: political, personal, and economic. The father of one New Brunswick resident was in the Austro-Hungarian army and "didn't like the way things were going so he left and came to the United States" (Borbely 2009, 3). The majority of the Hungarian immigrants who arrived during the 1880s were agricultural laborers, many of whom expected to return to Hungary after earning enough money "to improve their own and their family's economic base at home" (Molnar 1982, 84).

Alongside the farm laborers looking to escape a dreary peasant existence were immigrants drawn by family members' descriptions of employment opportunities in New Brunswick's factories. At one point, two-thirds of Johnson & Johnson factory employees were of Hungarian descent, and the corporation acquired the colloquial nickname "Hungarian University" (Gurowitz 2008, chap. 57; Karasik and Aschkeynes 1999, 100). According to J&J's company historian, "It was not unusual for several members of the same extended family—parents, aunts and uncles—and also multiple generations in the same family to work for Johnson & Johnson" (Gurowitz 2008, chap. 57). Hungarian employees often spent their entire working lives at J&J because of the generous benefits and steady employment (ibid.; Molnar 1982, 86). Moreover, "if you couldn't speak Hungarian, you couldn't

be a superintendent in the [J&J] plant because most of the people working there were Hungarian" (Borbely 2009, 3). Not surprisingly, many New Brunswick residents of Hungarian descent thought highly of J&J's contributions to the city. One remarked on the city's luck: "Talk about a city being on the right street corner at the right time . . . we have to thank Johnson & Johnson for being the savior of New Brunswick" (ibid., 19).

By 1910, 2,463 immigrants born in Hungary lived in the city, accounting for a very significant 40.7 percent of New Brunswick total foreign-born residents (6,048) and 10.5 percent of New Brunswick's total population (23,388) in that year. Perhaps it was at this time that New Brunswick acquired its reputation as "the most Hungarian city in the United States" (Gurowitz 2008, chap. 57). In addition to employment at J&J, these early Hungarian residents worked for various manufacturers in the area: the Rubber Shoe and Boot factory in Milltown, and, in New Brunswick, General Cigar Company, Consolidated Fruit Jar Company, John Waldron Foundry, Empire Foundry, India Rubber, United States Rubber, and various wallpaper factories. In a 1921 appreciation of New Brunswick's Hungarian residents, the Reverend S. Laky claimed, "It would be rather difficult to find a factory in New Brunswick where no Hungarian could be found" (Laky 1921).

Much of the Hungarian settlement in New Brunswick centered around the Fifth and Sixth Wards, neighborhoods located close to the river and the factories there. Laky remarked, "On Plum, Prospect, High, and Scott Streets one would hardly find other property owners than Magyars" (Laky 1921). With the increased Hungarian population came churches and social institutions, such as the First Magyar Reformed Church (founded in 1903), the Hungarian American Athletic Club (1913), a Hungarian print shop (1909), a burial and sick benefit society, and even an amateur theater troupe. James Borbley, born in the United States in 1921 to Hungarian immigrants and raised in New Brunswick, spoke of the close association with other Hungarians at the church he attended in the city: "We used that as our [center] . . . to be in plays and go to summer school and so that was our social network" (Borbely 2009, 3). One Hungarian immigrant who came to New Brunswick shortly after World War II was drawn to the city because his family had Hungarian friends who had earlier come to New Brunswick.[9] In 1922, the Magyar Building and Loan Association was chartered with 110 members and nearly $3,000 in deposits. The number of foreign-born Hungarians in the city totaled 3,209 in 1920, 2,304 in 1940, and 1,928 in 1950, accounting for about one-third of New Brunswick's foreign-born residents recorded in those decennial census enumerations.

The Hungarian community experienced two significant changes in the post–World War II period. First, with the turn toward suburban living, fewer Hungarians remained in close proximity to other families and cultural institutions in New Brunswick. The second major change came following the 1956 Hungarian Revolution, a nationwide revolt against the government of the Hungarian People's Republic and its Soviet-imposed policies. After the revolution was crushed, more than 200,000 Hungarians fled the country. From November 1956 until June 1957,

Camp Kilmer, across the Raritan River in Edison, took in 32,000 refugees. Eventually, 3,000 of them settled in the New Brunswick area, about 1,000 of them in New Brunswick itself (Karasik and Aschkenes 1999, 102). These new residents helped to revive a Hungarian culture in the city that had been slowly dying out. But the revival was short-lived: by 1980, there were only 561 Hungarian-born residents in the city, composing 12.7 percent of the community's total foreign-born population (4,419). The number of Hungarian-born residents and their share of the community's foreign-born population continued to decline: 298 in 1990 (4.3 percent), 140 in 2000 (0.9 percent), and 43 in 2010 (0.2 percent).

Nevertheless, the American Hungarian Foundation continues at 300 Somerset Street in New Brunswick. Formed in the mid-1950s to further the understanding and appreciation of the Hungarian cultural and historical heritage in the United States, it is housed in a former factory. The foundation operates a museum, library, and archives to collect documents and artifacts and to display them to the public. The museum has attracted more than 80,000 visitors since its opening in 1989.[10]

The Italian Community

In the 1860 census, only one person born in Italy was counted among New Brunswick's 2,880 foreign-born residents and the city's total population of 11,287. That presence would grow. Italian immigration to the United States was part of the "new" immigration wave that occurred after 1880 and brought people from southern and eastern Europe, including Poland, Italy, Russia, the Austro-Hungarian Empire, and elsewhere. The Italians came mostly from Sicily and the southern provinces of mainland Italy. Many were male unskilled laborers with the goal of "earning enough money to return to Italy and purchase a piece of land." However, about two-thirds of these early immigrants decided to stay in America and were soon joined by their families (Pane 1982, 96).

Early Italians listed in the 1866 New Brunswick Directory included Charles Conradi, a hairdresser on Peace Street, Henry Cordo, a laborer, and Justus Pasco, a machinist (Pane 1982, 97). The 1897 directory listed thirteen Italians, including three fruit dealers, two laborers, two clerks, two junk dealers, a tailor, a shoemaker, a ragman, and Rose Cereghino, a Johnson & Johnson employee; four years later, there were thirty-eight Italian names in the directory (ibid., 98). The 1910 federal census counted 344 Italian-born residents, about 6 percent of the city's total foreign-born population in that year (6,048).

Italian immigrants and their descendants found work mainly in skilled trades and as unskilled laborers in the construction and manufacturing industries. Many sidewalks in New Brunswick were laid by Italian workers. Other Italians worked in factories and for the large local corporations, such as Johnson & Johnson and Squibb; at one point, Bond Clothes had a workforce that was 95 percent Italian (Pane 1982, 100).

The Italian parish of Saint Mary of Mount Virgin was founded in 1904, and by the 1930s this church served 700 families (Pane 1982, 99). In addition, a significant

number of Italians attended New Brunswick's Saint Peter's Church, established nearly a century earlier to serve the city's then-large Irish population. While the church was the center of social activity for many Italians, various fraternal, social, and political groups offered other outlets. These included: the Italian Political Club (founded in 1922), the Italian-American Women's Republican Club, the Italian American Fusion League, the New Brunswick Italian Club (1934), the mutual aid society San Pier Niceto (1939), Saint Mary's Boys Band (1931), and the Congregazione di Maria S.S. di Montecarmelo (1924), which presented a Passion Play in Italian in the city for many years.

The 1920, 1940, and 1950 census enumerations counted about 1,000 to 1,200 Italian-born residents in New Brunswick, and in both 1940 and 1950 this group composed about 18 percent of the city's total foreign-born population. By the 1960s and 1970s, however, many Italians had joined the white migration to surrounding suburban communities. The number of Italian-born residents in New Brunswick declined: 430 in 1980 (9.7 percent of the total foreign-born population), 164 in 1990 (2.3 percent), 30 in 2000 (0.2 percent), and 80 in 2010 (0.4 percent).

In addition to its foreign-born residents, New Brunswick's racial and ethnic groups are key components of its demographic mosaic. These will be detailed in the following section after a broader consideration of racial and ethnic demographic trends in the United States, New Jersey, and New Brunswick.

National, New Jersey, and New Brunswick Racial and Ethnic Trends

It is important to acknowledge that the decennial census identification of race in the United States has changed over time in terms of both the means of assignment (by a census enumerator or by the census respondent) and the racial categories (that is, one race alone or mixed racial groups and the specific number, type, and nomenclature of racial groups) (Cohn 2010; Rastogi et al. 2011). Of particular note, there was a marked change in the racial enumeration before and after the 2000 census (Cohn 2014). Additionally, racial and ethnic minorities are likely to be undercounted in census enumerations (Cressie 1988, 123; Skerry 2000). For these reasons, caution is in order when considering census-based racial and ethnic data over time (especially pre- and post-2000); the census-derived racial information presented here is best viewed on an order-of-magnitude basis. Further, the racial presentation that follows in both text and tabular form (tables 2.3 to 2.5 and figures 2.2 and 2.3) focuses on the two major racial groups, white and black, that have historically composed most of New Brunswick's population; it does not detail additional racial groups, such as Asian or Native Americans, which constitute a much smaller share of the city's population relative to whites and blacks.[11]

Nationally, as detailed in table 2.3, the white population share of the total population in the United States generally grew (with some fluctuation) during the period from 1850 (84.3 percent) to 1940 (89.8 percent), and it has shrunk every decade since (87.5 percent in 1970, 80.3 percent in 1990, and 72.4 percent in

Table 2.3 White Population as Percentage of Total Population

YEAR	UNITED STATES	NEW JERSEY	NEW BRUNSWICK
1850	84.3	95.1	95.1
1860	85.6	96.2	95.3
1870	87.1	96.6	96.1
1880	86.5	96.5	95.7
1890	87.5	96.7	95.9
1900	87.9	96.2	96.1
1910	88.9	96.4	97.0
1920	89.7	96.2	96.5
1930	89.8	94.8	93.9
1940	89.8	94.5	93.6
1950	89.5	93.3	89.6
1960	88.6	91.3	84.2
1970	87.5	88.6	75.9
1980	83.1	83.2	63.1
1990	80.3	79.3	57.4
2000	75.1	72.6	48.8
2010	72.4	68.6	45.4

SOURCE: Decennial census for indicated years.
NOTE: 2000 and 2010 are white alone (see figure 2.2 for accompanying chart).

Fig 2.2 White Population as a Percentage of Total Population 1850–2010

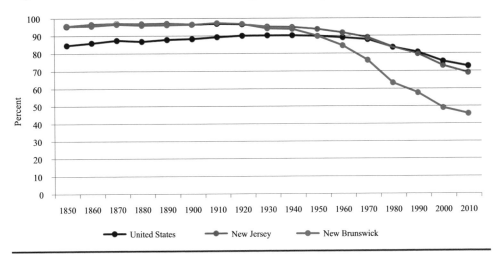

SOURCE: Decennial census for indicated years.
NOTE: Beginning in 2000, the Census Bureau began to identify race differently than in previous censuses, allowing people to select a single race (such as "white alone") or multiple races (such as "white: Asian"). Prior to 2000, people were identified as a single race only. Additionally, starting in 2000 people could select "some other race" if they did not self-identify with the census racial categories. The data in this figure for 2000 and 2010 are white alone (that is, the population identifying as white only), including both Hispanic and non-Hispanic whites.

Table 2.4 Black Population as Percentage of Total Population

YEAR	UNITED STATES	NEW JERSEY	NEW BRUNSWICK
1850	15.7	4.9	4.7
1860	14.1	3.8	4.4
1870	12.7	3.4	3.8
1880	13.1	3.4	4.3
1890	11.9	3.3	4.0
1900	11.6	3.7	3.8
1910	10.7	3.5	3.0
1920	9.9	3.7	3.4
1930	9.7	5.2	6.0
1940	9.8	5.5	6.3
1950	10.0	6.6	10.2
1960	10.5	8.5	15.4
1970	11.1	10.7	22.7
1980	11.7	12.6	28.5
1990	12.1	13.4	29.6
2000	12.3	13.6	23.0
2010	12.6	13.7	16.0

SOURCE: Decennial census for indicated years.
NOTE: 2000 and 2010 are black alone (see figure 2.3 for accompanying chart). For 1850 and 1860, the U.S. black population includes both the free and slave populations, while the New Jersey and New Brunswick population includes free only. The slave population in New Jersey was less than 1 percent of the total black population by 1850 and less than 0.1 percent by 1860.

2010). The white proportion of New Jersey's population, on the other hand, remained relatively stable from 1850 (95.1 percent) to 1920 (96.2 percent), before beginning to decline at a faster rate than the national proportion. New Jersey's white population share dropped below the national average for the first time in 1990 (79.3 percent) and has remained lower in the decades since. New Brunswick's white population share closely followed that of New Jersey's from 1850 to about 1930, before beginning a steep decline that has continued through the 2010 census. New Brunswick was overwhelmingly white (90 percent or more) from the mid-nineteenth to the mid-twentieth century; after 1950, when the city was just under nine-tenths white (89.6 percent), the white share of New Brunswick's population dropped rapidly to about three-quarters (75.9 percent) in 1970, about six-tenths in both 1980 (63.1 percent) and 1990 (57.4 percent), and then under half from 2000 onward. By 2010, New Brunswick's white population accounted for only 45.4 percent of the total population, compared to a New Jersey average of 68.6 percent. This steep decline in New Brunswick's white population, in both relative and absolute terms, is consistent with the broader white migration from urban areas that was seen around the country, as well as with the overall decline in the white portion of the country's total population.

Fig 2.3 Black Population as Percentage of Total Population, 1850–2010

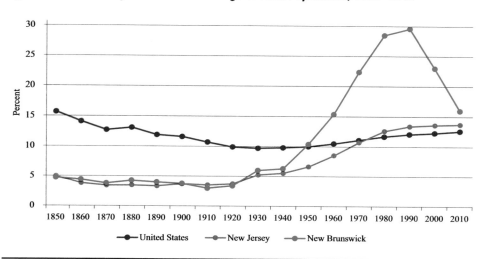

SOURCE: Decennial census for indicated years.
NOTE: Beginning in 2000, the Census Bureau began to identify race differently than in previous censuses, allowing people to select a single race (such as "black alone") or multiple races (such as "black or African American; Asian"). Prior to 2000, people were identified as a single race only. Additionally, starting in 2000 people could select "some other race" if they did not self-identify with the census racial categories. The data in this figure for 2000 and 2010 are black alone (that is, the population identifying as black only), including both Hispanic and non-Hispanic blacks.

The portion of the population identifying as black from 1850 to 2010 varies significantly for the United States, New Jersey, and New Brunswick, reflecting divergent migration patterns and other trends (table 2.4 and figure 2.3). For the United States as a whole, the black population declined as a portion of total population from 1850 (15.7 percent) to 1930 (9.7 percent), before beginning a period of moderate but steady growth from 1940 (9.8 percent) to 2010 (12.6 percent). The black population share in New Jersey, on the other hand, was historically much smaller than in the United States as whole, but it has seen growth in most decades from 1910 to 2010. In 1910, for instance, New Jersey's black population share was 3.5 percent compared to 10.7 percent for the United States as a whole. By 1980, the black population share in New Jersey (12.6 percent) had surpassed that in the United States overall (11.7 percent), and it has remained higher every decade since.

The growth of New Jersey's black population is primarily a result of migration from the rural South, which explains its sustained growth even during periods when the black proportion of the total U.S. population declined. World War I and World War II catalyzed major black movements to the North, and New Jersey absorbed a sizable number of these migrants. Research has also identified the period roughly from 1945 to 1970 as a major growth period for New Jersey's black population (Wright 1989); blacks accounted for 6.6 percent of all New Jersey residents in 1950 and 10.7 percent by 1970.

New Brunswick's black population share closely followed New Jersey's from 1850 to 1940 (ranging from about 3 to 6 percent; see table 2.4) before increasing

more rapidly than New Jersey's from 1940 to 1990. The number of black residents in New Brunswick grew from 3,973 in 1950 to 12,337 in 1990 (table 2.5). This rapid black population growth is consistent with the increasing concentration of New Jersey's black population in urban areas in the northern half of the state in the second half of the twentieth century (Shaw 1994). From 1990 to 2010, however, New Brunswick's black population share of all residents shrank from a high of 29.6 percent to 16.0 percent. (The 2010 share is for "black alone.") This decrease was a result of both an absolute decline in the black population and an influx of nonblack residents. The change in the census enumeration of race must also be taken into account. In 1990, the census counted 12,337 blacks in New Brunswick (up from 11,811 in 1980), and there were 3,664 persons of "other" races. In 2010, the "black alone" enumeration (a post-2000 census category) stood at 8,852, in addition to 14,122 persons of "some other race" and 2,424 persons of "mixed race"

Table 2.5 Race and Ethnicity in New Brunswick, 1850–2010

YEAR	TOTAL POPULATION	WHITE POPULATION[a]	% WHITE	BLACK POPULATION	% BLACK	HISPANIC POPULATION[b]	% HISPANIC
1850	10,019	9,533	95.1	475	4.7		
1860	11,287	10,761	95.3	495	4.4		
1870	15,058	14,472	96.1	577	3.8		
1880	17,166	16,430	95.7	732	4.3		
1890	18,603	17,843	95.9	744	4.0		
1900	20,006	19,233	96.1	755	3.8		
1910	23,388	22,681	97.0	690	3.0		
1920	32,779	31,634	96.5	1,124	3.4		
1930	34,555	32,450	93.9	2,086	6.0		
1940	33,180	31,069	93.6	2,098	6.3		
1950	38,811	34,783	89.6	3,973	10.2		
1960	40,139	33,810	84.2	6,187	15.4		
1970	41,885	31,792	75.9	9,517	22.7		
1980	41,442	26,145	63.1	11,811	28.5	4,883	11.8
1990	41,711	23,929	57.4	12,337	29.6	8,063	19.3
2000	48,573	23,701	48.8	11,185	23.0	18,947	39.0
2010	55,181	25,071	45.4	8,852	16.0	27,553	49.9

SOURCE: Decennial census for indicated years.
NOTE: 2000 and 2010 is black alone (see figure 2.3 for accompanying chart). For 1850 and 1860, the U.S. black population includes both the free and slave populations, while the New Jersey and New Brunswick population includes free only. The slave population in New Jersey was less than 1% of the total black population by 1850 and less than 0.1% by 1860.

[a]The white population includes both Hispanic and non-Hispanic whites. The white non-Hispanic population was 24,240 in 1980, 20,526 in 1990, 15,964 in 2000 (white alone), and 14,761 in 2010 (white alone).

[b]Hispanic population includes Hispanic persons of any race.

in the city. For larger context, New Jersey's black population grew only moder-
ately during this same period (13.4 percent of total population in 1990 and 13.7
percent of total population in 2010); as of 2010, New Brunswick's black popula-
tion share of all residents (16.0 percent) was still more than 2 percent higher than
New Jersey's (table 2.4).

Although the white and black populations have constituted the majority of
New Brunswick's residents as enumerated by race since 1980, additional racial
groups also contribute to New Brunswick's total population. Changes in census
racial categories over time make direct comparison from census to census impos-
sible, but some general trends emerge from the data. While both the black and the
white shares of New Brunswick's population have fallen from 1980 to 2010, the
Asian share has increased every decade, from 547 (1.3 percent of total city popu-
lation) in 1980 to 4,195 (7.6 percent) in 2010. Another growing racial category is

Table 2.6 **Hispanic Population as Percentage of Total Population**

YEAR	UNITED STATES	NEW JERSEY	NEW BRUNSWICK
1980	6.4	6.7	11.8
1990	9.0	9.6	19.3
2000	12.5	13.3	39.0
2010	16.3	17.7	49.9

SOURCE: Decennial census for indicated years.
NOTE: 1980 percentage is for "Spanish Origin." In 1990, the Census Bureau used "Hispanic Origin" and beginning in 2000 switched to
"Hispanic or Latino."

Fig 2.4 **Hispanic Population as a Percentage of Total Population, 1980–2010**

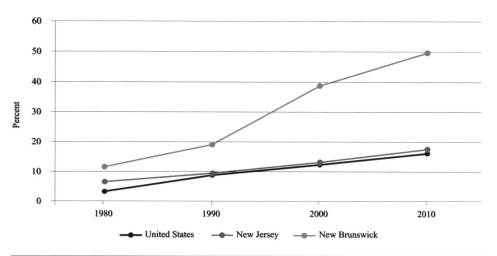

SOURCE: Decennial census for indicated years.

"other race" or "some other race," which increased from 2,829 "other race" (6.8 percent of total city population) in 1980 to 14,122 "some other race" (25.6 percent) in 2010. In addition, the 2010 census enumerated 2,424 persons of "mixed race" in New Brunswick (4.4 percent of total city population).

In addition to race, ethnic composition is an important demographic characteristic, and since 1980 the census has treated "Hispanic" as an ethnicity, meaning that those who identify as Hispanic can be of any race. Nationally, the Hispanic share of the country's total population has more than doubled, from just 6.4 percent in 1980 to 16.3 percent in 2010 (table 2.6 and figure 2.4). In absolute terms, the total Hispanic population in the United States increased 50 percent from 2000 to 2012, while the overall U.S. population increased only 12 percent during the same period (Brown 2014).

Since 1980, the growth of the Hispanic population share in New Jersey has very closely followed that in the United States as a whole. By 1980, New Brunswick's Hispanic population share (11.8 percent) was nearly double New Jersey's (6.7 percent) (table 2.6 and figure 2.4). From 1980 to 2010, this gulf widened as New Brunswick's Hispanic population share increased to 49.9 percent in 2010 (versus 17.7 percent for New Jersey) and to an estimated 53.6 percent according to the Census Bureau's 2009–2013 American Community Survey 5-Year Estimates.[12]

Unlike New Jersey's black population growth, which is driven primarily by domestic migration, the state's Hispanic population growth has historically been propelled by a combination of immigration and internal migration. The first wave of Hispanic migrants to New Jersey consisted of Puerto Ricans leaving economic turmoil in that U.S. territory caused by World War II. This group laid the groundwork for future emigration from the island. During the 1960s, Cubans immigrated to New Jersey in large numbers following Fidel Castro's revolution. By 1980, about 80 percent of New Jersey's Hispanic population was either Puerto Rican or Cuban, and less than 4 percent was Mexican (Shaw 1994). By 2010, nearly 14 percent of New Jersey's Hispanic population was Mexican, and more than 51 percent of New Brunswick's Hispanic population was Mexican; however, Hispanics in both the state and New Brunswick arrived from many countries.

Race and ethnicity are more than mere numbers. The sections below offer a narrative snapshot of New Brunswick's black and Hispanic communities.

The Black Community

The presence of a black community in the New Brunswick area can be traced to the earliest days of European settlement. When the Englishman John Inian established his ferry service across the Raritan River in 1681, "he used blacks for the heavy manual labor" (Stewart 1982, 77). A century later, the 1790 census found that black slaves composed one-twelfth of the Middlesex County population (Van Dyke 2000, 18). Some of the earliest census data (1810) for New Brunswick count 53 free blacks and 164 slaves. Those 217 blacks constituted 7.1 percent of New Brunswick's total population (3,042) in 1810. Statewide in 1810, there were 10,851 enslaved blacks among a total New Jersey population of about 245,000 (ibid.).

"Advertisements promoting the slave trade were commonly seen in the *New Brunswick Times . . .* and other New Jersey newspapers in 1810" (ibid.). The 1830 federal census of New Brunswick enumerated 558 blacks (57 slaves for life, 127 slaves for term, and 374 freed slaves), who accounted for 11.2 percent of New Brunswick's total 1830 population of 4,993. In 1838, New Brunswick was considered one of the most dangerous places for runaway slaves.[13] "New Brunswick, like every other community was deeply and tragically involved in racial oppression."[14]

Conditions for blacks in New Brunswick would improve over time. The New Brunswick African Association was founded in the city in 1817 for the "purpose of educating young men of color" (Hodges 1999, 219). Slavery was abolished by law in 1846, though New Jersey was the last northern state to pass abolition legislation (Cooley 1896, 438; Finkelman 1992, 755). By 1843, a free black man, Thomas Marsh, was the owner of the Temperance Restaurant at 148 Neilson Street in New Brunswick. In 1860, Stephen Lewis Brown operated a stagecoach line from New Brunswick to Princeton. A decade later, 130 black voters were registered. The first black student graduated from New Brunswick High School in 1895.

Churches were important in the lives of New Brunswick's blacks (Stewart 1982, 77–78). Christ Church, which dates to the mid-eighteenth century and is still active today, included black families in the congregation. Frank and Effie Hoagland were members in 1880; all fifteen of their children were baptized at the church, and two of their children are buried in the cemetery. The Methodist Church in New Brunswick, founded in the early 1800s, also received blacks. Mount Zion A.M.E. was established in 1827 on land donated by free blacks (now the site of the New Brunswick Spanish Seventh-Day Adventist Church, 25 Division Street). Jane and Joseph Hoagland were founding members of this church, which today is located at 39 Morris Street, near the site of the former Memorial Homes housing project discussed in chapter 5. In 1873, the Ebenezer Baptist Church was built by a group of black people, mostly from Mecklenburg County, Virginia, although black Baptists worshiped in the city as early as 1766. "Chippy's Chapel," Pentecostal Church, Bethel Church of God in Christ, and Saint Alban's Episcopal Church followed into the early twentieth century. Although blacks were allowed into churches with predominantly white congregations, they were usually forced to sit in the balcony or the last-row pews.

Blacks found employment in local factories and businesses but were generally restricted to menial roles. Pelton Swanna was a wagon driver who delivered products to customers for Johnson & Johnson, although the company generally did not employ blacks in its early years; such discrimination characterized many American businesses at the time. Not until after World War II were two black college graduates "among the first blacks hired by Johnson & Johnson in any notable capacity" (Stewart 1982, 78). Blacks could be found working in food services at Rutgers fraternity houses and the Bruns Catering Service, among other establishments in New Brunswick. A wave of black settlement in New Brunswick occurred in the late 1890s and early 1900s. These "hard working and community-minded" newcomers found employment in laundries, bakeries, small restaurants, rooming

houses, livery services, garages, carpentry shops, and construction jobs, even though blacks were generally barred from joining skilled trade unions (ibid., 75). The Nixon Nitration plant in New Brunswick was established by black entrepreneurs, as was a broom factory, among other businesses (ibid., 78).

In 1915, Paul Robeson became the third black student ever to enroll at Rutgers University, and he was the only black on campus at the time. He became a star football player, a member of the debate team, and a Phi Beta Kappa inductee; in his final year, he was awarded the Cap and Skull, an honor reserved for just four seniors who best represented the ideals and traditions of Rutgers. Robeson was considered a hero in the local black communities of Somerville, Princeton, and New Brunswick, not so much for his athletic feats as for his academic achievements. When he graduated, the New Brunswick YMCA presented him with a purse as a gesture of the local black community's respect and admiration (Boyle and Bunie 2002, 50). Today, the Paul Robeson Community School and Robeson Village public housing development in New Brunswick honor his name.

A study completed in 1942 interviewed one hundred black families in New Brunswick (Hill 1942). Of those, twenty-six families had been born in the city, and the remainder moved to New Brunswick (most often from Georgia, South Carolina, North Carolina, and Virginia) because of both "push and pull." The "push" came from poor educational opportunities and limited economic prospects in the South; the "pull" was hope for a better economic and social situation in New Brunswick.Some of the families had been recruited by agents for factories in the New Brunswick area. Among those interviewed, black women worked mostly as domestics, and black men held down industrial jobs. The survey revealed daunting problems in the community. The majority of the families "would not advise . . . other blacks . . . to locate in New Brunswick because of bad housing, lack of job opportunities, recreational facilities and poor race relations" (ibid., 117). As other researchers have documented, "Many, but not all, New Brunswick factories and businesses employed blacks, although for many years it was generally in menial capacities" (Stewart 1982, 78). It was not uncommon for blacks to be denied job titles and compensation commensurate with their capabilities and responsibilities.

Alice Jennings Archibald, a black woman who was born and raised in New Brunswick and graduated from the city's high school in 1923, recalled the everyday discrimination she and other black residents encountered and the tribulations and accomplishments of the city's black community in the twentieth century.[15] For example, as a girl going to movie theaters, she found these places "were kind of prejudice[d] in that they wanted to send you . . . of color, up to what they called the 'peanut gallery'" (7). Seeking a job as a teacher, she "found out you couldn't get in because of your color . . . when I graduated, there were no colored positions available" (8). After working at the Raritan Arsenal and other places, Archibald served as a staff person at the New Brunswick Urban League and saw some improvement in racial relations: "So the Urban League was instrumental in getting the first colored teachers in the schools" (26). The Urban League also

paved the way for black students to reside in dormitories at Douglass College (26), then the women's college of Rutgers University, and Archibald was the first black woman to graduate from the university's Graduate School of Education. She also shared many positive memories of New Brunswick: growing up, "we all loved to go downtown on Thursday nights. . . . Everyone you knew went downtown" (29). Archibald spoke of the "factory town" character of New Brunswick in its heyday: "Hungarians came here, settled here, got jobs at J&J . . . you had Squibb . . . the rubber factory . . . Rickitt's Blueing . . . United States Rubber. We had a lot of big plants here and people worked in there" (27).

During and following World War II, blacks became more visible in New Brunswick's business and professional sectors: Nelson H. Nicols set up a law practice in 1940; J. Herbert Carman became the first black policeman in 1943; and Dr. Herman Marrow established a dental practice on George Street. In 1945, the New Brunswick Urban League was founded under the leadership of Llewellyn E. Shivery; it was renamed the Civic League of Greater New Brunswick in 1983. The Urban League/Civic League has been involved in many supportive activities over time in New Brunswick and beyond, including housing (for example, advocating for tenants' rights in connection with New Brunswick's demolition of the Memorial Homes, as described in chapter 5), education (for example, involvement with Project 2000, which links corporate mentors with students), and community and neighborhood development (for example, partnering with black churches, New Brunswick Tomorrow, and others to improve conditions in the Georges Road Gateway area) (Brennan 2010).

As elsewhere in America, blacks in New Brunswick encountered various forms of discrimination. When in 1936 the Reverend William Byrnes Sr., who would ultimately become pastor emeritus of New Brunswick's Bethel Church of Christ, walked into a New Brunswick restaurant and sat down for lunch, a white employee came over and said, "You can't eat here" (Tamari 2004). Until the mid-1960s, a popular New Brunswick pool on Livingston Avenue and Reed Street was only open to members of the Sun and Splash Club and that club in turn was restricted to whites only (Hoffman 2007).

Although New Brunswick has been dominated by white politicians, there have been some exceptions. In 1967, Aldrage B. Cooper Jr. became the first black person elected to a seat on the city commission; he served as well as city council president and board of education member (Bradshaw 2015). In February 1974, Cooper was sworn in as the city's first black mayor, following the resignation of Patricia Sheehan, the city's first and to-date only female mayor. In 1978, Gilbert Nelson was appointed as mayor, to date the second and last black mayor of New Brunswick.

Historically, New Brunswick's black community has experienced both challenges and opportunities. These vicissitudes and other demographic forces resulted in a changing black population over time, from a modest start, to rapid growth in the postwar period, and, most recently, to some decline in numbers. In contrast, New Brunswick's Hispanic community has been flourishing in number.

The Latino Community

In 1980, the largest Latino church in New Brunswick, Our Lady of Mount Carmel on Morris Street, counted about 1,000 families in its congregation. By 2015, that number had risen to about 3,000, with 600 children baptized each year in the parish.[16] The first wave of Latino settlement in New Brunswick can be traced back to the family of Otilio Colon, which emigrated from Puerto Rico in 1948 (Colon 1982; Sanchez and Gutierrez 1982, 57). Early arrivals established grocery stores, barber shops, furniture stores, and repair shops. In 1959, the first two Puerto Rican students graduated from New Brunswick High School (Colon 1982).

In 1964, Otilio Colon became a member of the executive board of the Middlesex County Economic Opportunities Corporation. That same year, Epifanio Colon became the first Latino fireman in New Brunswick, and Guillermo Colon became the first local Latino policeman (Sanchez and Gutierrez 1982, 57). In 1966, Ana Celia Gonzalez became the first person of Hispanic origin to be employed by City Hall, serving as a case worker in the Welfare Department. Soon, Latinos could be found working for the Department of Public Safety, the board of education, in the public school system, and as the housing commissioner. In 1971, Mayor Patricia Sheehan appointed Blanquita Valenti to the board of education, the first Latina in the state to hold such a position.

In the 1980s, Hispanics in New Brunswick faced language, educational, vocational, and other challenges (Rojas 1981b); illegal Hispanic immigrants sometimes faced deportation (Cooke 1981). To address these challenges, various organizations, such as the Spanish-American Civic Association, the Hispanic American Resource Center, and the Puerto Rican Action Board (PRAB) mobilized to aid the city's Hispanic residents. PRAB was founded in 1969 by Puerto Rican volunteers to teach English to the newly arrived and to assist those seeking a high school equivalency diploma.[17] Two years later, it was incorporated as a nonprofit organization and shortly thereafter engaged in such activities as education (English as a second language and equivalency diploma programs) and bilingual/multicultural day care. In time, PRAB has expanded into a comprehensive human services organization involved in such activities as housing, early childhood education, and youth, family, and social services. In a 1976 *Home News* article announcing plans for Parque Bolivar, a new park envisioned adjacent to the Spanish Outreach Center, Jose Oyarzun, a member of the park board of directors, noted the Latino diversity in the city and the opportunity for unity: "Here in New Brunswick we have many Latin Americans—Puerto Ricans, Chileans, Argentineans, Cubans, Costa Ricans, and many more. . . . The dream of Bolivar was to unite all these people. Hopefully, the park can help do this" (Ledesman 1976).

In 1977, the Spanish American Civic Association sponsored a flag-raising ceremony in front of City Hall to observe the twenty-sixth anniversary of the constitution of the Commonwealth of Puerto Rico. The city's recreation director, Ed Zimbicki, raised the Puerto Rican flag and hailed the community's demographic diversity. Indeed, New Brunswick's Hispanic population is highly diverse—in 1981, a Hispanic festival at a New Brunswick church flew the flags of twenty-two

Latin American countries (Rojas 1981a)—and the profile of that community has changed over time. As mentioned earlier, New Brunswick's Hispanic population in the 1980s was composed primarily of Puerto Ricans and Dominicans;[18] there were relatively few Hispanics from Mexico (the 1980 census enumerated just 23 residents born in Mexico, and the 1990 census counted just 332 among the city's foreign-born). Yet over time, many Mexicans arrived in New Brunswick, with the majority coming from the Oaxaca area. Of the city's total 16,215 foreign-born in 2000, 6,134 (37.8 percent) were born in Mexico, and in 2010, of New Brunswick's total 19,538 foreign-born, 9,273 (47.5 percent) were born in Mexico.

By 2008, when the president of Mexico visited New Brunswick, the community was home to one of the largest Mexican populations in the tristate area. Of New Brunswick's 27,533 total ethnic Hispanics as of 2010, 14,104 (51.2 percent) are Mexican (not just Mexican-born), 4,139 (15.0 percent) are Dominican, 2,832 (10.3 percent) are Puerto Rican, 2,772 (10.1 percent) are Honduran, 1,103 (4.0 percent) are South American, and 1,341 (4.9 percent) are "other Hispanic or Latino." Expressed as a share of the total New Brunswick population of 55,181 in 2010 (recall that Hispanics in 2010 composed about half of the city's total population), Mexicans accounted for 25.6 percent of all city residents, Dominicans 7.5 percent, Puerto Ricans 5.1 percent, Hondurans 5.0 percent, South Americans 2.0 percent, and other Hispanic or Latino 2.4 percent.[19]

Rebecca Escobar, formerly of the Puerto Rican Action Board, indicated that social services programs helped to ease tensions between the African American and Hispanic communities during the early years of the first wave of Puerto Rican immigration to New Brunswick. Now there are more resources to deal with the challenges: "We have a diverse, vibrant community. We work well together. There are people committed to this town, whether they live here or not. The churches, administration, others are working together for the same goals."[20]

Although New Brunswick's diverse immigrant, racial, and ethnic communities may not always work well together, there is no denying the rich demographic mosaic of this city. Changes in the patterns of that mosaic over time only highlight New Brunswick's role as a crossroads of diverse people.

The Interconnection of New Brunswick's Economic and Social Changes

New Brunswick's changing economic fortunes, detailed in chapter 1, and the demographic changes described in this chapter are inexorably connected. The people of the city were the human capital that enabled New Brunswick's factories, retail businesses, and other economic activities to take root and flourish, and the city's residents suffered when New Brunswick's historic economic foundations began to implode in a postindustrial era. Once there had been at least 10,000 and perhaps as many as 31,000 manufacturing jobs in the city.[21] There remained only about 4,500 in 2002, and that number dropped to about 1,500 in 2010, fewer positions than some individual factories had maintained during the city's heyday.[22] New Brunswick resident Joan Suber bemoaned the change: whereas in the past

people "were able to get jobs [. . .] and work until they retire, [now] the factories are gone."[23] In New Jersey, the manufacturing share of all jobs in the state fell from 45.6 percent in 1950, to 34.7 percent by 1970, 14.6 percent by 1990, and just 6.7 percent by 2010.[24]

The evolution of one factory in New Brunswick reflects the fate of many other industrial complexes in the city. The building at 25 Water Street in the city's downtown was built in 1885 as a wallpaper factory and was later converted to leather manufacturing, where hundreds of workers were employed for many decades. The factory was touted in 1970 as "among [the] oldest concerns in New Brunswick" but it closed shortly thereafter and was demolished in 1975.[25] A local newspaper, the *Home News*, described the end: "bricks from the 14 inch walls now lie in a heap. . . . The people who worked in it helped build the city . . . and made the country grow. Now the building is coming down."[26]

New Brunswick's economic deflation was a microcosm of larger forces affecting the U.S. economy and America's cities in the postwar period (Beauregard 2003; Galster 2014.). Many American cities hemorrhaged retail activity; the dollar value of central business district retail sales declined (adjusted for inflation) between 1967 and 1977 by 48 percent in Baltimore, 44 percent in both Cleveland and St. Louis, 38 percent in Boston, and 36 percent in Minneapolis (Teaford 2006, 127). After studying retail trends in twenty central cities over the 1960s and 1970s, an Urban Land Institute report concluded that "most central cities are no longer the major marketplaces they once were" (Black 1978, 16).[27] Whereas New Brunswick was once a retail powerhouse in Middlesex County, over time it became the place not to shop, a declining dowager that paled against the beckoning new suburban malls described in chapter 1. In 1954, New Brunswick captured about one-quarter of all Middlesex County retail sales, and its businesses employed about 30 percent of the county's retail workers. By 1967, New Brunswick's share of both the county's retail sales and employment had dropped to about 15 percent. It would decline to under 10 percent by 1977 and drop to a bare trace (under 1 percent) by 2007 (see table 2.7).

Inevitably, the economic decline of New Brunswick affected the economic well-being of its residents. For almost all of the decades from 1960 through 2010, the median household income in Middlesex County was about 70 percent higher than in New Brunswick. Whereas in 1950 the median housing unit value was higher in New Brunswick ($9,778) than in Middlesex County ($9,638), from 1960 through 2010 that situation reversed, and average housing values in the county were typically one-quarter to one-third higher than in the city.

New Brunswick's burgeoning minority and ethnic populations were the most economically challenged. The decennial census first started counting the federally designated population living in poverty in 1970. For that year, 5.3 percent of all persons throughout Middlesex County were in poverty; in New Brunswick, the rate was much higher: 14.4 percent overall and 19.9 percent for New Brunswick's blacks.[28] For 1980, when Hispanics were first counted in the decennial census, 26.5 percent of this ethnic group in New Brunswick lived at poverty level, less

Table 2.7 Retail Activity in New Brunswick Compared with Middlesex County, 1954–2007

YEAR	ESTABLISHMENTS		SALES		ANNUAL PAYROLL		PAID EMPLOYEES	
	N	% of county total	In 1,000's	% of county total	In 1,000's	% of county total	N	% of county total
1954	508	22.8	79,370	26.3	9,646	29.1	3,604	30.1
1958	483	19.4	77,355	18.9	10,215	21.8	3,497	22.0
1963	413	15.2	78,177	13.3	9,529	14.2	2,773	13.7
1967	409	14.8	118,237	14.7	14,734	15.6	3,417	14.3
1972	312	11.4	126,293	9.6	17,797	10.9	3,226	9.7
1977	274	9.2	144,165	7.7	19,338	8.7	2,563	7.6
1982	228	7.1	173,272	5.8	21,106	6.3	2,317	5.9
1987	244	6.7	197,294	4.3	26,418	5.0	2,857	5.8
1992	249	6.4	180,922	3.2	27,896	4.2	2,309	4.9
1997	136	4.9	149,717	2.0	18,540	2.6	1,208	3.1
2002	129	4.8	149,659	1.7	15,505	1.8	898	2.3
2007	135	0.4	201,465	0.2	20,253	0.2	958	0.2

SOURCE: U.S. Department of Commerce, United States Census Bureau, *Census of Retail Trade* for indicated years.

than the 32.1 percent poverty rate of New Brunswick's blacks, but far higher than the 17.4 percent rate of New Brunswick's white population. And New Brunswick was not alone: America's cities more broadly confronted rising poverty in the second half of the twentieth century, especially for their minority residents. One study concluded that poverty is "twice as high in center cities as it is in suburban areas [and] the incidence of poverty among African Americans and Hispanics exceeds that of whites by several times" (Gabe 2015, 6, 9).

One consequence of these challenging urban economic and social conditions was riots in the 1960s in some of America's major cities. While New Brunswick was spared a riot in 1967 (described in greater detail in chapter 4), it was shaken by a civil disorder that could easily have disintegrated into violence (Rasmussen 2014, 144). If nothing else, these unfortunate events brought heightened attention to a perceived urban crisis in New Brunswick and in cities across America. To understand how these cities responded to their urban ills, it is imperative first to consider the background and evolution of national public sector housing and economic development programs and policies in the United States that attempted to aid urban areas. As the next chapter describes, these efforts evolved over nearly a century; some adversely affected New Brunswick and other American cities, while others were effectively employed to improve economic and social fortunes. Beyond government agencies, the effort to revitalize New Brunswick and other urban centers involved the private and nonprofit sectors, and those partnerships, too, figure in the narrative that follows.

| 3 |

★ THE NATIONAL CONTEXT OF URBAN REVITALIZATION

THIS CHAPTER and chapters 4 and 5 have a dual national and New Brunswick lens. Here we consider the historical evolution of the major housing and economic development programs and strategies in the United States, with a focus on their application in urban areas. With that national perspective established, the reader can better understand and place in context some of the most significant projects in New Brunswick, a review undertaken in chapters 4 and 5. To comprehend why the New Brunswick Memorial Homes were demolished and replaced, to appreciate how New Brunswick's Lower George Street area was revitalized, to follow the financing that made the building of the Hyatt Regency hotel possible and that enabled the Providence Square apartment building to house lower-income elderly, and to trace the steps that led to the opening of the city's Gateway Transit Village, it is imperative first to understand the national programs associated with all of these projects: public housing and Hope VI (Memorial Homes), urban renewal (Lower George), urban development action grants (UDAG, Hyatt), low-income housing tax credit (LIHTC) and rehabilitation tax credit (RTC, Providence Square), and new markets tax credits (NMTC, Gateway Transit Village). Considerable private monies from various sources and additional public subsidies were also instrumental in making these New Brunswick developments possible.

The question of how to effect housing and economic development, whether nationally or in New Brunswick, is not just of interest to technocrats; the answers reflect wider political, social, and economic forces. Public housing became an issue during the Great Depression of the 1930s; urban renewal was undertaken in the flush of post–World War II recovery; UDAG was the crown jewel of urban policy during the administration of Jimmy Carter; the LIHTC was crafted during Ronald Reagan's presidency specifically to replace what were perceived as the failed government housing subsidies of the 1960s and 1970s; and NMTC, created in 2000, reflects a contemporary approach to economic development

33. Easton Avenue, 1983

Photograph by George "Red" Ellis. Courtesy of George "Red" Ellis.

that emphasizes the private sector incentivized by lower-cost capital. Knowing the history of how America assembled its current toolbox of housing and economic development strategies sharpens our perception when considering what transpired in New Brunswick.

The Great Depression and Early Postwar Period (1930s–1950s)

The U.S. government was late and reluctant to assume some responsibility for providing lower-cost housing and for fostering economic revitalization and redevelopment in urban areas.[1] Great Britain, for instance, adopted a large-scale, government-aided housing program after World War I (National Commission on Urban Problems 1969, 108). In America, such government intervention was regarded as antithetical to laissez-faire private capitalism.

To be sure, there were some exceptions to this hands-off approach, but they tended to be both tepid and temporary. For example, one of the first federal actions related to housing was the formation of a congressional commission in 1892 to investigate slum conditions in the nation's cities. In times of emergency, the federal government built housing directly. During World War I, the U.S. Housing Corporation constructed and managed housing for defense workers, including some in New Brunswick, as mentioned in chapter 1, but this intervention was repudiated as soon as peace returned. With vigorous private housing production in the 1920s and booming cities, there was no sentiment for federal involvement in the housing or urban development sectors.

The housing boom went bust along with the rest of the economy in the Depression. Housing starts for 1933 plummeted to 93,000—a drop of 90 percent from their peak of 937,000 in 1925. Mortgage foreclosures soared to 1,000 daily, and half of the country's homeowners were in default (Listokin 1991, 159). These shocks goaded the nation into action. To stabilize the financial industry and to foster residential construction and jobs, the administration of Franklin D. Roosevelt created a constellation of programs and agencies: the Federal Home Loan Bank, the Federal Housing Administration (FHA), the Federal National Mortgage Association, and the Federal Savings and Loan Insurance Corporation. These agencies in turn generated a profusion of largely market-oriented programs, such as FHA Title I guarantees for home repairs and FHA Section 203 insurance for home mortgages. With such guarantees and insurance, lenders would be more willing to grant long-term, amortizing home improvement and home purchase mortgages.

The economic crisis also spurred the first efforts to produce lower-cost housing. The Relief and Construction Act of 1932 authorized the Reconstruction Finance Corporation (RFC) to make loans to low-income and slum redevelopment housing corporations; (B. Jacobs et al. 1982, 4). Among its numerous loan commitments were $8 million for Knickerbocker Village in New York City (affordable rental housing in what had been a slum area) and $15 million for rural housing in Kansas.

In 1933, the federal government intervened directly in housing production, both to provide shelter and to stimulate the economy and employment. The National Industrial Recovery Act of that year authorized the Public Works Administration (PWA) to construct lower-cost housing (B. Jacobs et al. 1982, 7). Ultimately, about 40,000 such housing units were produced. Nationally, this effort ended, however, when the U.S. Court of Appeals declared the PWA's use of eminent domain powers to be unconstitutional.

That 1935 decision proved to be only a temporary setback. The 1937 Housing Act created a landmark public housing program. Instead of intervening directly, the federal government would assist local public housing agencies that had eminent domain powers. Aid would be provided in the form of capital grants and loans, with a capital subsidy commitment made in the form of an annual contributions contract paying principal and interest for as long as sixty years (later reduced to forty years). With financing support, rents could be lowered to cover only the housing's operating cost. By 1939, the public housing program had produced a modest 5,000 units (National Commission on Urban Problems 1969, 130). It would ultimately develop into a large-scale effort to house the poor, with a peak of 1.4 million public housing units by the mid-1990s.

Some more overarching New Deal programs encouraged efforts to revitalize cities. For example, Detroit and New Orleans used Public Works Administration (PWA) funding to create local authorities to clear slum areas. These nascent urban renewal programs, however, represented piecemeal city actions rather than a comprehensive national effort (Gotham 2001, 5–6).

34. Hiram Street rubble, 1988

Photograph by George "Red" Ellis. Courtesy of George "Red" Ellis.

35. Water Street, 1970s

Courtesy of New Brunswick Development (DEVCO).

During World War II, Congress considered the nation's need for postwar housing and the necessity to alleviate slum conditions. A 1945 congressional report proposed "the establishment of a new form of assistance to cities in ridding themselves of unhealthful housing conditions and of restoring blighted areas" (U.S. Department of Housing and Urban Development 1974, 1–12). From 1945 to 1949, Congress debated the details of new housing and slum clearance legislation. The outcome was the 1949 Housing Act (Public Law 83–560), which declared the goal of "a decent home and a suitable living environment for every American" (Housing Act 1949, 2). Title I of the act established this landmark legislation's overall theme—"slum clearance and community development and redevelop-

ment" (National Commission on Urban Problems 1969, 152)—and authorized $1 billion in loans and $500 million in grants to aid local slum clearance programs. At first, the redevelopment was to be predominantly residential in nature, but that restriction was later waived to include nonresidential projects as well (Gotham 2001, 8). Title II of the 1949 Housing Act increased the FHA mortgage insurance authorization; Title III expanded the public housing authorization to a total of more than 800,000 units.

Urban renewal dominated early postwar community and economic development assistance in the United States (see figure 3.1). From 1949 to 1959, about $1.6 billion was authorized for urban renewal (National Commission on Urban Problems 1969, 159). By the late 1960s, $6.1 billion had been authorized (ibid.), and the urban renewal program ultimately involved $9.0 billion in federal/other public grants (Webman 1981, 192). To be sure, the program assisted numerous successful projects in such now-thriving communities as Philadelphia's Society Hill and Boston's Charlestown (Stipe and Lee 1987). Yet these were the isolated exceptions to the more frequent demolition-focused, socially destructive projects—the "federal bulldozer," as Martin Anderson (1964) called the policy. Kevin Fox Gotham summarized the negative impact: "Nationally, the program destroyed thousands more units than it replaced, dislocated tens of thousands of small businesses and residents, and became the target of intense civil rights protest from

Fig 3.1 **Expenditures and Foregone Taxes for Nine Community and Economic Development Programs, in 2007 Dollars**

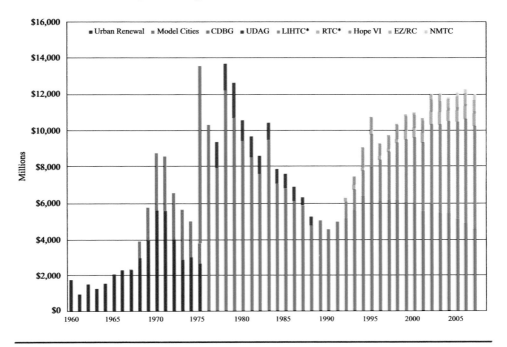

SOURCE: Abravanel, Pindus, and Theodos 2011, 106. Courtesy of the Urban Institute. RTC and LIHTC data are not available prior to 1992.

leaders who labeled it 'black removal' due to the large number of African American residents and neighborhoods cleared under the guise of 'urban renewal'" (Gotham 2001, 9).

Public housing, which was supposed to replace the housing stock lost to urban renewal and other federally aided demolition, did expand during the postwar period. The cumulative public housing inventory rose from 5,000 units in 1939 to 170,000 units in 1949, 422,000 units in 1959, and 792,000 units by 1969; by the mid-1990s, it would reach 1.4 million units. Yet, this production was offset by an even greater number of housing units demolished under urban renewal auspices—almost 800,000 by 1967 (National Commission on Urban Problems 1969, 160). In fact, an "equivalent demolition" mandate in the 1949 Housing Act *required* that for each public housing unit built, at least one unit be demolished. Thus, expansion of the nation's available affordable housing was curtailed.

There were other limitations. Public housing was built to a low standard of quality (sometimes open stairwells, barely adequate windows, and so on), in part to satisfy the 1949 Housing Act's mandate of a "20 percent gap" between the highest public housing rents and the lowest rents in private housing. Moreover, public housing was often built on a "superblock" as opposed to a traditional city-grid configuration, which impeded traditional neighborhood social interactions. (The massive Pruitt-Igoe public housing project in St. Louis, Missouri, was an example of superblock construction.) Finally, public housing was increasingly used as the permanent shelter of last resort for the poorest of the poor, beset by many social pathologies, as opposed to the program's original model of temporary housing for the "working poor," those whose circumstances did not allow them to afford privately produced housing.

On the periphery of urban areas, FHA mortgage insurance and mortgage assistance offered by the Veterans Administration (VA), along with federally aided interstate highway construction and other infrastructure projects (sewer treatment and water plants, for example), enabled the building of ever-expanding suburbs in the postwar period. These programs had notable statistical accomplishments. FHA and VA support helped lift the nation's homeownership rate from 44 percent in 1945 to 63 percent by the late 1960s. The Interstate Highway System, 46,876 miles long and built at a cost of $130 billion (the federal share was $114 billion in 1991 dollars), was the largest public works program in the world's history. Yet FHA and VA mortgage insurance was often denied in older and often interracial urban neighborhoods that were deemed "high risk"; such areas were literally "redlined" as off-limits in official government underwriting handbooks. Not surprisingly, the near total federal subsidy of roads and other infrastructure in the suburbs accelerated population growth there. As a result, many American cities in the postwar period were literally hemorrhaging residents and jobs to the beckoning suburbs. Thus, the New Brunswick postwar demographic and economic changes mirrored national trends.

Program Expansion in the 1960s

The decade of the New Frontier (John F. Kennedy) and the Great Society (Lyndon B. Johnson) witnessed an outpouring of housing and urban revitalization assistance. For example, Section 221(d)(3) of the 1961 Housing Act authorized below-market interest rate (BMIR) mortgages (about 3 percent) for privately owned multifamily housing available to moderate-income households (those above the public housing income limits). This effort was in part "spurred by five consecutive summers in the 1960s of racial unrest" in large American cities (Gotham 2001, 10), including Atlanta, Chicago, Cincinnati, Cleveland, Detroit, Newark, and Los Angeles. A shocked nation looked to recommendations from three national study commissions.

The 1968 National Advisory Commission on Civil Disorders (referred to by the name of its chair, then-Illinois governor Otto Kerner Jr.) was blunt in its description and prognosis. It analyzed the riots' underlying causes (among them, racial segregation, poverty, loss of urban jobs and tax base, and failed past public programs) and warned: "The future of these cities and of their burgeoning Negro population is grim. Most new employment opportunities are being created in suburbs and outlying areas. The trend will continue unless important changes in public policy are made" (National Advisory Commission on Civil Disorders 1968, 21).

The 1968 National Commission on Urban Problems (referred to by the name of its chair, then-Illinois senator Paul Douglas) examined historic, demographic, social, and economic trends in the United States, with a focus on cities and minority communities. Observing that "the balance of population growth has gradually shifted from the city to the suburb" (National Commission on Urban Problems 1969, 42), the commission noted a growing nonwhite population concentration in central cities as well as rising urban poverty and unemployment rates, which especially undermined minority communities. The Douglas Commission considered a wide range of responses, such as modifying existing public programs (urban renewal, public housing, and others), removing restrictive development codes, and modernizing governmental structure, finance, and taxation (National Commission on Urban Problems 1969, xi).

The 1968 President's Committee on Urban Housing (referred to by the name of its chair, industrialist Edgar Kaiser) analyzed the nature of housing problems in the United States, reviewed the accomplishments and limitation of federal housing programs, and then recommended "a 10-year goal of 26 million more new and rehabilitated housing units, including at least six million for lower income families" (President's Committee on Urban Housing 1968, 3). At the same time, the Kaiser Commission acknowledged that "better housing alone will not uplift the poor" and that wide-ranging public and private action was necessary to enable the poor to "enter the mainstream of American life" (ibid., 2).

The comprehensive perspective of the Kerner, Douglas, and Kaiser Commissions and their call for bold new policies and investment to address the challenges facing cities, minorities, and the less fortunate echoed themes in President

36. Meeting with John Heldrich (second from left) and Richard Sellars (middle), 1976

Courtesy of Johnson & Johnson.

Johnson's War on Poverty. To respond to the "crisis of the cities," Johnson empha-
sized the need for public action to be supplemented by private intervention, in-
cluding a response by "every corporate board room . . . in America" (President's
Committee on Urban Housing 1968, 2). As will be discussed in chapter 4, this
presidential call for corporate action was heard in the Johnson & Johnson board-
room in New Brunswick. Elsewhere, the Philadelphia Mortgage Plan (PMP) was
created in 1975 by that city's major lenders, Philadelphia National Bank, Phila-
delphia Savings Fund Society, and Girard Bank (Listokin, Wyly et al. 2000, 241).
In Connecticut, Hartford insurance companies formed a coalition with city gov-
ernment, community representatives, and others to tackle the intertwined hous-
ing, economic, and social challenges facing Connecticut's capital city; this
coalition's comprehensive strategy, referred to as the "Hartford Process," directly
influenced J&J.

An outpouring of major federal programs attempted to combat the ills the
national study groups had so ably documented. There were numerous new, very
generous housing subsidies, such as the Section 235 and 236 programs autho-
rized by the Housing Act of 1968. Section 236 offered a forty-year BMIR loan
with an interest rate as low as 1 percent for privately developed rental housing;
Section 235 provided similar assistance for homeownership. To foster more
lower-income homeownership, a Section 104 Special Risk Fund modified con-
ventional underwriting standards in older, declining urban neighborhoods. In
short, a multitude of low-cost loans and flexible financing options were offered to
households that were above public housing income levels but might nonetheless
experience difficulty in affording market-produced housing.

In addition to these targeted aids, there were also efforts at more comprehen-
sive interventions, notably, the Model Cities program, authorized in 1966. In con-

trast to the piecemeal approach of the urban renewal and public housing programs, Model Cities offered urban areas major federal grants to cover up to 80 percent of the cost of planning, developing, and implementing interconnected physical, economic, and social programs (National Commission on Urban Problems 1969, 171). The Model Cities legislation and the Economic Opportunity Act of 1964, which established federally funded community action programs, also called for "maximum feasible participation" by community residents in the intervention programs (Strange 1972, 459). From 1966 to 1974, about 150 communities across the United States received Model Cities funding of about $900 million (Schechter 2011, 4; see Model Cities annual funding levels in figure 3.1). The results were mixed: some participating cities could point to improvement compared with comparable communities (Schechter 2011, 3); housing service never achieved socioeconomic integration; and although there was some community participation, as in New Brunswick, it was far from maximal.

Reappraisal and New Directions in the 1970s

Troubles with the federal government's housing involvement mounted in the late 1960s and early 1970s. The demolition of the Pruitt-Igoe housing project in St. Louis in 1972 pointed to the distressing state of the nation's public housing program. Delinquencies and foreclosures escalated in the Section 221(d)(3), 235, 236, and other subsidized projects. FHA mortgage activity, especially in inner-city neighborhoods, was sometimes abused by realtors and mortgage bankers; the term "FHAing a neighborhood" was coined to describe the purposeful destruction of local communities (National Association of Home Builders 1986, 62). At the same time, outlays for federally subsidized housing exceeded $1 billion in fiscal 1972 and were increasing at a rate approaching a half billion dollars a year (Walsh 1986, 42).

In January 1973, the administration of Richard M. Nixon imposed a moratorium on subsidized housing production pending a reevaluation. A national housing policy review concluded that "our Nation's housing laws today . . . are a 'hodgepodge' of accumulated authorizations for some . . . 46 programs." It described these programs as characterized by "conflicts, duplication, and confusion" (U.S. Department of Housing and Urban Development 1974, 1–33). Technical studies conducted in conjunction with the policy review examined, among other topics, how block grants could replace categorical aid and how housing allowances to tenants could replace project-based subsidies (U.S. Department of Housing and Urban Development 1974).

This reappraisal ultimately led to some sweeping changes. For example, Title I of the 1974 Housing Act replaced urban renewal, Model Cities, and other categorical housing and community development programs with community development block grants (CDBG). Communities would either be entitled to or compete for CDBG monies. Once secured, the CDBG monies could be used for a variety of housing and community/economic improvement purposes. They could also be supplemented by numerous allied programs also authorized in 1974 to

stimulate housing and economic investment; these included the Section 108 Loan Guarantee, the Economic Development Initiative (EDI), and the Economic Development Administration's (EDA) Revolving Loan Fund. The 1974 Housing Act also established a major new multifamily housing subsidy under Section 8, which ultimately became a substantial subsidy. Under Section 8, the federal government would pay the difference between an established fair market rent and 25 percent (later amended to 30 percent) of the tenant's income. Eligible households were defined as those with incomes under 80 percent of the area's median adjusted for family size. Section 8 could be applied on new, rehabilitated, and existing privately owned housing. While Section 8 was originally predominantly project-based, in time it was made more portable to tenants who were given Section 8 vouchers and certificates, and they would find apartments that would then be subsidized by the federal government.

The new operating and financial assistance subsidies were very important to cities and were extensively used, resulting in a rapid rise in the number of aided housing units. In 1970, the Department of Housing and Urban Development (HUD) was supporting 932,000 housing units (830,000 public housing and the remainder mostly Sections 235 and 236). By 1980, HUD was subsidizing 3,268,000 units (including 1,192,000 public housing, 696,000 Sections 235 and 236, and 1,153,000 Section 8).

The advent of the Carter administration in 1976 brought renewed attention to urban policy and strategies to revitalize cities. The administration's national urban policy initiative, "A New Partnership to Conserve America's Communities," was released in 1978 (Rich 1992, 150). A prominent component of the initiative was the Urban Development Action Grant (UDAG) program authorized by the 1977 Housing and Urban Development Act.

UDAG offered competitive grants to cities and urban counties experiencing "severe economic distress." The UDAG funds were designed to attract and leverage private investment for economic development activities that assisted industrial, commercial, and housing projects. According to then-UDAG director David Cordish, the Carter administration recognized that "if the destroyed cities of this country were going to be rebuilt it would have to be done substantially with private sector investment" (Cordish cited in Nathan and Webman 1980, 7). UDAG monies could be used for a broad array of eligible activities, such as land acquisition, construction/permanent financing, "hard cost" new construction and rehabilitation, and "soft costs," including professional fees and interim insurance, tax, and other expenses.

Over its twelve years of its operation (1978–1989), UDAG awarded $4.6 billion to assist about 3,000 economic development projects in about 1,200 cities (Rich 1992, 153; see annual UDAG funding in figure 3.1). The UDAG awards, coupled with nearly $3 billion in other public funds (federal non-UDAG, state and local government), generated more than $30 billion in private investment (Rich 1992, 153–154). An estimated 500,000 new permanent jobs were created by UDAG-funded projects (Reed 1989, 93). Of the three assistance categories of

"neighborhood," "industrial," and "commercial," by far the most UDAG monies went to "commercial" proposals (55.3 percent), followed by "industrial" (24.3 percent) and "neighborhood" ones (20.4 percent) (Rich 1992, 154), reflecting the shift in the economy of cities from industrial to postindustrial. The most popular commercial projects for the use of UDAG monies were office buildings, followed by retail trade and then hotels (ibid.). The grants were used to jump-start some of the most prominent urban redevelopment projects of the late 1970s to mid-1980s, such as Harbor Place in Baltimore (spearheaded by entrepreneur James Rouse, who was involved in the development of Columbia, Maryland, Faneuil Hall in Boston, and other well-known projects) and the conversion of Union Station in St. Louis to a festival mall (Gotham 2001, 12).

Retrenchment and Shifting Approaches in the 1980s

Changed thinking about government intervention in cities was reflected in the report issued by the 1982 President's Commission on Housing, whose members were appointed by President Ronald Reagan. Chaired by William McKenna, former deputy administrator of the U.S. Housing and Home Finance Agency, predecessor of HUD, the commission directly criticized the model of a significant federal role in housing espoused by some earlier national studies and instead extolled the virtues of the private sector and an unfettered market economy (President's Commission on Housing 1982, xvii). Not surprisingly, cuts were soon made to numerous housing and economic development programs. From 1980 to 1990, funding for CDBG dropped from $6.2 billion to $2.8 billion, and economic development assistance dropped from $717 million to $160 million (Gotham 2001, 12–13). The increase in the number of HUD-subsidized units also slowed considerably. Whereas the number of HUD-assisted housing units under major programs almost tripled from about 0.9 million in 1970 to 3.3 million in 1980, it rose by about one-quarter from 1980 to 1990, reaching 4.5 million subsidized units by 1990.

The federal retrenchment on the housing and economic development fronts was accompanied by a not coincidental increase in the aid tendered by state and local governments (Nenno 1998; Schwartz 2010). For example, state housing and mortgage finance agencies became more important forces in aiding affordable housing, and states took other actions to realize this housing goal. New York State created an Urban Development Corporation (UDC) with considerable power to issue tax-exempt bonds for housing production and could even override local zoning restrictions. (This zoning override power was ultimately rescinded.) In New Jersey, after a series of state supreme court decisions striking down suburban exclusionary zoning (*Mount Laurel*), the state imposed numerical "fair share" targets for affordable housing for each of its nearly 570 municipalities and developed both inclusionary mandates—a share of new housing production had to be affordable—and mechanisms for suburbs to give housing aid to cities in the form of a Regional Contribution Agreement. Other states and local governments imposed similar strategies to foster affordable housing (for example, Massachusetts's

"Anti-Snob" zoning appeals statute; required local housing plans in California and Oregon; and inclusionary mandates in Montgomery County, Maryland, and Fairfax County, Virginia).

The 1980s and early 1990s also saw the beginning of a concerted effort by states and municipalities to spur economic development through means ranging from grants/tax breaks for urban or other needy areas to the designation of enterprise zones (EZ). The latter provided tax reductions (a lower sales or business tax) and other economic incentives (tax credit for each new job created), and sometimes regulatory relief for businesses locating within an EZ. By 1980, at least forty states had passed some type of EZ legislation. New Brunswick took advantage of a state program designating urban EZs (UEZs). Ultimately, in 1993 and later years, the federal government authorized conceptually similar tax-favored investment areas, such as Enterprise and Empowerment Zones and Renewal Communities (RC). (See figure 3.1 for annual federal EZ/RC assistance.)

In a paradigm change, an increasingly important role in the areas of housing and economic development was taken on by a nonprofit "third" sector. First started in the 1960s, community (or neighborhood) development corporations (CDCs) rose to prominence in the 1980s, when they were annually developing between 30,000 and 40,000 housing units (Koebel 1996, 11). Between 1998 and 2005, the 4,600 such entities produced 86,000 housing units and 8.75 million square feet of commercial and industrial space each year (Community-Wealth 2012).

CDCs were often aided by and worked with foundations. Two prominent examples are the Local Initiatives Support Corporation (LISC), begun by the Ford Foundation in 1979, and Enterprise, the creation of developer and urban visionary James Rouse. The latter was originally named Enterprise Community Partners Inc., in 1982, then Enterprise Foundation, and finally Enterprise Community Partners. As of 2011, LISC had invested $12 billion, which leveraged $33.9 billion in total project activity, to produce 289,000 affordable housing units and 46 million square feet of retail/community space, as well as other supportive community infrastructure (153 schools, 174 child care facilities, and 254 playing fields) (Local Initiatives Support Corporation 2012). Enterprise's mission focuses on affordable housing for low- and moderate-income people. By 2011, the foundation had "raised and invested more than $11.5 billion in equity, grants and loans to help build or preserve nearly 300,000 affordable rental and for sale homes" and in the process created 400,000 jobs nationwide (Enterprise 2012).

Private corporations also pitched in to aid housing and economic development as the federal government's presence waned. The Atlanta Mortgage Consortium was founded in 1988 by nine major banks to increase mortgage availability. There were also more examples of public-private partnerships (PPPs), where corporations joined with state and local governments, nonprofit agencies, and others to spur housing and economic development (Mullin 2002). In time, PPPs were involved in multibillion-dollar housing/economic development projects across the United States, including the Old Post Office in St. Louis, the Waterfront Initiative in Cleveland, and the downtown revitalization of Durham, North Carolina

(Urban Land Institute 2005). The redevelopment route taken by New Brunswick had definite links to this national development, as will be described.

Changing economic conditions and tax reform during the Reagan years did lead to the creation of some important and enduring housing and economic development programs. The rehabilitation tax credit (RTC) served as an economic development strategy, a major reason why it was launched in the early 1980s, an economically depressed period. Ultimately, the RTC was 20 percent for rehabilitation of historic income-producing residential and nonresidential properties, while a 10 percent RTC could be used for the rehabilitation of nonhistoric, income-producing, nonresidential properties. These RTCs could be applied against wage and investment income, and syndications targeted at affluent investors were common, with syndicators working closely with the developer-builders of the preservation projects. For example, a $1 million rehabilitation of a historic apartment building could qualify for a $200,000 RTC, which investors could deduct dollar-for-dollar against their federal income tax liability according to their pro rata ownership of the project. This arrangement reflected the PPP model of private investors motivated by a publicly provided "carrot," in this case a tax credit. The incentive worked: from 1978 through 2011, the historic RTC aided about $58 billion of rehabilitation activity (about $100 billion adjusted for inflation) at a federal cost of about $11 billion ($19 billion adjusted for inflation).

Although the RTC was not specifically an urban program or a housing program, it disproportionately benefited cities because urban places had the richest concentrations of historic stock, and it has been associated with considerable housing production as well as economic development. Researchers have estimated that from 1978 to 2011 the historic RTC generated about 2.2 million construction-period jobs (Listokin, Lahr, and Heydt 2012, 5). In the same period, the historic RTC (which can be applied in residential cases) has aided about 448,000 housing units (ibid.). Of this number, 122,000, or 27 percent, were affordable to low- and moderate-income (LMI) households.

The RTC LMI housing activity was made possible by layering the generous 20 percent tax credit afforded to historic rehabilitation with other housing subsidies, often the low-income housing tax credit (LIHTC), which was authorized in 1986. Like almost all initiatives since public housing, the LIHTC involved privately owned housing, and like the RTC, it used the lure of a tax reduction to realize its objective. Specifically, the LIHTC provides a 4 to 9 percent credit annually over a ten-year period, or about 40 to 90 percent total over the decade, for private developers who provide either new or substantially rehabilitated rental housing affordable to LMI households. Unlike the RTC, the LIHTC is capped to a maximum credit amount available in each state based on state population. From the beginning of the program in 1987 through 2008, the LIHTC has allocated $10 billion for federal tax credits granted for the production of 1,761,000 units of affordable housing (Danter 2012); about half of the housing units were located in central cities (Abt Associates 2009). (See figure 3.1 for annual LIHTC funding.)

Although the LIHTC provided a major housing subsidy for the poor, the original public housing projects were confronting major problems. One response was the appointment of a National Commission on Extremely Distressed Public Housing in December 1989. The commission found that public housing faced daunting interconnected physical, economic, social, and other problems (National Commission on Severely Distressed Public Housing 1992, 3–5, 17). Perhaps most significant in terms of subsequent action, the commission called for a demonstration project to "replace the oldest and least viable public housing projects with mixed-income, mixed-use lower density projects to catalyze positive community change" (Landis and McClure 2010, 323).

This proposal was adopted in the form of the HOPE VI initiative (Cisneros and Engdahl 2009; Turner 2009), which replaced 150,000 public housing units in 224 projects (Landis and McClure 2010, 323). As a result of these HOPE VI demolitions, as well as other losses to the public housing stock, the number of public housing units fell from 1.4 million in 1990 to 1.3 million in 2000 and to 1.1 million by 2008. This leaner public housing stock was far more viable, however, and the HOPE VI pruning was deemed successful by many accounts (Kingsley et al. 2004b). Yet advocates for housing for the poor, such as the National Low Income Housing Coalition, bemoaned the losses (Fitzpatrick 2000, 421). Chapter 5 details the controversy surrounding New Brunswick's failed public housing highrise, Memorial Homes, and its replacement by HOPE VI townhouses.

The 1990s and 2000s

With few exceptions, no major new housing and economic development programs on the scale of RTC, LIHTC, UDAG, and the like were created in the ten years before and after the 2000 millennium. To be sure, studies documented the need for investment in these areas. The annual reports of the Joint Center for Housing Studies at Harvard University regularly showed that the need for affordable housing, especially rental units, far surpassed the available supply (see, for example, Joint Center for Housing Studies, 2012, 6). A report released by the Millennial Housing Commission in 2002 concluded that "the nation faces a widening gap between the demand for affordable housing and the supply of it" (Millennial Housing Commission 2002, 7). To close the gap, the commission recommended expanded public subsidies to stimulate housing production, such as a homeownership tax credit (modeled after the rental LIHTC), and capital and other subsidies for mixed-income as well as extremely low-income multifamily rental housing (ibid., 9–10).

But these and similar recommendations were largely ignored. Instead, the major housing initiative of the era, embraced by the administrations of both Bill Clinton and George W. Bush, was to increase home ownership by making mortgage monies more readily available, especially among traditionally underserved minority and ethnic communities. Home ownership has long been subsidized by American tax policy, which allows home mortgage interest and home property taxes to be deducted against taxable income. The home mortgage deduction alone

is worth $80 billion a year—double the total annual federal cost of subsidized LMI housing (Freemark and Vale 2012, 423). So, although home ownership as a goal was not a new policy, it was given added emphasis in both administrations, which touted a home ownership society, especially for citizens heretofore denied this American dream. It was a national policy that could be comfortably agreed upon by both conservatives and liberals.

Progress was realized. In 1994, the overall homeownership rate in the United States was 64 percent, and it was just 43 percent among black households. By 2004, the overall home ownership rate rose to 69 percent, and about half of all black households owned their homes (Joint Center for Housing Studies 2012, 36). Among the factors contributing to this gain were an expansionist monetary policy by the Federal Reserve and other agencies; more flexible and aggressive mortgage products (in part due to revisions in 1995 to the Community Reinvestment Act [CRA]); and a major increase in secondary market mortgage purchases by two government-sponsored enterprises (GSEs), Fannie Mae (the renamed 1930s-era Federal National Mortgage Association) and Freddie Mac (the renamed Federal Home Loan Mortgage Corporation created in 1970) (Listokin et al. 2000; Listokin et al. 2002). Because the GSEs for a while were quite profitable, they were required to "give back" to the housing sector. Under the 1992 Federal Housing Enterprise Safety and Soundness Act, HUD created "affordable housing goals" for the GSEs with respect to the share of mortgages made available to underserved minority and LMI markets (Bhutta 2009; Thomas and Van Order 2011). In 2008, the two GSEs were charged with contributing to a National Housing Trust Fund (NHTF) that would construct 1.5 million new affordable housing units in mixed-income neighborhoods by 2018 (Landis and McClure 2010, 323).

Hopes that the GSEs would subsidize housing proved ephemeral, however. The mortgage bubble burst in the mid to late 2000s, and Fannie Mae and Freddie Mac were placed in federal receivership in 2008 without ever having funded the NHTF. Indeed, their futures remain uncertain. Whatever their implications for urban areas, the activities of the GSEs and other financial entities were no substitute for a comprehensive national urban policy. A spokesman for the National League of Cities concluded gloomily in 2005: "Under Democratic and Republican leaders alike, urban policy has receded into a Washington backwater, and is unlikely to reemerge as a priority any time soon" (Barnes 2005, 575).

The election of President Barack Obama in 2008 brought some heightened attention to cities and their larger metropolitan areas. In remarks at the Urban and Metropolitan Policy Roundtable, the president "stressed the interdependence of cities and their suburbs," and he noted how metropolitan regions were "crucial to the nation's economy."[2] Did the new administration have an urban policy? Some observers claimed that President Obama had a "stealth urban policy implicit in his budget priorities"; others saw only "an urban policy of sorts" (Silver 2010). The administration did establish a White House Office of Urban Affairs, and a number of new initiatives were put in place to help both urban areas and their larger metropolitan regions. These included: "Sustainable Communities" (grants to

metropolitan regions to integrate transportation, housing, and land use); "Choice Neighborhoods" (aid to distressed areas where subsidized housing is clustered); and "Promise Neighborhoods" (saturating services and investments in distressed areas, modeled after the Harlem Children's Zone) (Turner 2010).

Housing policy suggestions abounded as well. These included proposals to expand the existing rental housing voucher program and to reform onerous land use regulations that drive up housing costs, to expand/enhance existing HUD programs, such as Section 8 and community development block grants, to shift the federal housing emphasis from homeownership to rental assistance through such means as added vouchers, to restart the HOPE VI program (ended in 2004), and to adopt a new Housing Trust Fund to augment the faltering National Housing Trust Fund (Landis and McClure 2010, 323).

In a 2008 white paper on "Creating Urban Prosperity" (Obama and Biden 2008), the administration acknowledged the importance of cities and called for such actions as creating a GSE-funded Affordable Housing Trust Fund similar to the earlier proposed National Housing Trust Fund to develop affordable housing in mixed-income neighborhoods; restoring cuts in major HUD-funded programs (such as CDBG and public housing); addressing problems caused by the burst mortgage bubble such as rising foreclosures and homeowners faced with debt exceeding the value of their mortgaged property; and implementing a home ownership tax credit for taxpayers who do not itemize.

Some of these housing proposals did materialize. Funding for public housing and CDBG was on a more solid footing in the Obama years than in the prior Bush administration. Other elements, however, fared much worse. The White House Office of Urban Affairs had little practical national impact, the Affordable Housing Trust Fund was never capitalized, the essentially bankrupt GSEs had no funds to spare, and proposed funding in the fiscal 2010 and 2011 federal budgets was not approved. Other housing proposals, such as authorizing homeownership tax credits, had even less traction. In the wake of the deep economic recession of 2008, there was no appetite for bold new housing programs like the ones that followed the Kerner, Douglas, and Kaiser Commission reports of the 1960s. When housing was on the radar, most attention focused on dealing with home mortgage delinquencies/foreclosures through scattered legislation and programs, such as the Helping Families Save Their Homes Act of 2009 and the Making Homes Affordable initiative from the Departments of the Treasury and HUD, which provided mortgage relief to avoid foreclosure.

What are some of the broad themes and major subsidy strategies/programs of urban economic development in the contemporary era? Key elements here are a postindustrial market-centric conceptual framework and use of the tax system to attract private developers.

Many cities once grounded economically in manufacturing have sought to encourage postindustrial enterprise. As noted by Gotham (2001, 14), "many cities have attempted to redevelop themselves as entertainment destinations, devoting enormous public resources to the construction of large entertainment projects,

including professional sports stadiums, convention centers, museums, redeveloped riverfronts, festival malls, and casinos and other gaming facilities." Postindustrial functions also include knowledge-based activities involving health, educational, telecommunication, and other services. An example is Silicon Alley in New York City, which replaced the historic manufacturing and retail functions of this lower Manhattan corridor. The health care and education concentrations in New Brunswick, described in chapters 1 and 5, mirrored what was happening in other cities nationally.

In an echo of the turn in the 1980s from publicly owned and operated public housing to privately owned and managed, albeit publicly subsidized, low-income housing, contemporary urban economic development relies upon the private market incentivized by public subsidy, regulatory relief, and other aids (Gotham 2001, 14). This trend is epitomized by the New Markets Tax Credit (NMTC) offered from the Community Development Financial Institution (CDFI) fund within the Department of the Treasury. Authorized by the Community Renewal Tax Relief Act of 2000, the NMTC grants a 39 percent tax credit over seven years for investment in Community Development Entities (CDEs).

A CDE provides loans, investments, or financial counseling in "low-income communities" (LICs), defined as census tracts with a minimum 20 percent poverty level or where median income is at or below 80 percent of the area median family income. CDEs may comprise various entities, including for-profit community development financial institutions, for-profit subsidiaries of community development corporations, and specialized small business investment companies. The CDEs in turn make "qualified low-income community investments" (QLICIs). The QLICIs can take various forms: investments in or loans to a "qualified active low-income community business," that is, a business located in an LIC with a "substantial connection to that location"; financial aid to other CDEs through investing, lending, or purchasing loans; or financial counseling to LICs. As with the RTC and the LIHTC, syndicators often put together NMTC packages, with investors entitled to a share of the NMTC tax shelter according to their proportional investment. And like the LIHTC (but not the RTC), the NMTC is capped in amount.

The NMTC quickly became an extremely important revitalization investment vehicle. Analysis has found that 57 percent of the NMTC investment as of December 2010 was in communities with poverty rates exceeding 30 percent and that 60 percent of the NMTC activity occurred in places where the median incomes were at or below 60 percent of the area median. Since the NMTC program's inception, it has made about 900 awards to CDEs totaling about $44 billion in tax credit authority (U.S. Department of the Treasury, 2015). While CDEs can make many types of investments, in practice the most typical investment is a loan for commercial real estate. The NMTC tax credit allows an interest reduction on a loan equal to roughly 2.5 to 5.0 percent. Besides a below-market interest rate, the NMTC allows borrowers to secure better loan terms, such as permitting a longer than standard period of interest-only payments or lower

than standard origination fees. The NMTC is not directed toward urban areas per se, but it has frequently been applied for urban revitalization. As will be shown in chapter 5, the NMTC was tapped in New Brunswick's Gateway Village and Wellness projects.

In addition to the NMTC, which applies to federal income taxes, many jurisdictions, including New Brunswick, have experimented with property tax incentives to spur urban economic development. In 2008, local property taxes across the United States amounted to $397 billion, or about 28 percent of the total $1,401 billion in 2008 local general revenues (U.S. Department of Commerce, United States Census 2010, State & Local Government Finances). One type of property tax incentive is termed "tax increment financing" (TIF). TIF is a popular tool to finance new development or redevelopment (rehabilitation and new construction) by capturing the ensuing property appreciation and associated nominal higher property tax payments (Meck, Moore, and Ebenhoh 2006). One variation of the TIF strategy is a (property) payment in lieu of taxes, or a PILOT.

In another example of tax incentives used for urban redevelopment, the state of New Jersey awards tax credits for transit-oriented development (TOD); the use of TODs occurs disproportionately in the state's cities and older suburbs. The state of New Jersey also taxes gaming to raise revenues for purposes ranging from education to economic development; some of these revenues are disbursed by the Casino Reinvestment Development Authority (CRDA). As detailed in chapters 5 and 6, New Brunswick has used both PILOTs and TODs, as well as gaming-based funds.

Summary of National Housing and Economic Development

This chapter has presented the history, strategies, and major programs for housing and economic development of most significance to cities in the United States over the past century. Our discussion has attempted to show how changing economic and political forces influenced these programs over time as well as to identify some of the connections between housing and economic development assistance approaches.

An instructive way to conclude the national overview is to show cumulative subsidized housing units and cumulative expenditures and foregone taxes for major economic (and community) development programs. As of 2008, there were about 6.9 million HUD-subsidized housing units. The major components include vouchers (2.2 million units), the LIHTC (1.5 million units), project-based Section 8 with additional rental assistance (1.4 million units), and public housing (1.2 million units). The number of public housing units declined from a peak of 1.4 million in the early and mid-1990s after HOPE VI/other demolitions (Schwartz 2010, 9).

Figure 3.1 shows direct expenditures and foregone taxes from 1960 to 2007 (in inflation-adjusted 2007 dollars) for nine major economic/community development and housing programs. Evident are the changing program emphases over time. Thus, urban renewal dominates in the beginning years, it is then superseded

by other programs.. It is also evident that certain of these nine programs are much larger in their dollar magnitude compared to others (for example, LIHTC exceeds Hope VI). Figure 3.1 further reveals that some housing/community development subsidies (for example, LIHTC and CDBG) dwarf many programs focused on economic development aid (for example, EZ/RC). Spending trends show reduced support for CDBG and greater emphasis on LIHTC.

Although this chapter has focused on major federal housing and economic development programs, it is important to recognize that state and local governments and the nonprofit sector have become major players in these areas since the 1980s (Schwartz 2010, 209). Also deserving another mention is the increasing role and importance in recent decades of public-private partnerships (PPP) in the housing and economic development sectors. As the following chapters detail, many major housing and economic development projects in New Brunswick creatively combined federal subsidies and state and local support, with a dollop of PPP for good measure.

★ **NEW BRUNSWICK
TRANSFORMATION**
Challenge and
Strategic Response

AS DESCRIBED IN CHAPTERS 1 AND 2, economic and demographic trends from
the late 1950s onward were not favorable to New Brunswick. The changes were
stark. Whereas the city's central business district (CBD) was collecting $1.8 mil-
lion in property taxes in 1943, that amount had dropped to $300,000 by the early
1970s (Heldrich 1988, 3). A study conducted in 1979 cited the following losses in
New Brunswick between 1965 and 1979: seven department stores; 83 percent of
its smaller quality retail establishments; more than 3,000 white-collar jobs owing
to the relocation of corporate facilities to suburbs; six major industrial plants; and
2,000 industrial jobs (Historic Design Associates 1979, 4–5). During the same
period the assessed value of CBD properties declined by 77 percent, and the rev-
enues generated by property taxes fell 52 percent, even though the property tax
rate doubled. The city tried mightily to revive its downtown through such strate-
gies as having its CBD designated as a New Jersey Urban Enterprise Zone, which
then lowered the sales tax charged by downtown businesses, but to no avail as
activity declined steadily over time (see table 2.7). John J. Heldrich, an executive
at Johnson & Johnson and a noted civic leader, concluded that the city was expe-
riencing "the steady and inexorable cycle of urban deterioration that afflicted so
many American cities. Even worse than the physical and economic damage was a
feeling of helplessness. Everything seemed to stop. It was like waiting to die. We
had hit bottom" (Heldrich 1988, 4).

Perceptions of a Changed and Declining New Brunswick

Statistics alone cannot convey the sea change occurring in New Brunswick in the
postwar period. Interviews with longtime residents offer vivid descriptions of
personal experiences of New Brunswick's transformation.[1] Christopher Pala-
dino, who later would head the New Brunswick Development Corporation
(DEVCO), recounted:

This was the center of the universe. You came here to go to church. You came to New Brunswick to buy your school shoes. You went to the doctor. If you were lucky, you got to . . . eat at the lunch counter at . . . Arnold Constable or P. J. Young's. It's where you went and bought clothes, and this was the . . . early and mid-sixties. . . . [Constable, Young's, and five other department stores in New Brunswick, would all close.] It was also the place by the late sixties where your parents told you . . . "You're in New Brunswick." . . . [We would] lock the doors when we would drive though. I mean it had changed that quickly. (Paladino interview, 12)

Anthony Marchetta, who would later serve as an urban planner and assistant business administrator in New Brunswick, grew up in the city in the 1950s and 1960s, and had fond memories of the community of that era:

It was a vibrant, small town in central New Jersey. It was the county seat. It was a great community to grow up in. It was diverse. We had a lot of ethnic groups. Though we were Italian, we ended up in the Hungarian neighborhood. Accents were prevalent whether they were Hungarian or Italian or even Lebanese. . . . Saturdays you would go downtown in New Brunswick, and it was so crowded you could barely walk the streets, and there was lots of activity. It was that kind of place. There must have been a dozen men's clothing stores. . . . We had four movie theaters—the State, the Rivoli, the Strand, and the Albany. (Marchetta interview, 3–4)

Marchetta blamed suburban malls for gutting the downtown:

I remember our neighbor saying she had just gone to the new mall, Menlo Park, which at that point was not a covered mall, and she had taken the bus to get there. . . . To me [this] is the beginning of New Brunswick's ebb. . . . New Brunswick lost its reason for being in many ways, and it was no longer the commercial center of the region . . . and downtown New Brunswick lost its vitality. (ibid., 4)

Robert Campbell, former chief financial officer for Johnson & Johnson, bluntly described downtown New Brunswick of the 1960s: "You could shoot a cannon down the street at night here and not hit anyone" (Campbell interview, 15).

Still, even in its decline, New Brunswick had its attractions. Eric Krebs, who would found the George Street Playhouse in 1974, wistfully recalled a "wonderful meat store called the Pork Store on George Street" (Krebs interview, 14). David Harris, who served on the board of DEVCO, remembered "coming out of activism in the sixties": "I was living in South River and like all of the towns around the Hub City, the center of African American culture was in New Brunswick. It was a place where we could get our hair cut in a real barber shop and not someone's

kitchen. . . . The women found beauty salons and there were great black churches" (Harris interview, 1–2).

Rutgers University students at the time were wary of venturing into a city known for crime. "Back then," one recalled, "you were warned not to come into downtown. It was, you know, 'You stay on the campus'" (Vega interview, 1). A senior Rutgers administrator who arrived at the university in 1969 remembered that at that time "people avoided the city, especially at night. There was no reason to come. You know, the State Theatre was a pornographic theater and there weren't any restaurants" (Wheeler interview, 4).

New Brunswick in the 1960s and 1970s was by all accounts facing many challenges. John A. Lynch Jr., a long-serving mayor (1979–1991), acknowledged that "stores were empty and crime was rampant. Had all the symptoms of an aging urban community as we have seen in so many New Jersey [cities]" (Lynch interview, 5). Another former mayor, Patricia Sheehan, listed the challenges facing the city around 1967: a third of its land was tax-exempt (that is, owned by the county government, churches, educational institutions, and others), a third of its residents were of school age (posing expensive educational and other public service demands), and another third were over sixty-five and in need of costly senior citizen services. Sheehan ruefully observed that the children of long-term city residents fled to nearby suburbs:

> The over-sixty-five [population] was primarily in grandma's house, [on] a . . . twenty-five-foot-lot house that raised two [to] six children. They're all educated and they're all living in Kendall Park or North Brunswick or South Brunswick. A lot of them didn't go very far away, but they were out of New Brunswick. Who wouldn't want a new house and a car and a driveway, the American dream? (Sheehan interview, 9)

On a personal note, Sheehan poignantly described her family's difficulty in securing a mortgage in New Brunswick. When her husband, a war veteran, attempted to obtain a Veterans Administration loan for a home in the city, the application was denied by VA underwriters who declared that the city's housing stock was too old to qualify (Sheehan interview, 8). Faced with overt redlining, many would-be home buyers passed on New Brunswick in favor of easy-to-finance homes in the suburbs.

When John Heldrich returned to New Brunswick in the late 1960s after running a J&J plant in Decatur, Illinois, he "couldn't believe it was my same city because everybody was moving out to the suburbs" (Heldrich interview, 12). The out-migration was understandable; buyers could get "a no down-payment [mortgage] on a little house" (ibid.). But the population shift and other changes led Heldrich to describe New Brunswick in the late 1960s and early 1970s as "dying." The 1968 civil disorder, discussed shortly below, confirmed the worst expectations.

Changes in the School District

Accelerating the out-migration to the suburbs was the imploding New Brunswick school district (Schkrutz 2011, 14). For many years the New Brunswick High

School (NBHS) provided education in grades nine through twelve not only to the city's teens but also to pupils from some nearby communities, including most prominently the growing adjacent suburb of North Brunswick Township. Another nearby suburb, Milltown, also sent its students to New Brunswick. For a while, that arrangement worked well: North Brunswick could grow (its population increased by 65 percent between 1960 and 1970, from 10,099 to 16,691) without having to build and pay for its own high school. But over time, burgeoning North Brunswick wanted its own high school, in part to manage its own educational policy and also in response to perceived problems at NBHS. There were issues of general educational competence (for example, all New Brunswick schools closed on September 24, 1969, because the district's liability insurance expired; "New Brunswick Shuts Schools" 1969) and growing racial tensions arising from a largely white suburban community sending its upper-grade students to an increasingly minority city school. White students at NBHS boycotted classes in September 1969, seeking greater police protection. Ultimately, white parents in North Brunswick sued to sever the relationship with NBHS (Schkrutz 2011, 14). Anthony Marchetta, who graduated from NBHS, recalled that "the subtext was we were going to a safer environment, we're not going to have the minorities, we're not going to have poor people there, we're going to create our own little suburban enclave" (Marchetta interview, 6).

Marchetta remembered NBHS as having a "strong education system," with graduates going to all the major colleges, including Rutgers and "all the Ivies" (ibid., 4). New Brunswick school officials feared that "the loss of the out-of town students, virtually all of them white, would make the city's high school virtually all black" ("Busing" 1973). Nevertheless, North Brunswick was allowed to build its own high school, which was completed in mid-1973. As predicted, the end of the regional school arrangement tipped the racial balance at NBHS. When Marchetta came back to the high school as a substitute teacher in the early 1970s, he was "really shocked": "The whole attitude in the school system had changed dramatically. It became less formal, more casual, and less in control. The schools were dangerous. My apartment mate at the time had almost a full-time job because the teacher that he was substituting for had been pushed down the stairs. Twice!" (Marchetta interview, 7) As of 2012, the NBHS population was largely Hispanic and black, and 89 percent of seniors graduated.

A "Civil Disorder" in the City

What happened to New Brunswick in the postwar period mirrored the national urban situation: a population shift from the city to the growing suburbs, facilitated by the interstate highway program; redlining in older, poorer inner-city neighborhoods; and a growing nonwhite population concentration that inflamed racial tensions. Nationally, those racial tensions erupted into the urban riots of the late 1960s, major conflagrations that devastated Newark, Detroit, and other U.S. cities. New Brunswick also experienced civil disorder in the summer of 1967 (Schkrutz 2011, 10), though not a riot—a distinction explained below.

In the preface to a twentieth anniversary edition of the Kerner Commission report that documented the national riots and their causes, original commission member Fred R. Harris bluntly summarized: "Newark blew up in the summer of 1967" (Kerner Commission, 1988, ix). In brief, New Jersey's largest city experienced six days of what everyone agreed was a "riot"—a major outbreak of violence: twenty-six deaths and hundreds of injuries, fourteen hundred arrests, and over ten million dollars' worth of loss of property (ibid., 69; Rasmussen 2014, 137). Over the last days of the Newark riot, July 17 and 18, New Brunswick endured protests, vandalism, and looting, but no loss of life and few injuries. The events amounted to a civil disturbance for sure, but never reached the magnitude of a riot. The sequence of events in New Brunswick has been described by historian Chris Rasmussen:

> On . . . July 17, rumor gave way to reality, as protest, vandalism and looting erupted in New Brunswick. . . . Around 9:00 P.M., approximately 200 black residents, mainly teenagers, congregated at the corner of George Street and Remsen Avenue. . . . The youths streamed down George Street into the city's business district [and] suddenly . . . the crowd began smashing store windows . . . [and] looters rushed . . . to haul away merchandise. . . . Police fingered their weapons . . . [and] generally obeyed the mayor's order to refrain from . . . violence. . . . By night's end, thirty-two adults and eighteen juveniles, all black, had been arrested. . . . After 2:00 A.M., the streets fell quiet. Store owners had suffered considerable property damage . . . and downtown streets were strewn with broken glass and garbage, but only a handful of persons had suffered physical injuries, all of them minor. (Rasmussen 2014, 144)

While the July 1967 events were calamitous (Schkrutz 2011, 22), New Brunswick did not "blow up." A local newspaper reporter referred to the events in his city as "a little riot" (Lipson 1967, 19). The relative calm in New Brunswick was credited in part to the restraint of the police and to the good lines of communication maintained by Mayor Patricia Sheehan with the minority community. The Kerner Commission singled out Sheehan for praise (the only government official commended in the final report) and ended its narrative of what transpired in New Brunswick with the upbeat conclusion, "The New Brunswick riot had failed to materialize." Recent fascinating research by Chris Rasmussen also credits the New Brunswick minority community (black leaders and protestors alike), as well as the Middlesex County Economic Opportunity Corporation, an antipoverty group established under the War on Poverty, for their roles in averting violence (Rasmussen 2014, 137).

New Brunswick's civil disorder was prompted by many of the same grievances that fueled America's urban riots in the late 1960s. Rasmussen cites the many challenges facing the city's minority community, especially in the areas of housing and jobs. More than a quarter (29 percent) of New Brunswick's

nonwhite families were impoverished, and black neighborhoods, some of the poorest in Middlesex County, contained a disproportionate share of dilapidated housing. Segregation and discrimination were common in both private and public housing. Half of the city's black population had unskilled jobs, and discrimination by local employers limited opportunities for minorities. Exacerbating these grievances in the hot summer months was the lack of recreational facilities open to minorities. There are other parallels between New Brunswick and the national urban situation. The city had followed the national blueprint for urban revitalization. It started building public housing in the late 1930s and by the early 1950s had completed the Lambert Homes, Robeson Village, and the Schwartz Homes, along with garden apartment projects on Somerset, May, Reed, and Comstock Streets. Yet, these projects were "effectively segregated" in Rasmussen's view (2014, 140), with Robeson Village housing mostly black residents and Lambert and Schwartz Homes mostly white ones.

The national theme of clearance was echoed in numerous urban renewal projects in New Brunswick. A prominent example was the demolition in the mid-1950s of many older structures on an approximately thirty-five-acre site located between old Burnet Street and the Raritan River, which allowed for the construction of Memorial Parkway (Route 18) and the creation of Elmer Boyd Park. On a cleared six-acre site south of Memorial Parkway, once a neighborhood of largely African American homeowners, the New Brunswick Housing Authority (NBHA) constructed the four high-rise Memorial Homes towers (Schkrutz 2011, 9), which eventually housed mostly black residents.

Like the national programs for revitalizing America's cities in the postwar era, the urban revitalization efforts carried out by New Brunswick from the 1930s to the 1980s had at best an uneven record. The city's garden apartment public housing projects were a useful addition to the local housing stock, but Memorial Homes was an abject failure and was ultimately demolished. Many New Brunswick urban renewal sites would remain empty lots for decades. Thus, as in cities nationally, the urban renewal and public housing programs by themselves could not reverse the urban decline that New Brunswick faced. Something more was needed to jump-start the city's revitalization. That "more" turned out to be a public-private partnership (PPP) with the Johnson & Johnson Company.

Johnson & Johnson and Early Actions to Revitalize New Brunswick

As described in chapter 1, the Johnson & Johnson Company was founded in New Brunswick in the late 1880s and grew to an international scale, operating in sixty countries and with worldwide sales of $71 billion in 2014. J&J has always been headquartered in New Brunswick and resisted the trend in the 1970s for companies to leave their historic urban headquarters for literally greener pastures in suburban or exurban locations. From the mid-1960s onward, for example, many Fortune 500 companies left New York City; in the state of New Jersey, RCA Victor

fled the city of Camden and Campbell Soup reduced its presence there. Why did J&J stay in its home city?

Interviews with individuals involved in J&J's efforts to aid New Brunswick identify multiple factors influencing the original decision. The first, described by John Heldrich—who is generally viewed as the key J&J executive in leading the redevelopment of New Brunswick—was a meeting held in Washington, DC, in 1968 by President Lyndon Johnson, to which he invited leaders of companies in major cities, including Philip Hoffman, chairman and chief executive of J&J: "The outcome of the meeting was that the prime cause of the [1967] riots was underemployment and that we form a national alliance of business to work toward workforce solutions" (Heldrich interview, 5).

Here, a brief biography of Heldrich is instructive. Born in New Brunswick in 1926, he grew up in humble circumstances, "playing baseball off the walls of the New Brunswick Johnson & Johnson factories" (Schkrutz 2011, 26). He had two dreams: "one was to play for the New York Yankees and the other was to work for Johnson & Johnson" (Heldrich interview, 3). What the Bronx Bombers lost, J&J gained. Heldrich joined the company in 1950 after serving overseas in World War II and finishing his degree at Rutgers at night. He served in various posts and was finally promoted to the executive corporate suite by the 1960s. He would serve J&J for forty-one years (Attrino 2014).

Following the 1968 meeting in Washington, Hoffman summoned Heldrich to J&J's fifth-floor executive suite. Heldrich was apprehensive, because "you went there only to be hired or fired." Instead, Hoffman described his meeting with President Johnson and then told Heldrich that he wanted him to take the lead in working with New Brunswick to "help pull [the city] from the abyss." Heldrich believed he was given the New Brunswick assignment because "he was a native of the city and knew something about it." Other skills Heldrich had developed in his earlier J&J posts concerned labor and workforce development. Bolstering employment in New Brunswick, especially for minorities, was deemed critical. Hoffman made his expectations clear: "Just remember, I've never failed at anything" (Golway 2005.).

Where to begin? A first step by J&J and Heldrich was to establish an initiative called Project Action. Through Project Action, Heldrich and his J&J colleagues "developed a coalition between the [Middlesex County] employment service and the employment ends of our operations here in New Brunswick and Rutgers University" (Heldrich interview, 7). With local contacts like Roy Epps of the New Brunswick Urban League, the Project Action initiative attempted to ameliorate urban underemployment in the early 1970s. By that time, J&J had a new CEO, Richard Sellars, and he too strongly supported the Heldrich-led New Brunswick revitalization activity. In one meeting with New Brunswick civic, educational, and business leaders in June 1974, Sellars spoke passionately of J&J's then eighty-eight-year ties to New Brunswick and his own involvement with the city of some thirty years (Sellars 1974).

By the early 1970s, J&J "had a critical decision to make," Heldrich recalled. "We had outgrown our New Brunswick home, where the company was born a

century ago" (Heldrich 1988, 4). Within the company, there was conflict about where to build the new headquarters (Institute for Domestic and International Affairs 2009, 10). The tug of corporate history pointed to staying in New Brunswick, but the suburbs offered the lure of lower taxes and the ability to design an extensive campus "in some of the most beautiful suburban and rural locations in New Jersey" (Heldrich 1988, 4). Building in downtown New Brunswick would necessarily entail the purchase of many individual properties.

The J&J board of directors voted narrowly to stay in New Brunswick (Institute for Domestic and International Affairs 2009, 10). What tipped the scale for remaining in the city? Heldrich and others close to this decision emphasize the influence of the J&J corporate credo, crafted by the son of company founder Robert Wood Johnson in 1943. The credo speaks of three J&J responsibilities: (1) to doctors, patients, and all others using J&J products and services; (2) to J&J employees; and (3) to "the communities in which we live and work." Heldrich attributed the decision to stay in New Brunswick to "our decision-making process . . . driven by the third responsibility of our credo" (Heldrich interview, 5). Former New Brunswick mayor (and former J&J executive) Patricia Sheehan concurred:

> J&J has a very strong sense of public responsibility, and it's a company driven by what they call the Credo. J&J had a much closer identity with the communities in which it is located than many other corporations had, and so I think that ethic had a lot to do with it. That's not to say that it was a unanimous decision by a long shot, but there were enough John Heldrichs in the room to see that it happened. (Sheehan interview, 15)

Force of personality also likely played a role in J&J's decision. Heldrich was a strong advocate for his native city. When he died at age eighty-eight in 2014, the former executive was heralded by then J&J chairman and CEO Alex Gorsky as "a credo-based leader in our company" (Attrino 2014). There were others as well, such as Richard Sellars, chairman and chief executive from 1973 to 1976. In 1974, Sellars declared, "I am personally confident that under the right conditions, the city of New Brunswick can be revitalized and move into an era of progress and responsibility" (Heldrich 1988, 5). Thomas Kelso, legal counsel to DEVCO, described Sellars as "a critical, early leader in the revitalization":

> I'm sure that he was the single most important decision maker with respect to Johnson & Johnson deciding to stay in New Brunswick. But also, I think that he had the personality to be able to interact with, in the political arena, people like [Mayor] John Lynch and even county representatives. It always seemed to me to be a very strong, positive working relationship that he had. He had that charisma; he was a very charismatic guy. (Kelso interview, 10)

According to real estate developer Omar Boraie, J&J stayed in New Brunswick because of "people like Jim Burke and Dick Sellars [both J&J CEOs]. . . . They're

good people. They believed in New Brunswick. They felt like they wanted to fulfill the promise or dream of Robert Wood Johnson . . . as far as expanding in New Brunswick, since he [had] started in New Brunswick . . . and we were lucky at that time to have a good mayor . . . John Lynch. And they put things together and things started to move in the right direction" (Boraie interview, 14).

While the corporate credo and advocacy by some important executives may have tipped the scale, the vote for J&J to remain in its home city came with two conditions imposed by the company's board of directors: first, that the proposed extension of Route 18 go forward, and second, "that a study be conducted to determine if and how New Brunswick could be revitalized" (Institute for Domestic and International Affairs 2009, 10).

Route 18 and the Lynch Bridge

Transportation and access have always been important to the Hub City. As discussed in chapter 1, New Brunswick had evolving transportation modes: the river, canal, train, and automobile. In 1925, growing automobile ownership and a network of streets "laid out in a pre-automobile era" led a city planning commission to identify congestion as one of the most significant problems facing New Brunswick (Swan 1925, 10). The commission recommended street improvements and "a new bridge over the Raritan River to deal with congestion on Albany Street" (ibid., 25). Some thirty years later, following economic depression and war, the city and the state jointly funded a Burnet Street Parkway project. Burnet Street was one of the oldest named thoroughfares in New Brunswick—for William Burnet, governor of New York and New Jersey from 1720 to 1728—and "the scene of greatest activity during colonial and revolutionary days" (*New Brunswick Sunday Times* 1926).[2] The 1950s project consisted of widening the riverfront street from Voorhees Street east of the Rutgers Boathouse to Little Burnet Street near Albany

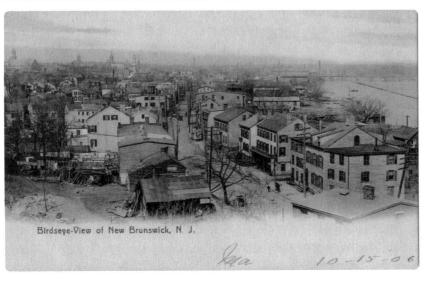

Birdseye-View of New Brunswick, N. J.

37. Bird's-eye view of New Brunswick, N.J.

Postcard, R. W. Reed, New Brunswick, New Jersey. Special Collections and University Archives, Rutgers University Libraries.

38. New Brunswick, N.J., riverfront

Postcard, Dexter Press, Pearl River, NY: "A booming industrial city of 40,000 people"... a "miracle mile of industry." Special Collections and University Archives, Rutgers University Libraries.

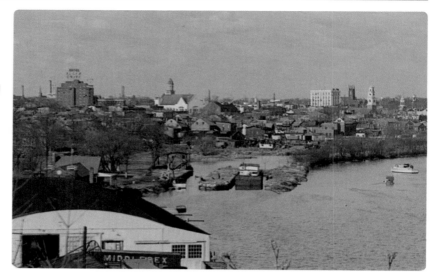

Street. Described in the *New Brunswick Sunday Times* of May 27, 1951, the project would benefit the city and its people by replacing an inadequate street with a modern divided highway, by eliminating a blighted low-ratable area and replacing it with modern housing, and by creating a riverside park.

Memorial Parkway (Route 18) opened in 1955 but did not completely alleviate traffic congestion in the downtown. Proposals for bypasses culminated with the state's plan to extend Route 18 to connect New Brunswick and Bound Brook, which would include a new bridge over the Raritan River, named after former mayor John A. Lynch Sr., father of future mayor John A. Lynch Jr. The plans were completed in 1962, and construction began in the late 1960s, including infrastructure for the bridge. During the mid- to late 1960s, however, significant opposition began to mount because of fear that the highway and bridge would pave over the Delaware and Raritan Canal through New Brunswick, include a major interchange in Johnson Park, and cause pollution for residents of Rutgers dormitories. A federal mandate requiring environmental impact studies galvanized environmental, student, and other groups opposed to the project (Schkrutz 2011, 17, 23). But the extension had strong proponents as well, including local, regional, and state officials and many local businesses. Johnson & Johnson was a major supporter because the extended roadway and new bridge would facilitate employees' commute, should the company choose to retain its headquarters in New Brunswick.

Both sides marshaled studies to support their viewpoints. For instance, the Rutgers University Center for Transportation Studies concluded in a 1970 report that the extension of Route 18 would "produce traffic emissions that would cause human impairments in vision, breathing, [and] hearing . . . and would violate state air pollution standards" (Barrett 1970, 1). Rutgers students argued that the extension of Route 18 just behind the university's three river dormitories would harm their quality of life ("Bardin Ruling on Route 18 Shift Awaited" 1975). Proponents

of the new highway and bridge cited arguments for the transportation enhancements they would bring. A 1975 comprehensive planning and strategy report for New Brunswick considered the city's dismal traffic situation:

> New Brunswick suffers several hours of extreme and costly congestion every working day due to a lack of road capacity across the Raritan River. . . . The two available bridges—Albany Street and Landing Lane—are totally inadequate to meet current demands. . . . This daily congestion, with its increased air pollution and wasted fuel from thousands of idling cars, continues to be a major unresolved issue that works against the advantages of location. . . . It is mentioned here to point out the urgency of a solution if New Brunswick is to move ahead with a revitalization program. (American City Corporation 1975b, 16–17)

New Brunswick mayors and executives of J&J lobbied extensively for the completion of the Route 18 bridge, and as noted earlier, the J&J corporate board made the completion of the highway a condition for maintaining the company's headquarters in New Brunswick. State officials added their voices. The commissioner of labor and industry declared that Route 18 was "vital to the economic revitalization of the New Brunswick area, and in the last analysis, is essential to the economic development of our state" ("Bardin Ruling on Route 18 Shift Awaited" 1975).

The lonely concrete bridge supports in the Raritan River stood as stark symbols of the impasse. One issue that delayed completion of the bridge concerned the navigability of the waterway and whether the highway would interfere with navigation. Environmentalists emphasized the negative impact on navigation while pro-bridge advocates argued otherwise; in a stunt staged to debunk the

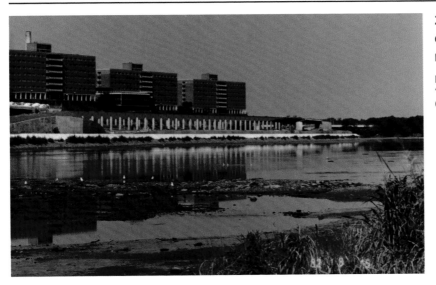

39. Route 18 construction near river dormitories

Photograph by George "Red" Ellis. Courtesy of George "Red" Ellis.

Table 4.1 Route 18 Chronology

1962	State plans highway to connect New Brunswick and Bound Brook.
1965	Significant opposition begins to mount.
1969	Construction begins on new Raritan River span.
1970	Federal mandates require environmental studies that delay the project for a decade.
1970s	Citizen and student groups seek to stop the project.
1975	Route 18 project receives all permits and approvals; a bikeway is mandated.
1977	Construction begins on a project of reduced size.
1983	Route 18 is completed at a cost of $40 million.

SOURCE: Wong 2007, 20, 28, 30, 33

river as a mighty waterway, two state senators walked across the Raritan at low tide in rubber boots (Sheehan interview, 16). It was New Jersey political theater at its best, or worst.

After a delay of almost a decade while environmental studies were conducted, approvals were finally received and permits issued in 1975 for a project reconfigured and reduced in size. Construction resumed in 1977, and the Route 18 extension was completed in 1983 (see table 4.1 for the chronology). What swayed the decision to complete the stalled highway and bridge? There was a generally favorable attitude in the 1970s and 1980s both nationally and in New Jersey toward building your way out of congestion. (This attitude has waned in more recent decades.) In addition, individuals with deep pockets and political clout undertook an extraordinary lobbying campaign to end the stalemate. Former J&J financial executive Robert Campbell indicated that "J&J felt that if it was going to stay, there had to be some quid pro quo here, and worked with the state in getting the extension of Route 18" (Campbell interview, 8).

Patricia Sheehan, mayor during the critical period 1967–1974, recognized that J&J would not "build a world headquarters if they couldn't get people in and out" (Sheehan interview, 16–17). To Mayor John Lynch, the bridge was one of those projects that, "regardless of how you look at it, it had to be done, but it just never should have taken that long to go through a process" (Lynch interview, 22). Former DEVCO head Christiana Foglio reflected on how the issue was handled:

> J&J had the power to get Washington funding, and enlisted all of their lobbyists for the purpose of getting highway dollars for the extension of Route 18 . . . it was a mess. And if you think traffic is bad now, back then you couldn't get anywhere. So I think people understood that unless you could move people in and out of the city, we were never going to attract any major [corporations] . . . we weren't even going to see expansion of Johnson & Johnson. (Foglio interview, 10)

With Route 18 and the new bridge back on track in 1975, the first condition set by the J&J board of directors was satisfied. Would the second condition be met—to conduct a study of whether and how New Brunswick could be revitalized? In a stroke of good fortune, the New Brunswick study was conducted by the American City Corporation (ACC), which was the brainchild of James Rouse, already mentioned in chapter 3 as the founder of Enterprise, a significant organization fostering affordable housing nationwide. Before discussing the New Brunswick study, it will be useful to consider the career of this important and influential thinker and leader in American urban renewal.

James Rouse, the American City Corporation, and the Hartford Process

James Rouse was born in Easton, Maryland, on April 26, 1914. Orphaned at age sixteen and with his childhood home foreclosed, he relied upon his older siblings to support several years of undergraduate education until the Depression forced him to leave school to work full-time. He attended law school at night at the University of Maryland while working as a clerk for the Federal Housing Administration (FHA). He graduated in 1936 and ran the mortgage department of a Baltimore bank until 1939, when he and a partner opened the Moss-Rouse Company, a mortgage banker (Goldberger 1996). After service in World War II, he became a prime spokesman and advocate for the Baltimore Plan, a project at the beginning of the era of urban renewal to rehabilitate deteriorated housing. He quickly was recognized as a keen observer of cities and social interactions and was appointed in 1953 to the President's Advisory Committee on Government Housing Policies and Programs. That committee made numerous recommendations (for example, to extend FHA insurance in older neighborhoods), some of which were adopted in the 1954 Housing Act, which aimed to improve the effectiveness of the urban renewal strategy.

In the 1950s, having bought out his partner, Rouse turned to the suburbs, and his company built some of the nation's first enclosed shopping malls. The latter were envisioned by Rouse as suburban town centers, though they did not always function in that capacity. In the 1960s, while still financing and building malls, Rouse embraced a new civic vision: the planned community. He started by developing the Village of Cross Keys in Baltimore on the sixty-eight acres of the former Baltimore Country Club. With a mix of housing, offices, and stores arranged around a village center, Cross Keys was attractive and successful. Rouse then attempted to build a literal "new city," called Columbia, on fourteen thousand acres he acquired in then-rural Howard County, Maryland, located midway between Baltimore and Washington, DC (Hoppenfeld 1967, 309). While continuing many of the design themes begun at Cross Keys (notably, the mix of housing and development arrayed around "village" centers), Columbia was much more ambitious in terms of both physical scale and concept. The latter was referred to as the Columbia Planning Process and encompassed a comprehensive physical, social, and economic multidisciplinary approach to planning and building that

involved experts in many fields as well as representation from government and the public at large. Rouse also separated the planning teams from the implementation entity, which at Columbia was Howard Research and Development, a corporation jointly owned by the Rouse Company and the Connecticut General Life Insurance Company. In the 1970s and the 1980s, Rouse's third influential innovation was the festival marketplace. First implemented with much success at Faneuil Hall in Boston, the strategy of mixing historic preservation, new development, and retail was used to revitalize urban areas ranging from Baltimore (Rouse was a major force in that city's Harborplace) to New York City (South Street Seaport) to St. Louis (Union Station).

As influential as Rouse was as a developer of suburban malls, planned communities, and urban shopping destinations, he himself believed that the capstone of his career was the Enterprise Foundation, which he and his wife founded after his retirement from the Rouse Company in 1979 (Goldberger 1996). As described in chapter 3, Enterprise is a major contributor to affordable housing and community development in the United States. Even before Enterprise, however, Rouse had founded the American City Corporation as a subsidiary of his company. It was no accident that the ACC was formed in 1968, during the period of national introspection following riots in the nation's older cities and also when Columbia was being launched. In the 1968 annual report of the Rouse Corporation, Rouse emphasized the need for and potential of the ACC "to remake existing cities into socially and economically successful organizations": "We believe that a private corporation, concentrating thoughtfully on urban problems, can contribute significantly to this process. . . . The purpose of this new subsidiary company is to provide a vehicle through which we can apply the experiences gained in planning, developing, and financing new communities to the restructuring of old ones" (Rouse Corporation 1968). With Leo Molinaro as its president, the ACC would go on to consult for cities across the United States and abroad. Its first major work was focused in Hartford, Connecticut, where the ACC formulated what was termed the Greater Hartford Process.

In the 1960s, Hartford faced many of the same urban challenges outlined in chapter 3: a loss of population and jobs to nearby suburbs and a growing impoverished population that was disproportionately minority. In response, the city attempted various urban renewal projects, most notably, the $42 million downtown Constitution Plaza, a commercial complex constructed between 1962 and 1964 that replaced a once largely Italian American neighborhood. But as in so many other American cities, urban renewal did not suffice to reenergize Hartford's economic and civic life and only exacerbated tensions with the ethnic and minority communities that had been displaced.

By the early 1970s, the business leaders who had supported Constitution Plaza and similar projects sought a different strategy. They approached the ACC, perhaps because the Connecticut General Life Insurance Company was James Rouse's partner in Columbia. Shortly after Rouse and Leo Molinaro spoke to Hartford business and city leaders, twenty-seven companies signed a $3 million

contract with the ACC to assess conditions in the city and to propose a plan of action. The ACC hired a staff of forty for this task and, after two years of study and analysis, recommended that two entities should be formed: the Greater Hartford Process Inc. (GHP) and the Greater Hartford Development Corporation (GHDC). The former, a collaborative planning entity, would examine the Hartford region, setting forth goals and designing specific proposals (Marx 2008, 160). The ACC recommended that the GHP have a broad-based board of directors that would include representatives from business, Hartford and suburban governments, and residents of the region. The GHDC, on the model of Columbia's Howard Research and Development, would spearhead implementation by acquiring land and engaging in development and management of the proposals decided upon by the GHP (ibid.). The ACC vision included both physical and social dimensions: rehabilitating Hartford's slums (especially the city's largely minority North End), revitalizing and adding to Hartford's downtown nonresidential core, building a twenty-thousand-person multi-race and multi-income "new town" in Hartford's suburbs, and enhancing social services to the poor.

Not surprisingly, the ACC study for Hartford reflects its Rouse and Columbia process intellectual roots. ACC's comprehensive strategy for Hartford's revitalization was long term (twenty years) and vast in scope (a $280 million project that would transform 40 percent of the city's property and 75 percent of Hartford's nonresidential space) (Bloom 2004, 49). It encompassed physical and social elements, included both urban renewal and controlled suburban growth, called for public-private collaboration, and advocated for citizen input. In its day, the ACC plan was widely praised. George Romney, then secretary of the U.S. Department of Housing and Urban Development (HUD), called the Hartford vision "the model for future metropolitan planning in the country" (ibid., 52). A *New York Times* columnist termed the Hartford plan "the largest, most visionary effort ever undertaken to renew and develop an entire metropolitan area in America" (Jack Rosenthal cited in ibid., 47).

Sadly, very little of the Hartford plan was ever implemented. The GHP and GHDC were formed, but accomplished little. The massive central business district and residential neighborhood revitalization never materialized, nor did the new planned suburb. Many reasons can be cited: the city government was a lackluster participant, Hartford's minority leaders feared displacement of their constituents, and local suburbs opposed any change to the status quo. In fact, some of the strongest original supporters of the Hartford plan left the area. The Connecticut General Life Insurance Company, for instance, had moved from its historic downtown headquarters in the late 1950s to a modern campus in the bucolic suburb of Bloomfield. Ironically, the new headquarters came to be regarded as a pioneering example of the International Style of suburban corporate architecture and was placed on the National Trust for Historic Preservation's list of endangered buildings in 2001 after Cigna, the result of a merger of Connecticut General and INA Corporation, announced plans to demolish it. Perhaps the most lasting legacy of the ACC plan for Hartford is the influence it had on the revitalization plan for New Brunswick.

New Brunswick Revitalization Study: Implementation and First Steps

As the point person for J&J's revitalization of its corporate home city, John Heldrich studied a number of different models and was attracted to the ACC's holistic strategy: "I became enamored with the [Hartford process and the] fact that they were forming a coalition of the business sector, the private sector, the public sector, and the community" (Heldrich interview, 7–8). Heldrich explained the Hartford process to J&J chairman Richard Sellars and arranged for Leo Molinaro, ACC's president, to meet Sellars. After the meeting, Heldrich recalled, Molinaro said to him, "He's not ready, John. He's not ready for what we're talking about— taking on a whole city," meaning ACC's philosophy of addressing physical, economic, and social issues simultaneously (Heldrich interview, 8–9).

Some time passed before Heldrich received a phone call from Sellars "out-of-the-blue one day." He wanted to meet with Molinaro again. It was then decided to conduct a formal study to determine the "odds of turning [New Brunswick] around." At this point, Sellars became "the convener within the community of the key players at that time" (Heldrich interview, 9). Sellars organized a meeting at the Johnson & Johnson guest house attended by the mayor of New Brunswick, the heads of area hospitals, President Edward J. Bloustein of Rutgers University, local bankers, and other community members. The group agreed to hire ACC to conduct a feasibility study and pledged money to fund it. Johnson & Johnson made up the difference between the pledges and the contractual fee, which, Heldrich noted, was "a major share" (Heldrich interview, 9–10).

The ACC issued its study, *Trends, Issues, and Priorities in the Revitalization of New Brunswick, New Jersey*, in January 1975. The cover letter from Molinaro spoke of "a series of findings and recommendations" where "the role of the private sector is emphasized." The report detailed numerous challenges facing New Brunswick, including the absence of generally shared community goals, a diffused community leadership, a pervasive negative image of the city, and the absence of a development capability organized to perform in the public interest (American City Corporation 1975b, 88). Yet the study also identified numerous New Brunswick resources and advantages, including location and transportation access (despite "current controversies," an allusion to the Route 18 morass); the fundamentally sound economic base of the city and region; an excellent health and education institutional base (hospitals and Rutgers); the presence of government at all levels (city, county, state); the Raritan River, the city's original and continuing attraction, though not fully accessible; the human resources represented by the city's striving ethnic and minority groups; and the economic resources represented by the city's corporate citizens (ibid., iii–iv). The report observed that two major components of New Brunswick, the central business district (CBD) and the residential neighborhoods—once among the city's best resources—now needed attention. It emphasized that their futures were inextricably linked economically, physically, and socially.

The study and its underlying philosophy stressed the importance of a public-private partnership (PPP) to revitalize New Brunswick: "Neither the private sector nor government alone can provide all the resources needed for a comprehensive revitalization program. The community development process works best when it is a joint venture of willing partners committed to a comprehensive set of goals, supported by both public and private investments" (Heldrich 1988, 7). The public half of the New Brunswick partnership would come from the city, county, and state governments, with the city playing the largest role. The private half of the partnership would come from the business community, the residential population, and others. To actualize the PPP, the ACC recommended the formation of two new organizations: New Brunswick Tomorrow (NBT), a non-profit community organization that would formulate and establish development priorities and create a positive image; and the New Brunswick Development Corporation (DEVCO), a nonprofit organization that would implement NBT's plans. DEVCO's board of directors would be composed of three equal categories: business corporate leaders, institutional and public officials, and resident community leaders. The ACC's strategy for New Brunswick clearly reflects its plans for Hartford and its intellectual roots in the earlier Columbia framework for development. NBT is almost a mirror image of the Greater Hartford Process and earlier Columbia planning process, while DEVCO is a clone of the Greater Hartford Development Corporation (and the earlier Columbia Howard Research and Development entity).

NBT was founded on July 1, 1975. David Nesbitt, an ACC project director, was named interim president, with a salary paid by J&J. J&J and Nesbitt then selected five NBT officers, who in turn appointed a twenty-four-member board of directors. Not surprisingly, the NBT board included many senior business persons (for example, bank and utility company executives). Other business representatives came from a variety of firms, including the local radio station, a prominent realtor/insurance brokerage firm, and a well-known jeweler. NBT's founding board also encompassed government officials (for example a Middlesex County freeholder and members of the New Brunswick City Council), representatives from the community (for example, Hungarian, Hispanic, and black leaders), and from academe (Rutgers University).

The ACC underscored the need for action and cautioned that the NBT "must *not* be seen as the UN . . . debating society made up of power blocks that only check-mate each other" ("New Brunswick Revitalization," emphasis in original). NBT's mandate included formulating short- and long-term community goals, creating a positive self-image, establishing development priorities, and creating a PPP with the city, the business community, health and educational institutions, and community organizations (Molinaro Associates 1993, 5). The organization had high aspirations. In an early pamphlet for public distribution, it rhetorically asked, "What is NBT? NBT can do what the name says—it can shape the future of the city" (New Brunswick Tomorrow 1977). To jump-start its operations, NBT initiated a fund-raising campaign, and shortly thereafter it had secured $1 million in

pledges from 231 individuals, companies, and institutions ("New Brunswick Tomorrow" 1979). A high percentage (98 percent) of these pledges, ranging in amount from $10 to $200,000, was collected (Heldrich 1988, 9). The New Brunswick Chamber of Commerce was active in the fund-raising, the City of New Brunswick contributed $85,000 (Howard 1988, 5), and the most significant financial support came from J&J.[3] With funds secured, NBT was able to hire a seasoned urban planner, Abraham Wallach, as permanent president. Wallach had previously served as Jersey City's planning director ("New Brunswick Tomorrow" 1979).

Following the recommendation of the ACC, the New Brunswick Development Corporation (DEVCO) was created in January 1976 (Heldrich 1988, 10). As described in an NBT pamphlet, "plans and ideas conceived by NBT will be turned over to DEVCO to finance, construct, and manage. . . . DEVCO was established to help transform the goals of NBT into reality." DEVCO was expected to seek outside developers if possible; but if none could be secured, then it would serve as the "developer of last resort" (Molinaro Associates 1993, 6).

The first chairman of DEVCO's board of nine directors was Richard Sellars of J&J. Other founding board members were William H. Tremayne, vice president and comptroller of the Prudential Insurance Company of America; Charles M. Marcinate, state AFL-CIO president; David Harris, an African American who had worked for the Middlesex County Economic Opportunities Corporation as director of citizenship education; and Robert C. Totten, Rutgers assistant vice president for facilities. Paul J. Abdalla, who had served as the New Brunswick City Council president and NBT vice chairman, was appointed as DEVCO's first president.

To create a system of checks and balances and also to foster inter-organization communication, two NBT board members, C. Roy Epps and Leonard Hill, served on the DEVCO board, and two DEVCO members served on the NBT board (Heldrich interview, 13). On both boards, some members and the organizations they represented clearly had more influence on decision making than others. Christiana Foglio, an urban planner working for New Brunswick and ultimately president of DEVCO in the late 1980s and early1990s, spoke of a biannual meeting where Richard Sellars of J&J, President Bloustein of Rutgers, and Mayor John Lynch would "lay out a course [of action] for the next six months, and they would look at who could deliver what" (Foglio interview, 9). David Harris did not stay on the board of DEVCO for long because he realized that "the meetings were essentially designed to get the community input on what they had already essentially planned" (Harris interview, 14). Nevertheless, NBT and DEVCO tried to bring diverse interests "to the same table" to realize a "unity of purpose" (Heldrich interview, 24).

With such a broad mandate, there was much to do—but where to begin? ACC had been engaged to conduct a series of community workshops, summarize this experience, and make recommendations. This study was entitled New Brunswick Tomorrow. Separate workshops were held with the New Brunswick Council of Churches, the city's Hungarian, Puerto Rican, and black communities, and others (for example, the New Brunswick Planning Board, the Rutgers University leader-

ship, and even the local Boy Scouts). Understandably, there were differences in perspective. The Hungarian community feared an influx of subsidized housing in their neighborhoods, and the black community worried that redevelopment would displace them—or, more broadly, that minorities would not "realize benefits from NBT in proportion to their population representation" (American City Corporation 1975a, 11). Nevertheless, the workshops revealed many common areas of concern (crime and worsening public services) as well as aspirations for the future (enhanced educational and cultural opportunities).

Following these workshops, the ACC developed recommendations for follow-up action:

1. **TRANSPORTATION.** Relieve congestion through improved traffic signals at the Albany Street circle, rehabilitate the railroad station, and press for restarting the stalled Route 18 project (American City Corporation 1975a, 30).

2. **HOUSING.** Build/rehabilitate 350 units annually, with "new-town-in-town" development to be encouraged at multiple locations in the city (such as Route 1 and Ryders Lane, and at buildable parcels along the Raritan River). Better access to mortgage credit was also needed.

3. **EDUCATION AND HEALTH.** Because the community "has lost confidence in its school system" (American City Corporation 1975a, 21), many educational improvements were recommended, such as building new schools, offering individualized instruction, and providing a family learning center for pregnant students. Better access to healthcare was also deemed essential.

4. **QUALITY OF LIFE (QOL).** Many QOL enhancements were needed, ranging from building more parks to fostering a "cultural center in the downtown area" (American City Corporation 1975a, 31).

5. **DOWNTOWN IMPROVEMENTS.** To revitalize the CBD, a comprehensive series of actions was put forth. Public safety had to be enhanced, along with the physical appearance of the downtown. Stress on significant new development emphasized a new J&J headquarters: "J&J being the focal point of the downtown, it should develop a principal high-rise structure complemented by various amenities and commercial areas (retail, restaurant, and open space)" (American City Corporation 1975a, 33). The city's Commercial Plaza urban renewal tract, with 10.3 cleared acres at lower George Street but only one 95,000-square-foot building (Plaza I) built to date, was viewed as another promising location for future development. ACC recommended that the Hiram Square area be developed with high-quality townhouses. Additionally, the report proposed a high-amenity business hotel with at least 200 rooms to be located across Albany Street, south of the J&J complex (ibid., 34).

The ACC community workshops and proposals were ambitious, and NBT, DEVCO, and J&J moved on many fronts to address the recommendations.

Some initial actions included working with the Urban League and banks to create a $1 million mortgage pool (to combat redlining); cooperating with the Urban League, the Hungarian Civic Association, and the Puerto Rican Action Board to improve physical conditions in the city's many ethnic and minority communities; keeping open the Family Health Care Center at Middlesex General Hospital (MGH) and helping the transformation of MGH into a much larger regional medical facility and teaching hospital; working with city government and a merchants group to improve the physical appearance and security in the downtown; and trying to improve educational services (for example, bringing together the chamber of commerce and board of education to enhance employment skill training).

There were also efforts to beautify the city and enhance the quality of life. NBT helped lead a Railroad Plaza planning process to spruce up the shabby downtown train station. An NBT task force addressed nonconforming uses in residential neighborhoods, such as taverns and junkyards. J&J purchased a burned-out hulk of a building on the city's busiest intersection (George and Albany Streets) and converted the space into Joyce Kilmer Park. Reflecting conditions at this time, this park was locked at night to keep out the homeless.

The ACC did other work for New Brunswick, as did the consulting firm eventually founded by Leo Molinaro. An example of the work by Molinaro Associates is "The New Brunswick Revitalization Process" (1993), an analysis conducted for NBT that reiterated many of the themes of prior ACC reports (for example, the importance of PPPs).

NBT also engaged the services of other top professionals, most prominently the internationally renowned architectural and planning firm I. M. Pei & Partners. In fact, the firm had two separate assignments in New Brunswick in the mid-1970s. Henry Cobb, senior principal architect responsible for both assignments, said that the firm's involvement with New Brunswick "began with our engagement by Johnson & Johnson to do a master plan for its new headquarters. And, more or less simultaneously, we were asked [by NBT] to do a sort of framework plan for downtown New Brunswick" (Cobb interview, 5). These assignments could be, and would be, perceived to be intertwined, given that the chairman of NBT, John Heldrich, was a J&J executive. Still, Cobb thought that it was "responsible" for J&J to "place its headquarters in the context of a larger plan" and regarded each as "a completely separate enterprise" (ibid., 5–6).

Johnson & Johnson Headquarters

In 1973, several nondescript corporations (Anngay Company, MEC Inc., and Attorneys Investors Company) began acquiring properties in a 12.5-acre, eight-block area bounded by Albany, George, Somerset, and Water Streets (with Neilson Street intersecting) in New Brunswick (Guidette 1981a, D1). These were, in fact, dummy corporations created by the Philadelphia law firm Morgan, Lewis & Bockious to hide the identity of the company interested in the properties, namely, Johnson & Johnson. Robert Campbell, then J&J's chief financial officer, recounts

being asked by an incredulous vice president of finance to "verify that bills from a Philadelphia law firm were legitimate" (Campbell interview, 2).

J&J's objective was to assemble a site suitable for a new corporate headquarters, should the deliberations by its senior executives end in a decision to stay in the company's home community. Despite the attempt to avoid inflating prices by disguising J&J's involvement, some speculators reaped "handsome profits" (Guidette 1981a, D1). Ultimately, J&J's interest in the site became public in the *New York Times* (Ross 1974). Richard Sellars acknowledged in a statement that the company was acquiring properties as a "possible solution to our long-range expansion and modernization requirements" (Schkrutz 2011, 14).

The 12.5-acre site represented three hundred years of New Brunswick history, including Dutch colonial settlers, a visit by George Washington, Hungarian immigrants after the turn of the twentieth century, and Hispanic residents after World War II (Guidette 1981b, A1). By 1965, the area had deteriorated markedly (Heldrich 1988, 13). As described in the local newspaper, "it wasn't popular with businesses, who were pulling out—if they were lucky enough to find a buyer for their depreciating property" (Guidette 1981b, A1). To be sure, a few thriving businesses lingered into the 1970s, including Tumulty's Pub, Ristorante Alfredo, and Aaron Plumbing Supply. It took J&J eight years and in excess of $10 million to acquire the entire site, composed of sixty-three mostly vacant buildings and eighty-nine parcels, with individual property prices ranging from $10,500 (a vacant lot on Neilson Street acquired in 1974) to $2 million (Tumulty's Pub, the last purchase in 1981) (Guidette 1981a, A1). Some of the businesses moved to other locations in New Brunswick (Tumulty's re-created its original building on George Street) or relocated out of town (Aaron Plumbing Supply moved to nearby Piscataway). Other businesses shut their doors forever.

Along the path to its site acquisition, J&J publicly announced in April 1978 that it would remain in New Brunswick and build its new corporate headquarters there. The ACC had recommended a high-rise structure that would be the focal point for the downtown (American City Corporation 1975a, 33). Henry Cobb recalled that his J&J clients had differing visions for their new home. The project's design began under the auspices of Richard Sellars and continued under his successor as CEO, Jim Burke. According to Cobb, Sellars thought of the headquarters in "monumental terms" and "wanted a skyscraper" (Cobb interview, 17). Cobb, on the other hand, "wanted to engage [the] property on a scale that seemed sympathetic to downtown New Brunswick." The idea was "a building in a park, and a park in the city—so we wanted people to feel that they were passing by a park, not just a corporate headquarters" (ibid.). Though Burke "actually would have preferred to have no tower," the tower vision ultimately prevailed. In the debate over what kind of presence Johnson & Johnson should have in New Brunswick, some advocated a building on George Street with retail on the ground level and offices above. In the end, security concerns tipped the decision toward a "park in the city." "The reality is that the park couldn't just be flung open to people," Cobb said, so the design "picked up on the Rutgers campus precedent of the low wall with a

raised ground level beyond it. It's an interesting thing that when you have a wall, if you raise the ground level beyond it, it reads much less like a wall" (ibid., 27–28).

The I. M. Pei & Partners plan for the J&J headquarters building was unveiled on April 5, 1978. A sixteen-story white aluminum-clad tower would be set back about one hundred feet from Albany Street in a grassy area separated by a wall from one of New Brunswick's major thoroughfares. Seven interconnected three- and four-story office buildings were set off from the tower. A four-level, 1,080-car garage would also be built. J&J broke ground on its new headquarters in February 1979, and it was completed at a cost of about $70 million eighteen months later.

Reactions to the building's architecture and its impact on the city differ widely. Rutgers University professor Anton Nelessen, an architect by training and a resident of downtown New Brunswick in the 1970s, viewed it as "anti-urban. It was suburban—it was a suburban solution to an office building, essentially a gated office park, if you will, with their own internal campus on the inside of it" (Nelessen interview, 31–32). Former Rutgers provost Kenneth Wheeler was more succinct: "It's ugly" (Wheeler interview, 28). David Harris, the black activist who had served on DEVCO's board, believed that J&J was concerned with the development of downtown New Brunswick at the expense of the rest of the city. In a sarcastic variation of "New Brunswick Tomorrow," he described J&J's program as "basically 'Downtown Tomorrow'" (Guidette 1981b, 10).

Others take a positive view of the J&J headquarters and what it symbolized. Long-serving city planning director Glenn Patterson agreed that the building "is a little remote from the rest of downtown" but insisted that "it has made a very attractive downtown. The J&J tower . . . everyone knows what it is. It is a good icon for the city . . . it showed . . . some world players were investing in New Brunswick" (Patterson interview, 11). The J&J building design in the context of its time will be discussed further in chapter 6.

Not part of the J&J headquarters but located next to it was a decommissioned Public Service Electric & Gas substation on Albany Street just southeast of the corporate campus boundary. When J&J finished its tower in 1982, it commissioned a muralist to paint a trompe l'oeil, "which transformed the plain brick wall of the substation into the side of a neoclassical building with detailed white cornices, impossibly tall windows and an interior passageway which appeared to link the sidewalk through to the other side of the building" (Schkrutz 2011, 30). To J&J and others, this gesture was simply a temporary civic-minded beautification of an obsolete building. The building and mural were demolished by J&J in 1987, with some regretting the loss of what had become a quirky local visual landmark; others felt that the substation needed to be cleared because it obstructed the vista of a modernized post-industrial Albany Street anchored by the gleaming tower of a Fortune 500 company.

Many other buildings and projects in revitalizing New Brunswick evoked both positive and negative reactions. Prominent examples are the Hyatt Regency and Hiram Market. Many of these projects were part of an I. M. Pei & Partners plan for downtown New Brunswick commissioned by NBT and released in 1976.

40. Johnson & Johnson headquarters building

Courtesy of Eric Draper Photography.

41. Haas mural on utility building in front of Johnson & Johnson, later demolished

Photograph by George "Red" Ellis. Courtesy of George "Red" Ellis.

The I. M. Pei Downtown Renewal Plan

Connections can be seen between Pei's vision of the major projects needed to revitalize New Brunswick's downtown and the recommendations that came out of the ACC community workshops discussed earlier in this chapter. Other influences came from the national debate on urban renewal. Henry Cobb, principal architect of the firm in charge of the assignment, described the prevailing design atmosphere: "By the end of the 1960s, we were very much aware of, I would say, more of the shortcomings of urban renewal than of its accomplishments" (Cobb

interview, 9). This reaction led the firm to see itself "as planners helping to develop a strategy for renewal, but eager to avoid prescribing too much . . . our work for New Brunswick Tomorrow was very much strategic" (ibid.). Cobb looked back to the New Brunswick Plan published in 1925 by the city planning commission led by Herbert Swan. The commission's "approach to planning was exactly what we had in mind, but very sensitive to—not at all sort of tabula rasa, wipe everything clean—but very much about going in and making a very limited surgical kind of [plan]—and very civically oriented. Very much about the quality of urban space and streetscape." He thought that the 1925 plan was "a wonderful model for how to deal with a city like New Brunswick" (ibid., 11).

Like the 1975 ACC study of New Brunswick, the Pei Downtown Plan (Pei 1976) acknowledged that the city faced many challenges (its CBD is "kind of sick")

Fig 4.1 I. M. Pei Downtown Plan for New Brunswick, 1976

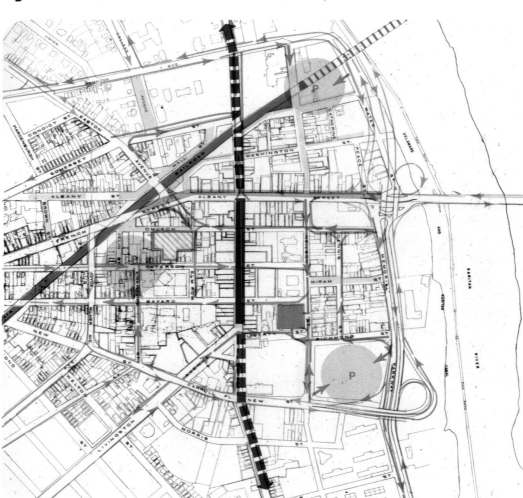

Courtesy of Pei Cobb Freed & Partners.

but noted such advantages as stable neighborhoods and a manageable city ("I. M. Pei Proposes" 1976; Schkrutz 2011, 12). Among its numerous recommendations for civic improvements were the widening of the right-of-way of Albany Street from the bridge to the railroad station to allow widened and tree-lined sidewalks and a landscaped median to separate opposing lanes of traffic (Pei 1976, 6); making George Street more pedestrian friendly; rehabilitating the existing train station; and providing intercept garages and other parking improvements to address traffic congestion. Weighing in on the Route 18 controversy, Pei described the extension "as 'vital to the future of New Brunswick' and a key element in creating a rational traffic pattern" for the CBD (ibid., 5). Additionally, Pei wanted the extension to better connect to New Brunswick's downtown by incorporating appropriate entrance and exit ramps.

The Pei plan also urged construction of a number of nonresidential and residential anchor projects:

1. A new office building on the 8.5-acre cleared but largely vacant George Street urban renewal tract "to close the open wound on George Street" and "trigger other downtown redevelopment" (ibid., 3).
2. A new "quality downtown hotel" on the south side of Albany Street, between Neilson Street and Memorial Parkway (ibid., 6).
3. Residential development in the ten-acre, four-block Hiram Street area. Pei put forth two density scenarios: "low" (375 town and row houses)

42. Liberty and Richmond Streets, Plaza I and Plaza II buildings

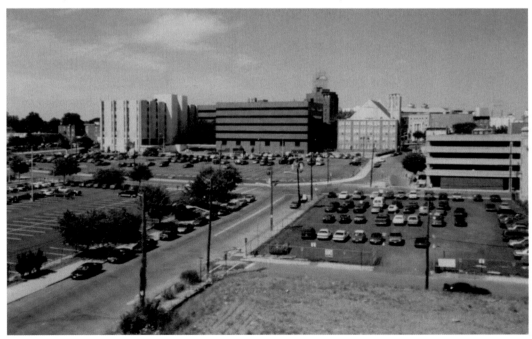

43. Hyatt Regency hotel

Photograph by Larry Levanti.
Courtesy of Larry Levanti.

and "high" (650 units of townhouses and other configurations). To make the Hiram Market area more attractive, it should be connected to a proposed riverfront park containing a marina and amphitheater.

4. Other projects at key city street intersections to enhance the community's civic and cultural functions.

As identified in this chapter's concluding section (and detailed further in chapter 5), many of the projects recommended in the Pei plans came to fruition. Chapter 6 discusses whether the development that occurred in New Brunswick was, in Cobb's words, "surgical" improvement or more typical of the era's enthusiasm for "wiping the slate clean" (Cobb interview, 9).

Phases of Redevelopment

New Brunswick's redevelopment has occurred over a forty-five-year period, beginning after the unrest of the 1960s with the initial feasibility and planning studies by the American City Corporation and later by I. M. Pei. Five major phases are identified and described below. Table 4.2 provides a list of DEVCO projects, illustrating their scale of magnitude. Interestingly, the first two phases were completed during

Table 4.2 DEVCO Major Projects, 1968–2015

YEAR COMPLETED	PROJECT	PROJECT STATISTICS	
		Square feet	Investment ($)
1968	Plaza I (office) (purchased by DEVCO 1977)	100,000	$5,000,000
1979	Plaza II (office)	125,000	15,625,000
1982	Hyatt Regency Hotel (hotel)	200,000	6,000,000
1986	George Street Playhouse (theater)	35,100	3,000,000
1987	Douglass Estates (residential)	65,000	2,500,000
1988	State Theatre renovations (theater)	40,000	4,000,000
1988	Casa Di Lusso (residential)	70,000	5,000,000
1989	Golden Triangle (office)	260,000	52,000,000
1991	Crossroads Theatre (theater)	24,500	3,000,000
1991	Kilmer Square (retail and office)	145,000	18,000,000
1991	Camner Court (residential)	50,000	3,000,000
1992	Comstock Court (residential)	50,000	3,000,000
1994	University Center (student housing)	452,400	52,000,000
1994	Delavan Court (residential)	55,000	3,700,000
1994	Renaissance Station (residential)	176,250	22,000,000
1994	Livingston Manor (senior housing)	40,000	6,000,000
1994	Providence Square (senior hwousing)	78,400	10,600,000
1994	Riverwatch (initial phase) (residential)	18,000	1,000,000
1995	Civic Square I: Center for Arts and Planning (academic–Rutgers)	175,000	47,000,000
1998	Liberty Plaza (office)	135,000	23,000,000
1998	Riverwatch Commons (residential)	140,000	12,000,000
1999	Riverwatch (final phase) (residential)	125,000	15,000,000
1999	Boyd Park (public park)		11,000,000
1999	Civic Square II: County Administration Building (office)	115,000	50,000,000
2000	Civic Square II: Public Safety Building (office)	118,000	
2000	Civic Square III: Middlesex Family Courthouse	108,000	30,000,000

(continued)

Table 4.2 DEVCO Major Projects, 1968–2015, continued

YEAR COMPLETED	PROJECT	PROJECT STATISTICS	
		Square feet	Investment ($)
2002	Lord Stirling Community School (school)	98,000	24,500,000
2003	Civic Square IV: Courthouse renovation (office)	230,000	33,000,000
2003	Skyline Tower (residential)	80,000	13,000,000
2003	State Theatre renovations (theater)		3,000,000
2004	The Highlands (residential)	700,000	58,500,000
2005	Child Health Institute of New Jersey (laboratories/clinical)	145,000	73,000,000
2005	Rockoff Hall Student Apartments (student housing)	261,000	55,000,000
2005	Morris Street Parking Garage (parking)	256,000	25,000,000
2005	Rutgers Public Safety Building (office—Rutgers University)	75,000	34,000,000
2005	Rutgers Public Safety Parking (parking—Rutgers University)	115,200	
2007	The Heldrich Redevelopment Project (hotel and residential)	365,000	120,000,000
2009	Rutgers Convent Renovation/Rutgers Catholic Center (office)	20,000	3,800,000
2009	Civic Square III expansion (office)	36,000	4,300,000
2010	New Brunswick High School (school)	400,000	185,000,000
2010	State Theatre renovations (theater)		1,000,000
2012	Gateway Transit Village (office, residential)	635,000	145,000,000
2013	Wellness Plaza/fitness center, supermarket, parking structure (retail, parking)	585,000	105,100,000
2013	The George (residential)		35,000,000
2014	New Brunswick Theological Seminary (academic—seminary)	30,000	6,600,000
2015–16	Rutgers College Avenue Campus Redevelopment (academic/residential—Rutgers University)	948,000	310,000,000
	Total	**7,779,850**	**$1,647,225,000**

SOURCE: New Brunswick Development Corporation.

John Lynch Jr.'s tenure as mayor, while the last three occurred during James Cahill's terms as mayor. Many of the individuals interviewed about the redevelopment process believed that the considerable progress realized had much to do with the consistency of governance in the city during this entire time. Two maps illustrate the major phases of redevelopment, as well as several additional housing projects undertaken during this period. Figure 4.2 provides an overview of the five phases of redevelopment by general areas. Figure 4.3 provides numbers for each of the major projects in the central downtown area. The numbers in the text below correspond to the numbers locating these projects on Figure 4.3. Although these maps and the chronological discussion that follows focus on major projects, it is important to note that many smaller-scale housing and community/economic development interventions were accomplished in the same periods throughout New Brunswick.

Fig 4.2 Map of Downtown New Brunswick with Redevelopment Phases

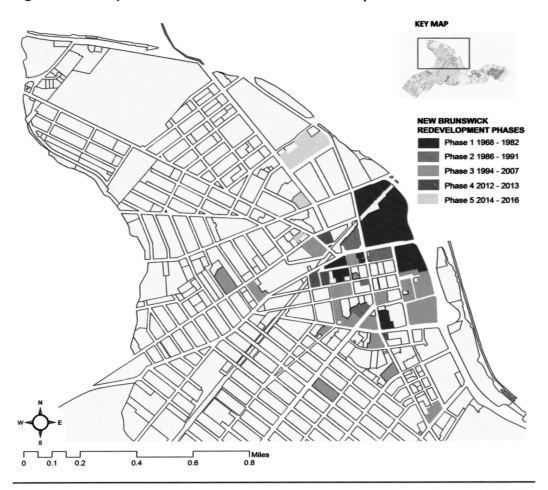

SOURCE: Swetha Ramkumar, Edward J. Bloustein School of Planning and Public Policy.

Fig 4.3 Map of Downtown New Brunswick with Numbered Projects

PHASE 1
1 Plaza 1 - 1968
2 Plaza 2 - 1979
3 Lynch Bridge over Raritan - 1980
4 Former National Bank of New Jersey
 Bldg - 1982
5 Ferren Parking Deck & Mall - 1981
6 J&J Headquarters Bldg - 1979
7 Hyatt Regency Hotel - 1982

PHASE 2
8 Albany Street Plaza, Tower 1 - 1986
9 Theaters: George Street - 1986,
 State - 1988, Crossroads - 1991
10 Golden Traingle - 1989
11 Office & Retail -
 Hoagland Law Firm - 1991
12 Kilmer Square - 1991

PHASE 3
13 University Center - 1994
14 Providence Square - 1994
15 Livingston Manor - 1994
16 Riverwatch (initial phase) - 1994
17 Civic Square 1 - Ctr. for Arts &
 Planning - 1995
18 Liberty Plaza - 1998
19 Riverwatch Commons - 1998
20 Riverwatch Final Phase - 1999
21 Civic Square II - County Admin
 Bldg - 1999
22 Civic Square II - Public Safety Bldg - 2000
23 Civic Square III - M'sex Family
 Courthouse - 2000
24 Hope Manor - 2001
25 Albany Street Plaza, Tower 2 - 2002
26 Civic Square IV - Courthouse Renov.,
 Skyline Tower - 2003
27 The Highlands - 2004
28 Child Health Institute of
 New Jersey - 2005

29 Rockoff Hall Student Apartments,
 Morris Street Parking Garage - 2005
30 Rutgers Public Safety Bldg - 2005
31 One Spring Street - 2006
32 The Heldrich Redevelopment
 Project - 2007

PHASE 4
33 Gateway Transit Village - 2012
34 Wellness Plaza / fitness center,
 supermarket, parking structure -
 2013
35 The George - 2013

PHASE 5
36 New Brunswick Theological
 Seminary, Rutgers College
 Avenue Campus Redevelopment -
 2014–2016
37 Easton Avenue Apartments - 2015
38 Rutgers College Avenue Campus
 Redevelopment - 2016

SOURCE: Swetha Ramkumar, Edward J. Bloustein School of Planning and Public Policy.

PHASE I: INFRASTRUCTURE IMPROVEMENTS
AND FIRST PROJECTS, 1968–1982

Plaza I (1) was a lone outpost on a cleared urban renewal site on George Street in New Brunswick. Not until about a decade after the office building was constructed in 1968 were other major infrastructure and building projects undertaken in the city. In 1977, after a decade of delay, the U.S. Army Corps of Engineers gave its approval for the Route 18 extension and bridge (3), and the state transportation department accepted construction bids on this project to alleviate traffic congestion in downtown New Brunswick. A second major infrastructure project completed during this period was the separation of the sanitary and storm sewer systems in the George Street retail district, a critical prerequisite for subsequent improvements to this area.

In 1978, J&J announced its decision to keep its headquarters in New Brunswick, and the new I. M. Pei–designed headquarters (6) was built between 1979 and 1987. During this same two-year period, DEVCO completed a $6.5 million Plaza II office building (2) designed by Pei next to the lone Plaza I building on the George Street urban renewal site ("Commercial Plaza") that had been vacant for more than a decade. Other building projects initiated following the I. M. Pei development plan included the $12 million Ferren Mall parking deck (5) on Albany Street across from the train station and, farther down Albany Street and

**Fig 4.4
Site Plan for
Plaza II Office
Building**

Courtesy of Pei Cobb Freed
& Partners.

across from the J&J headquarters, the Hyatt Regency (7). Two additional projects were the $12 million Paul Robeson School, made possible in part by development-induced increased tax revenues, and renovation of the 54,000-square-foot former National Bank of New Jersey building at 390 George Street into a major office space by Boraie Development (4).

PHASE II: ALBANY AND GEORGE STREETS, CULTURAL CENTER, AND FURTHER INFRASTRUCTURE, 1986–1991

A second phase of redevelopment, still following the Pei plan, emphasized new development to provide a critical mass at the major intersection of George and Albany Streets. The Golden Triangle office building (10) and the Albany Street Plaza (8) and Kilmer Square (12) projects provided mixed-use retail and office space along Albany Street from the Ferren Deck on George Street toward Neilson. To alleviate a parking shortage, a second major parking structure was built on lower Church Street, extending through the block to Paterson Street. Another major hub of development during this phase involved the three theaters that now compose the Cultural Center (9): the renovated State Theatre, a renovated building for the George Street Playhouse, and a new building for the Crossroads Theatre—all three side-by-side along Livingston Avenue at the other end of the business district along George Street.

These projects followed the recommendations of the Pei plan for improvements to the Albany Street Corridor from the Railroad Plaza to the Hotel Complex, for nodes for downtown parking, and for a cultural center. Two additional projects undertaken during this time were the Eric B. Chandler Community Health Center at George and Morris Streets and the renovation of another older building on George Street at Paterson into a 65,000-square-foot office and retail space (11).

PHASE III: GOVERNMENT, EDUCATION, HOUSING, AND HEALTH PROJECTS, 1994–2007

The third phase of redevelopment, following the election of Mayor James Cahill and the completion of the report Agenda 2000 by Molinaro Associates in 1993, expanded redevelopment beyond the George and Albany Street areas. One of the last recommendations in the Pei plan was for new housing in the Hiram Market area. After the neighborhood was deregistered as a historic district in 1992 (Yamin and Masso 1996, 23), construction began that year on the first phase of the Hiram Square Riverwatch condominium project (16) and was extended with the completion of the Riverwatch Residential Community (19, 20) in 1999 and the Highlands in 2004 (27). Additional major housing projects completed during this phase were luxury condominiums at One Spring Street (31) and The Heldrich (32) (which also enhanced the upgrading of Livingston Avenue in the theater district), university housing on Easton Avenue (13) and on George Street at Rockoff Hall (29), and the senior housing Providence Square project (14) on Somerset Street. Providence Square involved the adaptive reuse and historic

preservation of a former cigar factory; it was joined by the historic renovation of an apartment building, Livingston Manor (15), located on the city's once posh Livingston Avenue.

A second major area for redevelopment during this phase was the government building district from Livingston Avenue to Paterson Street along Kirkpatrick. Constructed during this period were the Civic Square I and II projects (17, 21, and 22), which included new university, county, and municipal educational and office buildings, as well courthouses. These initiatives represented New Jersey's first privately conceived, planned, developed, constructed, and maintained government complex (17, 21, 22, 23, 26).

Additional projects included Liberty Plaza (18), which provided 135,000 square feet of office and retail space on George Street in the business district; the second tower of Albany Street Plaza (25); the Rutgers Public Safety building (30), which together with Rockoff Hall extended the university's presence on the George Street corridor toward its Douglass campus; and the Lord Stirling Community School. During this time, the Robert Wood Johnson Hospital (previously Middlesex County Hospital) added the Child Health Institute of New Jersey (28) to its expanding facilities.

PHASE IV: TRANSIT-ORIENTED DEVELOPMENT AND A NEW HIGH SCHOOL, 2012–2013

Completed in 2012 in the area of the railroad station, the Gateway Transit Village Redevelopment Project (33), a 632,000-square-foot residential, retail, and parking building, includes two hundred residential units, the university bookstore, and restaurants, shops, and office space, and links the downtown and the railroad station to the College Avenue campus of the university. Also attracting new residents is a new Wellness Plaza (34) across from the train station, with a modern full-service supermarket, a 1,200-car garage, a fitness center, and an indoor pool. The George Apartments (35) at New Street and George also provide more housing along the George Street corridor.

Farther south along Route 27 toward Franklin Township is a new state-of-the-art New Brunswick High School building, built with a public-private partnership.

PHASE V: COLLEGE AVENUE CAMPUS, MORE HOUSING, 2014 AND BEYOND

Already under way are major changes to the College Avenue campus of Rutgers that will transform the New Brunswick Seminary site into a major academic hub for the university (36). This site now includes new Rutgers University academic and honors college buildings and a new seminary building. (For details, see the photo essay "The Transformation of Seminary Hill" following this chapter.) Additionally, DEVCO and Rutgers University are collaborating on new residential and retail buildings at the corner of College Avenue and Hamilton Streets (38). Further, new housing by private developers is going up along Easton Avenue (37), providing more housing for university students and others.

The Transformation of Seminary Hill

THE NEW BRUNSWICK THEOLOGICAL SEMINARY had its beginnings in 1784, when it was created by the Reformed Dutch Church (Coakley 2014).[1] In 1856, it moved into the first building on a campus that became known as Seminary Hill, overlooking today's Voorhees Mall on Rutgers's College Avenue campus, and facing the Old Queens campus located at the other end of the mall. The historical view of the campus is presented in photo 44. The first building—Hertzog Hall—was in the center of the campus (photo 45). It was eventually flanked on its left (when facing Hertzog Hall) or west side by the Gardner A. Sage Library, and on its right (east side) by Suydam Hall, a multifunctional building that housed classrooms, a gymnasium, a chapel, and other functions (photo 44). It was a delightful, symmetrical proud row of impressive classical buildings. Photo 46 provides a close-up of the east side of the campus, with Hertzog Hall on the left and Suydam Hall on the right. Subsequently, two residential buildings were built on each side of the campus, flanking the Sage Library and Suydam Hall (photo 44).

In 1965, in the context of changing educational needs, the seminary decided "to raze both Hertzog Hall and Suydam Hall and construct in their place a 'multi-purpose building' containing classrooms, offices, chapel, visual aids, etc." (Coakley 2014, 73). This was a significant architectural loss—an abandonment of the nineteenth-century vision of the campus (ibid., 105). Zwemer Hall, the replacement structure, was dedicated in 1967 (photo 47). It was described as a "new and dynamic" architectural style (ibid., 75). It was quickly labeled by many observers as an inverted Dixie Cup.

44. Theological Seminary of the Reformed Church in America,
New Brunswick, N.J., Summer View

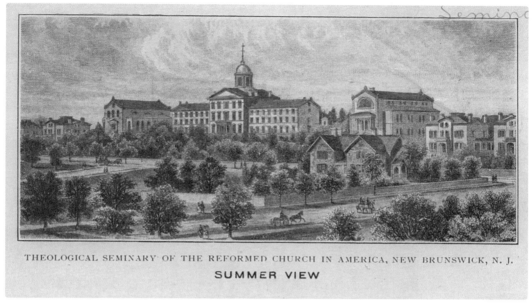

Artist's rendering, no attribution. Special Collections and University Archives, Rutgers University Libraries.

45. Hertzog Hall, Theological Seminary, New Brunswick, N.J.,
and statue of William the Silent on Bleeker Campus of Rutgers University

Postcard, Lynn H. Boyer Jr., Wildwood, NJ. Special Collections and University Archives, Rutgers University Libraries.

46. Theological Seminary of the Reformed Church of America, New Brunswick, N.J.

The Temme Company, Orange, NJ. Made in Germany. Courtesy of the New Brunswick Theological Seminary.

THEOLOGICAL SEMINARY OF THE REFORMED CHURCH OF AMERICA, NEW BRUNSWICK, N.J.

47. Theological Seminary Zwemer Hall

Postcard, Durnin Collection. Courtesy of New Brunswick Free Public Library.

48. Theological Seminary main building today

Photograph by Allison V. Brown. Courtesy of Allison V. Brown/AV Brown Photography.

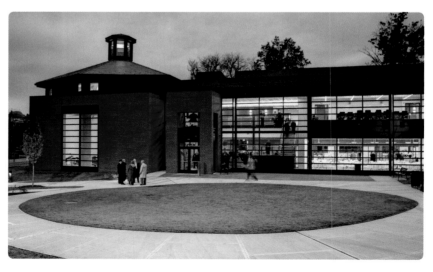

Fortunately, there is a happy architectural/design ending. In a complicated financial transaction, the New Brunswick Development Corporation (DEVCO) engineered a plan to acquire the entire seminary property, using one-third of the site for a new seminary campus, comprising the Sage Library—the only remaining original seminary structure—and a new multipurpose building (photo 48). The remaining two-thirds of the property would be the site of two Rutgers buildings—the Honors College and the Rutgers Academic Building. The site plan of the entire redevelopment is shown in figure 4.5. Moving left to right across the plan is the new seminary building and Sage Library (also photo 49), the Rutgers Academic Building in the middle (also in photo 50), and the Honors College on the right (also photo 51). Thus, Seminary Hill had a remarkable transformation from a grand harmonious ensemble of nineteenth-century collegiate buildings, to architectural loss and a prosaic mid-century (twentieth) modern replacement, and finally a return to a new dignified collegiate order.

Fig 4.5 Site Plan of New Brunswick Theological Seminary and Rutgers Academic and Honors College Buildings

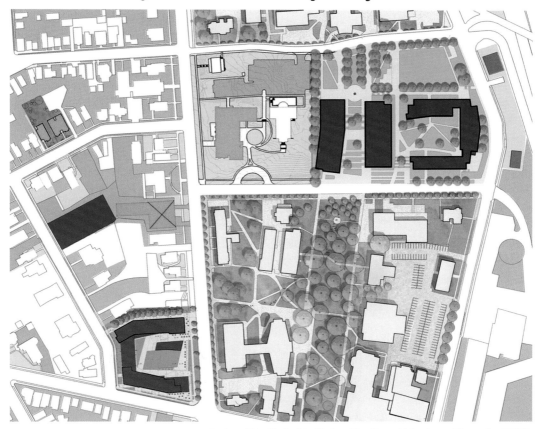

Courtesy of Elkus Manfredi Architects and New Brunswick Development Corporation (DEVCO).

49. New
Seminary
building and
Sage Library

Photograph by
Ramona M. Larsen.
Courtesy of
Ramona M. Larsen.

50. Rutgers
University
new academic
building
(completion
expected 2016)

Courtesy of Elkus Manfredi
Architects and New
Brusnwick Development
Corporation (DEVCO).

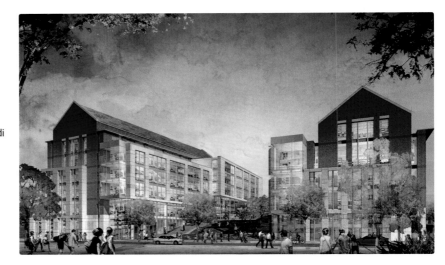

51. Rutgers
University
Honors College,
2015

Courtesy of Elkus Manfredi
Architects and New
Brunswick Development
Corporation (DEVCO).

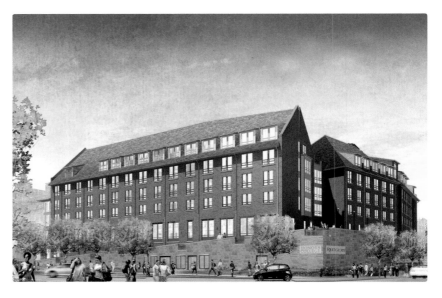

★ **NEW BRUNSWICK TRANSFORMATION**
Critical Projects in a
Multi-Decade Revitalization

THE PREVIOUS CHAPTER concluded with an overview of the different phases of redevelopment in New Brunswick. This chapter looks in detail at some of the most significant, praised, and sometimes controversial redevelopment projects in the city:

1. The original Memorial Homes public housing and its Hope VI replacement. New Brunswick's Hope VI project included a new elementary school (Lord Stirling), which in turn laid the groundwork for a new high school in the city, also constructed via public-private partnership.
2. Multiple projects in the city's lower George Street urban renewal area, including Plaza II, Liberty Plaza, and other buildings.
3. The Hyatt Regency hotel and nearby Hiram Square development; construction in the Hiram Square historic area provoked much debate.
4. The New Brunswick Cultural Center, which epitomizes a reenergized arts service function in the community.
5. The two New Brunswick hospitals (Robert Wood Johnson and Saint Peter's) that are central to New Brunswick's postindustrial economic function.
6. Major developments near New Brunswick's train station, including Gateway Transit Village and the New Brunswick Wellness Plaza (both built), and a proposed Hub@New Brunswick Station.

Public Housing: Memorial Homes and Hope VI

In 1938, New Brunswick's mayor, Frederick Richardson, stated that he favored private investment in low-income housing over federally funded public housing. Because private investment was not forthcoming at that late point in the Great Depression, the city signed on to the federal public housing program, and New

Brunswick formed a local housing authority (NBHA), which has also acted as the official New Brunswick Redevelopment Agency. In 1939, the NBHA built and operated Lambert Homes. Right after World War II, both Robeson Village (1946) and the nearby Schwartz Homes (1947–1950) were constructed by the NBHA as affordable housing. Locally referred to as Schwartz-Robeson, they together included about 260 garden-style apartments containing one- to four-bedroom units. In the late 1950s, the four Memorial Homes public housing towers were built on land cleared during an urban renewal project in "what had once been an African American community" (Schkrutz 2011, 18). The site was strategic: it was on the fringe of the city's central business district and just south of the community's principal thoroughfare—Memorial Parkway (later Route 18)—which in turn was adjacent to the Raritan River.

The design of Memorial Homes mirrored that of public housing elsewhere in the country. The four high-rise (nine-story) buildings each contained 64 dwellings, for a total of 246 housing units. Like other public housing developments, Memorial Homes stood apart from its surrounding neighborhood, both because it towered over the rest of the low-rise landscape and because it had been constructed on the "superblock" (stand-apart plaza) model. Thus, Memorial Homes was "in visual discordance with, and disconnected from, the surrounding neighborhood" (Abt Associates 2003, 77).

Although the project was well maintained initially and harbored "a close-knit community" (Abt Associates 2003, 77), it had inherent, near-fatal design flaws: it lacked amenities (for example, no laundry facilities and subpar mechanical systems) and was essentially indefensible, that is, "cut off from the surrounding neighborhood and characterized by stairwells, doors and roofs that made it virtually impossible to police" (ibid., 7). David Harris, director of the Greater New Brunswick Day Care Council, described the apartments as being a "built-in failure": "You cannot have four buildings and over 1,000 people, eight [sic] floors with one elevator in each building" (Harris interview, 5). The population density at Memorial Homes "was greater than Central Harlem," according to Harris, and the lack of essential amenities indicated that "this was a temporary, a transitional stroke." Indeed, Harris believed that Memorial Homes was "just an interim step to clear the area, which at one point had been mostly minority homeowners" (ibid.). He suspected a plan by the city to "take back that very potentially valuable land along Route 18" (ibid., 4).

As drugs and crime spread through Memorial Homes in the 1970s, the condition of the project spiraled downward. Less than stellar maintenance by the city's housing authority contributed to the decline (Abt Associates 2003, 7). Beginning in the early 1980s, there was talk among city and housing authority officials about demolishing the towers and constructing a better alternative. Memorial Homes, along with the then-incomplete Route 18, was viewed as a major impediment to downtown revitalization (Schkrutz 2011, 18). "Everyone believed that there was no way that [the Riverwatch Commons apartments] would get off the ground unless you could tear Memorial Homes down," said Christiana Foglio, president

of the New Brunswick Development Corporation (DEVCO) during the later 1980s and early 1990s. "So for probably 50 percent of my time here we were working on strategies to tear the public housing down" (Foglio interview, 18). By the 1990s, the four deteriorating towers had become "one of the worst places in the city, a place of desolate plazas, dangerous stairwells and doorways" (Abt Associates 2003, 77–78). Rehabilitating the existing complex would cost an estimated $25 million and still leave a project that was isolated from its surrounding neighborhood and essentially indefensible against crime.

One response nationally to failed high-rise public housing projects was the HOPE VI program, created in 1992 under the U.S. Department of Housing and Urban Development (HUD) to reconfigure these failures into mixed-income developments. In September 1997, HUD approved New Brunswick's demolition and disposition plan for Memorial Homes. The city then applied for a HOPE VI grant toward what was then contemplated as a $30 million project. After two rejections, the application was finally approved in 1999 for a $7.5 million HOPE VI award. Then began a long process of negotiations, planning, and assembling the financial package. Besides the complexity of dealing with different types of replacement housing and securing funds from multiple sources, Hurricane Floyd struck New Brunswick in September 1999 and flooded the downtown Memorial Homes area. The event led to a redesign of the project to meet flood hazard codes.

The NBHA, DEVCO, New Brunswick Tomorrow (NBT), and a Memorial Homes residents' council met repeatedly—by some estimates, more than three hundred times—to work out the details of the HOPE VI project. Overall, the working relationship among the groups was described as "generally good" (Abt Associates 2003, 79). Inevitably, though, there was change for the Memorial Homes tenants, and "some mourned the loss of the community they lived in for decades" (ibid., 87). The last tenants were relocated in June 2001, the existing towers were demolished that summer, the first residents moved into new homes in December 2001, and the different phases were finally completed in 2008.

As at other HOPE VI projects across the nation, the principal goals of the Memorial Homes plan were to reduce density, improve design and security, and foster a more mixed-income community. The four high-rise towers containing nearly 250 rental housing units would be replaced by about 200 new units in one- to three-story structures. Almost all of the units would be rental and contain multiple bedrooms and thus be suitable for families; some units, however, would be privately owned, and some smaller units were intended for senior citizens. A replacement elementary school for the area was planned, as were some new retail spaces.

The New Brunswick HOPE VI project took advantage of many of the subsidies described in the overview of national housing policy in chapter 3. Toward the ultimate cost of about $43 million, the largest subsidy was provided by the Low Income Housing Tax Credit (LIHTC), which contributed about $20.3 million (47 percent). Although the LIHTC was a relatively new program then, adopted in

1986, the underlying strategy of using the tax system to provide housing has become a significant factor in affordable housing production.

The next largest public subsidy, at $7.5 million (17 percent), was the HOPE VI grant itself. Other federal housing aid included $2.4 million in a HUD Capital Grant program, originally authorized for public housing in 1992, and about $800,000 in HOME monies, a program begun in 1990. Home ownership for some of the relocated Memorial Homes tenants was subsidized by Section 8 vouchers.

In addition to the federal subsidies, the NBHA applied for affordable housing aid from the state of New Jersey in the form of a Regional Contribution Agreement (RCA) allocation, which amounted to $3.4 million. As noted in chapter 3, a series of New Jersey Supreme Court decisions (collectively referred to as *Mount Laurel*) mandated that all communities in the state, including suburbs that previously practiced exclusionary zoning, had to contribute to affordable housing. An RCA is a financial contribution by a suburb to a city to enable delivery of affordable housing in that city. It is an example of the devolution over time of housing policy authority from the federal government to state and local governments. RCAs were ultimately suppressed in New Jersey as the mechanism was criticized as negating the "opening of the suburbs" objective of *Mount Laurel*.

In addition to the public subsidies, the Memorial Homes HOPE VI project benefited from other sources. The nonprofit organization New Brunswick Tomorrow effectively contributed $1.2 million in in-kind services. Monies also came from financial regulators and private lenders; for example, the Federal Home Loan Bank contributed a grant of $600,000. There was also a private lender first mortgage of about $5.1 million. In sum, the creative layering of multiple subsidies that supported the Memorial Homes HOPE VI project exemplifies how affordable housing is delivered in the United States today.

It is still too early to gauge the long-term effects of the housing component of the HOPE VI effort in New Brunswick. Yet literally even before the paint was dry on the construction, there were contesting perspectives, as reported by *New Brunswick Patch* in July 2011, just before the tenth anniversary of the demolition of the Memorial Homes towers:

> "When a project is demolished, what ought to be done is that every unit of affordable housing is replaced by another one," said Matt Shapiro, president of the New Jersey Tenants Organization. "Most of the projects are never anywhere close to that. As a result, you have fewer affordable housing units."
>
> "This is gentrification by another name," added Shapiro. "Its purpose is to get rid of poor people."
>
> But housing officials and HOPE VI advocates say reducing the density of the housing was essential to improving the living environment. Also, they maintain that including housing for middle-income families in the new structures has changed the social dynamic and reduced issues like crime.

In New Brunswick, 246 family apartments came crashing down in the Memorial Homes demolition in August 2001. In their place, at the same site and at two nearby locations, the New Brunswick Housing Authority built 144 townhouses and 48 senior apartments, officials said.

John Clarke, executive director of the housing authority, maintains that the redevelopment has actually increased the number of affordable units in the area. In addition to the new units that were built, the agency distributed about 110 Section 8 vouchers to former tenants of Memorial Homes, he said. Section 8 vouchers subsidize rents for people with low incomes and allow them to lease apartments outside government-owned and -operated projects.

But C. Roy Epps, president of the Civic League of Greater New Brunswick, a community nonprofit group, says building senior apartments in place of family units hasn't been a good trade-off in a community that desperately needs affordable housing for families. He also disagrees with Clarke's take on the Section 8 vouchers.

"They didn't create new housing," Epps said. "That housing already existed. They moved into housing that other people would have been living in."

Tenants' experiences in Section 8 housing [have been mixed], according to Epps. "In some cases it works out fine. In other cases, they lose their social structure and they feel isolated," he said. . . .

"One of the goals of our HOPE VI was to allow families the opportunity to choose where they wanted to live and to move to communities where they wanted to raise their families," said Clarke. "Through our HOPE VI grant, all of the families that were relocated from Memorial Homes were given that choice. Some families moved out of the city and state and became homeowners. Most chose to stay in the City of New Brunswick and to remain part of our community" Clarke added. "I think that is one of the real success stories of our HOPE VI grant." (Malinconico 2011)

As the preceding back-and-forth discussion highlights, there are many perspectives on the long-term effects of the New Brunswick Memorial Homes HOPE VI project.

One aspect of the project has received much praise and little if any criticism, however: the construction of a new Lord Stirling Community School. The need for a new school for the elementary-age residents of the Memorial Homes towers had long been evident. Opened in 1910, the original school building felt the strain of an increasing and needy student body. The old building was converted to Section 202 senior housing, and a new Lord Stirling Community School was built on George Street just outside downtown New Brunswick and only a block away from the new HOPE VI residences. Indeed, the new Lord Stirling was envisioned as an important educational asset for the New Brunswick Hope VI revitalization.

During the period when the Hope VI project was being planned, the New Jersey Department of Education underwent substantial changes. The School Construction Corporation (SCC), charged with overseeing and funding school construction in the state, was just forming, and the New Brunswick school district was struggling to realize a new Lord Stirling school. These unique circumstances enabled the school district to invite DEVCO to assist in the project. Then, as now, New Jersey laws did not contemplate contractual arrangements that would allow public-private partnerships (PPPs) for school construction (Listokin and Brennan 2011). In order to engage DEVCO to develop Lord Stirling, the school had to be classified as a "redevelopment project." In fact, Lord Stirling was the state's first redevelopment school. Many observers saw the new school's realization as a model that the SCC and later the New Jersey School Development Authority (SDA)—a new state entity charged with school construction oversight—would try to replicate in school construction. The new Lord Stirling project showed how to provide school and community infrastructure in New Jersey's so-called special needs school districts, building not just a school but also a community center with adult education facilities and a health and dental clinic available to students and their families.

DEVCO acted as the developer in the effort and brought in experienced construction and design professionals. Joseph Jingoli & Son constructed the 103,000-square-foot "new" Lord Stirling Community School based on an architectural design provided by the Vitetta Company. The school, because of its private-developer partnership, was able to include amenities often associated only with wealthy suburban school districts, such as an art studio, a performing arts auditorium, and a state-of-the-art technology laboratory.

That PPP model was also followed with the New Brunswick High School. Although the high school was not part of the HOPE VI project, it was inspired by the Lord Stirling School component. Plans to construct a new high school for the New Brunswick school district had been circulating since the early 2000s. Growing class sizes and run-down facilities at the old Livingston Avenue location demanded change. It was decided that the replacement high school would be built under a PPP arrangement, with DEVCO selected as the developer (Listokin and Brennan 2011).

The community and the New Jersey School Development Authority then developed a statement-of-needs plan for the school. Meetings with teachers and community members informed the characteristics of the school. DEVCO, as the developer, met with the architect—Vitetta Group Incorporated, the same architect used for Lord Stirling—and the Board of Education to translate those needs to visual form. The next step was to choose a general contractor. DEVCO used Joseph Jingoli & Son, just as it had for the Lord Stirling Community School, and entered into a guaranteed minimum-price contract. Jingoli incorporated a construction apprenticeship: workers who learned on the job and finished this project would be eligible to pursue union membership (Clarke 2010). The SDA approved each step of the development process but allowed DEVCO to manage,

and thus expedite, the decision making. In effect, DEVCO acted as an extension of the SDA, with a full-time staff dedicated to handling the management, legal review, land acquisition, and other project details.

Construction of the New Brunswick High School began in 2007 on a former industrial site, off Route 27 near the Franklin Township border that needed extensive environmental cleanup. Today, the facility includes a twenty-six-acre campus with a 435,000-square-foot high-tech and high-quality school building that can accommodate 2,000 students. Educational amenities include specialized classrooms (for technology and graphic arts, for example), a gymnasium that can seat 2,000 spectators, a professional-quality auditorium, and extensive support services for students (an infant-care center, for example). The school also provides community-wide facilities for athletics, theater, and medical care. Construction of the $187 million New Brunswick High School was completed seven months ahead of schedule (Fox 2010).

Urban Renewal: Lower George Street

Like many other cities, New Brunswick turned to urban renewal to reverse its dramatic post–World War II economic and physical decline. The city's involvement in the federal program authorized by the 1949 Housing Act began in the 1950s, when studies conducted by the city resulted in a series of planning documents. For example, Planning for New Brunswick's Central City (1958) laid out a plan of action to encourage new businesses in the central business district (CBD.) Ultimately, New Brunswick designated five sites for urban renewal, mostly in or near the downtown. The following is the tale of one of them: Lower George Street, defined as the area on or near George Street west of Route 18 (formerly Memorial Parkway) and lying between Morris Street to the north and Liberty/Richmond Streets to the south.

The Lower George Street area was targeted for urban renewal in the early 1950s. A 1954 Market Analysis and Reuse Value Report "indicated the desire to clear the then-blighted area and redevelop it with the highest and best use of the land which was determined to be: a major department store, 125,000 square feet in retail space and the provision of parking and certain subterranean accessory uses to be located beneath a plaza" (cited in Nathanson and Lerner 1975, 13). The study envisioned that the New Brunswick CBD would remain a primary retail hub for the region, but the regional shopping locus was already migrating to nearby suburban areas. So although portions of the Lower George Street area were cleared for new uses that were expected to be primarily retail, this redevelopment vision did not materialize.

A revised urban renewal plan prepared in May 1963 recognized the challenges suburbanization presented to the New Brunswick CBD but offered only very broad objectives for development. The planners assumed that redevelopment would occur through site clearance, followed by the construction of a variety of retail, office, restaurant, hotel, recreation, and parking facilities (Nathanson and Lerner 1975, 13). The central design theme of the 1963 plan was a plaza extending east from the elevation of George Street.

The only new construction that resulted from the 1963 plan was a 95,000-square-foot building on the corner of George and New Streets, built in 1967 on land cleared by urban renewal. Originally designed as a Holiday Inn hotel, Commercial Plaza (later Plaza I) was ultimately used for office space. It was a lone island of new construction surrounded by a 10.2-acre urban renewal area that encompassed a motley mix of older buildings fronting George and other streets and desolate cleared land extending east to Memorial Parkway, as seen in figure 5.1.

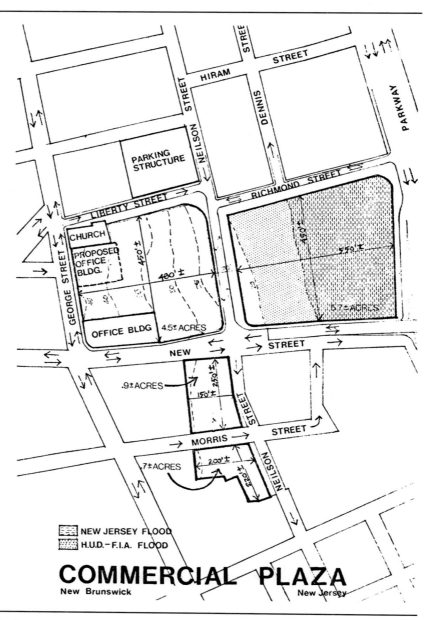

Fig 5.1
Vacant Land and Development Status of a Portion of Lower George Urban Renewal Area, ca. 1975

SOURCE: "A New Approach to Land Disposition and Development," Department of Community Affairs, published in conjunction with the Housing Authority of the City of New Brunswick and its consultants, Charles C. Nathanson and Associates, December 1975, 50. Courtesy of State of New Jersey Department of Community Affairs.

A new study and master plan for the CBD, including the Lower George Street area, accepted that New Brunswick would never regain its regional retail dominance and called for an emphasis on "finance, services, transportation, government, health, entertainment and industry as opposed to commercial uses" (Nathanson and Lerner 1975, 14). Reflecting the thinking of the time that downtown urban areas should be predominantly business in use, it downplayed residential development in the city's CBD (ibid., 14). Other planners, however, had a more flexible vision for Lower George. A December 1975 plan envisioned that a successful revitalization of Lower George would include many uses— housing, nonresidential (office, retail, and motel), government (a civic complex), and recreation (ibid.). A design sketch reflecting this mixed-use vision is shown in figure 5.2.

Fig 5.2 **Conceptual Plan for Redevelopment of a Portion of the Lower George Urban Renewal Area, ca. 1975.**

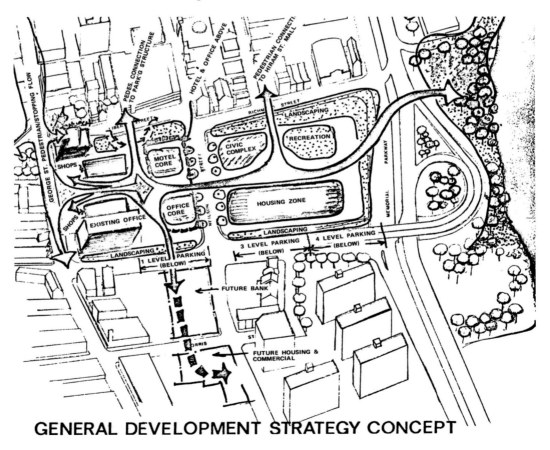

SOURCE: "A New Approach to Land Disposition and Development," Department of Community Affairs, published in conjunction with the Housing Authority of the City of New Brunswick and its consultants, Charles C. Nathanson and Associates, December 1975, 52. Courtesy of the State of New Jersey Department of Community Affairs.

It would take four decades for that vision to materialize. If we include a spatially enlarged concept of the Lower George area to expand beyond its original urban renewal boundaries to encompass nearby locations in downtown New Brunswick, such as Livingston Avenue near George Street and blocks by City Hall, an impressive series of projects was ultimately accomplished in Lower George over time.

First to rise was Plaza II, realized in 1979 by DEVCO on George Street on a lot long ago cleared by urban renewal. Built adjacent to Plaza I, it was the first new construction outpost in this area in a decade (see photo 42). Another fifteen years

52. City Hall and Post Office, New Brunswick, N.J., ca. 1930.

Postcard, Meiner & Boardman News Dealers, New Brunswick, NJ. Special Collections and University Archives, Rutgers University Libraries.

53. New Brunswick City Hall

Photograph © 2015 George Shagawat. Reprinted by permission of George Shagawat

passed before Rutgers University came downtown and opened the Civic Square Building in 1995 on Livingston Avenue near George Street (see photos 61–63). The spacious (175,000 square feet) $47 million building houses two university units with an urban persona: the Mason Gross School of the Arts (arts) and the Edward J. Bloustein School (planning/public policy). Consistent with its name, the Civic Square Building offers such resources as a 150-seat public forum auditorium. Shortly thereafter, in 1998, Liberty Plaza was completed on George Street just north of the Plaza I/II buildings. This mixed-use complex (115,000 square feet of office space and 20,000 square feet of street-level retail and restaurant

54. Court House and County Offices, New Brunswick, N.J., ca. 1920s.

Postcard, Lynn H. Boyer Jr., Wildwood, NJ. "New Brunswick is County Seat of Middlesex County. It is a manufacturing city located on Raritan River. The first Provincial Congress met here in 1774." Special Collections and University Archives, Rutgers University Libraries.

55. Civic Square, Public Safety Building, Kirkpatrick Street

Photograph © 2015 George Shagawat. Reprinted by permission of George Shagawat.

space) was important strategically: located in the heart of New Brunswick's CBD, it attracted some national chain retailers (such as GNC) and bolstered the city's emerging postindustrial health care economy by serving as the administrative headquarters of the University of Medicine and Dentistry of New Jersey (UMDNJ, now a part of Rutgers University). The late 1990s to mid-2000s saw a proliferation of additional civic-oriented developments near the Civic Square Building and New Brunswick's City Hall. These included a new Middlesex County administration building (115,000 square feet); a new public safety complex (118,000 square feet) housing the city's police, court, and other units (see photo 55); and the new Middlesex County courthouse.

56. Middlesex County Administration Building, Bayard Street

Photograph © 2015 George Shagawat. Reprinted by permission of George Shagawat.

57. Middlesex County Courthouse, 1958

Postcard, Lynn H. Boyer, Jr., Wildwood, NJ, Curteichcolor. Courtesy of New Brunswick Free Public Library.

58. Middlesex County Courthouse

Courtesy of New Brunswick Development Corporation (DEVCO).

As planners came to realize, however, a downtown needs both businesses and residents. In 1999, the Riverwatch residential community was completed on a long-cleared urban renewal site located just west of Route 18 and bounded by Hiram/Richmond, Burnett, New, and Neilson Streets. The upscale single-family townhomes and luxury rental apartments house about 500 residents, who are served by some convenience retail space. In 2005, Rutgers University contributed to the downtown's residential presence with Rockoff Hall at the intersection of George and New Streets, which contains 186 apartment suites (planned to house about 700 Rutgers students) and 12,000 square feet of retail space. Two years later, the Heldrich building was completed on a 1.8-acre cleared site on Livingston Avenue at the corner of George Street. The 365,000-square-foot Heldrich features a 250-room hotel and conference center, retail space, academic space, and luxury condominiums. The cornerstone of this mixed-use facility is the Bloustein School's John J. Heldrich Center for Workforce Development, just across the street from the Mason Gross and Bloustein Schools housed in the Civic Square Building. After shunning New Brunswick's downtown for so long, Rutgers began to see the advantage of a CBD location. Others came as well, such as the builders of the $35 million private rental apartment tower located at the intersection of George and New Streets, which opened in 2013 and was appropriately named The George.

The many significant projects built in the Lower George Street area led the smart growth advocacy organization New Jersey Future (NJF) to give the area a "Livable Place and Smart Growth" award in 2003. The citation praised the city of New Brunswick and its partners for their creativity in "leveraging public and private resources in order to spark the revitalization of the lower George Street

59. The Heldrich

Photograph by Larry
Levanti. Courtesy of
Larry Levanti.

60. The George

Photograph by Allison V.
Brown. Courtesy of
Allison V. Brown/AV Brown
Photography.

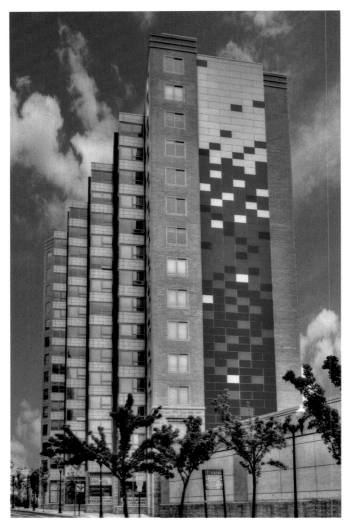

neighborhood. . . . The city's partnerships with DEVCO and other local stakeholders have made the neighborhood attractive for redevelopment in a way that is good for the community as a whole" (New Jersey Future 2003). In fact, many of these projects took advantage of the housing and economic development programs described in chapter 3. Riverwatch was jump-started by an Urban Development Action Grant (UDAG), benefited from Federal Housing Authority (FHA) mortgage insurance, and received private mortgage financing. The $120 million Heldrich benefited from a $20 million loan from the Atlantic City–linked Casino

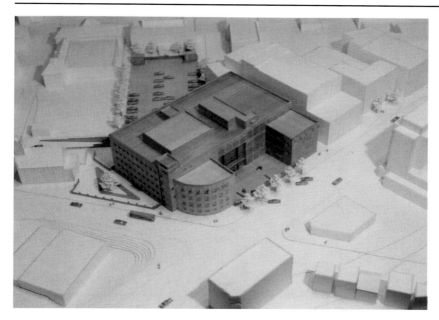

61. Civic Square building model

Courtesy of New Brunswick Development Corporation (DEVCO).

62. Civic Square building construction

Courtesy of New Jersey Economic Development Authority.

Reinvestment and Development Authority (CRDA), a package of $11.4 million in grants and loans from the New Jersey Redevelopment Authority (NJRA), a $4 million grant from the New Jersey Economic Development Authority (EDA), and a $1.7 million grant from the New Jersey Department of Community Affairs (DCA). Also very important to the Heldrich's financing was about $70 million of bonds issued by the Middlesex County Improvement Authority (MCIA), thus enabling a lower than market interest rate. The Civic Square Building was financed from multiple sources: Rutgers University, the State of New Jersey Governor's Fund, Middlesex County, the Port Authority of New York and New Jersey, and other donors (Holcomb n.d.).

A public-private participation (PPP) strategy is evident in all of these Lower George Street area projects. The Heldrich, for example, was developed by DEVCO, constructed by a private contractor (Keating Building Corporation), and financed by private monies coupled with considerable support from public agencies, and it is owned by MCIA. Even as New Brunswick's economy improved over the decades, it still took much public support to build in the city's downtown.

Also evident in the Lower George transformation are shifts in development patterns. Plaza I and Plaza II were predominantly single-use facilities, but some later projects in the area, such as the Heldrich, have mixed uses. Additionally, there were some limited efforts toward adaptive reuse. For example, the original fourteen-story Middlesex County administrative building was stripped down to its steel skeleton and converted to a lower-level (first three floors) court complex and an upper-level residential rental tower with seventy apartments, 20 percent of them designated affordable.

63. The Heldrich construction

Courtesy of New Brunswick Development Corporation (DEVCO).

64. Old rear of Liberty Plaza site

Courtesy of New Brunswick Development Corporation (DEVCO).

65. Liberty Plaza

Photograph by Larry Levanti. Courtesy of Larry Levanti.

Like the Memorial Homes demolition, the urban renewal projects in the Lower George Street area have not been without their critics. C. Roy Epps, president of the Civic League of Greater New Brunswick, believed that the Rockoff Hall residence hall "would have gone up anyway" and that the downtown revival has done little to benefit the city's low-income residents (Malinconico 2011). Many of the same criticisms would be aimed at efforts to build a hotel near the new Johnson & Johnson (J&J) headquarters and to redevelop the Hiram Market district.

Urban Development Action Grant:
Hyatt Regency Hotel and Historic Hiram Market

HYATT REGENCY HOTEL

One of the conditions imposed by J&J's board of directors when it voted to keep the corporation's headquarters in New Brunswick was a study and plan for the city's revitalization. According to retired J&J executive Robert Campbell, architect I. M. Pei insisted on "something across the street" from the headquarters. "Albany Street couldn't be the dividing line between New Brunswick and J&J and Rutgers. . . . So the concept of the hotel came up—the Hyatt hotel" (Campbell interview, 10–11). New Brunswick's former major hotel, the Roger Smith, had

66. Making way for the Hyatt Regency

Photograph by George "Red" Ellis. Courtesy of George "Red" Ellis.

67. Hyatt Regency

Photograph by Larry Levanti. Courtesy of Larry Levanti.

closed, and its absence was keenly felt. A Hyatt near the J&J building would be an important public-private partnership step toward New Brunswick's revitalization (Marchetta interview, 53).

Pei proposed a large hotel/conference center to be built on a site bounded by Albany Street to the north, Hiram Street to the south, Neilson Street to the west, and Memorial Parkway (later Route 18) to the east. This "major downtown anchor facility" was intended to "attract pedestrian and commercial traffic into the city's central business district, stimulate weekend and night-time use of the area, and extend shopping hours of stores in the retail core. The hotel would also complement the ongoing and impending institutional development activity in the heart of the city" (Historic Design Associates 1979, 5). Former New Brunswick mayor John Lynch Jr. described the Hyatt as "another vision" by former J&J chairman and CEO Richard Sellars: "He saw it in terms of the credibility" (Lynch interview, 18). It would be an important step toward the post-industrial economic future of New Brunswick.

The high cost of land and the need for expensive structured parking were thwarting the plan announced by DEVCO in August 1978. Acquiring a large site in the New Brunswick CBD, even in its depressed state, would cost millions. Notwithstanding J&J's decision to stay in the city and a nearly ideal location, "a new hotel was a risky and expensive project" (Reed 1989, 102), especially at a time when construction interest rates were soaring at about 16 percent (Kelso interview, 6).

In the earlier decades of urban renewal, the multimillion-dollar costs that often challenged urban municipalities would have been subsidized by the federal government, but the urban renewal program had been phased out by 1974. In its place, the Urban Development Action Grant (UDAG) program, launched in 1978, was designed to make urban revitalization projects feasible by providing a subsidy to reduce the costs borne by private developers. New Brunswick applied for a UDAG in 1977 and was successful in securing $6 million. It was the city's first UDAG and was one of eight awarded to projects in New Jersey as of the late 1970s (Reed 1989, 100). Behind the scenes and crucial for making the Hyatt financially feasible was J&J, helping to bring the financing together. Former New Brunswick mayor John Lynch Jr. described how the city partnered with J&J in securing the grant: "So we spent a lot of time at HUD in Washington, and we were definitely partners in that process" (Lynch interview, 41–42). For a small city, according to former DEVCO president Christiana Foglio, New Brunswick "got an enormous amount of federal support" (Foglio interview, 13). J&J, she continued, "brought all the bankers together that they had relationships with, and the bonds for that development were parceled and purchased by all those banks, and so that would not have [otherwise] been a financeable project. And the Hyatt was a UDAG, and the UDAGs were really driven into New Brunswick from the J&J lobbying point of view" (ibid.).

The total Hyatt project cost $20 million: $14 million in privately raised capital supplemented by the $6 million UDAG. "The UDAG provided both gap

financing and financing at a cost lower than what was available from conventional banks" (Reed 1989, 104). The exact financing and deal structure was complicated, to say the least:

> There is a $6 million UDAG that is divided into two portions. Half of it will go directly to the New Brunswick Housing and Development Authority. With that money, the authority will acquire the site, clear it, and relocate those businesses and persons currently occupying the site. Having done those things, the Housing and Development Authority will then convey the site at zero cost to the developer of the hotel, conference center, retail project. The developer of this project is a newly formed company called Revite, Inc., organized by the New Brunswick Development Corporation (DEVCO) and Routan Realty, a subsidiary of Johnson and Johnson Corporation. Each of the two partners in Revite put $3 million into the capital fund for this project. The $3 million from DEVCO is the other half of the action grant. In addition to that $6 million in financing from UDAG and Routan Realty Company, Revite will borrow $11 million from Prudential Life Insurance. (Nathan and Webman 1980, 36–37)

When it opened, the Hyatt Regency New Brunswick proved to be quite successful, perhaps in part because J&J "made it a priority for all Johnson & Johnson subsidiaries to use the Hyatt for overnight stays for training" (Foglio interview, 13). Some faulted its appearance. Principal architect of Pei-Cobb, Henry Cobb, wished it were "a better piece of architecture" (Cobb interview, 28). Anton Nelessen, an architect and Rutgers professor specializing in urban design, described the result as "terrible": "It is such a bad design from an urban design perspective, from a scale perspective, from a materiality perspective" (Nelessen interview, 33). Important to New Brunswick residents, however, was that one-third of the four hundred Hyatt jobs had been set aside for city dwellers. John Heldrich of J&J and Ted Hardgrove (then president of NBT) traveled to Chicago to meet with the Hyatt leadership and press for a 30 percent local hiring pledge. NBT was further involved in employment skill training and other services to ensure that local residents were aware of and trained for positions at the Hyatt. (Later, when the Heldrich was built in 2007, DEVCO again did the physical planning, while NBT, according to its then president, Jeffrey Vega, "was a part of the effort of making sure New Brunswick residents had a leg up in the process of the [hotel] jobs that were forthcoming" [Vega interview, 9]).

The new hotel also ultimately helped to revitalize the immediate area. Not long after the city received the UDAG award, Betsy Alger and her husband, Jim Black, bought a nearby former industrial site at 29 Dennis Street and three years later opened their restaurant, The Frog and the Peach. "It was a viable neighborhood; we thought it was charming, and we thought we were getting in on the ground floor of the revitalization plan," she remembers. They were rewarded for their foresight and hard work with a thriving residential and commercial neigh-

borhood (Yeske 2009, 28), and their restaurant is one of the epicurean gems of both the city and the state.

When the Hyatt UDAG grant was given to New Brunswick in the late 1970s, metropolitan cities in the United States were ranked by amount of UDAG assistance on a per capita basis. Divided by the city's estimated population of 47,000 at that time, New Brunswick's award of $6 million gave it a UDAG per capita capture of $127, the fourth highest of all metropolitan cities in the United States at that time (fiscal years 1978–79 cumulative) (Nathan and Webman 1980, 112). No other New Jersey city was in the UDAG per capita top twenty. Before the national UDAG program ended in 1989, New Brunswick would cumulatively capture $24 million in funds, or more than $500 per person. On a per capita basis, New Brunswick received more UDAG support than almost any other city in the United States. Besides the Hyatt Regency, the UDAGs helped fund many of New Brunswick's signature redevelopment projects, including Kilmer Square, the Albany Street Plaza, the Golden Triangle, and the Riverwatch residential community.

Many of the principals involved in these projects emphasize the importance of UDAGs in making these efforts feasible. Christopher Paladino, current president of DEVCO, is proud that "New Brunswick has probably used [UDAG] wiser than any other city in New Jersey" (Paladino interview, 21). The $6 million Hyatt UDAG was repaid to the city of New Brunswick in 1991, well ahead of the original 1996 anticipated repayment date. This $6 million was then reused by New Brunswick for other economic development investments. Mayor James Cahill observed:

> New Brunswick was among the leaders in taking advantage of the Urban Development Action Grants, a great program. You first get money from the federal government; it's a loan. The developer actually gets it; the developer is then required to repay the loan to the municipality and then, in turn, the municipality is required to reinvest that money into other items that help the economic wherewithal in the development of the city, so you get to recycle the dollars twice. I mean it quite frankly doesn't get much better than that. (Cahill interview, 7)

Other observers are more critical of the role of the UDAG program, both in New Brunswick and nationally. For example, Professor Nelessen, who was ultimately displaced from his New Brunswick neighborhood near the Hyatt, concluded that the hotel was "wasteful and would have a negative impact on an historic district":

> Our study proved that new infill development could be compatible with an historic district and further that a hotel with an identical building program could be constructed on half of the site. . . . If this is happening in New Brunswick, I would suppose that it is happening in other cities and with other UDAG projects as well. I am also concerned that the overall national "urban" policy of which UDAG is a component . . . is not "urban"

revitalization at all but is something other than that—it is more suburban. The question is whether this is appropriate as part of the national urban policy to rebuild cities. (Nelessen quoted in Nathan and Webman 1980, 42–43).

HIRAM SQUARE MARKET

As alluded to by Nelessen, a major controversy surrounding the UDAG-financed Hyatt project concerned its impact on a neighborhood that he and others claimed was historic and deserving of preservation. Related to this question was the fate of Hiram Square, an area bounded by Hiram Street, Memorial Parkway (later Route 18), Albany Street, and Neilson Street, a location significant in New Brunswick's earlier history.

As described in chapter 1, marketing and trade were important economic activities in the nineteenth century, and they were concentrated in the Hiram area, specifically at the Hiram Market House. Built in 1811, this large shed (25 feet by 150 feet) housed marketing, public, and other functions (Yamin and Masso 1996, 16). Unlike some larger cities such as Philadelphia, which could support numerous such markets, "New Brunswick had only one centralized location, not only for the city but also for the surrounding farmlands of Middlesex and Somerset counties" (B. Listokin 1976, fig. 5 in original). Also located in the area were nascent banks and well-established churches, such as the First Dutch Reformed Church on Neilsen Street between Bayard and Paterson Streets, which opened the doors of its third building in 1812, and Christ Episcopal Church on Neilsen and Church Streets, originally built in 1773 and remodeled in 1803 and 1852 (ibid., figs. 18 and 20 in original). Not surprisingly, then, the Hiram Market area was "the hub of the city's religious, financial and commercial activities for at least seventy-five years of the nineteenth century" (Yamin and Masso 1976, 21).

Over time, Hiram became less the place to be. The Hiram Market House was lost to fire in 1865, and the city's commercial district ultimately moved south to George Street (Yamin and Masso 1996, 21). Industrial activity moved out, followed in time by the impact of the federal urban bulldozer in the adjacent Lower George area. Decades of landlord disinvestment did not help matters. By the late 1960s and early 1970s, the Hiram area was physically decrepit.

But where some saw decay, others became enthralled with the potential. Bob Schneider, owner of the J. August Café on Church Street, was drawn to the area. He had graduated from Rutgers with an urban planning degree (his dog, which had attended every graduate class with him, received an honorary degree) and had a free-spirited and energetic personality (Nelessen interview, 5). Schneider networked with like-minded neighbors, friends, and acquaintances. When Harvard-trained architect Anton Nelessen arrived in the early 1970s to teach design in the Rutgers planning program, Schneider urged him to move to Hiram: "Look at this place, it's deteriorating, it's funky, it's interesting, this could be one of the greatest places to live anyplace" (ibid., 6). An urbanist at heart (he later would become a

national authority on the New Urbanism), Nelessen moved his family to the six thousand-square-foot top floor of the King Block building on Burnet Street, a late 1870s nonresidential structure with a beguiling Italianate façade, and constructed a play area on a balcony for his two young sons.

Schneider and numerous other merchants and residents in and near Hiram organized events to publicize the area, such as a 1975 "City of Lights" celebration for which almost three hundred volunteers hung fourteen miles of lights on all the Hiram and other downtown area buildings and an annual Oktoberfest (Nelessen interview, 13). In time, the diverse cadre of persons interested in preserving Hiram included Schneider, Nelessen, a Rutgers historian, a Rutgers graduate student (also involved in trying to stop the Route 18 extension), restaurateurs, local ministers, the local gay community, and the founders of Crossroads Theatre, among others (ibid., 8).

While this local spirit was growing in the mid- to late 1970s, DEVCO was refining plans to redevelop the Hiram Market area, plans that emphasized considerable demolition and new construction. In response, proponents of preserving the area formed the Historic Hiram Market Preservation Association (HHMPA) in January 1978 and shortly thereafter produced a walking-tour map of the area featuring the King Block, Christ Church, the *Home News* print shop at 29 Dennis Street, and sixteen other buildings. The HHMPA hoped to create a groundswell of support for designating the area as a historic district, which would afford it some protection. The Rutgers historian concluded, "What we need to do is get this on the National Register" (Nelessen interview, 7).

Designation of the Hiram area as a historic district would have momentous consequences for the city's redevelopment plans. Governmental undertakings that affect resources (buildings, districts, sites, and objects) that are on a historic register undergo heightened regulatory scrutiny. In mid-1978, DEVCO's Hyatt project near the Hiram Market area was slated to receive financial assistance from the UDAG program. As a project funded in part with federal dollars, the Hyatt would technically be considered a governmental undertaking. If the Hiram Market district were placed on a national historic register, then construction of the Hyatt (and other projects in the area that had a similar governmental financial connection) might very well be delayed, if not halted, by preservation agencies.

What transpired was both common and unusual on the American historic preservation scene. (See Masso 1989 for a detailed chronology.) Hiram Market was accorded historic register status in the late 1970s. Shortly thereafter, in February 1980, the federal Advisory Council on Historic Preservation (ACHP) and the New Jersey State Historic Preservation Office (SHPO), agencies that routinely collaborate on reviewing governmental actions affecting historic resources, "reached a Memorandum of Agreement (MOA) with city officials that called for a moratorium on all demolition, new construction and zoning changes within the Hiram Market District" (Yamin and Masso 1996, 23).

Federal and state preservation offices regularly try to resolve preservation threats with consultation and MOA. But historic designation and memorandums

do not necessarily assure preservation for older buildings needing stabilization, repairs, and rehabilitation. Omar Boraie, a New Brunswick realtor and later a developer in the city who was asked by J&J CEO Richard Sellars to acquire property in Hiram for DEVCO in the early 1980s, spoke of the sorry condition of the neighborhood. "It was completely deteriorated. The King Building, which [some] think should have been preserved, was in terrible shape" (Boraie interview, 6). Preservationists looked past those physical deficiencies: "There was so much [history] there . . . from the third reading of the Constitution to early . . . bank notes and riverboats and whorehouses . . . and nylon stockings and rubber tires" (Nelessen interview, 26, 27). At the same time, pro-development interests had commissioned reports questioning Hiram's historic merits. One found that "the area lacks cohesion and integrity and instead appears a jumble of scattered buildings" (Historic Design Associates 1979, 29–32).

The vision for Hiram proposed by the preservationists, led by Nelessen, Schneider, and others, sought to keep the old while allowing some new construction. Nelessen's alternative to DEVCO's plan involved a multistory atrium leading almost to the J&J headquarters doorstep, a pedestrian "entertainment street" lined with restaurants and jazz clubs, a scaled-down new hotel, and even a poten-

68. Bill's Trading Post

Photograph by Harry Rubel.
Courtesy of Jacque Rubel.

tial science center (Nelessen interview, 14–16). The plan was fleshed out in a Nelessen-led Rutgers urban planning studio class, to which Kenneth Wheeler, a former Rutgers provost and urban historian, was invited. At a public forum in New Brunswick where the dueling DEVCO and preservationist plans were presented, Richard Sellars from J&J complimented Nelessen on the "great plan" he presented but averred that "the only plan I have money for" entailed demolition and new construction (David Harris interview, 13).

Preservationists accused DEVCO of "demolition by neglect" in Hiram. Whatever the cause, in short order the properties acquired by DEVCO through Boraie did deteriorate, and Hiram structures were lost. In one example, the city building inspector condemned nine properties as uninhabitable in December 1983, and

69. Burnett Street and Fire House, ca. late 1970s

Courtesy of New Brunswick Development Corporation (DEVCO).

70. Hiram building demolition

Courtesy of New Brunswick Development Corporation (DEVCO).

71. Hiram District demolition

Photograph by George "Red" Ellis. Courtesy of George "Red" Ellis.

they were demolished; street widening for hotel access significantly altered the character of the Hiram Market District (Yamin and Masso 1996, 23). The "historic fibre" of the district had been irreversibly compromised, and the city sought in 1985 and received in 1992 permission to remove its protective designation (ibid.). Such deregistration of historic district status is a rare occurrence in the United States.

In 1979, the Hiram historic district contained about eighty buildings. Only a handful of buildings, now mostly restaurants, were preserved. The demolished buildings were replaced by new for-sale townhouses on the site of the old Hiram Square and elsewhere, other new housing (both ownership and rental), new commercial buildings, parking garages, and other improvements. The King Block building where Nelessen lived was demolished in 1994; frustrated, he left the city to live in a 1700s farmhouse in a rural area of a nearby township. Robert Schneider stayed in the city but, sadly, succumbed to cancer at an early age.

Not surprisingly, numerous individuals involved in the project that replaced Hiram Market or were otherwise in positions of authority viewed the neighborhood as not worth saving or as a hindrance to a brighter future for New Brunswick. Andy Baglivo, a publicity consultant with J&J, expressed his frustration with historic preservationists, who "held us up for a while and cost us a lot of money" (Baglivo interview, 37). Mayor James Cahill remembered the properties in the Hiram district as "junk" when he was growing up. "And quite frankly, . . . if it was that important, efforts should have been taken over the decades before that to do something about it. And if we only become concerned about historical buildings when somebody is going to take it away, then how really interested are we in

72. Former National Bank of New Jersey building preserved (became Old Bay Restaurant)

Photograph by George "Red" Ellis. Courtesy of George "Red" Ellis.

73. Frog and Peach Restaurant building preserved

Photograph by Kathe Newman. Courtesy of Kathe Newman.

74. Delta Restaurant (formerly J. August Café) building preserved

Photograph by Kathe Newman. Courtesy of Kathe Newman.

75. Bulldozer at Hiram Street

Photograph by George "Red" Ellis. Courtesy of George "Red" Ellis.

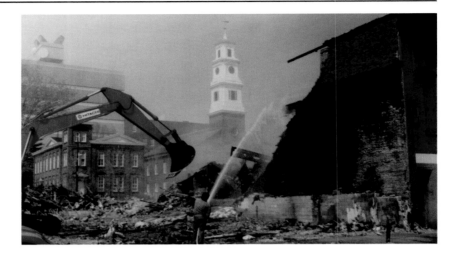

76. Hiram Square today

Photograph © 2015 George Shagawat. Reprinted by permission of George Shagawat.

77. Riverwatch completed

Courtesy of New Brunswick Development Corporation (DEVCO).

those?" (Cahill interview, 28–29). Former mayor John Lynch Jr. "always respected the opinions of the people who wanted to preserve" the district but observed that preservation would have required "an enormous amount of money, and there wasn't a lot to restore" (Lynch interview, 23).

Naturally, Nelessen and others in the preservation camp viewed the Hiram district as both worthy of and suitable for preservation. C. Roy Epps thought that the Hiram Market had "some significant, historical significance" and that "there was still a sense of small community in that area and people felt that they were being pushed out" (Epps interview, 13). Christiana Foglio was in graduate school at the time and also working for the city. Behind the struggle to flatten Hiram Market, she contends, was J&J: Hiram Market "looked messy," which conflicted with J&J's "clean-desk mentality" (Foglio interview, 14–15). Architect Nelessen commented on the unique moment in American preservation history when the Hiram Market area, once designated "historic," was "de-designated." "I was embarrassed for the profession," he said (Nelessen interview, 17).

Jacqueline "Jacque" Rubel, who was instrumental in the New Brunswick Cultural Center, was married to a man whose family owned a business on lower Church Street where the Hyatt was built. She spoke about the dislocation of small businesses and families: "There were a lot of longtime family businesses in New Brunswick. . . . And they were not happy; they were not part of the dialogues, as far as I understand, when these decisions were being made. And they were pushed out, bought out, I don't know how. . . . Family businesses would have been wonderful for what's going on now" (Rubel interview, 19). According to Rubel, many people supported the creative reuse of the old buildings. She and a group of artists went to Alexandria, Virginia, to look at an old torpedo factory that had been

78. King Block building demolition

Photograph by George "Red" Ellis. Courtesy of George "Red" Ellis.

renovated into an art center to see if it could be a model for some of the Hiram buildings. And in fact, some historic resources in the city were preserved and/or adaptively reused with much sensitivity to the existing historic fabric. Two of those projects, Providence Square (United Cigar factory) and Livingston Manor, deserve brief mention here.[1]

The United Cigar Manufacturers' Corporation established a factory on Somerset Street near Prospect Street around 1903. Known locally as New Brunswick Cigar, it became the largest cigar producer and one of the largest employers in the city, with 1,400 workers. Centered in the Hungarian neighborhood, the firm hired many immigrant women. Employment peaked at 1,700 in 1909 and, with the advent of mechanization, fell to less than 800 in 1918. The company continued production at the site, under the name General Cigar, until the mid-1950s. By the early 1990s, the United Cigar building had been abandoned and posed problems as an eyesore and worse to the surrounding primarily residential neighborhood, where many Hungarian Americans still lived. Further, the building stood only three blocks from the Robert Wood Johnson University Hospital, an important foundation for New Brunswick's postindustrial future. At the same time, New Brunswick Tomorrow conducted a study pointing to the need for more senior housing choices in New Brunswick, and the closed United Cigar building was flagged as a strategic location for such housing (Donna Harris 2009, 39). Because of the building's historic and architectural legacy and character, DEVCO made the decision in the early 1990s to rehabilitate and reuse it for senior housing. Pennrose Properties, a company with many decades of experience in historic preservation, was chosen as the developer.

Pennrose extensively renovated the existing L-shaped building, added a sympathetic four-story structure to form a U-shaped complex, and created ninety-eight affordable apartments for subsidized independent living by seniors (Pennrose Properties 2012). Amenities include a community center and recreation center, all enhanced by and integrated with attractive landscaping and architectural details. When the renovated building, renamed Providence Square, opened in 1993, one of its first residents was "a 92-year-old lady who had rolled cigars in the factory as a 14-year-old" (ibid.). A $10.7 million development was financed with federal historic rehabilitation and low-income housing tax credits, monies received from the *Mount Laurel*–linked Regional Contribution Agreements, as well as bank loans (Donna Harris 2009, 40).

Like the Providence Square project, another DEVCO-Pennrose collaboration took advantage of the historic rehabilitation and low-income housing tax credits. Livingston Manor was a six-story apartment building located at 119 Livingston Avenue. Constructed in the 1920s when New Brunswick was the place to be and Livingston Avenue was an upscale residential neighborhood, Livingston Manor and the nearby Brunswick Arms represent "the final period of development within the [historic] district and . . . [are] examples of the use of the Classic Revival style . . . in multi-residential structures" (Gombach Group 2013). By the 1990s, however, Livingston Manor was a blighted presence among the residential and

79. Livingston Manor

Photograph by Will Irving. Courtesy of Will Irving.

office properties on Livingston Avenue and a detriment to the nearby city library and city public school. In 1994, Pennrose undertook an extensive rehabilitation of the building, maintaining as much as possible of the footprint and character of the original structure. The new Livingston Manor, with fifty affordable one-bedroom apartments for seniors, was placed in service in 1995.

So, despite the loss of many older buildings in the Hiram Market and elsewhere in the city, there were efforts to preserve some of New Brunswick's architectural and cultural past. One such jewel, the State Theatre, restored to its vaudeville-era multi-hued splendor, is described next.

Arts in the City: The New Brunswick Cultural Center

The New Brunswick Cultural Center (NBCC), known locally as the city's cultural district and as Little Broadway, encompasses a number of important arts institutions located next to one another on Livingston Avenue, off George Street: the George Street Playhouse, the Crossroads Theatre Company, the State Theatre, and the Mason Gross School of the Arts Visual Arts Gallery. Today, the strategy of capitalizing on the arts and their audiences is widely recognized as critical to the revitalization of urban areas. In the 1970s, however, it took a leap of faith to imagine that the section of Livingston Avenue where the decrepit State Theatre showed pornographic movies could become New Brunswick's cultural jewel. Fortunately for New Brunswick, there were a few visionaries.

After circling the city in a J&J helicopter, I. M. Pei conceptualized four cornerstones for revitalizing New Brunswick: the J&J headquarters, the Hyatt Regency hotel across Albany Street, a government center near the New Brunswick City Hall, and a cultural center on Livingston Avenue. The latter would serve as "a foothold further down in the town," according to retired J&J executive Robert Campbell, and provide a "multiplier effect," bringing people into local restaurants

(Campbell interview, 10–11). Another visionary was then Highland Park resident Jacque Rubel, founder of the Middlesex County Culture and Heritage Committee and operator of summer arts camps. She had long dreamed of a cultural complex on Livingston Avenue that would encompass the State Theatre, the YMCA building there, and other existing and new buildings. One day she, Eric Krebs (founder of the George Street Playhouse), and George Segal (an internationally known sculptor who lived and worked nearby) "walked Livingston Avenue from George Street up, talking about what would a cultural center look like":

> And they had the old Arnold Constable [department store] still on the corner there. They had the old storage company, and the State Theatre—wonderful architecture, wonderful history—and there was an insurance [office] opposite on the corner, and then, of course, the Elks building, and then up the street is the library and the historical house. . . . That's what we hoped would become the center of the Cultural Center of New Brunswick. . . . We projected that the Elks building would be . . . like a black box where you could do poetry and experimental theater and keep the restaurants. (Rubel interview, 12)

In its landmark 1975 report, the American City Corporation mentioned the need for a performing arts center in the city. The report indicated that the site chosen should be of strategic value to the revitalization process (American City Corporation 1975b, 115). Some visionaries had already seen promise in the State Theatre. In the 1970s, Kenneth Wheeler, then academic provost at Rutgers, consulted with an architect who was knowledgeable about the construction of old vaudeville theaters. Then Wheeler and Bob Totten, a Rutgers employee and devout Baptist, inspected the theater (then a porno movie house) to see if conversion to other uses was "acoustically feasible." Rather than scheduling an appoint-

80. Future Crossroads Theatre location on Livingston Avenue

Photograph by George "Red" Ellis. Courtesy of George "Red" Ellis.

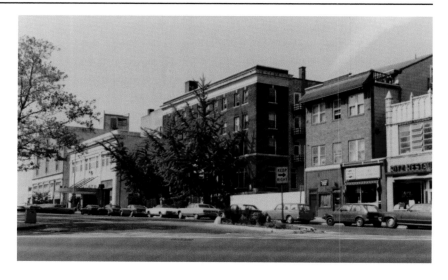

81. State
Theatre

Photograph by Larry
Levanti. Courtesy of
Larry Levanti.

ment and alerting the owners to possible interest, they two bought tickets to a show. Totten backed in, so he would not have to see the screen, and they noted that the theater could be transformed (Wheeler interview, 13). To seize this resource for future loftier purposes, John Heldrich of J&J persuaded the company's CEO, Richard Sellars, to buy the State Theatre "out of his own pocket" and hold it until DEVCO had the resources to secure it.

DEVCO acquired the State Theatre in 1979 and, after some "initial renovations," the 1,800-seat theater reopened in the fall "with a series of musical performances of outstanding artists." New Brunswick Tomorrow and DEVCO continued to cooperate on "other immediate uses" while undertaking "long-range planning" (New Brunswick Tomorrow 1979, 9). Today, the renovated State Theatre showcases about 150 entertainments a year, from the Vienna Boys Choir to heavy metal bands. Audiences—2.5 million since 1980—are now "shopping" for culture in the CBD.

The rehabilitation of the State Theatre is just one aspect of a story that involves many courageous individuals and institutions. To better appreciate how the New Brunswick cultural district materialized, we need to look back to the late 1960s and the efforts that led to the creation of the George Street Playhouse.

Eric Krebs graduated from Rutgers University in 1966 as an English major. Though he did not "particularly think about theater as a career," the community appealed to him, and he wrote plays. After graduation, during a brief stint teaching preparatory school, Krebs directed his first shows and "got hooked on theater" (Krebs interview, 2). In 1968, as a twenty-three-year old, Krebs launched a seventy-five-seat theater in a storefront on 47 Easton Avenue in New Brunswick. Brecht West lasted at that location for one season and "then moved down to 61 Albany Street, exactly where the entrance to the Johnson & Johnson headquarters is

now." Krebs described the theater as "the consummate, wonderful, welcoming experience for the arts in New Brunswick" (ibid., 4–6).

Downtown New Brunswick in the early 1970s was a "little working part of a little working town that had kind of gone to seed," Krebs remembered (Krebs interview, 15). The city was "very conservative and very counter to our [the theater's] culture," which he described as "an oddball kind of radical-seeming sort of counter culture–oriented group of folks" (ibid., 13). The *New York Times* described Brecht West as a "leftist coffee house setup" (Klein 1999). Al Pacino directed the play *Rats* there and was paid $75 plus his bus fare (Krebs interview, 8–9). Surprisingly, the theater's most loyal patrons were "the East Brunswick professionals commuting to New York," not the Rutgers academic community (ibid., 11). Another supporter was Jacque Rubel, who was "instrumental in everything that happened in the arts early on in New Brunswick" (ibid., 12). There were "pockets of support" at Rutgers, including the director of public safety, Robert Ochs. When Krebs faced the dilemma of having to provide parking to receive a theater license, Ochs permitted theatergoers to park in Rutgers lots. Even so, "there was absolutely no engagement whatsoever from the Rutgers undergraduate theater department," Krebs said. "J&J was completely uninvolved with Brecht West in any way; it was so counter to their image," he added (ibid., 12–14).

Krebs next rented a former Acme supermarket on George Street across from where the J&J headquarters would be built and converted it to a theater in 1974. The building was spacious, and the rent was low—$450 a month—a reflection of the dismal real estate market in New Brunswick's downtown at that time. The theater—the George Street Playhouse—opened its first season with George Bernard Shaw's *Arms and the Man*, charging $4, and $2 for students. The Playhouse started with six plays and 110 subscribers. Ralph and Barbara Voorhees were charter supporters, and Ralph would later serve on the board of the New Brunswick Cultural Center. J&J donated $4,500 to renovate the bathroom plumbing, but the city of New Brunswick and Rutgers provided "almost no engagement at all." Krebs added that New Brunswick Tomorrow was not involved and that Mayor John A. Lynch Jr. never attended. Governor Thomas Kean once came to a benefit event during a "horrible rainstorm." Krebs spent the performance "in a tuxedo up on the roof . . . pushing a broom to brush the water away from [a leak] over the spot where the governor was sitting" (Krebs interview, 16–20).

By word of mouth and other means, the Playhouse attracted a growing audience. Early on, Anthony Marchetta, then New Brunswick's assistant business administrator, and his wife saw *Sleuth* there and were "stunned at . . . how good the performance was. We immediately signed up as subscribers." Marchetta believes that the theater "helped the city along" its revitalization process. "It stayed there. It was open at night. It brought people into town" (Marchetta interview, 37). Marchetta joined the Playhouse board in the 1970s and later became board president. During that time, the theater was in "financial disarray"; one reason was that the New Brunswick streetscape was being remodeled, and visitors had trouble accessing the theater. As a precaution, each board member pledged

five thousand dollars for an emergency fund. To help solidify the theater's funding, Marchetta secured loans from Middlesex County Bank, Franklin State Bank, and Chicopee, a Johnson & Johnson subsidiary (ibid., 37–40).

In 1979, Rubel and Krebs presented their vision of a New Brunswick cultural center to John Heldrich of J&J, Paul Abdalla of DEVCO, and Hugh Boyd of the *Home News* at the apartment of Rae and Morris Landis. "The cultural center she envisioned was the State Theatre, the YMCA, the Elks building, new construction, and a closed [to vehicular traffic] Livingston Avenue" (Krebs interview, 22). DEVCO, New Brunswick Tomorrow, and others were already beginning to see the value and potential of the cultural center idea, and moved to secure the State Theatre. A New Brunswick Arts Development Commission, chaired by William Wright of the Rutgers Office of Physical and Capital Planning, issued a report in 1982 on "A Cultural Center for New Brunswick." "All of the ingredients to achieve success are in place" (New Brunswick Arts Development Commission, 1982, 2), it noted:

- DEVCO owns the State Theatre, which protects future options for its use.
- The YMCA is for sale, and it, along with other properties around the State Theatre, is adaptable to Cultural Center use.
- The City has designated the Ballet, Opera, and Orchestra to be resident companies of New Brunswick. They have all established bases in New Brunswick, and the Ballet has also established a school here.
- The Mason Gross School of the Arts is committed to remaining in the downtown area, but is in need of permanent facilities.
- The Arts Resource Center at 146 George Street provides gallery, office, and conference space for five professional arts organizations.

The commission identified several buildings on Livingston Avenue surrounding and including the State Theatre as a proposed location for a cultural center. It recommended further study of land use and other nearby buildings by architects and other professionals to develop a more detailed plan for the physical presence of the cultural center. That study, valuable and visionary, deviated from the precedent set by the construction of the Hyatt hotel and J&J headquarters by recommending the adaptive reuse of existing facilities instead of demolition. The State Theatre was recognized as a "monumental resource" and imagined as an anchor to the cultural center.

Related to the State Theatre is the New Brunswick Cultural Center Board, formed in 1982 with Richard Sellars, Jane Tublin, Sam Landis, Ralph Voorhees, and Thomas Kelso as the original five members. Attorney Kelso said, "It was critical to be able to get a structure in place, which not only would just simply own the facility but would be able to operate it and operate it successfully" (Kelso interview, 15). He explained how the State Theatre project was funded after Richard Sellars provided the loan that allowed NBCC and DEVCO to buy the building:

Middlesex County acquired the building from the Cultural Center for $3 million and leased it back to the Cultural Center for $1 a year for 99 years. What did that do? It was a simple mechanism to put $3 million into the building to get it to a point where you could open it up. And if you didn't have the cooperation of the Middlesex County government, the city government, and the Cultural Center Board to look at that and say "that's a good way to get this facility up and operational," it would have never happened. (ibid., 16)

The dynamic of leadership, stability, and "willingness to cooperate" stands out in this example. Later, Middlesex County provided an additional $3 million in Open Space funds to further refurbish the theater (Kelso interview, 17). Kelso credits Mayor John Lynch Jr. with the idea of bringing the county government into the funding scheme. Lynch was also behind the original idea to use State of New Jersey Green Acres funding (originally aimed at conserving open space) to preserve arts infrastructure. As with so many other aspects of New Brunswick's revitalization, Lynch found creative financial and other solutions at the local and state levels to seemingly intractable barriers to action. Omar Boraie spoke about the leaders as catalysts: "There are not so many mayors around who have that vision like John Lynch had at that time. Dick Sellars, of course, had a vision; also at the hospital site Harvey Holzberg had a vision," and there was the "help of Middlesex County at that time. David Crabiel had the same vision. Why not expand New Brunswick because we have all these catalysts in New Brunswick" (Boraie interview, 4).

In 1983, with eyes on their property on George Street, DEVCO and J&J approached the George Street Playhouse about selling its then home in the former Acme building. The board of the Playhouse agreed, so long as a fair price could be negotiated and a new location found. The new location became a contentious issue. Paul Abdalla, president of DEVCO, proposed the former Davidson's grocery store located at George and Morris Streets. The board rejected this offer, fearing that the regional customer base would not follow the Playhouse from its location near the New Brunswick train station and across the street from J&J to a location "in front of a public housing project [Memorial Homes] in a much more desperate part of New Brunswick" (Marchetta interview, 42–43). At the same time, the YMCA, also on Livingston Avenue, was for sale for an advertised $950,000, and it was determined that the interior of the building could be reconfigured as a theater for the George Street Playhouse. The program could be accomplished for about $2 million, according to Eric Krebs: "knock out the back wall of the gym, build a whole stage house . . . and [redo] the whole first two floors of the building into a theater" (Krebs interview, 29).

Marchetta reached out to John Heldrich: "I asked if he could help us by funding a site-selection effort, and we would engage a consultant that knew theaters, that would explore possible locations in New Brunswick" (Marchetta interview, 43). The consultant considered the Davidson grocery store location, the YMCA,

and the possibility of a reconfigured Ferren Parking Deck. The latter appealed to Marchetta because of its physical space and because of its proximity to the train station (convenient to the Playhouse audience and artistic personnel coming from New York City), although the YMCA location was significant from a "long-term perspective" because of its location next to the State Theatre (ibid., 43–44).

When it was decided that the YMCA would be purchased as the George Street Playhouse site and that DEVCO would convert it to a theater, the NBCC began to take shape. Krebs described the YMCA's conversion to a theater as "one of the linchpin moments when the cultural center really happened" (Krebs interview, 29). In fall 1986, the George Street Playhouse opened its first season on Livingston Avenue in a space twice as large as its former location. However, in the initial years, the assumption that a larger facility would sustain the theater proved mistaken. "We almost went into bankruptcy," Krebs admitted, "because we fell into the edifice complex, which is . . . a small organization gets a big building and can't support it" (ibid., 26). Still, the Playhouse thrived in its new location; today, it has roughly 4,500 subscribers. Eric Krebs eventually left George Street Playhouse to pursue theater interests in New York City, and by then there was more pressure by the board to produce less controversial plays. David Saint was appointed artistic director in 1998. Jacque Rubel described Krebs's importance to the redevelopment of New Brunswick: "He was the key player in bridging between DEVCO, New Brunswick Tomorrow, and the cultural folks. He was there in town. He was in the trenches" (Rubel interview, 12).

About fifteen years after the George Street Playhouse moved into the renovated YMCA, the Crossroads Theatre Company joined the Livingston Street scene. Crossroads started in the late 1970s when Ricardo Khan, who had become active in theater arts while a student at Rutgers, and L. Kenneth (Lee) Richardson approached Krebs about helping them establish a black theater company. Krebs said yes "in about two seconds." Crossroads became a project of the Playhouse under the federal Comprehensive Employment and Training Act (CETA) program. Kahn described the epiphany moment:

> Lee and I were at lunch one day . . . and we sat down and on a napkin I wrote out the mission. . . . So we took the mission, we took the program design, we built it into an application, and we got the funds. And at that point we were able to hire, I think . . . a total of twelve people. Half of them were actors. We figure one would be a house manager, one would be a stage manager, one would be publicity, one would be administration. . . . and we all went around and then finally we found 320 Memorial Parkway. . . . The ceilings were very high; it was an old sewing factory (Khan interview, 12–14).

The intimate space was both a challenge and an opportunity for the company because there was a Y-beam in the middle, which was incorporated into each performance.

82. Performance at old Crossroads Theatre

Photograph by Harry Rubel. Courtesy of Jacque Rubel.

83. Performance at old Crossroads Theatre

Photograph by Harry Rubel. Courtesy of Jacque Rubel.

The space may have been small, but the founders' vision was lofty:

There's a power in theater beyond just escapism. There's a power to the image. There's a power to the word. And there's a power when you bring people of many different backgrounds together instead of turning a blind eye to color, instead seeing it as something quite beautiful. And then I became proactive about wanting to do theater to create a community of people that never exists normally, that comes from all different backgrounds racially, economically, age-wise. And they come, they see a play, together they may have different reactions, but they see it all together. And then they leave. If we did our job right, they leave just a little different than they were when they came in. (Khan interview, 18)

That artistic quest inspired the company's name:

> What name, what name? . . . we wanted . . . to break barriers down between the traditional theater audience which is white, and us as the nontraditional theater and the nontraditional theater-going audience which is primarily black and Latino, and Theater. And one day, Dan Irving is on a ladder . . . and he sees all these streets coming together . . . , and it just hit him, "Crossroads." And all of a sudden it just made total sense because on so many levels that was our mission. (Khan interview, 16).

To make Crossroads a reality, Khan and Richardson cultivated foundations and corporations and developed "enough steam" to launch. The CETA money was an important financial foundation, and the theater company in turn "was a role model for CETA, a huge success" (Khan interview, 18). Other funders were needed, however. Eventually, the State Arts Council under Governor Kean awarded a grant of $300,000 to Crossroads, and then a second $300,000 because "we were a major impact organization and they were funding the 'extraordinary'" (ibid., 33), which included creating new works and partnering with the artistic community in New York.

Along with the rest of the old Hiram Market district and Memorial Parkway buildings, the Crossroads Theatre at 320 Memorial Parkway became a target for demolition in the 1980s. The 1990–91 season was the last one in the older space. In 1991, the Crossroads Theatre Company opened its doors in a new Egyptian revival–style building evocative of the muse's life/death transformative journey that had been built for it, primarily with Middlesex County funds, next to the George Street Playhouse on Livingston Street.

The first Crossroads show featured Bill Cosby, who had never performed in New Jersey outside of Atlantic City. Cosby, in fact, contacted Khan (who thought

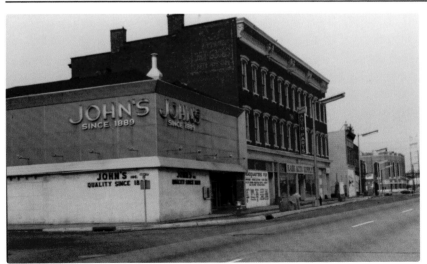

84. Old Crossroads Theatre in the King Block building on Memorial Parkway

Photograph by George "Red" Ellis. Courtesy of George "Red" Ellis.

the initial telephone inquiry was a prank) and graciously offered, "What can I do for you?" (Khan interview, 27). When house lights dimmed and Cosby looked out at the new theater and large number of minorities present, the first thing he said was, "We're so proud . . . it looks so beautiful . . . [and] man, it looks like Las Vegas out here, but it looks like Alabama back there" (ibid., 28). That Cosby event was a huge financial success, and Crossroads was launched in its new home. Other guest artists, including Ray Charles, Smokey Robinson, Wynton Marsalis, and Dionne Warwick, performed benefit concerts for Crossroads. The new Crossroads Theatre building was a beautiful and much larger space—and had no Y beam. According to Khan, "It was a very, very interesting set of lessons we learned to try to figure out how to do our work in a venue that has no obstacles" (ibid., 29). It was also important to find a way to preserve the sense of intimacy that existed in the old space.

Crossroads commissioned August Wilson to create a play, and *Jitney* almost landed the theater a Tony Award. Later, in 1999, Crossroads was recognized with a Tony Award for Outstanding Regional Theatre in the United States. Although Crossroads suffered financial challenges, in part due to its larger venue, it remains an active and nationally important African American cultural center. In time, Crossroads co-founder and artistic director Ricardo Khan left for other professional opportunities, but he returned in 2013 as playwright (with Trey Ellis) of the Crossroads production *It's Got That Swing* about Satchel Paige and others.

Some of the redevelopment case studies described earlier in this chapter, such as Memorial Homes and the Hyatt Regency hotel, left lingering debates over their positive and negative consequences. That is decidedly not the case with respect to the New Brunswick Cultural Center. Many of the individuals interviewed about its creation agreed on the importance of the NBCC for the economic health of the city. Anthony Marchetta, who served for many years on the

85. New Crossroads Theatre on Livingston Avenue

Courtesy of New Brunswick Development Corporation (DEVCO).

86. Three theaters on Livingston Avenue

Photograph by Danny Zeledon. Courtesy of New Brunswick Cultural Center, Inc.

board of the George Street Playhouse, linked the rise of theater with restaurant growth: "None of the theater growth that occurred in New Brunswick—the restaurant growth—would have occurred in New Brunswick without [the NBCC]. . . . All of a sudden, New Brunswick became a restaurant spot on the New Jersey map, and to this day, I think, between Hoboken and New Brunswick, you have more Zagat-rated restaurants than anywhere else" (Marchetta interview, 50).

Current mayor James Cahill believes that the creative arts represent the "heart and soul of the city" and that the NBCC "creates a vibrant city, it creates a forum of expression, it's a place for people to gather and socialize. . . . Economically, it's also a practical business sense. . . . For every ticket price or dollar that somebody spends for a ticket, the compounding factor of that in investment elsewhere in the community is several-fold. So investment in the arts is a good investment" (Cahill interview, 23).

For former mayor John Lynch Jr., the arts have been "a huge part of the change in the dynamic of the central business district and the perception of New Brunswick. . . . The perception that the arts could succeed in New Brunswick was generated in no small measure by Eric Krebs and what he did at a time when there was nothing" (Lynch interview, 50). Finally, C. Roy Epps, who found so much to criticize about the Memorial Homes and Lower George projects and their failure to benefit lower-income residents, sees many positive outcomes from the NBCC:

> The Cultural Center brought people in, which helped generate the kind of resources for the restaurants to bloom. When you look back on it, when we first started, people didn't stay downtown. People came in, went to work, and left. Now . . . people, before or after a performance, end up going to eat—and if they are going to eat, they are going to drink. . . . I think we have moved away from it being a shopping center, . . . to being more of a cultural and entertainment center, which is where we are right now. People who now are coming to New Brunswick and saying, "Wow, this is really good," have no idea what we went through to get it where it is today. (Epps interview, 18).

New Brunswick as "Health Care City"

Both Saint Peter's Hospital and Robert Wood Johnson Hospital trace their origins to the late nineteenth and early twentieth centuries, when hospitals nationally were being established to replace almshouses and at-home care in urban areas. The first Saint Peter's Hospital, sponsored by the Catholic Church, opened in 1872 but lasted only two years because of lack of funds (Whitfield-Spinner 2011, 98).

87. St. Peter's Hospital, New Brunswick, N.J.

Postcard, Lynn Boyer Jr., Wildwood, NJ. Special Collections and University Archives, Rutgers University Libraries.

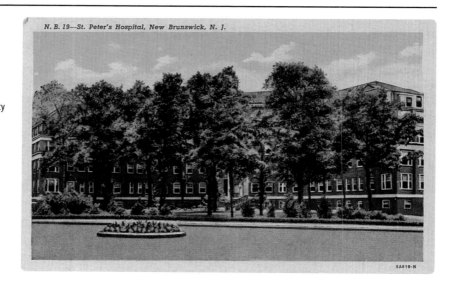

N. B. 19—St. Peter's Hospital, New Brunswick, N. J.

Table 5.1 Development of the Robert Wood Johnson Hospital

1885	New Brunswick City Hospital incorporated by a group of prominent New Brunswick citizens inspired by the founding of a Ladies Hospital Aid Association. In 1888, John Wells donates $5,000 to building the John Wells Memorial Hospital with 20 beds.
1928	Building expands bed capacity to 40. Named changed to Middlesex General Hospital (Whitfield-Spinner 2011)
1930s	Expansion to a 100-bed capacity.
1940s	Addition of a residence for nurses.
1958	New building added, increasing bed count to 237.
1970s	A new Robert Wood Johnson Memorial Tower is built on the site of the original Wells Building, and the hospital becomes the primary teaching hospital for the College of Medicine and Dentistry–Rutgers Medical School.
1980s	Name changed to the Robert Wood Johnson University Hospital (RWJUH), in honor of the late General Johnson.
1990s	Heart Center of New Jersey, CORE Pavilion, and Cancer Institute of New Jersey added.
2000s	Bristol-Myers Squibb Children's Hospital and Emergency Department open. Bed count rises to 584, with 4,630 hospital staff and 1,505 medical personnel caring for 34,000 in-patients, 110,000 outpatients, and 62,000 emergency department visitors. RWJUH included in *US News & World Report* top hospitals. In 2014, the hospital merged with Somerset Medical Center to create a 965-bed center (RWJUH flyer).

SOURCE: Robert Wood Johnson University Hospital, Marketing and Public Relations communications to authors.

Table 5.2 Development of Saint Peter's Hospital

1907	Saint Peter's Hospital opens at Somerset and Hardenberg Streets.
1910	New wing added.
1929	New five-story facility opened on Easton Avenue on the hospital's current site.
1930s	Several construction projects to accommodate an increase in patients and nurses.
1931	Nursing school dedicated.
1952	Ownership and control given to the Diocese of Trenton and Grey Nuns.
1959	Three additional wings built.
1962	Saint Peter's affiliated with Rutgers Medical School; by 1965 a Rutgers Medical Service program provided clinical opportunities for medical school students.
1976	Five-story tower built.
1982	Ownership and control moved to the Diocese of Metuchen.
1993	Pavilion for women and children added.
1998	Name changed to Saint Peter's University Hospital.
2003	Expansion and reorganization. Initiated an affiliation with Drexel, New Jersey Institute of Technology, and Children's Hospital of Philadelphia.
2007	Saint Peter's Health System established with facilities in Somerset and Monroe.
2015	St. Peter's facilities included 478 licensed beds, 3, 242 healthcare professionals and support personnel, and 1, 170 medical and dental staff members; treated more than 23, 000 inpatients and more than 250, 000 outpatients annually; total projected 2015 gross patient revenue of $2,491,226,000.

SOURCES: Nayan K. Kothari and Palma E. Formica, "A Century of Caring: Saint Peter's University Hospital" (New Brunswick, NJ: Saint Peter's Healthcare System, 2009); Saint Peter's Healthcare System website, 2015, http://www.saintpetershcs.com/saintpetersuh; personal communication to author from Saint Peter's Healthcare System administrator.

88. Saint Peter's University Hospital, 2008

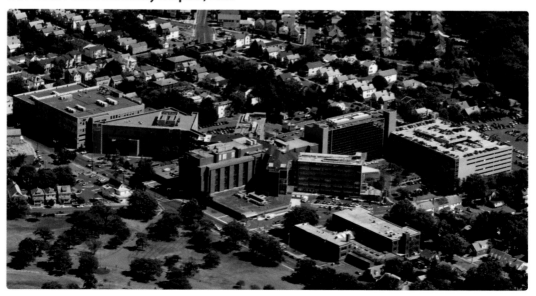

Courtesy of Saint Peter's University Hospital.

New Brunswick City Hospital, the precursor to Robert Wood Johnson Hospital, was incorporated on March 13, 1884, and began operations in 1885. A new Saint Peter's, on the corner of Somerset and Hardenberg Streets, began operations in 1907 (See tables 5.1 and 5.2.) At that time, with the establishment of J&J in the city, New Brunswick was already considered a "health care city." The city's growing population and economic importance demanded modern health care facilities (ibid., 86).

New Brunswick's revitalization has been aided by the significant scale and growth of its two major hospitals, Robert Wood Johnson University Hospital and Saint Peter's. Robert Wood Johnson University Hospital (RWJUH) is part of the larger Robert Wood Johnson Health System, which has about 10,000 employees, 3,300 medical staff members, and 1,700 beds. RWJUH New Brunswick is the flagship for the Rutgers University Cancer Institute of New Jersey, the principal hospital of the Rutgers Robert Wood Johnson Medical School, and host for the Bristol-Myers Squibb Children's Hospital. In recent years, total patient gross revenues amounted to about $3.7 billion. Saint Peter's University Hospital is a 478-bed facility that employs 3,242 health care professionals and support staff (personal communication to author from Saint Peter's Healthcare System administrator, 2015). Total gross patient revenue is about $2.5 billion (American Hospital Directory, 2015). Assisting in the success of these two hospitals was the close relationship that J&J established with them. In 1953, when both hospitals were facing growing demands for more space, the Reverend George Ahr, bishop of Trenton, and General Robert W. Johnson initiated a $3 million fund-raising drive, with half going to each hospital.

Robert Campbell, J&J's chief financial officer and then vice chairman of its board in the 1980s, served for several years on the board of the Cancer Institute of New Jersey. He emphasized the importance of the hospitals to the city's revitalization: "The whole health care system . . . gave a lot of people not necessarily living in New Brunswick a reason to keep coming to town" (Campbell interview, 18). Campbell also noted J&J's contributions to the hospitals:

> J&J has always been very much involved with the hospitals, not only from a financial point of view, but from a time and talent point of view. Many, many J&J executives have been on the boards of the hospitals, boards at the Cancer Institute, Child Health Institute. They've had leadership positions with those, and personally have contributed funds to those. . . . It's been a continuum really, even before New Brunswick started going downhill. . . . It wasn't something that suddenly started as part of the revitalization. It was there, and General Johnson . . . started the Robert Wood Johnson Foundation. Actually, it was originally called "the New Brunswick Foundation" back in the thirties. If you look at where his money went in those days, it was for people to get an operation or a stay at the hospital or something of that type. So there was always that connection. (Campbell interview, 20–21)

89. Middlesex County Hospital Building, 1958

Courtesy of Robert Wood Johnson University Hospital.

Many civic leaders credit Harvey Holzberg, CEO of the Robert Wood Johnson Hospital from 1989 to 2009, with having the administrative and political skills necessary to push "this whole thing ahead as a healthcare city, and he really made that institution move" (Lynch interview, 13). When Holzberg announced plans to retire, James Knickman, chair of the hospital's board of directors, praised Holzberg's leadership in expanding Robert Wood Johnson "from a struggling community hospital into a major academic medical center" (Robert Wood Johnson University Hospital, news release, ca. 2009). Knichtman summarized Holzberg's "strategic plan based on a fourfold mission: patient care, research, medical education, and community outreach. . . . Thanks to Mr. Holzberg's leadership, New Jerseyans no longer have to leave the state to receive world class medical care" (ibid.).

At the end of Holzberg's tenure, the hospital included the Bristol-Myers Squibb Children's Hospital, the Cancer Institute of New Jersey, UMDNJ–Robert Wood Johnson Medical School, the New Brunswick Health Sciences Technology High School, Children's Specialized Hospital, Child Health Institute of New Jersey, a cardiovascular institute, and the Institute for the Development of

90. Robert Wood Johnson University Hospital

Photograph © 2015 George Shagawat.
Reprinted by permission of George Shagawat.

Healthcare Technology. Unfortunately, a bond issue referendum for a proposed stem cell research institute was not approved by the voters and was not built.

Former mayor John Lynch Jr. has asserted that the growing prestige of the city's hospitals was a major contribution to its rejuvenation:

> The affiliation agreement [with Middlesex General Hospital] and the emergence of Robert Wood was . . . critical to the city in terms of its . . . appeal, its job base, and the quality of life generally, but just as importantly, the perception of it changes the New Brunswick vision from afar. . . . You couldn't get people from East Brunswick to come to New Brunswick, and the word always was, "It will never happen. They're not secure. You can't park. You can't do this. And how are you ever going to make this thing work?" The hospitals, in particular, and particularly Robert Wood Johnson and the medical school, Robert Wood Johnson Medical School, brought a lot, a lot of people into the community who otherwise would not have been there. Created an aura of excellence that was very much involved in the rebirth of the city from the standpoint of not only actuality but perception, which is always critical. I mean, they became to us what the Cleveland Clinic is [to] Cleveland. (Lynch interview, 13)

Indeed, just as the Cleveland Clinic lifted the public view and fortunes of its namesake city, so too was health care envisioned as New Brunswick's new economic niche and brand. Fortunately, as noted by Robert Campbell, the city already had a critical mass of health institutions—"the Cancer Institute of New

Jersey, the Child Health Institute, [and] the Cardiovascular Institute"—and those "led to the whole concept of 'New Brunswick, the Healthcare City'" (Campbell interview, 18–19).

Knowledgeable observers like Campbell and Lynch bemoan what they perceive as an unfortunate missed opportunity: the failure to merge Saint Peter's and Robert Wood Johnson into a single medical institution, which would have moved the Health Care City closer to the Cleveland Clinic powerhouse model. Around the year 2000, a merger plan ran into Vatican concerns about what it would entail regarding "services objectionable to Catholic doctrine" (Singer and Lantz 1999, 12–13). While there was precedent for separating such services in "an independent entity outside of the joint system" (Singer and Lantz 1999 12–13), the details proved insurmountable. Besides religious concerns, the mergers of hospitals, like those of any large institutions and corporations, are fraught with administrative and financial challenges, and more often than not are studied but not consummated. Former mayor John Lynch Jr. cites the failed merger as one of his biggest regrets: "We collectively didn't do enough to propel the integration of the two hospitals. . . . It could have happened . . . the specialties could have been expanded dramatically . . . the level of expertise would have risen. . . . It was a missed opportunity . . . if you talk about hindsight, if you go out fifteen, twenty years and look back, it will be very obvious" (Lynch interview, 34, 28, 40).

91. Aerial view of Robert Wood Johnson University Hospital

Courtesy of New Brunswick Development Corporation (DEVCO).

Gateway Transit Village, the Wellness Plaza, and Ferren (the Hub) Development

Although rail transportation was eclipsed by the automobile for much of the post–World War II period, both in the Hub City and nationally, that trend has shifted, and now locations near transit are prized. As is evident from figure 5.3, the three projects described in this section—the Gateway Transit Village, the New Brunswick Wellness Plaza, and Ferren (the Hub)—are all a stone's throw from the New Brunswick train station and reflect the current emphasis on transit access.

GATEWAY TRANSIT VILLAGE

"How is it possible," asked a February 2011 article in the real estate section of the *New York Times*, "that a major mixed-use project . . . can actually be proceeding" in the current "sluggish" economy? (Martin 2011, 9). The answer came from Christopher Paladino, president of DEVCO: "Stubborn determination and extreme cooperation" (ibid.). That DEVCO project is Gateway Transit Village (the Vue), an ambitious and strategically located development, completed in 2012–2013, that capitalizes on the city's excellent transit access.

Fig 5.3 Aerial View of New Brunswick Completed and Planned Developments Near the Train Station: Gateway, Wellness, and The Hub

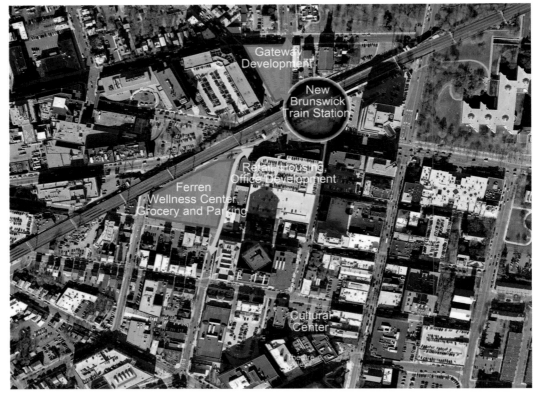

Courtesy of New Brunswick Development Corporation (DEVCO).

In recent years, the planning profession has stressed the importance of locating development near transit ("transit-oriented development," or TOD) as a way to reduce dependence on the automobile and to further smart growth. To encourage TODs in New Jersey, the state initiated a program in the mid-2000s to designate areas near transit as "transit villages." Downtown New Brunswick received one of the earliest designations in 2005 (New Jersey Future 2012), which gave it priority access to state revitalization monies. One such program was the Urban Transit Hub Tax Credit (UTHTC). Authorized in 2007, the program issued generous tax credits that could be applied against state taxes for capital projects located within a mile of a transit center in eligible New Jersey municipalities (nine New Jersey cities, New Brunswick included): up to 100 percent for nonresidential investment and up to 35 percent for residential projects. The credit was capped statewide at about $1.5 billion. UTHTC was one of the many subsidies that enabled Gateway Transit Village and, more generally, a number of prominent recent projects, including the Wellness Plaza and new Rutgers campus buildings on College Avenue.

At twenty-three stories and 635,000 square feet, Gateway is one of the most significant developments completed in New Brunswick to date. It contains a

92. Gateway

Photographed by Allison V. Brown.
Courtesy of Allison V. Brown/AV Brown
photography.

45,000-square-foot Rutgers University Barnes and Noble bookstore, 12,000 square feet of additional retail space, 58,000 square feet of office space, 150 rental residences (25 percent available at below-market rents), 42 condominium residences, and 657 parking spaces. A walking promenade and handsome outdoor café space link the Rutgers campus directly to the New Brunswick train station.

Gateway is a public-private partnership (PPP) involving DEVCO, Pennrose Properties (the developer of Providence Square and Livingston Manor), the New Brunswick Parking Authority (NBPA), and Rutgers University. The $150 million project drew on multiple sources of funding: about $25 million in federal New Markets Tax Credits, about $28 million from the state UTHTC, and about $59 million from the NBPA. The latter's contribution consisted of $49 million in NBPA-issued Build America Bonds (a federal stimulus program authorized by the 2009 American Recovery and Reinvestment Act) and $10 million in New Jersey Department of Transportation funds. In addition, Rutgers University issued a $16 million bond. The remaining funds came from conventional sources: mortgage loans from both national and local lenders—, such as Bank of America and Magyar Bank—and developer equity.

To begin the planning process, New Brunswick's municipal planner, Glenn Patterson, declared the proposed 1.5-acre Gateway site to be an "area in need of redevelopment" (Tarbous 2005, A-1). The existing buildings at 104–120 Somerset Street contained such businesses as Neubies Restaurant in the Hennessey building at 120 Somerset, Vagabond Tours, Little Teddy's, and New Jersey Books. Patterson described the block as substantially underdeveloped, with stores covering up architectural features with illegal signs, truck trailers being used as parts of buildings, and other undesirable features. Many preservationists in New Brunswick, however, criticized the rush to declare the area in need of redevelopment. Morris Kafka of the New Brunswick Historical Association pointed out that the site contained "the last intact nineteenth-century row of commercial buildings in this entire area, and it fronts on [Rutgers] Old Queens, which is arguably one of the most important sites in the county if not the state" (Kafka interview, 19). He noted that the cast iron ornamentation of the Hennessey building (on the corner of Easton and Somerset) was particularly distinctive and that the building was structurally intact (Kafka 2014, 18). Preservationists hoped at least to retain the façades of some historic buildings on the Gateway development site or, if all else failed, to construct a much scaled-down new building.

Proponents of the Gateway proposal countered with a series of arguments. First, the location next to the New Brunswick train station was ideal for a TOD, and a TOD would further smart growth redevelopment of the city. Second, the historical significance of most of the structures on the Gateway site was questionable, and many of them were in a deteriorated condition. Third, the approximately $15 million property acquisition and relocation costs necessitated a building with significant scale to amortize this considerable expense. Fourth, it was impractical to incorporate the façade of the Hennessey building into a new structure. Finally, the Gateway proposal was designed to harmonize as best it could with the his-

93. Gateway behind Saint Peter's Church and rectory

Photograph by Larry Levanti.
Courtesy of Larry Levanti.

toric setting of the adjacent Saint Peter's Church and some of the oldest buildings on the Rutgers College Avenue campus, including Old Queens and Winant's Hall. Gateway's mass was set back and away from its historic neighboring buildings, and the "bulky" parking garage was set yet farther away from Saint Peter's and Winant's–Old Queens, so as not to overwhelm these far more modest buildings from a pedestrian perspective. For similar reasons, Gateway's final tower height was reduced from 330 feet to 257 feet. Additionally, Gateway's developers followed a recommendation made by New Jersey's State Historic Preservation Office and used some building materials and colors (red-tinged brick) sympathetic to its historic neighbors.

After Gateway was built, New Jersey Future gave the project its 2012 Smart Growth Award for Transit-Oriented Development Partnership. The citation noted that, "as ambitious as this project is, care was taken to ensure it did not compromise the [adjacent] historic setting" (New Jersey Future 2012). To Morris Kafka, however, Gateway represents minimal compromise to preservation sentiments and the goal of a vibrant city that synthesizes both old and new (Kafka interview, 2014). Speaking more broadly about the redevelopment of New Brunswick and

the city's historic stock, Kafka concluded: "The sad thing is we're all the losers. This is the tragedy. This is not an esoteric group of historic artifacts. This is concern for the holistic health of the city. The city will become an anonymous anyplace when everything of history is gone" (ibid., 23).

TOD projects across the United States have sometimes sparked similar preservation controversies. In part, conflict is inevitable, for transit nodes are typically located in older and generally more historic downtowns, and TODs target precisely these locations. Fortunately, other projects near the New Brunswick train station have not provoked this kind of controversy.

NEW BRUNSWICK WELLNESS PLAZA AND FERREN (THE HUB)

Located across from the New Brunswick train station, the John A. Ferren Parking Garage and Mall opened in 1983 and was one of the early redevelopment projects in the city's modern era. The five-story structure offered retail space and 1,228 parking spaces for daily and monthly use. The Rutgers bookstore, which traditionally had been cocooned on the College Avenue campus, moved to Ferren. Having Rutgers come downtown was important both symbolically and financially because the bookstore was Ferren's anchor tenant. Other tenants over time included restaurants, medical offices, PNC Bank, and a customer service center for Public Service Electric and Gas (Rabinowitz and Kratovil 2013).

Over three decades, however, Ferren went from downtown darling to decrepit dowager. The aging facility was expensive to run, costing more than one million dollars annually, and more appealing nonresidential structures, notably the Golden Triangle and Albany Street Plaza office buildings, were built nearby. The mundane Ferren was increasingly incongruous in the epicenter of a city on the upswing.

Another glaring downtown problem was the absence of a large modern supermarket. This situation was not unique to New Brunswick. The many urban areas without ready access to fresh, healthy, and affordable food because of the absence or dearth of supermarkets have been described as "food deserts" (U.S. Department of Agriculture 2015). Food deserts contribute to a poor diet and attendant health problems, such as obesity and diabetes. Moreover, the poor are disproportionately located in food deserts and are often forced to pay higher prices for lesser-quality food. Given this situation, it is no wonder that supermarkets are viewed as important to urban revitalization.

If not entirely a food desert, New Brunswick was surely food parched. In 1952, Davidson Bros. Inc. opened a 10,000-square-foot Davidson supermarket at 263–271 George Street, on the corner of Morris Street in downtown New Brunswick. Davidson moved from that store in 1978 and took over an existing supermarket about two miles away on Elizabeth Street near the North Brunswick border—a long trek for downtown residents. When it sold the George Street store in 1980, Davidson added a restrictive covenant in the conveying deed, declaring that the George Street property "shall not be used as and for a supermarket for a period of forty years" (New Jersey Superior Court 1994, 161). The covenant led to

the closing of the George Street supermarket in 1980, and not surprisingly, there was an uptick in sales at the Elizabeth Street store (Trial Court 1990, 1).

The residents most affected by the closure were the poor and elderly living in or near the Memorial Homes project. According to the New Brunswick Housing Authority, they "were forced to take public transportation and taxis to the Elizabeth Street store [as] there were no markets in downtown New Brunswick, save for two high-priced convenience stores" (New Jersey Trial Court 1990, 2). This unfortunate situation lasted for six years. In 1986, the NBHA purchased the George Street property and leased it for a token dollar a year to C-Town, a regional operator of urban food stores. When C-Town opened a supermarket there, Davidson contested the violation of the restrictive covenant. Complex litigation then ensued. The city of New Brunswick argued that the covenant was unenforceable because it severely disadvantaged some 3,200 households in the downtown (26 percent below poverty level and 37 percent having no vehicle), which had "no other supermarket within walking distance" (New Jersey Superior Court 1994, 165). An expert witness testified for the city that the absence of a supermarket in a low-income neighborhood made food more expensive and had negative dietary and health implications. These arguments ultimately prevailed in 1994, and the New Jersey Superior Court declared the covenant to be unenforceable because it was "so contrary to public policy" (Superior Court 1994, 164). This ruling allowed C-Town to continue its supermarket operation in the George Street store and further established the legal precedent in United States jurisprudence that supermarket access is a public policy goal.

Over the next two decades, however, the George Street operation lost ground in meeting the needs of downtown New Brunswick. It was only a fraction of the size of modern suburban supermarkets (40,000–60,000 square feet) and offered few fresh food options. Also, new residential development was bringing a growing population with higher expectations to downtown: Riverwatch opened in 1999, the Highlands in 2004, and One Spring Street in 2006. Where would they find a modern supermarket to meet their needs? This vexing challenge was part of the larger New Jersey "food desert" problem, which led the state to create a public-private partnership in 2009, the New Jersey Food Access Initiative, funded with $3 million in state money and, later, a $12 million pledge by the Robert Wood Johnson Foundation (Lang and Kim 2012).

New Brunswick's creative solution to its parking, food, and health concerns combined the closing of the Ferren deck and its replacement by the adjacent New Brunswick Wellness Plaza (NBWP). Located at 100 Kirkpatrick Street across from the New Brunswick train station (figure 5.3) and owned and operated by the New Brunswick Parking Authority (NBPA), the nine-story NBWP encompasses a 49,000-square-foot grocery store on the ground floor, a 63,000-square-foot health and fitness center above it, and a parking garage with 1,275 spaces (Kratovil 2014a). Of the $106 million project cost, the parking garage required about $66 million, the fitness center about $24 million, and the supermarket approximately $16 million. As was true with many urban redevelopment projects, funding came from multiple sources:

Parking Authority Bonds

Recovery Zone Facility Bonds	$24,600,000
Recovery Zone Economic Development Bonds	$26,200,000
Build America Bonds	$41,544,239
New Jersey Open Space Grant	$3,000,000
Urban Transit Hub Tax Credit Proceeds	$3,500,000
New Market Tax Credit Proceeds	$7,682,300
Total Project Sources	$106,526,539

The provision of 1,275 parking spaces, along with the 657 spaces in the nearby Gateway project, permitted the NBPA to close not only the Ferren garage with its 1,228 spaces but also the 525 spaces at another aging facility, the Wolfson garage at Liberty and Neilsen Streets (Rabinowitz and Kratovil 2013).

The NBWP is much more than a parking "musical chairs" story; the project provided a showcase space for a modern supermarket and a health facility in the heart of New Brunswick's downtown. Census tracts within half a mile of the site showed the lowest median household incomes and lowest vehicle availability in

94. Wellness Center

Courtesy of Paulus, Sokolowski and Sartor Architecture, P.C., and New Brunswick Development. Corporation (DEVCO).

the entire city (New Jersey Transit and Rutgers University 2012). Recognizing the importance of a modern supermarket to New Brunswick's future, Mayor James Cahill courageously gave a green light to the NBWP project to proceed even before a supermarket operator signed on as a tenant (Kratovil 2014b).

Eventually, Fresh Grocer, a six-store Philadelphia-area chain that was looking to expand into New Jersey, became the anchor tenant. Besides having experience in operating in an urban area, Fresh Grocer already had close partnerships with two colleges, which boded well for a location near the College Avenue campus of Rutgers (Lan 2014). In addition, Fresh Grocer was chosen because it displayed an "ability to connect with and serve a diverse community" (ibid., 1.).

The NBPA went the extra mile to cement the deal with Fresh Grocer. It helped the chain secure a liquor license to sell wine and beer, an important profit center. The rent for the grocery space was set at thirteen dollars a square foot (Kratovil 2014a), a modest sum for a downtown location, and the NBPA provided free space for the grocer's personnel needs (staff recruitment and training) while the store was being completed. Finally, the NBPA agreed to three hours of free parking for customers who spent a minimum of ten dollars (ibid.). These arrangements culminated in Fresh Grocer's opening in the NBWP in November 2012. Open all day every day, the store employed almost 300 people, 70 percent of them from New Brunswick ("Fresh Grocer Supermarket Opens" 2012).

Opening day was a proud moment. Lieutenant Governor Kim Guadagno, responsible for dealing with the state's food deserts, praised Fresh Grocer for providing both jobs and access to fresh, healthy food. DEVCO's Christopher Paladino declared that the full-service store filled a vacuum for New Brunswick ("Fresh Grocer Supermarket Opens" 2012). The new supermarket appeared to be an oasis in New Brunswick's food desert.

Unfortunately, the supermarket component of the NBWP stumbled. After the promising start, Fresh Grocer closed its doors in May 2014, owing the NBPA about one million dollars in back rent. Various explanations have been put forth. Management "privately blamed the store's unsustainability on unrealistic projections of revenue from food stamps, failing to account for the large number of potential shoppers [from New Brunswick] that are non-citizens and therefore do not qualify for food stamps" (Kratovil 2014b). Fresh Grocer was also faulted for such miscues as "high prices and staff turnover, poor management and marketing," and inappropriate product selection (ibid.). As of August 2015, however, the supermarket space in the NBWP was reopened with a new operator, Key Food.

On the other hand, the remaining component of the NBWP has been a thriving success from day one. The well-equipped fitness and wellness center is a joint venture between Robert Wood Johnson University Hospital and Fitness and Wellness Inc. New Brunswick residents receive a 50 percent discount on the monthly membership fee and account for about 60 percent (3,800) of the facility's 7,000 members (Paladino 2014). In addition, the fitness center offers free Red Cross swimming lessons to children in New Brunswick's elementary schools. This program has proved to be extraordinarily popular, and there is nearly 100 percent

school attendance on lesson days (ibid.). The discounted facility membership for New Brunswick residents and the free swimming lessons cost almost two million dollars yearly, and this subsidy is made available from the tax credits discussed earlier (ibid.).

True to its name, the wellness center provides other community health services. A demonstration kitchen offers free ongoing lessons in healthy food preparation, physicians are available for community outreach, and free lectures offer information on such topics as living with diabetes and caring for aged parents (Paladino 2014).

To come full circle, a significant redevelopment project is planned for the site of the former Ferren parking garage. The Hub@New Brunswick Station will include up to 800,000 square feet of commercial, office, and research space, an additional 100,000 square feet of street-level retail space, about 600 residential units, and approximately 700 parking spaces ("Next Innovation Center" 2014, 13). In addition, the Hub is planned to contain three signature public spaces, such as a sixty-foot-wide colonnade open to pedestrians (Paladino 2014). Initial design renderings by the architecture firm Kohn Pederson Fox feature a "cluster of futuristic [angular] low and high rise buildings" (Muñoz 2014). The Hub is expected to attract commercial tenants and residents who seek to be near Johnson & Johnson, Rutgers University, and the city's hospitals, and who value the proximity to transit. Reflecting a theme of this book, the Hub is primed to capitalize on New Brunswick becoming an important center of "New Jersey's re-emerging knowledge-based economy" ("Next Innovation Center" 2014, 11).

Conclusion

This chapter's review of some of New Brunswick's major redevelopment projects points to the diversity of such undertakings. They include recasting old approaches (Memorial Homes to HOPE VI), reinvigorating stalled approaches (ultimately building on the cleared Lower George urban renewal site), opportunistically capturing available resources (using UDAG for the Hyatt hotel and Transit Hub tax credits at Gateway Transit Village and the New Brunswick Wellness Plaza), and expanding the functions of the city's downtown (culture replacing retail as the main draw of the CBD). There are other diverse characteristics. Whereas most of the projects involved new construction (HOPE VI, Plaza II, the Hyatt, and the high school), some employed rehabilitation and adaptive reuse (the State Theatre, George Street Playhouse, Providence Square, and Livingston Manor).

While the projects reflect diversity, there are also similarities. Almost all the developments described in this chapter involved DEVCO and/or New Brunswick Tomorrow (NBT), and most relied on public-private partnerships. With the exception of the Lord Stirling Community School and the New Brunswick High School, which were financed primarily with state funds, most of the rest were accomplished with both public and private monies. For example, Gateway Transit Village and HOPE VI each tapped almost a dozen sources of public and private financing.

Another recurring factor is the presence of visionary and energetic principals who persevered to realize seemingly impossible goals. While this component was perhaps most evident with respect to the New Brunswick Cultural Center, it characterized many of the other projects as well. Yet another common characteristic is some measure of controversy over end goals and the means to reach these goals. The most heated debate, still lingering today, involved Hiram Market, but there were conflicting perspectives concerning HOPE VI and Gateway as well. Underlying the conflicting viewpoints is the fundamental question: What has New Brunswick's redevelopment wrought? The answer(s) will be considered in chapter 6.

6

★ LOOKING TO THE PAST AND FUTURE OF NEW BRUNSWICK AND NATIONAL URBAN REVITALIZATION

IN CHAPTER 3 we presented a brief history and context of urban revitalization in the United States. The discussion in chapters 4 and 5 examined the local scene of urban challenge and response in New Brunswick, with a detailed presentation of many of the city's most significant redevelopment projects. This final chapter connects these national and New Brunswick threads of urban revitalization, then assesses whether the outcomes in New Brunswick can be deemed successful and serve as a model for other cities.

Interconnections between National and New Brunswick Urban Revitalization: Themes and Programs

Large swaths of downtown New Brunswick as it existed three decades ago have largely been replaced by the new central business district (CBD) developments described in chapters 4 and 5.[1] Much of New Brunswick's CBD has thus been "redeveloped" as opposed to "renewed," a policy choice that was carried out in downtowns throughout America in the post–World War II era.

Title I of the Housing Act of 1949 authorized $1.5 billion in aid for what was labeled "slum clearance and community development and redevelopment" (National Commission on Urban Problems 1969, 152). American city planners heralded the act for making possible "the replanning and reconstruction of American cities on [an] . . . undreamed of . . . scale" (Wheaton 1949, 41). Early in Title I's implementation, planners focused on clearing a few city blocks at a time; however, the limitations of this approach quickly became apparent. The program was given a midcourse correction in the Housing Act of 1954 (Housing and Home Finance Agency 1964), which "shifted the emphasis of Title I from slum clearance and urban redevelopment to slum clearance and urban renewal." The new term "urban renewal" was defined "to include a number of activities designed to encourage improvement of entire neighborhoods. These activities included

conservation of existing housing that had only begun to be threatened by blight and rehabilitation of blighted housing that could be improved without clearance" (Fefferman 1966, 57).

As opposed to the "redevelopment" approach of the Housing Act of 1949, the "urban renewal" strategy of the Housing Act of 1954 emphasized four goals:

1. The underlying objective of renewing older city centers.
2. The maximization of existing neighborhoods and buildings throughout the city. Urban renewal brought more attention to rehabilitation and conservation and the means to accomplish these objectives (for example, housing codes and new Federal Housing Administration [FHA] programs). The 1953 report of the Advisory Committee on Government Housing Policies and Programs, whose recommendations strongly influenced the Housing Act of 1954, emphasized that cities could not rely on slum clearance but should instead take action to prevent blight through conservation and rehabilitation.
3. Encourage regional planning. Section 701 of the Housing Act of 1954 provided one of the first major funding sources for state, metropolitan, and regional planning in the United States, again reflecting the recommendations of 1953 Advisory Committee. The committee's report spoke of the interdependence of cities and suburbs, the associated problems of urban blight and suburbs developed in a "spatterdash method," and the need for regional planning to deal with these and other issues (M. Scott 1969).
4. Social equity sensitivity. The sponsors of the 1954 act hoped to reduce the social dislocation caused in the first five years of implementation of the Housing Act of 1949 by mandating that relocation planning be included in the program that guided revitalization actions and by providing FHA Section 221 housing to relocated families.

The luxury of looking back at programs initiated sixty years ago is that we know how they played out. In some instances, urban renewal did in fact conserve and revitalize existing neighborhoods. Examples include Society Hill (Philadelphia), Charlestown (Boston), Vieux Carré (New Orleans), College Hill (Providence, Rhode Island), and Pikes Place (Seattle) (Stipe and Lee 1987). Yet these were the isolated exceptions to the more frequent demolition-focused, poorly planned (with little or no regional planning and integration), and socially and culturally destructive projects (the program's derogatory sobriquet was "Negro removal"). Approved projects across the nation from 1949 to 1960 demolished a total of more than 400,000 existing housing units, forced the relocation of more than 300,000 families (54 percent nonwhite), and cleared almost 57,000 total acres, or about 90 square miles (Collins and Shester 2011, 5). Of the cleared acreage, about 35 percent was proposed for residential development, 28 percent for nonresidential (commercial and industrial) development, and the remaining 38 percent for streets, public rights of way, and other public or semi-public uses

(ibid., 15). In short, the outcome of the 1949 and 1954 Housing Acts was decidedly more "urban redevelopment" than "urban renewal." In parallel, New Brunswick's urban revitalization also emphasized "redevelopment" as opposed to "renewal."

Beyond this overall national and New Brunswick similarity in strategic urban revitalization there are connections between specific New Brunswick projects and specific federal programs over time. Monies for property acquisition and demolition from the 1949, 1954, and other national housing acts provided the building sites for many developments in New Brunswick, including Plaza I, Plaza II, Liberty Plaza, and Riverwatch. The design, financing, and operation of New Brunswick's Memorial Homes was shaped by the federal public housing program initiated in the 1930s. The demolition of Memorial Homes in 2001 was preceded and followed by the implosion of many other failed high-rise, superblock public housing complexes that warehoused the poor throughout America, such as the thirty-three buildings of the Pruitt-Igoe public housing project in St. Louis, which were completely cleared in the mid-1970s. The replacement of Memorial Homes with smaller-scale and more sympathetically designed townhouses was guided by the national Hope VI program started in the early 1990s. The Hyatt Regency, Albany Street Plaza, Golden Triangle, and Riverwatch are just some of the important developments in this city that used federal Urban Development Action Grants initiated in the late 1970s. Providence Square, Livingston Manor, and Civic Square IV–Skyline Tower are examples of New Brunswick housing developments that used the low-income housing tax credit, a federal program originating in the 1980s. The 1986 federal historic tax credit aided both the Providence Square and the Livingston Manor housing projects. The 2000 federal New Markets Tax Credit was instrumental in enabling Gateway Transit Village, located near the New Brunswick train station. Thus, the grant, loan, tax credit, and other subsidies that helped finance the many new buildings in New Brunswick's current downtown

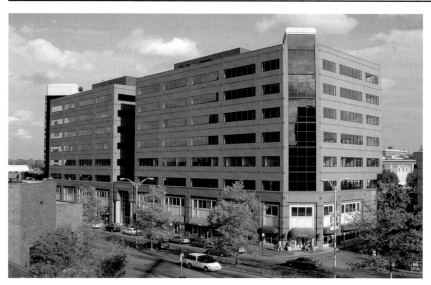

95. Albany Street Plaza with second tower completed

Courtesy of Boraie Development.

96. Golden Triangle

Photograph by Larry Levanti. Courtesy of Larry Levanti.

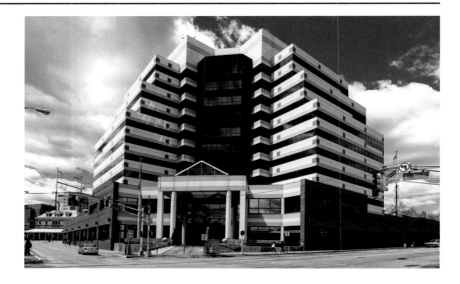

came largely from the menu of federal economic, housing, and community development assistance programs of the postwar period.

To encourage development, many federally aided urban revitalization projects were permitted to remit a payment in lieu of taxes (PILOT) instead of conventional property taxes. This policy started with the national public housing program of the 1930s and was broadened with sister programs in the decades that followed. The PILOT effectively provided an additional subsidy because the annual payment typically was lower than the standard property tax obligation. States, in turn, built on this strategy. New Jersey, for example, allows PILOTs for up to thirty-five years in areas designated as "in need of redevelopment." In New Brunswick, just about all of the buildings that constitute the new downtown, from the J&J corporate headquarters to the Hope VI housing, remit a PILOT instead of conventional property taxes. As elsewhere in New Jersey, PILOTs offer a number of benefits to New Brunswick's revitalization projects:

1. The annual PILOTs are often 10 to 20 percent less than the standard property taxes. This added subsidy is especially critical in the first few years of project operation, before a building is fully rented and reaches a more robust and stabilized financial condition.

2. Although the PILOT amount is typically less than conventional property taxes, much more of the payment remains in New Brunswick's municipal coffers. Of total conventional property taxes in New Brunswick, Middlesex County typically receives about 20 percent, the local school district about 40 percent, and the municipal government about 40 percent. In contrast, about 95 percent of an annual PILOT goes to the New Brunswick municipal government (the county receives 5 percent). Local taxpayers benefit because more of the PILOT stays as a local source of public revenue.

3. A PILOT may not reduce state aid or not reduce aid as much as it would
 with the property tax.[2] In New Jersey, state aid to local governments is
 often granted inversely to local wealth, where the latter is usually
 measured by the amount of property tax wealth per resident or public
 school child; the same is true in many other states. If the many buildings
 that are part of New Brunswick's downtown revitalization had gone on
 the property tax roll instead of remitting PILOTs, the city's property tax
 base per capita and per pupil would have increased significantly; higher
 local wealth would then mean reduced aid from the state, especially
 school aid (the state currently pays for about 80 percent of New
 Brunswick's school expenditures). New Brunswick would be forced to
 make up this shortfall, thus diminishing the resources available for
 revitalization. The PILOT program enabled the city to capture the annual
 payments in lieu of taxes while benefiting from considerable state aid.

New Brunswick's mayor from 1979 to 1991, John Lynch Jr., recognized the
benefits of the PILOT program at its inception and aggressively pursued this
strategy. In time, other New Jersey urban areas did as well; Jersey City, for exam-
ple, used PILOTs to revitalize its Hudson River waterfront "gold coast." Atlantic
City, on the other hand, failed to employ PILOTs for casino development, a choice
that hurt the community's efforts to revitalize.

New Brunswick's policy of authorizing PILOTs to aid revitalization is paral-
leled elsewhere throughout the United States for public housing projects and
most other subsidized housing, as well as more broadly for community and eco-
nomic development projects. Other revitalization strategies related to property
taxes include tax increment financing (TIF), an important redevelopment
resource in California, Illinois, and many other states. TIFs originated in Califor-
nia in 1952 as a way to provide local matching funds for urban redevelopment.
The property tax revenues in an area of a city at the time it is designated as a TIF
district become a "frozen" base for a certain number of years; incremental
increases collected above the base, generated by ongoing improvements, can be
used to fund more public improvements in the district. In time, California TIFs
generated $3 billion in annual funds for development. In Chicago, TIF districts
generated $500 million annually, and the city's 160 TIF districts encompassed
about 30 percent of its land area and about 10 percent of its property tax base
(Peterson 2014). Although there has been growing criticism of TIFs and retrench-
ment in California, Chicago, and elsewhere, TIFs are still widely used. Thus the
multiplicity of PILOTs in New Brunswick is matched by the thousands of PILOTs,
TIFs, and other property tax incentive programs throughout the United States.

The national events that prompted the federal urban revitalization programs
described in chapter 3 also broadly influenced New Brunswick's redevelopment.
J&J's decision to stay in the city in the 1970s is inextricably linked to themes of the
War on Poverty and to renewed attention to America's deteriorating urban areas.
The public-private partnerships (PPPs) developed in New Brunswick were part of

a wider application of that strategy. The plan New Brunswick followed to improve its fortunes was developed by the American City Corporation (ACC), a consulting entity linked to developer James Rouse, who had an outsized influence on American thinking about cities, housing, and renewal.

Yet, although there are many thematic interplays between the national scene and New Brunswick in the quest to revitalize challenged urban cores, what transpired in New Brunswick did not always follow national trends. Especially in the treatment of its historic building stock, New Brunswick fell far short of preservation efforts elsewhere. Looking back, preservation sentiment, until almost the mid-twentieth century, was alien to an American society with a reverence for all things new.[3] There were but a handful of exceptions. In 1816, the city of Philadelphia purchased Independence Hall, which had been slated for demolition, and Mount Vernon was saved by a private women's group in the 1860s (Hosmer 1965). Private philanthropy from the Rockefeller family helped to reconstruct colonial-era Williamsburg, Virginia, in the mid-1920s (Greiff 1971). In the Depression, the federal government's job creation programs included some archival and preservation actions, such as the Historic American Buildings Survey and restoration work at Yorktown and other battlefields (Murtagh 1988, 56). And from the 1930s to the 1950s, a handful of communities, most notably New Orleans and Charleston, South Carolina, established local preservation commissions to identify and protect selected historic districts (Listokin 1985, 32.).

More typical was the destruction of even acknowledged landmarks. Pennsylvania Station in New York City is a prime example; this masterpiece of Beaux-Arts architecture was demolished in 1963 and replaced by a lackluster skyscraper and new incarnation of Madison Square Garden (Whitehill 1966). In fact, federal programs, ranging from urban redevelopment/urban renewal to the Interstate Highway System, accelerated the demolition of the country's historic legacy (Jacobs 1961). Seattle's Pioneer Square, Boston's Quincy Market, and New York's SoHo were almost lost to urban redevelopment (Gratz 1994, xxvii); many equally prominent areas were not saved.

Partly in reaction to the widespread loss and to growing concern for the natural and built environment, a preservation system developed by the 1960s. At the federal level, the National Historic Preservation Act (NHPA) of 1966 created a National Register of Historic Places (administered by the National Park Service) and a review process (Section 106 of the NHPA) to evaluate federal undertakings that threaten resources listed on the National Register. Other legislation complementing the NHPA included the 1969 National Environmental Policy Act (NEPA), which requires impact assessments of major federal actions affecting the environment, including historic resources.

Parallel actions commenced at the state and local levels during this period. Federal funds from NHPA helped to establish state historic preservation offices (SHPOs), which were charged with identifying candidates for the national and state registers. Many states further enacted "mini 106" and "mini NEPA" procedures to evaluate government actions threatening properties on state or local registers.

Of great significance was the establishment of local preservation commissions (LPCs) to conduct surveys to identify historic resources and then designate them as landmarks (Cassity 1996). Once a resource is designated, there are varying consequences, depending on whether the LPC has "weak" or "strong" oversight. In a "weak" situation, the LPC can merely advise against actions that threaten a designated landmark or can delay only for some weeks or months demolition or other harm, such as inappropriate alteration. In a "strong" situation, the historic property cannot be demolished and its façades cannot be altered in a fashion not historically appropriate without the approval of the LPC (Cox 1997; Duerksen 1983; Listokin 1985). Whereas federal and state regulations typically focus on governmental actions that might threaten historic resources and are not directed at private actions by the owners of these resources, LPCs with "strong" oversight can regulate private actions (Fowler 1976; Listokin 1985). In response to the loss of Pennsylvania Station, for example, New York City enacted a local preservation ordinance in 1965 that gave its LPC "strong" regulatory oversight. Once a property is designated by the New York City LPC, with rare exceptions it cannot be demolished, and changes to a landmark's façade are allowed only if compatible with the existing historic fabric. As of 2014, the New York City LPC oversight had been extended to about 1,300 individual landmarks and about 30,000 properties in more than a hundred historic districts (New York City Landmarks Preservation Commission 2014).

Many other American cities have opted as well for "strong" LPC oversight, though usually not on the scale of New York City. In New Jersey, in 1971, Haddonfield was the first municipality in the state to designate historic properties, and the state legislature subsequently amended its municipal land use law to allow all local governments to identify, evaluate, designate, and regulate historic resources (C. Scott 1996, 3). About 100 local governments in New Jersey out of a total of 565 municipalities have opted for "strong" preservation oversight.

In New Brunswick, preservation sentiment and regulatory oversight have been much fainter. The city offers some outstanding examples of historic preservation and adaptive reuse, including a few historic bank buildings now used for retail and restaurants, three Hiram district buildings that are popular restaurants, and the Providence Square and Livingston Manor projects described in chapter 5. But these are the exceptions to the city's more prevalent emphasis on demolition and new construction. Eligibility and designation of Hiram Square for national and state registers, and ensuing federal and state 106 review, did not stop the wrecking ball in this neighborhood. Moreover, removal of historic district status, such as occurred in Hiram Square, is a rare action on the American preservation scene. And although support for preservation and regulatory oversight has grown stronger nationally, New Brunswick's officials have not embraced that trend. Morris Kafka, a member of the city's Historic Board, which was created in 2004, complains that "we're denied any resources, and we're minimized and sort of ignored in the official proceedings. . . . Nothing of substance happens" (Kafka interview, 22–23).

In conclusion, there are many interconnections between national trends and New Brunswick revitalization themes and programs. At times, what happened in the Hub City mirrored national policies (urban redevelopment clearance of challenged public housing); in other instances, especially with regard to historic preservation, the New Brunswick record differs from the postwar national urban revitalization effort. What does New Brunswick's revitalization mean for its citizens? More broadly, how has the city changed over the postwar period? To answer these queries, we must consider both quantitative and qualitative information on New Brunswick's condition over time.

Census and Other Quantitative Profiles of New Brunswick

Quantitative data from the decennial census and other sources allow us to assess how New Brunswick has changed over time. Planners often consider such critical metrics as poverty, crime, construction pace, and property taxes. These metrics, which will be examined in detail, indicate that New Brunswick has improved markedly over its revitalization period in both absolute and relative terms. Lingering challenges remain, however, including the fact that the city's rising tide has not yet lifted all its residents' boats.

Poverty rate is an important measure of community well-being. The incidence of poverty in New Brunswick over the period 1980–2010 (the decennial census span corresponding to the city's major revitalization effort) is placed in context by considering the changing poverty rate in the six largest cities in New Jersey: Camden, Elizabeth, Jersey City, Newark, Paterson, and Trenton. The Big Six communities, as they are often referred to, have long been regarded as prime indicators of the urban condition in New Jersey. Further context is provided by considering the poverty trend line in both Middlesex County (including New Brunswick and twenty-seven other municipalities) and the entire state of New Jersey.

From 1980 through 2010, New Brunswick's poverty rate (that is, its share of persons whose income is below the federally designated poverty threshold) rose by about one-tenth, from 23.5 percent (1980) to 25.8 percent (2010). The median

Table 6.1 Percentage of Persons Below Poverty

LOCALITY	1980 (%)	2010 (%)	CHANGE (%)
New Brunswick	23.5	25.8	+9.8
Big Six Cities (median)	23.2	24.8	+6.7
Middlesex County (average)	6.3	7.4	+17.5
New Jersey (average)	9.5	9.1	−4.2

SOURCE: U.S. Department of Commerce, Bureau of the Census 1980 Decennial Census; American Fact Finder, "Poverty Status in the Last 12 Months," 2006–2010. American Community Survey, 5-Year Estimates.

NOTE: The median is "the middle number in a series of items in which 50 percent of all figures are above the median and 50 percent are below" (Harvey Moskowitz, Carl Lindbloom, David Listokin, Richard Preiss, Dwight Merriam, *The Complete Illustrated Book of Development Definitions* [New Brunswick, NJ: Transaction Publishers 2015, 314]). The average is "a number calculated by adding quantities together and then dividing the total by the number of quantities" (http://www.meriam-webster.com/dictionary/average).

Table 6.2 Percentage of Persons Below Poverty by Racial/Ethnic Group

	BLACK			HISPANIC			WHITE		
LOCALITY	1980	2010	% Change	1980	2010	% Change	1980	2010	% Change
New Brunswick	32.1	27.7	−13.7	26.5	20.8	−21.5	17.4	25.6	+47.1
New Jersey Big Six (urban) median	32.1	25.8	−19.8	34.9	24.9	−28.7	16.0	19.4	+21.3
Middlesex County average	19.3	12.4	−35.8	21.1	15.7	−25.6	5.0	7.0	+40.0
New Jersey overall average	26.0	17.8	−31.5	26.5	17.6	−33.6	6.4	6.6	+3.1

SOURCES: U.S. Department of Commerce, Bureau of the Census 1980 Decennial Census; American Fact Finder, "Poverty Status in the Last 12 Months," 2006–2010; American Community Survey, 5-Year Estimates.

poverty rate in the New Jersey urban Big Six also rose slightly over this period, from 23.2 percent to 24.8 percent (see table 6.1). About one in four persons in New Brunswick faced impoverishment in 2010, a far higher rate than in Middlesex County (7.4 percent) and statewide (9.1 percent).

Looking at the racial and ethnic incidence of poverty in New Brunswick (table 6.2), Hispanics have experienced the biggest decline in impoverishment, about one-fifth, from a 26.5 percent poverty rate in 1980 to 20.8 percent in 2010. Whites experienced a near one-half increase in poverty (from 17.4 percent to 25.6 percent). In contrast, the rate of poverty of New Brunswick's blacks declined by about one-eighth: 32.1 percent in 1980 and 27.7 percent in 2010. Elsewhere in New Jersey, such as in the Big Six cities and Middlesex County, the change in poverty over the period 1980–2010 was also mixed for whites, Hispanics, and blacks (table 6.2). On the plus side, the city's largest minority group, Hispanics, reduced their rate of poverty by about one-fifth. Yet, New Brunswick's black community saw a lesser reduction in poverty over the three decades of major revitalization.

That mixed situation is repeated when the trend line regarding crime rate is examined. As mentioned in chapter 4, New Brunswick was viewed as dangerous in the late 1970s and early 1980s. Mayor John Lynch Jr. observed that "crime was rampant" (Lynch interview, 5), and Rutgers students "were warned not to come into downtown" (Vega interview, 7). Indeed, New Brunswick was beset in 1980 with 110.2 crimes per 1,000 population (all-crime rate); its 1980 violent crime rate was 11.8 per 1,000 population (see table 6.3). (Further references to crime rates will not repeat the "per 1,000 population" base.) New Brunswick's all-crime rate in 1980 was almost identical to the all-crime incidence in the Big Six cities (108.6), though New Brunswick's violent crime rate in that year was markedly lower than that in the Big Six (17.9). More broadly, New Brunswick's all-crime level in 1980 was about double that of Middlesex County (53.2), and its violent

Table 6.3 Crime Rates per 1,000 People (All Crime/Violent Crime)

LOCALITY	1980		2010		1980–2010 % CHANGE	
	All crime	Violent crime	All crime	Violent crime	All crime	Violent crime
New Brunswick	110.2	11.8	31.4	6.5	−71.5	−44.9
New Jersey Big Six (urban) median	108.6	17.9	43.7	10.9	−59.8	−38.9
Middlesex County average	53.2	3.4	19.1	1.8	−64.1	−47.1
New Jersey overall average	64.0	6.0	23.9	3.1	−62.7	−48.3

SOURCE: U.S. Department of Justice, Federal Bureau of Investigation, Uniform Crime Reporting Statistics, Crime in New Jersey for indicated years (https://www.fbi.gov/about-us/cjis/ucr/crime-in-the-u.s.).

crime rate was more than three times higher. By 2010, New Brunswick's all-crime rate had fallen by about seven-tenths (to 31.4), while its violent crime rate fell by more than 40 percent (to 6.5). Crime fell dramatically in New Jersey's Big Six cities as well, though not as steeply as in New Brunswick. More broadly, crime declined in Middlesex County, statewide, and nationally. Still, New Brunswick's 2010 all-crime rate (31.4) is about two-thirds higher than the incidence in Middlesex County (19.1), and its 2010 violent crime rate (6.5) is almost four times higher than the county's (1.8).

Another measure of a community's well-being is the local tax burden. One of the many ways that burden can be measured is through the local property tax rate. Total local government spending, less all non-property sources of revenue, leaves the amount to be raised from the property tax (or the property tax levy). For example, if a local government budgets $5 million in expenses and receives $1 million in intergovernmental revenue (such as state or federal assistance), $1 million in non-property taxes (sales or income tax), and $1 million in charges and miscellaneous income (tennis court fees, parking ticket fines, and so on), then it would have to raise $2 million from the property tax levy. If the community had a total property tax base with a market value of $100 million, then its property tax rate would be $2 per $100 of market valuation, or 0.0200, or 2 percent. It is most meaningful to express that percentage as a share of a property's market value, and in that case the property tax rate is termed as the equalized property tax rate, or EPTR. In the above example, with an EPTR of 2 percent, a house with a market value of $100,000 would be obligated to pay $2,000 yearly in property taxes.

That background provides the context for examining the property tax situation in New Jersey, New Brunswick, and elsewhere (table 6.4). New Jersey relies on the property tax more than almost any other state. On average nationally, the local property tax in 2008 provided 28 percent of all local (city, town, township,

Table 6.4 Equalized Property Tax Rate, 1980–2010

LOCALITY	% 1980	% 2010	% CHANGE
New Brunswick	3.55	1.90	−46.5
New Jersey Big Six (urban) median	4.90	2.21	−54.9
Middlesex county average	2.40	1.93	−19.6
New Jersey overall average	2.74	1.87	−31.8

SOURCES: New Jersey Department of Community Affairs, Abstract of Ratables for indicated years; New Jersey Department of Community Affairs Forty-third Annual Report of the Division of Local Government Services (1980) Statements of Financial Condition of Counties and Municipalities, Trenton.

school, district, municipality, borough, and county) general revenues; in New Jersey, the 2008 property tax accounted for 54 percent of total local general income. New Jersey also has the dubious distinction of having one of the highest EPTRs of all fifty states. While the average 2005 EPTR in the United States was 1.07 percent, the average EPTR in New Jersey in that year was 1.73 percent, third highest in the nation (Listokin 2007). The 2005 average annual property tax obligation per housing unit in New Jersey was $6,033—the highest in the nation and far exceeding the national average of $2,325 (ibid.). Between 2006 and 2010, New Jersey had the highest annual average property taxes per capita of all fifty states (Tax Foundation).

In 1980, New Brunswick had an EPTR of 3.55 percent, higher than the average EPTR in Middlesex County (2.40 percent) and the state overall (2.74 percent), yet much lower than the 1980 median EPTR of 4.90 percent in the Big Six cities (table 6.4). Over the next three decades, the EPTR in all these places declined for various reasons, such as increased intergovernmental aid, especially state support to schools, and rapidly appreciating real estate. For instance, the average EPTR in Middlesex County was 1.93 percent in 2010, a drop of about 20 percent from 1980, and the average statewide EPTR declined by about 30 percent to 1.87 percent. New Brunswick fared even better: its 1980 EPTR of 3.55 percent was nearly halved to 1.90 percent by 2010. Further, whereas New Brunswick's EPTR in 1980 was appreciably higher than the average EPTR in Middlesex County and the state, by 2010 New Brunswick's EPTR was essentially at the same level of the county and state.

The EPTRs in the Big Six cities fell dramatically as well over the three decades, from a median of 4.90 percent in 1980 to a median 2.21 percent in 2010. This decline of 55 percent, sharpest of all the places examined here, was largely due to increasing state school aid to all six cities as a result of New Jersey Supreme Court decisions between 1985 and 1997 that mandated more state school assistance to impoverished communities. Yet while the EPTR was lessened dramatically in the Big Six, New Brunswick's EPTR in 2010 was even lower.

How did New Brunswick realize a lower EPTR than the Big Six and reach parity with respect to Middlesex County and the state overall—a most unusual

achievement in New Jersey, where urban places traditionally have borne a far higher relative property tax burden? The answers are complicated, and the analysis here touches on just some of the influences. First of all, New Brunswick has lower public expenditures relative to the Big Six. According to the 2013 Legislative District Data Book compiled by the Rutgers University Center for Government Services, the New Brunswick municipal budget per capita was $1,328—much lower than the median $2,028 municipal spending per person in the Big Six. At the same time, the New Brunswick school budget per pupil ($17,778) was fractionally lower than the median outlay per student in the Big Six ($18,032). But New Brunswick actually receives a lower percentage of state school aid (82 percent) than the average among the Big Six (approximately 90 percent), which would tend to put upward pressure on the property tax levy.

A second important factor, new development, has two beneficial effects with respect to New Brunswick's advantageous EPTR: most of the new buildings in the city's downtown remit PILOTs rather than conventional property taxes. Through this program, the value of these properties is not added to the city's property tax base, keeping it lower for all residents. Moreover, the city keeps almost all of the PILOT, reducing the amount of revenues it needs to raise from the property tax levy.

Given that development can beneficially affect the EPTR, how can development be measured? One way is to track construction activity, such as housing units or office space square footage authorized by building permits. This information is presented in table 6.5 for the period 2000–2013 for New Brunswick, the Big Six cities, and New Jersey statewide. One way to compare rates of production is to express them on the basis of per 1,000 population. This "normalizing" to a standard rate shows that the number of the housing units authorized by building permits per 1,000 population was 40.2 in New Brunswick, 48.1 on average in the Big Six, and 41.6 statewide. Thus, New Brunswick mirrored the state housing activity and fell somewhat below construction in the Big Six. (The robust Big Six housing activity was driven predominantly by Jersey City—sometimes referred to as the "sixth borough" of New York City—where 21,237 housing units were authorized from 2000 to 2013.)

If New Brunswick fell somewhat short of the Big Six in housing activity, it realized outstanding nonresidential construction gains over the period. From 2000 through 2013 the square footage of office space authorized by building permits was about 2.0 million (1,999,791) in New Brunswick, about 11.8 million total in the Big Six (with Jersey City accounting for 6.5 million of this 11.8 million), and approximately 133.5 million statewide. When measured by square footage per 1,000 population, New Brunswick has clearly been a winner in generating significant office development (table 6.5).

What is feeding the demand for office space in New Brunswick? One important contribution is job creation in both the private and the public sectors. In 2013, there were 43,147 persons working in the city of New Brunswick (17,608 in the public sector and 25,539 in the private sector). In the Big Six cities, a total

Table 6.5 Construction Authorized by Building Permits, 2000–2013

LOCALITY	ALL HOUSING UNITS		SQUARE FEET OF OFFICE SPACE		SQUARE FEET OF RETAIL SPACE		SQUARE FEET OF OTHER NONRESIDENTIAL SPACE*	
	Total	Per 1,000 population	Total	Per 1,000 population	Total	Per 1,000 population	Total	Per 1,000 population
New Brunswick	2,221	40.2	1,999,791	36,240.6	121,497	2,201.8	8,886,335	161,039.8
Big Six	46,069	48.1	11,784,433	12,299.0	2,343,706	2,446.0	59,197,484	61,782.3
New Jersey	365,760	41.6	133,466,249	15,180.6	64,402,780	7,325.2	543,309,753	61,796.7

SOURCES: New Jersey Department of Community Affairs [NJDCA], *Building Permits: Yearly Summary Data, Housing Units Authorized by Building Permits, 2000–2013* (http://www.nj.gov/dca/divisions/codes/reporter/building_permits.html#1); NJDCA, *Building Permits: Yearly Summary Data, Square Feet of Office Space Authorized by Building Permits, 2000–2013* (http://www.nj.gov/dca/divisions/codes/reporter/building_permits.html#3); NJDCA, *Building Permits: Yearly Summary Data, Square Feet of Retail Space Authorized by Building Permits, 2000–2013* (http://www.nj.gov/dca/divisions/codes/reporter/building_permits.html#4); NJDCA, *Building Permits: Yearly Summary Data, Square Feet of Other Nonresidential Space Authorized by Building Permits, 2000–2013* (http://www.nj.gov/dca/divisions/codes/reporter/building_permits.html#5).

* This aggregate category created by the NJDCA includes many subcomponents: hotel/motel, storage, industrial, assembly ("gathering of persons for purposes such as civic, social or religious functions; recreation, food or drink consumption, or awaiting transportation"), education, multifamily/dormitory, and hazardous (manufacturing or storage) buildings. An additional "other nonresidential" subcomponent tabulated by NJDCA—"signs, fences, utilities, and miscellaneous"—is not represented in the figures given here.

of 433,598 persons were working: 136,437 in the public sector (49,485 of them in Trenton) and 297,161 in the private sector (88,496 of them in Jersey City). Expressed on a normalized basis, New Brunswick had 782 persons working within its municipal borders for every 1,000 residents, far higher than the average 453 workers per 1,000 residents for New Jersey's six largest cities. Not all of these workers require office space, but many do, and that need has contributed to New Brunswick's active pace of such development. This discussion admittedly oversimplifies a more complex public finance and economic reality, yet affords a glimpse of the underlying dynamic. Office construction added significantly to New Brunswick's fiscal base (office space has a property value of $150 to $250 per square foot) and contributed to the relatively advantageous EPTR discussed earlier.

With respect to retail space in the period 2000–2013, New Brunswick somewhat underperformed relative to the Big Six cities, which in turn vastly underperformed relative to the state. However, with respect to "other nonresidential" space (for example, hotels and education), New Brunswick has realized stellar performance from 2000 to 2013. On a per 1,000 population basis, New Brunswick's activity here far surpassed that of the Big Six and the state as a whole (table 6.5).

Not surprisingly, given the statistics on housing, office, retail, and nonresidential space authorized by building permits, New Brunswick realized a considerable dollar value from construction over the period 2000–2013 (see table 6.6). Expressed

Table 6.6 Estimated Cost of Construction Authorized by Building Permits, 2000–2013

LOCALITY	ALL CONSTRUCTION		NONRESIDENTIAL CONSTRUCTION		RESIDENTIAL CONSTRUCTION	
	Total ($)	Per 1,000 population ($)	Total ($)	Per 1,000 population ($)	Total ($)	Per 1,000 population ($)
New Brunswick	1,181,469,389	21,410,801	911,230,741	16,513,487	270,238,648	4,897,313
Big Six	14,379,031,124	15,006,889	7,741,578,490	8,079,613	6,605,112,016	6,893,523
New Jersey	176,477,617,527	20,072,764	86,410,733,722	9,828,455	90,066,883,805	10,244,310

SOURCE: New Jersey Department of Community Affairs, Building Permits: Yearly Summary Data, Estimated Cost of Construction Authorized by Building Permits, 2000–2013, http://www.nj.gov/dca/divisions/codes/reporter/building_permits.html#6.

in dollars per 1,000 population, New Brunswick gained $21,410,801 from both residential and nonresidential construction, as against $15,006,889 for the Big Six, and $20,072,764 for the state. If the cost of nonresidential construction is examined alone, then New Brunswick's 2000–2013 accomplishment expressed per 1,000 residents ($16,513,487) far outpaced that of the Big Six ($8,079,613) and the state ($9,828,455). The cost of New Brunswick's 2000–2013 residential construction was considerable ($270 million), albeit the cost expressed per 1,000 residents in New Brunswick ($4,897,313) was considerably outpaced by this metric in both the Big Six ($6,893,523) and the state ($10,244,310). Because property ratables count so much when calculating the local property tax rate in New Jersey, it becomes evident that New Brunswick's relatively advantageous EPTR is due in part to the considerable development in the city, especially nonresidential activity.

But even though New Brunswick's EPTR of about 2 percent is much less than its property tax burden of the 1980s and hovers around both the county and the state average, other communities in the state have still lower EPTRs, and the national average EPTR is about one-half that in New Brunswick. Places that New Brunswick and, more broadly, New Jersey, compete against to attract new businesses and households or keep those already in the city and state (such as retirees) have lower EPTRs. In 2005, for example, the average EPTR in Florida and North Carolina was about 0.8 percent, Maryland had a 0.9 percent average, and in neighboring New York and Pennsylvania it was 1.6 percent (Listokin 2007). (Of course many factors besides the property tax rate influence a city or state's ability to retain its residents and businesses and to attract new households and firms.) Further, New Brunswick may confront upward pressure on its EPTR because of future changes out of its control, such as reduced school aid.

Thus far, the quantitative analysis of New Brunswick's changing fortunes in the context of the state's Big Six cities and elsewhere has considered individual-by-individual metrics of poverty, crime, property tax rate, and so on. What about an aggregate index of well-being or, even more ideally, an aggregate municipal revitalization index (MRI)? In fact, the New Jersey Sustainable State Institute (NJSSI) compiled such statistics for all 566 municipalities in New Jersey in 1996

and 2007 (New Jersey Sustainable State Institute 2008). In brief, the NJSSI's MRI considers and aggregates eight data sets, including population change, per capita income, per capita equalized property value, EPTR, Aid to Families with Dependent Children per 1,000 population, unemployment rate, and age and condition of the housing stock. The municipalities were then ranked from 1 to 566, with higher numbers indicating greater aggregate socioeconomic and housing distress and a lower degree of "revitalization." When the MRI was developed, there were 566 municipalities in New Jersey; today there are 565. In both 1996 and 2007 Camden had an MRI of 566, giving it the dubious distinction of being the "most challenged" and "least revitalized" municipality, one where no improvement in conditions had occurred.

In 1996, the Big Six cities had a median MRI of 558, reflecting the considerable challenges they faced. In the same year, New Brunswick's MRI was 546. A decade later, the median MRI for the Big Six was 555, indicating minimal revitalization. New Brunswick's MRI, in contrast, fell markedly, from 546 in 1996 to 489 in 2007. Here again, however, there is both good news and bad news. New Brunswick's MRI score of 489 still meant that almost 500 communities in New Jersey were in better shape in terms of the eight data metrics. Especially telling is the median MRI score of 227 for all Middlesex County municipalities in 1996 and a median of 263 in 2007.

In summary, our quantitative analysis of New Brunswick over time points to many positive accomplishments on both an absolute and a relative basis. From 1980 through 2010, the city's all-crime rate has declined by about seven-tenths, and its violent crime rate has diminished by about four-tenths; New Brunswick's EPTR has been nearly halved; and few cities in New Jersey have realized its pace and value of nonresidential construction or have attracted such a large concentration of jobs relative to its population. New Brunswick's MRI has also markedly improved from 1996 to 2007, indicating better housing/socioeconomic conditions, whereas the MRI of the Big Six cities has essentially been stuck in place.

At the same time, however, the metrics point to continuing challenges. About one in four residents of New Brunswick lived under the poverty threshold in 2010; the city's total poverty rate far exceeds the average incidence in Middlesex County and statewide; and, at 28 percent, the 2010 poverty rate for blacks in New Brunswick has only marginally improved since 1980. Although the pace of construction in the city remains at a high level, the building of housing units has been less vigorous; in the area of nonresidential construction, retail has lagged behind office development. New Brunswick's relatively low EPTR for a New Jersey city also will be a challenge to maintain, and there are competing jurisdictions with lower property tax rates elsewhere in the state and especially out of state. Finally, New Brunswick's socioeconomic and housing conditions, as reflected in its MRI scores, have improved but cannot match those in many other communities, including sister municipalities in Middlesex County. But quantitative metrics can go only so far in characterizing the vibrancy and/or limitations of a city. Next, we will consider what the people of New Brunswick think.

Residents' Perception of New Brunswick

In the late 1970s, New Brunswick Tomorrow (NBT) commissioned the Center for Public Interest Polling at Rutgers University's Eagleton Institute of Politics to conduct a survey of city residents on conditions and changes in New Brunswick (hereafter NBT/Eagleton). Between 1978 and 2008, NBT/Eagleton contacted 1,000 residents via telephone every two years. As with all surveys, there have been hurdles, such as reaching all segments of the city population, especially often underrepresented minorities. Moreover, the survey did not contact the same residents over time; rather, it included newcomers as well as long-term residents. Despite its limitations, however, the NBT/Eagleton biennial survey offers a unique compilation of residents' changing perceptions over time. It is "believed to be the longest-running public opinion study of a community" in the United States (Rutgers University, Eagleton Institute 2000, i).

The Eagleton questionnaire is quite detailed. Although some of the survey questions have changed over time, there is a common core of queries. Presented here are some illustrative key fields of data, starting with residents' evaluation of "New Brunswick" and "your neighborhood" as places to live.[4]

"HOW WOULD YOU RATE NEW BRUNSWICK AS A PLACE TO LIVE?" ("EXCELLENT," "GOOD," "ONLY FAIR," OR "POOR")

In 1978, when NBT/Eagleton first started tracking opinions of New Brunswick as a place to live, only 32 percent of all residents interviewed rated it "excellent" or "good," markedly lower than the 62 percent positive rating thirty years later (see figure 6.1). Overall satisfaction remained low between 1978 and 1982; in that period net positive ("excellent" or "good") ratings ranged from 32 percent to 41 percent. More than 50 percent of residents were net positive about New Brunswick for the first time in 1984. This steep increase to 54 percent was perhaps due to a number of factors related to infrastructure, including the completion in the early 1980s of several important initial revitalization construction projects, such as the Johnson & Johnson headquarters, the Hyatt Regency, Ferren Mall, and improvements to Route 18, George Street, and Albany Street. The elevated positive rating lasted until 1992, when overall satisfaction fell to 48 percent. The decline may have been tied to the national recession of the early 1990s. This depressed rate lasted until 1998, when overall satisfaction increased to 58 percent. The uptick started a decade-long period of relatively higher net positive satisfaction, ranging from 58 percent to 65 percent. The increase was perhaps due to the completion of another round of construction projects, including Civic Squares II and III, Liberty Plaza, Riverwatch, Hope VI, the New Jersey Cancer Institute, the Heldrich building, the Vue, Skyline Tower, the Child Health Institute, Lord Stirling Community School, Rockoff Hall, the Rutgers Public Safety Building, and the Middlesex County Family Courthouse, among others.

In sum, from 1978 to 2008, New Brunswick residents' positive opinions about their city as a place to live rose by 30 percentage points (from 32 percent to about 62 percent). To give perspective to this markedly improved attitude, during the

Fig 6.1 **Survey of New Brunswick Residents:**
How Would You Rate New Brunswick as a Place to Live?

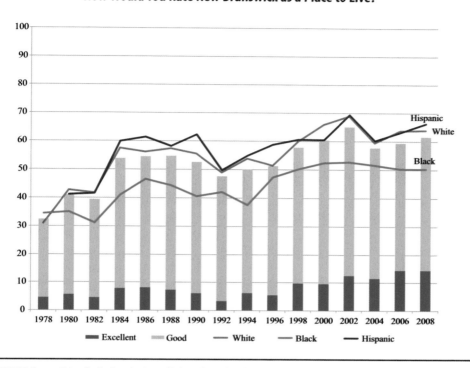

SOURCES: Rutgers University, Eagleton Institute of Politics, Center for Public Interest Polling, Survey of New Brunswick Residents, conducted for New Brunswick Tomorrow for indicated years; charts created by Marc Weiner and Orin Puniello, Edward J. Bloustein School of Planning and Public Policy.

NOTE: Hispanic ethnicity was not tracked in this survey prior to 1980.

roughly comparable period 1977–2007 New Jerseyans' positive opinion about their state as a place to live rose by a much lower 7 percent (from 62 percent to 69 percent). (Rutgers University, Eagleton Institute of Politics, 1985; Zukin, Thonhauser, and Applebaum 2007).

In terms of race and ethnicity, however, satisfaction in the black (African American) community with New Brunswick as a place to live consistently falls below ratings by white and Hispanic residents, which have generally moved in concert with each other over the years. From 1978 to 2008, on average, satisfaction with New Brunswick was more than 10 percent lower among blacks than among white and Hispanic residents. For example, in 2008, about half the black residents surveyed rated New Brunswick positively as a place to live compared with about 65 percent of both whites and Hispanics. While it is hard to pinpoint reasons for the difference in perception, the relatively greater socioeconomic stress experienced by members of New Brunswick's black community and their declining population may underlie their less positive view of their hometown. But as noted earlier, satisfaction with New Brunswick as a place to live has increased among all groups—blacks, whites, and Hispanics—since the early to mid-1990s.

"HOW WOULD YOU RATE YOUR NEIGHBORHOOD AS A PLACE TO LIVE?" ("EXCELLENT," "GOOD," "ONLY FAIR," OR "POOR")

Unlike the rating of New Brunswick overall as a place to live, satisfaction with residents' own neighborhoods has not gone through any noticeable upward or downward intervals (see figure 6.2). In 1978, when NBT/Eagleton started to track this issue, 68 percent of residents rated their neighborhoods "excellent" or "good"; as of 2008, 65 percent held the same opinion. Indeed, it appears that no matter what was happening in the wider city or at the state and national levels, New Brunswick residents generally like their immediate surroundings.

Race and ethnicity do factor in the rating of neighborhoods. Whites consistently report higher levels of satisfaction than Hispanics and blacks, and Hispanics consistently rate their neighborhoods higher than blacks. Among whites, the mean satisfaction ("excellent" or "good") level from 1978 to 2008 was 71 percent; among Hispanics, 62 percent; and among blacks, 53 percent. Blacks may have the least positive opinion of their neighborhoods because they endure the highest poverty rate of all racial and ethnic groups in New Brunswick.

**Fig 6.2 Survey of New Brunswick Residents:
How Would You Rate Your Neighborhood as a Place to Live?**

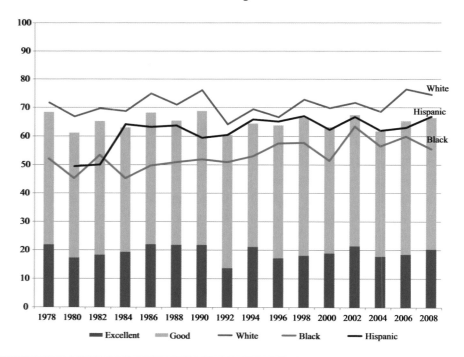

SOURCES: Rutgers University, Eagleton Institute of Politics, Center for Public Interest Polling, Survey of New Brunswick Residents, conducted for New Brunswick Tomorrow for indicated years; charts created by Marc Weiner and Orin Puniello, Edward J. Bloustein School of Planning and Public Policy.

NOTE: Hispanic ethnicity was not tracked in this survey prior to 1980.

"WHAT WILL NEW BRUNSWICK BE LIKE IN FIVE YEARS?"
("MUCH BETTER," "SOMEWHAT BETTER," "SAME," OR "WORSE")

How do New Brunswick residents perceive the future of their city? Since 1980, NBT/Eagleton has asked respondents whether New Brunswick will be better or worse in five years. At each two-year interval, more than 50 percent of respondents have indicated that New Brunswick will be net "much" or "somewhat" better in the near future (see figure 6.3). However, a general trend line emerges from the data. In 1980, 80 percent of respondents indicated that New Brunswick would be much or somewhat better in five years. This rating stayed stable until 1988, when it started to decline (74 percent); after hitting bottom in 1992—coinciding with the 1989–92 recession—at 58 percent, optimism started to rebound and plateaued in the 72–76 percent range from 2002 through 2008. Surprisingly, respondents' opinions seemed to be unaffected by the economic recession in the early 1980s. A decline in optimism in the early 1990s did coincide with another recession, but the recessions in the early 2000s and at the end of that decade had no effect on the outlook for New Brunswick's future.

Fig 6.3 **Survey of New Brunswick Residents:**
What Will New Brunswick Be Like in Five Years?

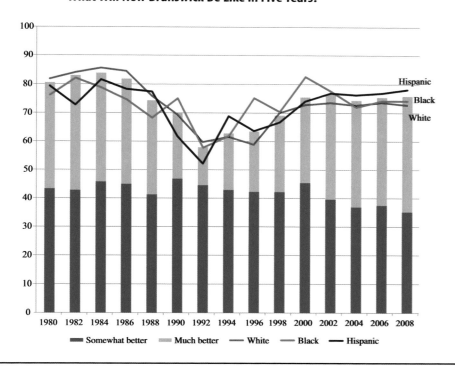

SOURCES: Rutgers University, Eagleton Institute of Politics, Center for Public Interest Polling, Survey of New Brunswick Residents, conducted for New Brunswick Tomorrow for indicated years; charts created by Marc Weiner and Orin Puniello, Edward J. Bloustein School of Planning and Public Policy.

The generally positive attitude may stem from a few factors. The first is the vast physical transformation of New Brunswick during the survey period. Construction of the new Johnson & Johnson corporate campus started in March 1979 and finished in December 1982. This project, along with the construction of the Hyatt Regency, was the start of a long process of downtown building and development for New Brunswick. Second, it may have been difficult for respondents to estimate trends five years into the future. If the question had asked for residents' outlook on the next six months or year, the trend lines might have been more sensitive to the booms and busts of the economy.

The trend lines for racial and ethnic groups matched the overall trend lines. White, black, and Hispanic respondents all have an optimistic perspective regarding New Brunswick's future.

"WILL REVITALIZATION/REDEVELOPMENT HELP OR HURT THE POOR?"

Public opinion on the effect of revitalization/redevelopment on the less advantaged members of the New Brunswick community has been highly variable over the years (see figure 6.4). In 1980, the first year such perception was measured, 57

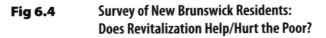

Fig 6.4 **Survey of New Brunswick Residents: Does Revitalization Help/Hurt the Poor?**

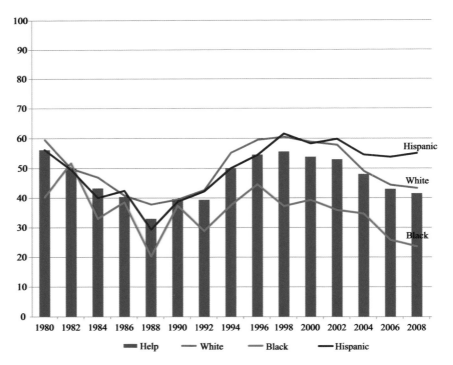

SOURCES: Rutgers University, Eagleton Institute of Politics, Center for Public Interest Polling, Survey of New Brunswick Residents, conducted for New Brunswick Tomorrow for indicated years; charts created by Marc Weiner and Orin Puniello, Edward J. Bloustein School of Planning and Public Policy.

percent of respondents thought that revitalization helped the poor, the high point in the time-series. By 1988, only 33 percent of respondents thought it helped the disadvantaged. Opinion of revitalization improved in the mid-1990s and very early 2000s; more than 50 percent of respondents thought it helped the poor. But opinion shifted again in the mid- to late 2000s (with a 42 percent helpful rating in 2008). During this last decline, respondents were less sure about the either/or impact of revitalization, and the percentage of respondents indicating that it was both helpful and harmful slowly increased (11 percent in 2008).

The trend lines for perceptions of revitalization by racial and ethnic categories generally matched the overall pattern until recent years. As of 2008, there appeared to be a wide gap in opinion about revitalization among white, black, and Hispanic respondents. Black respondents were significantly more likely to have a negative opinion; in 2008, 66 percent indicated that revitalization hurts the disadvantaged. In the same year, whites were on the fence: 44 percent of respondents thought it helped, and 43 percent thought it hurt. On the other hand, Hispanics were the most likely to think that revitalization helps the poor, with 56 percent indicating so in 2008. This perception may have been influenced by the fact that the Hispanic poverty incidence in New Brunswick had declined markedly over time, whereas the black poverty rate had diminished by a lesser margin from 1980 to 2010.

"QUALITY OF LIFE"

The NBT/Eagleton survey probed residents over the decades on a dozen or so "quality of life" characteristics in the city. In general, perspectives on housing, schools, crime, and culture improved over time. Whereas 60 percent of respondents in 1978 named housing issues as a top concern, by 2008, only 20 percent ranked that category highest, though blacks were more vexed than whites or Hispanics (Santos 2010, 6). Almost half of all surveyed residents in 2008 viewed New Brunswick schools as either "excellent" or "good," compared with only one-fifth of residents having this positive perspective in 1978 (ibid.). Blacks again were less sanguine concerning local school quality relative to whites and Hispanics. The NBT/Eagleton survey also revealed an enhanced perspective over time regarding public safety, shopping, and other quality-of-life issues.

Culture in the city is viewed in an especially positive light. The NBT/Eagleton survey defines the concept of culture very broadly to include such examples as "the arts," "theater," and "concerts." Since NBT/Eagleton began tracking the importance of culture to residents, it has had a net "very" and "somewhat" important rating hovering around 90 percent (see figure 6.5). Even the proportion of respondents rating culture as "very" important has remained stable and fairly high. In the first year of measurement, 1982, only 49 percent of respondents thought culture was very important; 1988 was the only other year when this number dipped below 50 percent. Starting in 1992, the very important rating went up to 63 percent, and it has stayed in the mid- to low 60s ever since. Moreover, all ethnic and racial groups—blacks, whites, and Hispanics—rate culture as very important for revitalizing New Brunswick, with net importance generally above 90 percent.

Fig 6.5 **Survey of New Brunswick Residents:**
Importance of Culture in Revitalizing New Brunswick

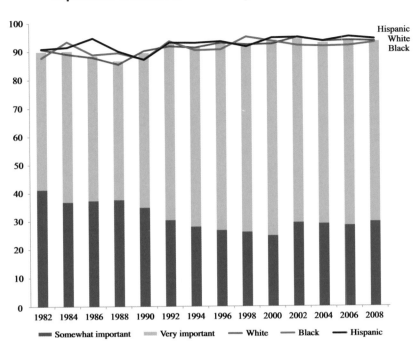

SOURCES: Rutgers University, Eagleton Institute of Politics, Center for Public Interest Polling, Survey of New Brunswick Residents, conducted for New Brunswick Tomorrow for indicated years; charts created by Marc Weiner and Orin Puniello, Edward J. Bloustein School of Planning and Public Policy.

NOTE: Hispanic ethnicity was not tracked in this survey prior to 1980.

In sum, the longitudinal NBT/Eagleton survey points to an improved New Brunswick over time in many significant aspects. It also indicates some lingering concerns and reflects as well as frequent differences in perception by racial/ethnic group, with blacks often less sanguine about the city's progress compared with whites and Hispanics. Echoes of the varying survey results are heard in the comments by city residents in a section of the report called "New Brunswick Voices" (Rutgers University, Eagleton Institute 2000).

"New Brunswick is built up and it's clean. There are more jobs now."
—Two-year resident, East area (of New Brunswick),
African American female, age seventy

"Some people have had to relocate outside of the city. The jobs created haven't always gone to them. They need more training so they can benefit."
—Lifelong resident, East area,
African American male, age fifty-seven

"The crime situation is not perfect, but it's gotten better in the last
four or five years"

—Lifelong resident, Easton Avenue area,
white female, age sixty-four

"It's good that new housing is going to be built for the people.
If people want to stay in New Brunswick, they should be able to."

—Lifelong resident, Central area,
Hispanic female, age twenty-nine

"Downtown is safer, nicer, cleaner. And there are more things to do."

—Lifelong resident, East area,
African American male, age thirty-five

"The drug problem has gone down and the police are more visible."

—Twenty-five-year resident, Jersey Avenue area,
African American female, age forty-eight

"The best thing about New Brunswick is the diversity. There are people
of different nationalities as well as college students so it's fun."

—Eight-year resident, Easton Avenue area,
white female, age fifty-four

New Brunswick's Revitalization Effort: A Success?

Is the multi-decade New Brunswick revitalization a success? The oral history interviews conducted by Dorothea Berkhout and David Listokin are a case of "Rashomon on the Raritan." In the famous 1950 movie *Rashomon*, the testimony of witnesses to a past event varies significantly, depending on the witnesses' interpretations of their own behavior and of the motives and actions of the others. These interviews are replete with both high praise of the city's efforts to revitalize and severe criticism, and there are many mixed evaluations that acknowledge both accomplishments and limitations. Examples of high praise include former mayor Patricia Sheehan's conclusion that she would give the redevelopment outcome a grade of "1,000 percent" (Sheehan interview, 30). While noting the limitations of New Brunswick's transformation, former Rutgers provost Kenneth Wheeler observed that "I don't know of another city that's had as great a success" (Wheeler interview, 18). Though a harsh critic of much of what transpired in New Brunswick, Professor Anton Nelessen of Rutgers acknowledged that, as "an experiment in corporate redevelopment and as that model goes, it's got to be considered as very successful" (Nelessen interview, 40). With the perspective of both service on DEVCO's board and long involvement in New Brunswick's neighborhoods, David Harris agreed that New Brunswick realized "an enormous accomplishment" from a "brick-and-mortar" perspective. But he stressed the importance of "peeling back that layer" to look closer at New Brunswick's people and neighborhoods, such as the Memorial Homes area: "you see the unfinished business," which "cost us in a moral sense" (Harris interview, 12 and 29).

Oral histories of New Brunswick residents from different sources paint a similar mixed picture of the city's redevelopment. Whereby one long-term city resident praised the redevelopment and Johnson & Johnson and Rutgers's role in it as a "godsend" ("because otherwise we would have been a ghost town . . . [and] we have to thank J&J and Rutgers for being the savior of New Brunswick") (Borbely 2009), another long-term resident decried "taking the whole side of a street down [for the Johnson & Johnson headquarters]" which "wiped out all the little stores that were down there." This second observer further opined that while the redevelopment changed the city "for the better economically," as well as the aesthetic appearance of the community, the economy "for people living in town has gone down" as has the availability of affordable housing; more generally, New Brunswick lost its "home town feeling" (Suber 2007).

Much of the urban revitalization in the United States has been planned from the top down, with different elites (professional, business, and institutional) having an outsized influence on decision making as opposed to the poor and minorities in affected neighborhoods. The clarion call of the federal Model Cities program for "maximum feasible participation" has rarely been heeded. For this reason, central business districts have received the bulk of revitalization investment, and nonresidential development has been emphasized over housing. Because J&J was so important to what transpired in New Brunswick, understandably much of the revitalization here was emphatically top-down. As noted by one observer, referring to J&J, "They are hierarchical. And so you do what you are accustomed to doing" (Wheeler interview, 20–22). As described in chapter 4, major decisions about New Brunswick's revitalization were made by an inner circle of individuals, including Richard Sellars of J&J, Mayor John Lynch Jr., and a few others (Foglio interview, 9).

Neighborhood input has been particularly scarce in the New Brunswick revitalization. To be sure, NBT and others solicited neighborhood perspectives on contemplated revitalization actions. The founding board of NBT included minority and ethnic representatives (from the Urban League and from the Hispanic and Hungarian communities); the early American City Corporation planning process involved workshops in the city's Hungarian, Puerto Rican, and black communities; and no city in the United States has mounted the equivalent of the biennial NBT/Eagleton survey to gather the perspectives of residents on their changing city. Yet, community input in New Brunswick fell far short of community empowerment in this city. David Harris left DEVCO's board because "the meetings were designed to get the community input on what they had already essentially planned" (Harris interview, 14). A former DEVCO director admitted that "one of the downfalls of New Brunswick is that there hasn't been an empowering in the neighborhoods" (Foglio interview, 24–25).

Related to the decision-making process in New Brunswick's revitalization, especially in early years, was the emphasis on commercial as opposed to residential projects. A major architect of New Brunswick's renewal, former mayor John Lynch Jr., acknowledged that "we didn't put enough emphasis on neighborhood

housing," but he defended the downtown as "the lifeblood of the community." Its well-being affects "perception, business, jobs, as well as taxes that help with your schools, your parks, your infrastructure, etc." Still, "I don't think you can ever do enough housing" (Lynch interview, 39).

In part as a consequence of what was and was not emphasized, the city's over-all poverty rate stands at a stark 26 percent, and it has only moderately declined for the city's blacks since 1980. No wonder, then, that New Brunswick's black residents have more misgivings about their hometown, as reflected in the NBT/Eagleton survey. Similar shortcomings bedevil many of the national postwar efforts to revitalize America's cities.

Nevertheless, New Brunswick has realized exemplary positive accomplishments, especially in its downtown. Cumulatively to date, all of the redevelopment in New Brunswick has entailed an investment of more than a $2.1 billion, which generates about $22 million yearly in city revenues (Cahill 2014). The DEVCO portion of the New Brunswick redevelopment alone amounts to about $1.65 billion, and DEVCO's projects in the city cumulatively amount to about 7.8 million square feet (table 4.2). New Brunswick's considerable development activity from 2000 to 2013, as measured by building permits, was detailed earlier in this chapter (tables 6.5 and 6.6).

All of this activity has created both temporary and permanent jobs. The expansion of the Robert Wood Johnson and Saint Peter's Hospitals has been particularly important; the two hospitals combined employ about 13,000 persons and offer both entry-level and more skilled employment opportunities. Figure 6.6 shows the annual incidence of unemployment for New Brunswick, the state of New Jersey, and the nation over the past decade (2005–2014). Each area experienced the

Fig 6.6 Unemployment Rate Local, State, Nation (%)

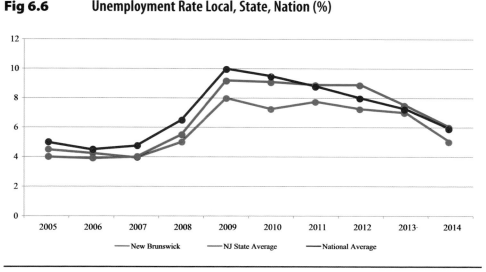

SOURCE: "Homefacts: New Brunswick, NJ," http://www.homefacts.com/unemployment/New-Jersey/Middlesex-County/New-Brunswick.html (accessed December 16, 2014).

economic roller coaster of initial relative prosperity followed by a near depression and, most recently, a recovery from that economic trough. While New Brunswick has not been immune from the vagaries of the past decade's fluctuating economic cycle, the city's unemployment rate for almost every year has been lower than that of the state and the nation. New Brunswick has also shown resiliency in recovering from the devastating recession of the late 2000s, much more so than the state of New Jersey overall.

To be fair, New Brunswick's emphasis on the nonresidential sector is what the private market dictated, especially when revitalization began in the late 1970s and early 1980s. In that era, private housing construction in New Jersey was largely focused in suburban and exurban locations; a developer who gets too far ahead of the market does so at his or her peril. Take the case of the Riverwatch townhouses, built in New Brunswick's Hiram Square in the early 1990s. Despite the units' good size, amenities, and attractive no-money-down mortgages from the New Jersey Housing and Mortgage Finance Agency, the initial market response to Riverwatch was tepid. Only three people showed up at the inaugural open house weekend. The major reason for the soft initial response, aside from the development's unfortunate timing—Riverwatch came to market in the economic and real estate downturn of the early 1990s—was likely minimal interest then in living in downtown New Brunswick. Today, however, Riverwatch housing is highly sought after, as indeed is other market housing in New Brunswick and other New Jersey

97. One Spring Street

Courtesy of Boraie Development.

cities, notably Hoboken and Jersey City. Omar Boraie describes his high-rise luxury condominium building, One Spring Street, as a "New York–style condo building" (*NJBIZ*, 8). His new apartment building, The Aspire on Somerset Street, like One Spring Street, "will bring another segment of the population back into the city . . . people . . . who like to work, live, and enjoy the culture and entertainment offered in downtown New Brunswick" (ibid., 9). But this change in perception and market demand took time; only more recently, as the market solidified for urban residential product, has New Brunswick offered more housing choices.

In fact, it is simply not true that New Brunswick's revitalization completely lacked a housing component. Cumulatively, 3,500 housing units have been produced (Cahill 2014) since the beginning of redevelopment (table 6.5 covers just 2000–2013), mostly market rate but including affordable housing as well. In addition, a portion of the approximately $22 million in annual revenues generated by redevelopment, along with federal monies from such sources as the Community Development Block Grant and HOME programs, help fund housing rehabilitation and related housing improvement efforts in many of New Brunswick's neighborhoods. These are not high-profile projects but are nonetheless important to ensure the viability of New Brunswick's housing.

Perspective is needed as well on the downtown focus of New Brunswick's revitalization. A more even distribution of attention to the outlying neighborhoods would have been difficult to effect, and such a policy would not necessarily have been optimal. Johnson & Johnson was a prime catalyst, especially at the beginning of the redevelopment, and understandably favored investment in the immediate vicinity of its newly constructed world headquarters on Albany Street. J&J's view of redevelopment, according to a former DEVCO director, "was to stand from the executive lunch room and look out the window, and the border of New Brunswick was only as far as they could see" (Foglio interview, 6). Given that perspective, it is no wonder that the earliest redevelopment projects were literally across the street from the J&J headquarters, first on the other side of Albany Street (the Hyatt and Kilmer Square), then across George Street (410 George Street, known as the Golden Triangle). Following these developments bordering J&J were projects just behind them, such as Riverwatch adjacent to the Hyatt, and then the concentric circle of development spreading somewhat farther into the downtown. All of this investment occurred within a ten- to fifteen-minute walk from the J&J tower.

This concentration on the CBD was about more than protecting the J&J investment, however. Observes the current DEVCO president, "The operating principle of investing in an urban area is the importance of critical mass" (Paladino 2014), which will attract investors and assuage the concerns of lenders. Similarly, in explaining why he built Albany Plaza at the intersection of Albany and George Streets, developer Omar Boraie cited this location's proximity to the J&J headquarters, the Golden Triangle, and the New Brunswick train station. Boraie explained why he thought New Brunswick was an ideal place to build: "I liked New Brunswick because I saw Rutgers University. I saw . . . two hospitals. I saw

98. Kilmer Square

Photograph by Larry Levanti. Courtesy of Larry Levanti.

Cook College on the other side of town. I saw Squibb Pharmaceutical at the time . . . I saw a lot of potential because of the train station. [It is] close by the Turnpike, Route 1, 287, Route 27 . . . Princeton University . . . and we have Johnson & Johnson in New Brunswick" (Boraie interview, 2).

The concept of creating a critical mass by focusing on downtown redevelopment has been employed in other challenged cities across the United States. Detroit, Michigan, is a city of about 140 square miles that has hemorrhaged population (from a peak of 1.9 million in 1950 to about 700,000 today) and jobs (down 150,000 jobs in the postwar era). To jump-start Detroit's redevelopment, Dan Gilbert, the entrepreneur who started Quicken Loans, one of the nation's largest mortgage lenders, has spent approximately $1 billion acquiring about 3 million square feet of office buildings and other real estate in a two-square-mile section of the city's downtown (Segal 2013). He moved his company's employees from a nearby suburb to the downtown and hopes to attract both other businesses and new residents. He describes his approach as the "Big Bang"—"Bring in as many stores and people at the same time, as quickly as possible" (ibid., 7). Like J&J in New Brunswick, Quicken Loans works to create a zone of revitalization around its downtown headquarters.

Inevitably, however, focus on the downtown means less attention to other parts of a needy city. The president of Detroit's local chapter of the National Association for the Advancement of Colored People cautioned, "What we don't want to see is two Detroits, one for those who are downtown and one for those in the neighborhoods" (Segal 2013). Such a criticism can be answered only if a city's downtown critical mass activity eventually enables investment in more outlying neighborhoods.

New Brunswick can be applauded for many of the strategic social visions and strategies that have accompanied the city's redevelopment. The American City Corporation blueprint emphasized both brick-and-mortar and social intervention, and this dual track materialized in the formation of DEVCO and NBT, respectively. As noted, DEVCO has been an exemplary development dynamo. The NBT metrics are not as readily summarized because this organization deals

with complex quality of life issues, such as education, health, food, and safety, and attempts to serve all residents, from infants to the aged, by fostering public and private networks of institutions and community organizations. NBT's president observes that its mission is "to respond to the needs of the community," and he believes that there is no organization like it in any other community (Vega interview, 6–8). Whether or not NBT is unique, it surely has accomplished much in fostering such projects as the partnership for healthy kids, a summer soccer academy, the healthier New Brunswick initiative, school-based youth services, and intervention to revitalize New Brunswick's Esperanza neighborhood (partnering with the city government and the Puerto Rican Action Board). So the combined accomplishments of DEVCO and NBT merit praise in considering what happened in the city.

As noted throughout this book, a public-private partnership (PPP) model also characterizes the revitalization of New Brunswick. The J&J executive who shepherded his corporation's investment praised PPP as "a wonderful model . . . forming a coalition between the business sector . . . the public sector and the community" (Heldrich interview, 7–8). He is echoed by New Brunswick's current mayor, who concluded that "the pooling of energies and resources, creating as best you can a commonality of vision . . . was critically important . . . and that's one of the reasons we perhaps have been more successful than most in getting things done" (Cahill interview, 8).

As many of the oral history interviews indicate, New Brunswick's theaters and restaurants brought a renewed vibrancy to the city. However, they also admit that retail business, mainly on George Street and Easton Avenue, has not yet caught up. This lag may be explained in part by the fact that New Brunswick has only recently developed enhanced housing with occupants who can support an expanded retail base. Glenn Patterson also explained that the problem for downtown retail "has a lot to do with the existing layout" (Patterson interview, 23). DEVCO president Paladino predicts that these older, smaller retail spaces will eventually be replaced with larger multiuse buildings: "All of our projects should be multiuse because we only have limited resources, so you aren't even going to build an office building anymore. It's going to have parking. It's going to have retail. . . . We also started to show that if you develop, if you build quality retail space, you can get good tenants" (Paladino interview, 25).

Other plans for the city could have a positive impact. Like many other cities built on rivers, New Brunswick could become more attractive to residents and visitors if it were reconnected to the Raritan. However, it will take a lot of effort to overcome the barrier caused by Route 18. The development of Boyd Park and its marina is a positive sign, as is the new Rutgers University master plan for the College Avenue campus, which includes a future boardwalk along the river.

In summary, New Brunswick has realized many, if not all, elements of its upgrading mission. Quantitative and qualitative facets of this success were documented earlier in this chapter and include declining crime rates, a reduced property tax burden owing in part to the significant downtown development, and a

**99. Route 18,
March 2007**

Photograph by
Robert Belvin.
Courtesy of Robert Belvin.

more positive perception of their hometown and its public services by city residents. Challenges of course remain, and progress has been uneven in some parts of the community. Whether New Brunswick's degree of success can be replicated elsewhere is the subject of the final section of this chapter.

New Brunswick's Revitalization Success: Contributing Factors and Replicability

In enumerating the factors contributing to New Brunswick's revitalization, a number of favorable circumstances immediately come to mind, particularly the presence of significant institutions: a Fortune 500 corporation, the county seat of government, large hospitals, and a state university campus. But those same institutions were present in Camden, once the headquarters of two major corporations, Campbell Soup and RCA Victor, yet Camden is now one of the most challenged cities in New Jersey, if not the nation. About 40 percent of Camden's residents lived in poverty in 2010, and Camden has had the dubious distinction of enduring one of the highest crime rates in the United States. Recent developments in Camden give promise for the future.

Another factor cited in the story of New Brunswick's success is the guidance of the American City Corporation (ACC). The ACC blueprint for New Brunswick was a near mirror of its recommendations for Hartford, Connecticut, however, and Hartford has remained a city under duress. Its poverty rate increased from 26 percent in 1980 to 37 percent in 2010. There is no simple formula for "better performing" urban revitalization. Instead, there are multiple contributors. To paraphrase John F. Kennedy, "Victory has a thousand fathers; defeat is an orphan." New Brunswick's revitalization definitely had numerous fathers—and mothers.

Many of the oral history interviewees (see appendix A) emphasize the importance of Johnson & Johnson to New Brunswick's turnabout: J&J "was the single

driving force" (Wheeler interview, 19); "J&J obviously was the grandfather of revitalization in New Brunswick" (Cahill interview, 12); "J&J was the key" (Sheehan interview, 14–15); "First and most important was that J&J stayed in town . . . if they had moved out . . . New Brunswick would have gone downhill" (Voorhees interview, 14). Crossroads Theatre Company founder Ricardo Khan added that J&J's decision to stay was "a big [positive] message sent to us" (Khan interview, 35–36).

J&J was indeed the extraordinary component in New Brunswick's redevelopment. First, J&J is a Fortune 500 company that conducts business in 60 countries through more than 275 operating companies and employs more than 128,000 people (Company Spotlight 2015). Like the insurance companies in Hartford, J&J could have joined the corporate exodus and moved from New Brunswick in the 1970s to major sites it already owned throughout New Jersey's suburbs or, for that matter, elsewhere in the United States or abroad. That it elected to remain was likely due to a confluence of influences, including a corporate credo that emphasizes responsibility to the communities in which it works and the personal ties of high-level J&J executives to New Brunswick and its environs. The company not only built its new world headquarters in New Brunswick but also provided high-level corporate leadership to work for the city's revitalization, offered financial backing for the ACC plans and the launching of DEVCO and NBT, was the effective mortgage mainstay for many early projects (Plaza I, Plaza II, and the Hyatt), used its financial clout to bring in other firms to extend credit to important projects, exercised its political influence to secure needed government funding, and did much else to aid the city.

Sometimes virtue is rewarded. Today, to attract the most talented workers, to foster constructive collaborative thinking, to reduce carbon footprint, and to satisfy other business and social reasons, more and more corporations seek city locations near transit. The New Jersey companies that left their urban locations in the 1970s and 1980s or reduced their presence there and built huge corporate campuses in the state's exurban counties are now burdened with white elephants.

The context of the times may have colored other J&J decisions regarding New Brunswick. Its corporate headquarters, described as a "tower in a park in a city," has been criticized as being too removed from the public street and not urban- or pedestrian-friendly. At the time, however, the design likely gave J&J a measure of comfort; its employees could enjoy a modicum of suburban-like green space outside its door and a secure campus. In a related vein, critics fault the J&J building for amenities, such as employee cafeterias, that tend to encourage employees to stay inside rather than patronize local businesses. An analogy is the Gateway commercial complex in Newark, New Jersey. After Newark's devastating riots of the 1960s, few corporations would invest in that city. Prudential Insurance Company, which was headquartered there, was an exception and extended $18 million in mortgages to finance the office, retail, and hotel complex. (Prudential has since aided many significant projects in Newark, New Jersey, including the very significant New Jersey Performing Arts Center.) Some have criticized the Gateway Center for not

being "in" Newark because the complex relies on internal skywalks, including one that connects to the Newark's Penn Station. A commuter can disembark, traverse the skyway, and literally never set foot on a city sidewalk.

J&J has also been faulted for not supporting the Hiram Market and other historic preservation in New Brunswick, but here again the context of the time comes into play. In the 1980s, historic preservation did not have the popular resonance it has today. A proposal now to save factory lofts in Hiram Square might well find support in the J&J corporate suite, but at the time, demolition and new construction were the dominant cures for urban decay. The main point is that J&J's decision to remain in New Brunswick, coupled with its extensive corporate commitment of human and financial capital, was foundationally central to the revitalization of New Brunswick.

Although a separate entity from Johnson & Johnson, the Robert Wood Johnson Foundation (RWJF) was funded with a large bequest of stock when the J&J president died in 1968. RWJF is the fourth-largest philanthropy in the United States by asset size and the largest philanthropy in the United States focused solely on health (Foundation Center, 2015). Although its work is national in scale, RWJF does support some local, mainly health-related activities in New Brunswick. For example, the foundation has long aided NBT programs and has given large grants to DEVCO. Of particular importance is the foundation's support to New Brunswick's hospitals, especially its namesake institution. New Brunswick's revitalization has been aided by the significant scale and growth of its two major hospitals Robert Wood Johnson and Saint Peter's. Clearly, the employment and other economic opportunities afforded by New Brunswick's two major health facilities have made a major contribution to New Brunswick's revitalization.

Another institutional behemoth in New Brunswick is Rutgers, The State University of New Jersey. It has three campuses (New Brunswick, Newark, and Camden) and a total student body of around 65,000, about 40,000 of whom are enrolled at the Rutgers–New Brunswick campus, which includes the Livingston and Busch campuses outside the New Brunswick's municipal borders. The College Avenue, Douglass, and Cook campuses extend over 968 acres (1.5125 square miles) in New Brunswick, or 29 percent of the total land in the city (5.227 square miles). In the 2014–2015 academic year, Rutgers–New Brunswick employed about 2,000 full-time faculty and 5,700 full-time staff (Rutgers University 2011). In fiscal year 2014, Rutgers University collected $820 million in student tuition and fees and spent more than $849 million for instruction (Rutgers University 2015). More than 436,000 alumni—who live in every state and on six continents—have come in contact with the city of New Brunswick at some point (Rutgers University 2015).

Although these metrics convey the magnitude of the Rutgers operation in New Brunswick, the university for a long time distanced itself from the city and played only a minor role in revitalization. Communication between the city administration and Rutgers officials was often strained in the late 1960s and early 1970s, as the city's mayor noted during that period: "Town and gown . . . only

threw bricks at each other" (Sheehan interview, 6). University officials "wouldn't even admit they were in a city" (ibid., 17). Housing officials bemoaned the deleterious impact of students on the local housing stock; competition from them drove up rents to the dismay of permanent residents and discouraged homeownership (Patterson interview, 21–22). University facilities that logically could have been built in New Brunswick's downtown were instead cocooned on campuses removed from the city and its residents; the River Dormitories had a nice view but were far from downtown, as was the Nicholas Music Center, tucked away on the Douglass campus.

Over time, Rutgers became more actively involved in New Brunswick's efforts to revitalize. High-level officials, including President Edward J. Bloustein and Provost Kenneth Wheeler, were engaged in some of the early NBT discussions, and a biannual top-level meeting of Bloustein, Richard Sellars of J&J, and Mayor John Lynch laid out the "course of [redevelopment] action for the next six months" (Foglio interview, 2).

Though more engaged with the revitalization, Rutgers initially moved slowly. An important breakthrough was the building in the early 1990s of a Rutgers dormitory—University Center—on Easton Avenue just across from the New Brunswick train station. Here and in some other cases, though, Rutgers "had to be dragged to the table" (Patterson interview, 13–14). In fact, Mayor Lynch, who was then a state senator as well, "held up the Rutgers budget in the Senate until we got a commitment for the [University Center] housing" (Foglio interview, 9). This project served a number of needs. The private construction sector was anxious for the work, the adjacent Robert Wood Johnson Hospital needed parking, and a growing Rutgers needed more student housing. Interestingly, University Center

100. University Center residence hall, Easton Avenue

Photograph by Larry Levanti. Courtesy of Larry Levanti.

at that time became "the number one requested dormitory in the system" (Patterson interview, 13–14).

In time, Rutgers would locate more of its operations in the heart of New Brunswick. Civic Square on Livingston Avenue, built in the mid-1990s, houses both the Edward J. Bloustein School of Planning and Public Policy and the Mason Gross School of the Arts. About a decade later, Rutgers partnered with DEVCO on a student housing project, Rockoff Hall, on George Street, just a stone's throw from Civic Square. The new Rutgers University bookstore opened in the Gateway Transit Village, which was completed in 2012 adjacent to the New Brunswick train station.

In addition to its increasingly important presence in New Brunswick's downtown, the university has contributed to the city's revitalization in other ways, especially as a major employer. On the economic interconnection of Rutgers and New Brunswick, David Harris observes: "It is our central asset . . . when you have a university of the level of Rutgers in your midst, those jobs will continue for the local folks [even in] an economic downturn. It's like the way of the hospital. There are jobs for the indigenous population" (Harris interview, 19).

New Brunswick's centrality as the county seat of government also aided its revitalization. Middlesex County encompasses more than 815,000 residents, making it the second most populous county in New Jersey. The county employs thousands of people, with a large share of its workforce in New Brunswick. Also, the county courts are in New Brunswick, which brings a large number of attorneys to maintain offices or otherwise do business in the city. In addition, the county has helped the city secure state and federal grants for a wide variety of housing and community-economic development purposes. As described in chapter 5, Middlesex County used $3 million in state Green Acres funds, originally targeted to preserve open space, to assist the New Brunswick Cultural Center and applied another $3 million of county monies to help purchase the State Theatre.

Supporting this creative county support for New Brunswick was David Crabiel, who served on the county's board of chosen freeholders for almost thirty years after serving as mayor in Milltown, New Jersey, and was the county freeholder director for many years (1994–1995 and 1998–2008). Crabiel, along with his fellow freeholders, collaborated with New Brunswick mayors, such as John Lynch Jr., and he has been credited with sharing Lynch's strategic vision for the city. In part, the effectiveness of this alliance grew out of a shared political outlook: both the city and the county are Democratic bastions. In the past six presidential elections, beginning in 1992, Middlesex County voters have backed the Democratic candidate with margins ranging from +7 percent (1992) to as much as +22 percent (2012). In the city of New Brunswick, Barack Obama won more than 80 percent of the local vote in both 2008 and 2012. Not surprisingly, then, city and county political leaders often agreed upon and collaborated on New Brunswick's revitalization.

Further fostering the effectiveness of the city and county collaboration was the stability and longevity of the political leadership. Besides Crabiel's long ser-

vice at the county level, John Lynch Jr. guided the city during the critical period 1979–1991, and the current mayor, James Cahill, has been in office since 1991. Such long political terms, along with the continuity of key planning and other staff associated with redevelopment, are viewed positively by developers contemplating projects in New Brunswick. One oral history interviewee noted the importance of New Brunswick's political stability: "We've had two mayors for the last thirty-something years . . . people feel comfortable investing here . . . they're not going to get in the middle of the project and get cut off at the knees" (Patterson interview, 27–28). When asked what contributed to the success of the city's redevelopment, Lynch himself observed that "having political stability is critical [and] that's not necessarily transferable" (Lynch interview, 36–37).

Lynch's political power extended beyond New Brunswick. He served as a state senator from Middlesex County from 1982 through 2002 and was senate president from 1990 to 1992. Lynch also headed an important political action committee that wielded influence statewide. No wonder Lynch was considered "one of New Jersey's political power brokers" (Kocieniewski 2006b) and the "face of the state's political-boss system" (Kocieniewski 2006a). While Lynch's political influence waned (ibid.), by then New Brunswick's change in fortune was already on track, and Mayor James Cahill, a savvy politician and leader in his own right, had assumed the city's political helm.

Also deserving mention is the political clout of Johnson & Johnson. J&J has ties to the Republican side of the political aisle and as a corporate giant could always expect at least respectful attention from whatever party was in power in Trenton or Washington, DC. That fusion of "blue" and "red" political backing gave the case for New Brunswick's revitalization a rare purple hue that was attractive to would-be government and other funders. This bipartisan support may very well have tipped the scales in the city's favor when it successfully competed for federal Urban Development Action Grants and state Urban Transit Hub Credits.

To remove politics from the public sector, reformers long ago established stand-alone public authorities, often with access to a non-tax, dedicated source of revenue, such as utility or toll charges. In the case of New Brunswick, the city Parking Authority (NBPA) has been a less visible but nonetheless important contributor to the city's revitalization. The NBPA manages fifteen ground-level and multistory parking facilities across New Brunswick. Almost all of its revenue comes from parking fees, and the rest is derived from rental income and other sources. In 2013, its total assets amounted to $31.7 million, and its net financial position (assets less liabilities) was $23 million (NBPA 2013). The operating revenue of the NBPA exceeds that of the parking authorities of far larger cities in New Jersey. For instance, the NBPA has three times the revenue of its Paterson equivalent ($24.1 million versus $7.2 million in 2013), even though Paterson's population is 2.5 times larger than New Brunswick's (146,000 versus 55,000 in 2010).

The NBPA significantly aided New Brunswick's redevelopment in two ways. First, it provided structured parking in or near many important projects, such as the Heldrich building, Gateway Transit Village, Rockoff Hall, and the Wellness

Center, to name just a few examples. Structured parking can cost upward of $50,000 per space. To a private developer, that upfront infrastructure cost can be daunting: it can take many years for a parking garage to pay for itself. The NBPA removed this constraint by building the structured parking itself. It could absorb the upfront cost and the initial financial loss through the profits generated by older garages in its inventory that had already paid for themselves.

In addition to this important cross subsidy, the NBPA "can secure public monies not available to a private developer" (Paladino 2014). For example, the NBPA provided $59 million of the Gateway Transit Village's $150 million cost from two sources that were available to it as a government agency: $49 million from Build America Bonds, authorized by the 2009 American Recovery and Reinvestment Act (ARRA) to help governments pursue capital projects, and $10 million from New Jersey Department of Transportation funds. Of the $106 million New Brunswick Wellness Plaza cost, the lion's share ($92 million) came from various bond sources unavailable to private developers but successfully tapped by the NBPA. These included $41.5 million in Build America Bonds and $26.2 million in Recovery Zone Economic Development Bonds and $24.6 million in Recovery Zone Facility Bonds (both authorized by ARRA). Such large sources of funds highlight the important financial role played by the NBPA in the city's revitalization.

Another explanation for New Brunswick's greater success in its revitalization efforts relative to other places is its smaller and compact size (5.2 square miles, or about 14 square kilometers). Size matters in city redevelopment, a variation of the critical mass perspective discussed earlier in this chapter. Placing all of New Brunswick's redevelopment projects in Detroit's 140 square miles would dissipate their citywide ameliorative impact, but within New Brunswick's six square miles they had a kind of stereophonic uplifting effect. In the words of a New Brunswick attorney, "We weren't so big that you couldn't see positive results":

> I look at cities like Camden and I look at Newark and you know for all of the efforts that you have in those places, you sometimes think, "Can you ever really do enough to make a difference?" [New Brunswick] is five and a half square miles; it's got a defined downtown. It's got natural resources and the university and J&J and the cultural district and the county seat. . . . You have all of these things that are there and yet you could do a project and make a difference because it's meaningful within a five-and-a-half-square-mile radius, physically. (Kelso interview, 13)

New Brunswick's "manageable" size appealed to Robert Campbell, a former J&J CFO and vice chairman: "You could stand up in the J&J tower and kind of look at the various edges of New Brunswick, so to speak, where, if you stand up in the Prudential Building or something in Newark, its all over the place" (Campbell interview, 29–30).

The interviewees of the oral histories conducted by Dorothea Berkhout and David Listokin cited other city assets that contributed to New Brunswick realiz-

ing more success in its revitalization effort than others places. Having a train station on the main line of the country's most important rail corridor was viewed as significant, especially at a time when access to transit is prized: "The railway station is in . . . downtown New Brunswick. Gateway will work in large measure because its right downtown. . . . The reason why One Spring Street works is because it is a block from the train station" (Marchetta interview, 53–54). The presence of locally based banks was also cited. Chapter 4 described the participation in NBT of such New Brunswick–based financial institutions as the National Bank of New Jersey and the People's National Bank. A former mayor recalled, "We had Magyar Bank, we had New Brunswick Savings Bank, and both with corporate offices here, and they had to do something to protect and a future to look for" (Sheehan interview, 22). Local bankers did more than serve on boards; they also opened their coffers to help finance some early projects, such as Plaza I and Plaza II. With the considerable consolidation in the financial industry over the past few decades, there are fewer lenders headquartered in New Brunswick today, but some remain and have helped with recent projects. For example, Magyar Bank, founded in 1922 by a group of Hungarian immigrants as the Magyar Building and Loan Association of New Brunswick, New Jersey, served the immigrant community's financial and banking needs. Now serving the New Brunswick community at large, the bank provided some of the crucial initial financing for Gateway Transit Village at a time when the mortgage implosion of the late 2000s had significantly restricted lending for real estate.

Last, but not least, are the personal qualities of the people who initiated and followed through on New Brunswick's revitalization. Personal attributes are often overlooked or given short shrift in social science analysis, but they can matter a lot. By all accounts from the oral history interviews, the principal participants in the revitalization, such as John Heldrich and John Lynch Jr., to name just two, had unusual vision, energy, and leadership skills. As noted in *Regenrating America's Legacy Cities*, "the key characteristic in seizing opportunities for change is leadership" (Mallach and Brachman 2013, 34). Further, Heldrich, Lynch, and other participants, such as Rutgers president Edward J. Bloustein, had "personalities that work well together" (Patterson interview, 27–28). Lynch and Heldrich in particular "had a very good relationship" (Voorhees interview, 11). There was also affection for and connection to New Brunswick that remained even after those who were born in the city left. When Heldrich moved from his hometown of New Brunswick, he merely crossed the Raritan River to Highland Park, and he continued to worship in the New Brunswick church of his youth. Ralph W. Voorhees similarly noted that many churches remained in New Brunswick after their congregants moved out of the city; the congregants continued to return to New Brunswick for services (ibid., 10).

Then there were personal friendships. Heldrich and Voorhees grew up together in the New Brunswick area, worked on a joint paper route, and later attended the same elementary and high school. No wonder, then, that they found it natural later in life to collaborate to help New Brunswick. Thus, church ties, life

histories, and other personal factors contributed to form a cadre of individuals interested in and working to better New Brunswick.

Was there a measure of good luck as well that fortuitously aided New Brunswick's revitalization? To cite just two examples, the New Brunswick turnabout originated just when the UDAG program was created, and these grants proved ideal for jump-starting some of the important early commercial projects in the city, such as the Hyatt Regency and Kilmer Square. When the Great Recession of 2007–2009 and its aftermath dried up real estate financing, the state of New Jersey adopted the Urban Transit Hub Tax Credit, which proved crucial to many of the more recent redevelopment projects in the city, such as the Wellness Plaza, Gateway, and Rutgers campus buildings (honors college, university apartments, and academic buildings.) Was the timing of these aid programs a stroke of good fortune? Yes, but the "luck" here and elsewhere regarding New Brunswick is more in line with the adages of Thomas Jefferson ("I'm a great believer in luck, and I find the harder I work, the more I have of it") or the Roman stoic philosopher Lucius Seneca ("Luck is what happens when preparation meets opportunity").

In summary, many factors contributed to New Brunswick's revitalization achievements:

1. The decision by a major corporation (Johnson & Johnson) to stay in its hometown and commit extensive financial and human capital to the redevelopment
2. The adoption and generally faithful implementation of a revitalization strategy (by the American City Corporation) that emphasized public-private partnerships and attention to both the bricks and mortar (DEVCO) and social (NBT) needs of New Brunswick
3. Aid from General Robert Wood Johnson and the bishop of Trenton that fostered the transformation of two local hospitals into major medical centers employing thousands (Robert Wood Johnson University Hospital and Saint Peter's University Hospital). Aid from the Robert Wood Johnson Foundation supported health, social welfare, redevelopment, and other important activities
4. The spending, employment, and large student and faculty presence of a major university campus (Rutgers–New Brunswick) and the decision of its academic leadership, albeit belatedly, to be both in and of downtown New Brunswick
5. The presence of the Middlesex County seat of government, a public entity with a large budget and staff, which serves as a magnet to attract attorneys and other professionals to locate in or otherwise do business in the city
6. The willingness of the New Brunswick Parking Authority to commit its extensive financial resources to support many revitalization projects
7. The political longevity, stability, and acumen of many senior politicians and administrative staff in both city and county governments, and the

political clout of a global corporation, which facilitated bipartisan
support for redevelopment

8. A compact physical size that allowed New Brunswick's redevelopment
projects to resonate significantly within its almost six square miles

9. The presence of additional assets, such as a downtown train station and
locally based financial institutions

10. The exemplary vision, energy, and leadership skills of the participants,
along with interconnected friendships that solidified their ties to New
Brunswick

11. Fortuitous timing regarding program funding cycles and the vision and
hard work to take advantage of them

Can these factors be found elsewhere, and can New Brunswick's success be
replicated? The basic model of establishing public-private partnerships, address-
ing dual physical and social concerns, and following many of the other strategies
described in this chapter are transferable; indeed, the New Brunswick revitaliza-
tion plan was recast from the ACC's original blueprint for Hartford. Participants
concur that the New Brunswick revitalization template could be applied else-
where. A former president of NBT thinks that, "conceptually, . . . it's very transfer-
able" (Hardgrove interview, 28), and former mayor Lynch believes that "most of
the principles that are involved are transferable" (Lynch interview, 26–27).

Some believers tout the New Brunswick case not only as one that can be rep-
licated but also as a model to be followed. Thirty years ago, New Jersey governor
Thomas Kean praised New Brunswick for its nationally recognized partnership to
revitalize an urban center (Prior 1988, 1). More recently, a governor's advisory
commission to revitalize Atlantic City's worsening economic fortunes recom-
mended the formation of a development corporation along the lines of DEVCO,
arguing "why not model off a winner?" (Lei and Seidman 2014).

Calling something a model should always give one pause. Indeed, many lin-
gering challenges pull at the edges of the fabric of revitalization that New Bruns-
wick has created. At the same time, New Brunswick's improving fortunes would
be the envy of many cities in the state and nation. So, can its formula for success
be copied elsewhere?

The truthful, albeit annoying, answer is that "it depends." This chapter has
identified about a dozen factors contributing to the positive outcome realized by
New Brunswick; presumably, cities where more of these factors are present will
have a higher probability of success. Yet a positive revitalization outcome may well
depend upon a mixture of the identifiable chemical-like "compounds" discussed
in this chapter (business commitment, political support, energetic leaders, and so
on) and a more elusive alchemy. The latter is perhaps what former New Brunswick
mayor Patricia Sheehan had in mind when she described her city's revitalization
outcome as a "confluence of stars that I'm not sure you can replicate."

Where is New Brunswick going, and what does the future portend for urban
America? There are both positive and negative headwinds. More so today than for

most of the postwar period, contemporary American cities, New Brunswick included, are increasingly sought out by both the young and the old as the "place to be." The changing tone of the titles of scholarly monographs on cities reflects this paradigm change. For example, James Q. Wilson wrote about "America's Urban Crisis" in the late 1960s,[5] and as late as 2003, Douglas Rae entitled his masterful New Haven monograph *City: Urbanism and Its End.* By 2011, Edward Glaeser could title his book *Triumph of the City,* and the following year Alan Ehrenhalt chronicled *The Great Inversion*, the demographic shift of the affluent from the suburbs to the central cities. Leigh Gallagher was blunter, writing in 2013 on *The End of the Suburbs.* And in New Jersey, James W. Hughes and Joseph J. Seneca in 2015 sketched out the newly emerging economic geography of the state in *New Jersey's Postsuburban Economy.*

Another fundamental shift that is taking place is impacting New Brunswick—a changing regional geography. During New Brunswick's fall and subsequent rebound, New Jersey was the regional economic locomotive. In 1950, New Jersey's total employment base was less than half that of New York City. By 2004, it was 13 percent greater. Between 1950 and 2004, New Jersey added 2,342,300 jobs, New York City just 81,800 jobs. So, even though suburbanization reigned during most of this period, at least the state's strong employment growth performance provided economic tailwinds for New Brunswick.

The post-2004 period has been dramatically different. Between 2004 and 2014, New York City gained 552,200 jobs while New Jersey lost 36,900 jobs. New York City has become the regional economic locomotive, New Jersey the caboose. The state is now providing economic headwinds for New Brunswick. A partial compensation, however, is New Brunswick's direct rail connection to the New York City economic locomotive.

Demographically, New Jersey is still growing, and the suburbs surrounding New Brunswick have continued to grow. But New Brunswick and many other cities across the nation are attracting more residents than in former decades. The urban mix of different races, ethnic groups, cultures, and age cohorts found in New Brunswick can make cities what Ricardo Khan called his theater, a transformative "crossroads" that has a "power when you bring people of many different backgrounds together" (Khan interview, 8). Yet there is also a disturbing motif as the poor, minorities, and disenfranchised in cities often confront a challenged existence. The problems are "so great," in the opinion of George Street Playhouse founder Eric Krebs, "that I'm not sure any city can address them, but I don't think New Brunswick has particularly made much progress in addressing those kinds of core issues of what it means to be poor and pretty much disenfranchised in a world of real estate, money, and powerful organizations" (Krebs interview, 39).

Besides the conundrum of dealing with the less advantaged, American cities face daunting challenges. Urban utility, road, and other capital plants have aged, and retrofitting them will be disruptive and expensive. As cities grow and new development abuts existing buildings and neighborhoods, how can they "save the best of what's old and capture the best possible new design . . . to have harmony,

101. Aerial view of New Brunswick, 2015

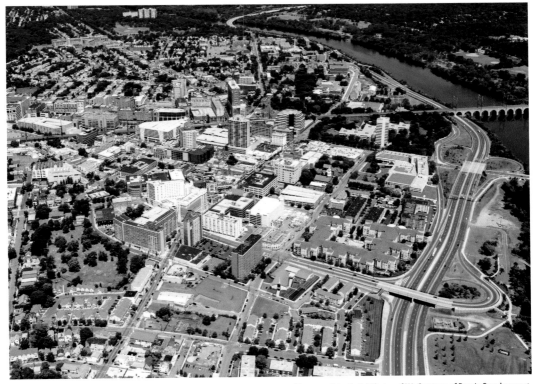

Photograph by Aerial Photos of NJ. Courtesy of Boraie Development.

a synergy here. People like to hear that, but putting that into practice has not been easy or effective" (Kafka interview, 10). What should be the relationship between cities and their suburban environs? In some places, cities have simply annexed their surrounding areas. San Antonio, Texas, for example, expanded via annexation from 262 square miles in 1980 to 486 square miles in 2014 (Koppel 2014). Yet annexation is not an option for most cities in the Northeast and Midwest, and even in Sunbelt cities such as San Antonio there is increasing resistance to continued annexation. To bring this question back to New Brunswick's situation, recall the devastating impact to New Brunswick High School when surrounding suburbs stopped sending their students in the early 1970s. A proposal for a regional school system now, with a more balanced social, ethnic, and racial student body, would be resisted by surrounding suburbs. Yet it is perhaps only through regionalization that the New Brunswick school system can thrive and complete this city's rebirth. Suburban resistance to a regional school approach might be mitigated by a regional tax-base-sharing system (TBS), and more generally, TBS could foster more integrated city and suburban solutions to regional problems. Chasteningly, however, TBS is rare on the American landscape, with only two prominent applications nationally (the Minneapolis–St. Paul region and

the New Jersey Meadowlands). Although the urban and suburban communities in a region may ultimately share a destiny, the concept of sharing revenues and cooperating regionally in providing educational and other services and making land use and transportation decisions is still, unfortunately, an anathema in most regions of the United States.

So we end our intertwined tale of revitalization of New Brunswick and the broader tableau of urban America on a mixed note: much has been accomplished, and much remains to be improved in the future.

APPENDIX A

New Brunswick Oral History
Interviews, 2009–2015:
Biographical Information

INTERVIEWS with the following individuals were conducted by Dorothea Berkhout and David Listokin between 2009 and 2015.

Angelo (Andy) Baglivo, publicity consultant, Johnson & Johnson

Omar Boraie, CEO, Boraie Development

James Cahill, mayor, New Brunswick, 1991–present

Robert Campbell, former vice chairman of the board, Johnson & Johnson

Henry Cobb, partner, Pei/Cobb; architect, Johnson and Johnson headquarters

C. Roy Epps, president, Civic League of Greater New Brunswick

Christiana Foglio, former president, DEVCO

Orrin (Ted) Hardgrove, former president, New Brunswick Tomorrow

David Harris, director, Greater New Brunswick Day Care; former board member, DEVCO

John Heldrich, former vice president for corporate affairs, Johnson & Johnson

Morris Kafka, historic preservationist

Thomas Kelso, New Brunswick attorney with redevelopment experience

Ricardo Khan, artistic director, Crossroads Theater

Eric Krebs, Broadway producer; founder, George Street Playhouse

John A. Lynch Jr., former mayor, New Brunswick, 1979–1991

Anthony Marchetta, professional planner; positions in local and state government and the private sector

Anton Nelessen, architect; professor, Bloustein School, Rutgers University

Christopher Paladino, president, DEVCO

Glenn Patterson, director, New Brunswick planning and economic development

Jacqueline (Jacque) Rubel, founder, Middlesex County Cultural and Heritage Commission

Patricia Sheehan, former mayor, New Brunswick, 1967–1974

Jeffrey Vega, former president, New Brunswick Tomorrow

Ralph Voorhees, former vice president, Paine Weber and UBS

Kenneth Wheeler, former provost, New Brunswick Campus, Rutgers University

ANGELO (ANDY) BAGLIVO was born in Newark, New Jersey. He covered politics for the *Newark Evening News* for about twenty years. When the newspaper closed down in the early 1970s, Baglivo took a position as the state director of public information for Governor William T. Cahill (1970–1974); he helped write speeches, managed public information agencies, and worked on strategy. After Governor Cahill left office, Baglivo started a public relations firm. One day he received a phone call from Lawrence Foster, the corporate vice president of public relations at Johnson & Johnson and a former colleague at the *Newark News* asking if his firm would be interested in working with Johnson & Johnson on New Brunswick redevelopment efforts. Baglivo was a likely candidate for this position because of his familiarity with Rutgers University and New Jersey politics.

OMAR BORAIE was born in Egypt and graduated from Alexandria University with majors in chemistry and biology. He was employed by Kraft Paper in Suez, his home city. After spending two years in Europe as part of an engineering exchange, he came to the United States to pursue a PhD at Rutgers University, based on the recommendation of the chairman of his company, a Rutgers alumnus. However, while in the process of purchasing a house, he was persuaded by a local real estate firm to work in that business. After achieving success, he decided to change careers. He and his wife, Madiha, both worked in real estate, selling single-family homes and residential and commercial space. Eventually, Boraie helped Johnson & Johnson acquire property to be redeveloped. He then began his own commercial and residential building business in New Brunswick.

JAMES M. CAHILL is the sixty-second and present mayor of New Brunswick. He has held this position since being elected in 1991. Cahill was born in New Brunswick in 1952 and is a lifelong resident. He attended Saint Peter's High School and studied at Middlesex County College and Glassboro University. He earned a master's degree in criminal justice from Rutgers University and a law degree from Seton Hall University. In 1980, he became an assistant city attorney in New Brunswick, appointed by John A. Lynch Jr., the sixty-first mayor (1979–1991). In this position, Cahill participated in the day-to-day operations of the city of New Brunswick and in revitalization matters. After working for five years at the law practice of William J. Hamilton, Cahill started his own private practice, which later became Cahill, Branciforte, and Hoebich.

ROBERT CAMPBELL grew up in Passaic, New Jersey, a city with a history similar to that of New Brunswick. After graduating from Fordham University, he was recruited to work for Johnson & Johnson in 1955. Campbell then left to serve for three years in the United States Air Force, returning to New Brunswick in 1959. He received his MBA from Rutgers in 1962. Campbell spent his entire career with Johnson & Johnson, beginning as an accounting trainee and eventually rising to chief financial officer and vice chairman of the board of directors, until his retirement in 1995. He also served on the boards of Robert Wood Johnson Hospital and the Cancer Institute.

HENRY COBB is principal architect at the firm I. M. Pei & Partners and was involved in the creation of the firm's plan for the renewal of New Brunswick as well as the design of the Johnson & Johnson headquarters.

C. ROY EPPS grew up in the South Bronx and attended Wilberforce University in Ohio. He worked for a short time for Johnson & Johnson in New Brunswick as a researcher and then was drafted into the army. He returned to New Brunswick, where he began a graduate program at Rutgers University's Food Science department. Epps then worked for the Colgate-Palmolive Research Center in Piscataway. After the urban riots of 1967, Epps changed careers. He worked for the Urban League as a community social worker and in 1970 became its president and chief executive officer. Epps earned his master's degree in urban planning from Rutgers while working for the Urban League.

CHRISTIANA FOGLIO is a past president of DEVCO. Following a colloquium on redevelopment in New Brunswick that she attended at Rutgers University, she was recruited by Mayor John A. Lynch Jr. to work at City Hall. She changed her plan to attend the London School of Economics and instead enrolled in the graduate program in urban planning at Rutgers. While in graduate school, Foglio worked at the city's Department of Planning. Foglio became an official planner for the city of New Brunswick about a year after she graduated in 1986. She worked for the New Jersey Department of Community Affairs for about eight months. Foglio returned to New Brunswick to continue working in the Department of Planning and then, a few years later, became president of DEVCO. After leaving DEVCO in 1994, Foglio became head of the New Jersey Mortgage Finance Agency and then started Community Investment Strategies, a developer of affordable housing in New Jersey, which she headed for twenty years.

ORRIN T. (TED) HARDGROVE grew up in Folcroft, Pennsylvania, a small town bordering Philadelphia. He went to Kings College, a Christian liberal arts school in New York, and attended seminary for four years in Manhattan. He was ordained as a Baptist minister and later received his master's degree in counseling at the Post-Graduate Center for Mental Health in New York City. Hardgrove served as the Union County director of the Comprehensive Employment and Training Act (CETA) program and then as the director of the Unified Vailsburg Community Services Organization in Newark. His tenure as president of New Brunswick Tomorrow extended from 1981 to 1995. Afterward, he worked for the Robert Wood Johnson Foundation program office.

DAVID HARRIS lived in South River, a borough southeast of New Brunswick, in the early 1960s and was a part-time student at Rutgers University, studying political science. He worked for DuPont in Parlin for five years and then came to New Brunswick in 1965 to work for the Middlesex County Economic Opportunities Corporation as the director of citizenship education. Harris served on the DEVCO board of directors and currently is the director of the Greater New Brunswick Day Care Council.

JOHN HELDRICH was born in New Brunswick, the son of German immigrants. Heldrich served in World War II and fought in the Battle of the Bulge. After returning from the war, he enrolled in night classes at Rutgers University, becoming the first in his family to graduate from college. While taking classes, Heldrich started a business and then was hired as a manufacturing trainee at Johnson & Johnson. He spent twenty years in manufacturing and ran several plants for J&J. He was promoted to the Domestic Operating Company, the mother company within the

J&J corporate structure, and then to the corporate level by the end of the 1960s. In 1968, he was selected by Philip Hoffman, chairman and chief executive of J&J, to organize community leaders to work toward a holistic citywide revitalization and to build an administrative structure for the redevelopment process. Heldrich died on October 28, 2014, at age eighty-eight.

MORRIS KAFKA graduated from Rutgers University with a major in art history. He is an advocate for fair housing practices, thoughtful growth, and the conservation of resources in his hometown of New Brunswick. He has served as an appointee of the mayor on the New Brunswick Historical Association since its inception, is a charter member and vice president of the New Brunswick Historical Society, has served on the city Rent Control Board for twenty-seven years, and is president emeritus of the Second Ward Neighborhood Block Club of New Brunswick. For over thirty years he has renovated and managed historic residences in New Brunswick. He writes and lectures on history and historic architecture in New Brunswick. He has received the NAACP Community Service Award and a US Certificate of Congressional Recognition for his community work.

THOMAS KELSO grew up in Philipsburg, New Jersey, and arrived in New Brunswick in 1968 as an undergraduate at Rutgers University. After going on to graduate from Brooklyn Law School, he lived in Edison, then returned to New Brunswick in 1975. Kelso started his own law practice there with Robert Gluck. Since then, he has continued to practice law in New Brunswick, where he also lives. In 1982 Kelso served as manager for John Lynch Jr.'s mayoral campaign in 1978.

RICARDO KHAN was born in Washington, DC, where his mother from Philadelphia and father from Trinidad first met as students at Howard University. They moved to Philadelphia and then to Camden, where Khan lived during most of his early and teenage years. He entered Rutgers in 1969 and majored in psychology but took all of his electives in theater arts. After receiving an MFA from Rutgers in both acting and directing, he co-founded the Crossroads Theatre Company in 1978 along with Mason Gross colleague L. Kenneth Richardson. Khan led the company through twenty-one years that culminated in the 1999 Tony Award for Outstanding Regional Theatre. He served as board president of the Theatre Communications Group, the national organization for America's professional not-for-profit theaters, from 1995 to 1998. He has since participated as artist-in-residence at Lincoln Center for the Performing Arts in New York City and as creative advisor and founding director to Crossroads.

ERIC KREBS, a graduate of Morris Hills Regional High School in Rockaway, New Jersey, matriculated at Rutgers University, where he studied English and worked in theater. After graduation, during a brief stint teaching preparatory school, he directed his first shows. He then launched a seventy-five-seat theater in a storefront on 47 Easton Avenue in New Brunswick, which he named Brecht West. It lasted at that location for one season and then moved to 61 Albany Street for the next three years. Later, he became a faculty member at Rutgers. In 1974, he founded the George Street Playhouse, which moved to its new location on Livingston Avenue in 1985. Krebs left George Street in 1988 to produce plays in New York City. He was also instrumental in the establishment of the Crossroads Theatre Company in New Brunswick and served as its first executive director.

JOHN A. LYNCH JR. served as the sixty-first mayor of New Brunswick (1979–1991) and has deep roots in the city. In the first half of the nineteenth century his family immigrated to New Brunswick from Ireland; his great-grandfather was involved in building the sewers that would be replaced during his tenure as mayor. His father, John Lynch Sr., also served as mayor of New Brunswick (1951–1954). Lynch Jr. helped Richard Mulligan run his successful 1978 campaign for mayor of New Brunswick. Mulligan abruptly resigned, and Lynch won the mayoral election later that year. Like his father, Lynch Jr. served in the New Jersey State Senate during his term as mayor.

ANTHONY MARCHETTA grew up in New Brunswick, graduated from the local high school in 1967, went to Rutgers University, where he received an MCRP and MBA; he eventually worked for the city of New Brunswick in housing rehabilitation as part of the Federally Assisted Code Enforcement program. Marchetta joined the George Street Playhouse board and later became board president from 1981 to 1985. After working with Matrix Development Group, Baker Residential Inc., and LCOR Inc. (serving as vice president), Marchetta became executive director of the New Jersey Housing and Mortgage Finance Agency in 2010.

ANTON NELESSEN is an architect, urban designer, city planner, and professor at the Edward J. Bloustein School of Planning and Public Policy at Rutgers University. In 1973, after accepting a teaching position in the nascent urban planning program at Rutgers, Nelessen left Harvard University and moved with his wife to New Brunswick. He settled in the Hiram Market area, which would later be transformed through the planning efforts of DEVCO and Johnson & Johnson. Nelessen worked with other local residents to develop an alternative plan for the area, which ultimately was not used. In addition to his academic career, Nelessen has extensive professional experience in planning and urban design.

CHRISTOPHER PALADINO was born in New Brunswick and grew up in North Brunswick. He attended Rutgers University in New Brunswick and then law school in Camden. He worked at a law firm in Roseland and later for Governor James Florio. While serving as deputy director of the New Jersey Economic Development Authority, he became involved in real estate. He was asked by George Zoffinger, New Jersey's commissioner of commerce and economic development, to take over as president of DEVCO after the departure of Christiana Foglio in 1994.

GLENN PATTERSON has been director of planning, community, and economic development for New Brunswick since 1991. He grew up in Point Pleasant Beach, where his father was chairman of the zoning board and his uncle served as mayor and freeholder. He studied political science at American University and developed an interest in urban affairs. In 1983, he enrolled in the graduate urban planning program at Rutgers University. Patterson spent some time working for Asbury Park. Eventually, Christiana Foglio, a New Brunswick city planner and later president of DEVCO, asked Patterson to be her assistant in the Planning Department. He has worked there ever since.

JACQUELINE (JACQUE) RUBEL was born in Canada and married Harry Rubel, a photographer, whose family owned a business at the site where the Hyatt Regency New Brunswick hotel is located. In the late 1960s, Jacque and her hus-

band established a summer arts program for children. Working with the director of Princeton's McCarter Theatre, the director of the New Jersey State Arts Council, the commissioner of education, and the director of the State Museum, she developed the New Jersey State Teen Arts Program. She was appointed to the Middlesex County Cultural and Heritage Commission and was the first director of that agency. In that capacity, Jacque worked with Eric Krebs, artist George Segal, and Rutgers University's Mason Gross to establish New Brunswick as a cultural center in the 1970s. After more than fifty years of professional work as a program developer, director of government and nonprofit arts and education agencies, and arts consultant, she is now director of the not-for-profit Aging in Place Partnership Inc., which she founded in 2008.

PATRICIA SHEEHAN was born and raised in Newark, New Jersey, and attended Trinity College in Washington, DC. She met her husband, Daniel, who grew up in the New Brunswick area, while he was a student at Georgetown Law School. Sheehan stayed in Washington after college and worked for the Air Transport Association. She then moved to New Brunswick in the late 1950s, when Daniel was appointed city commissioner. She was elected mayor of New Brunswick in 1967 as part of the New Five, a coalition that displaced the former New Brunswick political regime of twenty-seven years. She left an unexpired term in February 1974 to serve as commissioner of the New Jersey Department of Community Affairs. She then returned to work for Johnson & Johnson, a position she held while serving as mayor.

JEFFREY VEGA enrolled at Rutgers in 1985 and subsequently was accepted into the graduate fellowship program at the university's Eagleton Institute of Politics. After graduate school, Vega worked for the Center for Non-Profits, providing technical assistance to small nonprofits funded by the New Jersey Division of Youth and Family Services. This work introduced him to nonprofit organizations in New Brunswick and to people in the community, such as David Harris. In 1993 Vega was hired by New Brunswick Tomorrow and served until the end of 2014 in different capacities, most recently as president.

RALPH VOORHEES lived in the New Brunswick area for most of his life. His family name is well known in the area, as members have been major contributors to Rutgers University. Voorhees had planned to become a teacher and worked at two preparatory schools. His career took a different direction after he studied business at New York University: he then became a broker while remaining involved with community service. Voorhees went on to become a senior vice president of Paine, Weber, Jackson & Curtis Inc. Voorhees passed away in November 2013. He served on cultural and hospital boards in New Brunswick.

KENNETH WHEELER is a former Rutgers University provost and urban historian who earned his PhD at Ohio State University. He served on the New Brunswick Tomorrow board and often represented Rutgers University in city of New Brunswick organizations.

New Brunswick Redevelopment
and Economic History: A Timeline

NUMBERS IN PARENTHESES refer to numbered buildings on the figure 4.3 map.

1968

Philip Hoffmann, chairman of the board of Johnson & Johnson, attends a meeting in Washington, DC, with other CEOs to establish a national alliance of businesses to seek workforce solutions. Hoffman asks John Heldrich to take the lead in bolstering employment in New Brunswick.

(1) Plaza I building completed at the corner of George and New Streets in the Commercial Plaza urban renewal tract.

1975

The American City Corporation report released in January finds strong potential for revitalization in New Brunswick and recommends a partnership of the private and public sectors.

New Brunswick Tomorrow (NBT) is officially organized on July 1 with a board of directors representing many segments of the community. John Heldrich is elected chairman.

1976

The New Brunswick Development Corporation (DEVCO) is created in January as a private, nonprofit organization to serve as NBT's implementation partner for economic development. Richard B. Sellars (CEO of Johnson & Johnson) is elected chairman.

A completed blueprint for downtown revitalization by renowned architect and planner I. M. Pei is announced in May. Eight community meetings are held to gather input on the plans.

Results are announced in August from the first citywide poll of New Brunswick residents by the Eagleton Institute of Rutgers University. Commissioned by NBT, the survey reveals a generally supportive and optimistic view of revitalization.

1977

After decades of delay, the US Army Corps of Engineers gives final approval for the Route 18 extension and bridge, and the state Department of Transportation accepts construction bids. Opposed by environmentalists, the project is viewed by Johnson & Johnson and others as key to relieving downtown traffic congestion and opening the way for development.

DEVCO begins construction of the $6.5 million Plaza II office building designed by I. M. Pei on a George Street urban renewal site that has been vacant for over a decade.

The closing of the Family Health Center at Middlesex General Hospital because of financial crisis is averted through action by NBT.

1978

Johnson & Johnson announces in April that it will remain in New Brunswick and will construct a new worldwide headquarters in the heart of the downtown area.

1979

(2) The new Plaza II office building on George Street is opened, representing the first new commercial development in over a decade in downtown New Brunswick.

(6) Johnson & Johnson breaks ground in February for its new headquarters, to be completed in 1982.

Arts Development Associates, a Minneapolis-based consulting firm, recommends development of a major downtown cultural center, with a new George Street Playhouse and renovation of the State Theatre as the top initial priorities.

1980

NBT announces that it will focus on social and human services issues to ensure that the economic benefits of revitalization result in an improved quality of life for city residents.

New Brunswick celebrates the three hundredth anniversary of its founding with a River Festival and Tercentennial Day parade in September.

(3) The new $12 million Route 18 bridge across the Raritan River is opened in October and dedicated to the late former mayor and state senator John A. Lynch Sr.

1981

Ground is broken for the $5 million Paul Robeson Community School.

The city begins improvements to the George Street retail district, with separation of sanitary and storm sewer systems as the initial phase.

(4) 390 George Street, originally built in 1909 as a 54,000-square-foot National Bank of New Jersey building, is acquired by Boraie Development with the intention of maintaining the original character of the design during extensive refurbishment of the interior and exterior, to be completed 1982.

(5) Construction begins on the New Brunswick Parking Authority's $12 million Ferren Parking Deck and Mall across from the railroad station, to be completed 1982.

1982

The NBT Education Task Force announces a leadership development program for New Brunswick school administrators funded by a $30,000 grant from Johnson & Johnson. NBT also creates a Human Services Task Force.

(7) The new Hyatt Regency hotel is dedicated in September at ceremonies attended by Governor Thomas Kean.

NBT launches an innovative education investment contract program to provide jobs and training for non-college-bound high school seniors.

The New Brunswick Cultural Center Corporation is organized in December, with Richard B. Sellars as chairman.

1983

The NBT board approves a $30,000 grant to help initiate a family day care network.

The Cultural Center Corporation announces plans to renovate and recycle four buildings on lower Livingston Avenue, including the State Theatre.

A news conference announces the second phase of downtown public-private redevelopment, featuring projects for the Golden Triangle, lower and upper Church Street, and the Hiram Market area.

The new Johnson & Johnson worldwide headquarters opens in April.

Ferren Mall opens. Its first retail tenants include a new Rutgers bookstore relocated from its campus site.

The United Auto Workers Union opens a new 214-unit building to house senior citizens.

1984

The Eagleton Poll shows that, for the first time, a majority of city residents believe New Brunswick is an excellent or good place to live.

In a major sign of increasing confidence by private investors, the DKM Realty Corporation purchases the Plaza I and II complex from DEVCO for $12.3 million.

NBT forms a new task force on employment, training, and health services.

1985

Mayor John A. Lynch Jr. announces a youth services system to expand recreational, cultural, and counseling services to young people. NBT contributes a grant of $25,000 to help start the system.

Attempt to deregister Hiram Market district from the National Register of Historic Places is finalized in 1992.

1986

Saint Peter's Medical Center announces a five-year, $38 million plan to construct new medical-surgical units, an ambulatory care center, and a new parking deck.

(8) Construction begins on the $11.5 million Albany Street Plaza commercial-retail project on the site of twenty-one buildings that were razed during one of the first urban renewal projects in the downtown. The 130,000-square-foot commercial office and retail complex will also include a parking garage with 180 spaces.

NBT's Health Task Force publishes a comprehensive health care services directory for the community.

(9) Renovation work begins on the historic State Theatre.

Johnson & Johnson celebrates its centennial in the city.

(9) George Street Playhouse moves into the renovated YMCA on Livingston Avenue and presents its first production, *A Streetcar Named Desire*, in its new home in the former YMCA building on Livingston Avenue.

1987

The Eric B. Chandler Community Health Center, operated by the University of Medicine and Dentistry of New Jersey (UMDNJ), opens in modular facilities adjacent to the Redshaw Elementary School.

NBT facilitates creation of the New Brunswick Child Care Consortium.

Ground is broken for the $34 million Golden Triangle Plaza office building at 410 George Street, to be completed in 1989..

1988

New Brunswick is selected to develop a school-based youth services program at New Brunswick High School.

NBT creates an incentive program to encourage high-achieving graduates of the city's elementary schools to attend New Brunswick High School.

(9) The State Theatre opens in April after $3 million in renovations with a sold-out performance by the Jerusalem Symphony Orchestra.

Albany Street Plaza opens.

The city council creates a downtown special improvement district and establishes City Market Inc. to administer it.

1989

NBT adopts a new mission statement, organizing its human services activities in a holistic model around the human life cycle: infant/child, youth/teen, adult/family, and seniors.

(9) Construction begins on the New Brunswick Cultural Center's new $3 million home for the Crossroads Theatre.

(10) Golden Triangle Plaza opens.

The New Brunswick Parking Authority opens its new $3.5 million lower Church Street parking deck, adding 420 downtown spaces.

The new $4.1 million Hungarian Heritage Center is dedicated.

1990

New Brunswick announces a major plan to improve the riverfront area of Boyd Park and make it more accessible to the public. This project is to be funded primarily by state Green Acres money.

1991

(11) Renovations are completed at 358 George Street, formerly the P. J. Young Department Store and home to the Rutgers University Mason Gross School of the Arts. The building was acquired in 1989 and converted into a 65,000-square-foot office and retail space for the Hoagland Law Firm.

(12) The Kilmer Square office and retail complex between lower Albany and Church Streets opens.

The NBT-facilitated Parent Infant Care Center (PIC-C) begins providing services to young parents at the Greater New Brunswick Day Care Council.

Through NBT, the state Department of Human Services provides a $290,000 grant to expand the school-based youth services program from the high school to the city's elementary schools.

The city dedicates a $1.1 million addition to the Senior Resource Center.

The new 264-seat Crossroads Theatre opens in late October, with comedian Bill Cosby featured in a special show during a week of festivities.

1992

NBT begins a comprehensive study of the needs of seniors, with grants, including one from the Fund for New Jersey, and in cooperation with the Rutgers Institute for Health, Health Care Policy, and Aging Research.

Ground is broken for University Center at Easton Avenue, a $50 million joint project of Rutgers, the city of New Brunswick, and Robert Wood Johnson University Hospital to provide housing for Rutgers students, parking, and retail space.

(16) Construction begins on the first phase of the Hiram Square Riverwatch condominium project.

1993

The Agenda 2000 report commissioned by NBT from Leo Molinaro & Associates recommends priorities and directions for revitalization for the coming years and into the twenty-first century.

The Renaissance 2000 initiative to revitalize the Route 27 corridor area is announced in August. The partners—the First Baptist Community Development Corporation, the city of New Brunswick, and NBT—engage the Molinaro firm to begin planning.

A new Parent Infant Care Center opens at New Brunswick High School.

The study of seniors' needs, begun by NBT in 1992, is completed and issued.

(17) Plans are unveiled for a $42 million Civic Square project featuring two new facilities for Rutgers, the Edward J. Bloustein School for Public Policy and the Mason Gross School of the Arts, to be completed in 1995.

1994

A-STEP, the Alliance for Successful Teen Employment Program, is launched as a public-private training partnership among NBT, the city, and the New Brunswick Center of Middlesex County College.

(13) Major openings include the University Center at Easton Avenue, the Puerto Rican Action Board Mario Gonzalez Child Care and Education Center, and the Salvation Army Community Center.

(14) The $10.7 million Providence Square senior residential facility opens in a renovated cigar factory on Somerset Street with ninety-eight units.

(15) Extensive rehabilitation makes the 1920s Livingston Manor available for senior housing.

DEVCO reorganizes under the chairmanship of George R. Zoffinger, chairman of CoreStates New Jersey National Bank and former state commissioner for commerce and economic development.

The Molinaro consulting firm presents its initial conceptual plan for Renaissance 2000.

1998

(18) Liberty Plaza, a mixed-use facility located in the city's downtown, is completed. Location: Central business district on George Street, at the intersection of Liberty Street and Livingston Avenue. Size: 115,000 square feet of administrative space, 20,000 square feet of street-level retail and restaurant space. Occupancy: Administrative headquarters of UMDNJ; retail tenants.

1999

(19) (20) Riverwatch Residential Community is completed in July. Location: Hiram Market, near the central business district between Neilson Street and Route 18. Size: 199 market-rate apartments in three buildings; 30 townhouses. Occupancy: Market-rate owners and residential leasing tenants.

(21) The Middlesex County Administration Building, opened in October, is the first government building completed as part of the Civic Square initiative, representing New Jersey's first privately conceived, planned, developed, constructed, and maintained government complex. Location: Central business dis-

trict, Bayard and Kirkpatrick Streets. Size: 115,000 square feet. Occupancy: County of Middlesex.

2000

(22) The Civic Square Public Safety Building is completed in May. Government services are located in a more convenient, attractive, and accessible environment, with high-security functions contained in a separate structure. Location: Kirkpatrick Street. Size: 118,000 square feet. Occupancy: United States Postal Service, New Brunswick Police Department, New Brunswick Municipal Courts, Middlesex County prosecutor.

(23) Middlesex County Family Courthouse is opened in June after a complete floor-by-floor modernization of the former aging and inefficient courthouse. Location: New Street. Size: 108,000 square feet. Occupancy: Middlesex County Superior Court.

2001

Memorial Homes high-rise housing project is demolished in August.

(24) Hope Manor Apartments is built to provide affordable rental units to former residents of Memorial Homes.

2002

The new Lord Stirling Community School is completed, the state's first public school to be constructed as a redevelopment project. The high-amenity facility includes a performance auditorium, a gymnasium, and facilities for enhanced arts and technology education for students from pre-kindergarten through grade 8. Location: Lower George Street redevelopment area. Size: 103,000 square feet. Occupancy: New Brunswick Board of Education.

(25) Tower 2 of Albany Street Plaza is constructed. It consists of 70,000 square feet of office space on six new floors added on top of a two-story portion of the original building from 1986.

2003

(26) Civic Square IV is completed, consisting of courthouse renovations and Skyline Tower.

2004

(27) The Highlands apartment complex is constructed on Richmond Street.

2005

(28) The Child Health Institute (CHI) of New Jersey is completed in May. CHI includes laboratories, office and administrative space, a transgenic and gene targeting facility, and vivarium. The CHI further strengthens New Brunswick's concentration in the health care industry. Location: Situated among the campuses of Robert Wood Johnson University Hospital, UMDNJ–Robert Wood Johnson Medical School, and the Cancer Institute of New Jersey, bordered by Plum and Scott Streets. Size: 145,000 square feet. Occupancy: Robert Wood Johnson Medical School.

(29) Rockoff Hall, a mixed-use project in New Brunswick's downtown corridor, is completed in August. The partnership between Rutgers University and DEVCO provides Rutgers with additional housing to meet a growing demand for upgraded student residence options and adds 670 residents to the urban core. Location: George Street between New Street and Morris Street. Size: 261,000

square feet (186 apartment suites, street-level retail, and a parking garage with 815 spaces). Occupancy: Rutgers University students; retail leasing tenants.

(30) The Rutgers Public Safety Building is completed in the George Street redevelopment area. The structure houses the university's extensive public safety operations and also serves as a direct link between the main College Avenue campus and the Douglass and Cook College campuses at the southern edge of the city. Location: George Street at Commercial Avenue. Size: 75,000 square feet of office and administration space, plus structured parking for approximately 385 vehicles. Occupancy: Rutgers Division of Public Safety, including Police Emergency Services, Parking and Transportation, and administrative functions.

2006

(31) One Spring Street, a 400,000-square-foot mixed-use building is completed. The twenty-five floors include ground-level retail space, commercial office space, and 121 luxury condominiums and associated parking. The site had been used for surface parking prior to acquisition by Boraie Development.

2007

(32) The Heldrich, a 250-room hotel and conference center, is completed. It also features retail space, academic space, and luxury condominiums. The cornerstone of this mixed-use facility is the John J. Heldrich Center for Workforce Development. Location: Livingston Avenue between George Street and New Street. Size: 365,000 square feet. Occupancy: the Heldrich , the Rutgers University John J. Heldrich Center for Workforce Development, forty-eight condominiums, street-level retail space.

Ground breaking for the Stem Cell Institute of New Jersey. This project was not completed due to lack of state funding.

2010

New Brunswick High School is completed in January. The goal of this Board of Education and DEVCO partnership is to provide a high-amenity school facility for New Brunswick students and to coordinate the high school and neighborhood revitalization efforts. Through structured "small learning communities," general instructional areas have been designed to maximize flexibility.

2011

Demolition begins to clear the site for the New Brunswick Wellness Plaza.

The former Mandell's Pharmacy on the corner of George and Church Streets is completely renovated by Boraie Development to feature a two-floor restaurant, with apartments on the third floor

2012

(33) The mixed-use Gateway Transit Village offers structured parking, considerable retail spaces, and a significant residential component. The facility is directly connected to the Northeast Corridor rail line platform by way of a pedestrian promenade. Location: Somerset Street and Easton Avenue, adjacent to the Northeast Corridor train line. Size: 623,893 square feet on a 1.2 acre parcel, 298 feet in height. Occupancy: 200 residential units (222,123 square feet, 15 stories), destination retail, including a new university bookstore, quality restaurants and shops, a 656-space parking structure on nine levels

2013

(34) The completed Health and Wellness Center opens with a Fresh Grocer, the city's first new supermarket in years, on the street level. This $95.3 million project includes a 1,200-space parking garage and a pedestrian bridge to the New Brunswick train station platform.

(35) The George, a fourteen-story luxury apartment building, opens on George and New Streets.

(36) (38) DEVCO breaks ground for a $330 million project on the College Avenue campus that will include a university academic building, a residential honors college, Rutgers Hillel, and the New Brunswick Theological Seminary. In addition, a new student apartment building, green space, and retail space are planned for the corner of College Avenue and Hamilton Street. Completion for all of these projects is targeted for 2016.

2014

(37) Constructed by Boraie Development on the site of eight two-story multi-family houses, 44 Easton Avenue, the Aspire, consists of 238 apartments, retail space, and 240 parking spaces. This property was completed in 2015.

2015

(36) Rutgers University honors college building and (37) Boraie Development apartment building completed.

2016

(36) Rutgers University academic building and (38) residential complex were scheduled to be completed in 2016.

SOURCES: New Brunswick Development Corporation (DEVCO) and New Brunswick Tomorrow.

MAP 1. "Novi Belgi Novaique Angliae," 1684

MAP 2. New Brunswick, New Jersey, within Region

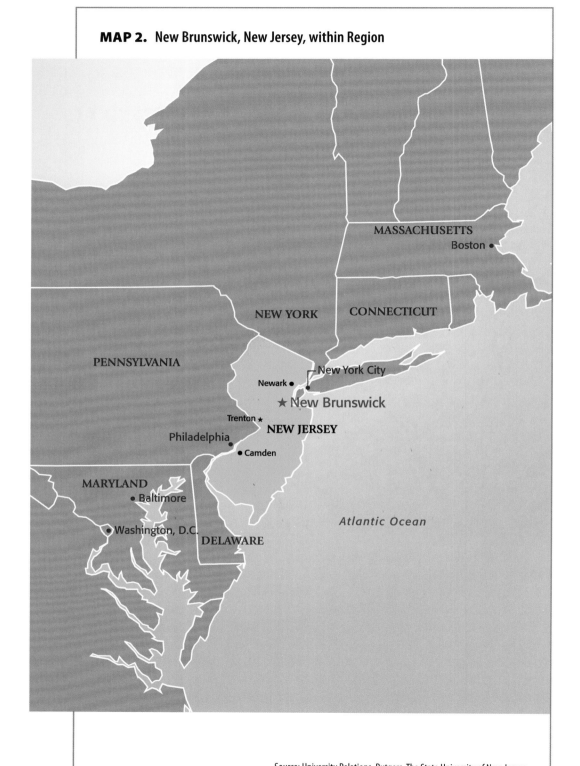

Source: University Relations, Rutgers, The State University of New Jersey.

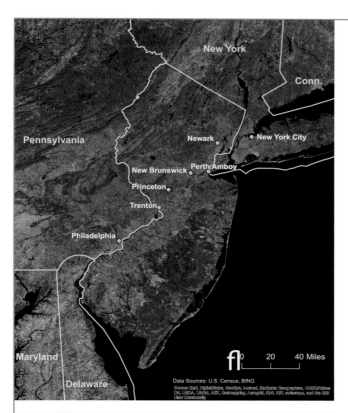

MAP 3.
New Brunswick,
within State

Data source: US Census, Bing.
Map creation: Jennifer Whytlaw,
Edward J. Bloustein School of
Planning and Public Policy.

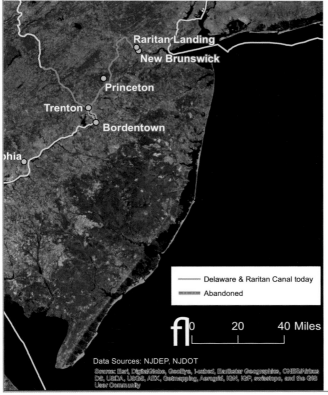

MAP 4.
Delaware and
Raritan Canal

Data source: NJDEP, NJDOT.
Map creation: Jennifer Whytlaw,
Edward J. Bloustein School of
Planning and Public Policy.

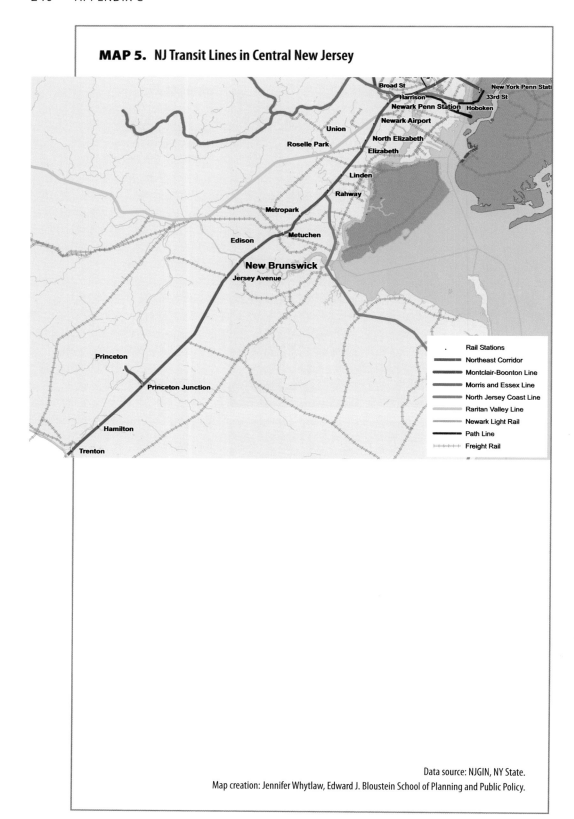

MAP 5. NJ Transit Lines in Central New Jersey

Data source: NJGIN, NY State.
Map creation: Jennifer Whytlaw, Edward J. Bloustein School of Planning and Public Policy.

MAP 6. Major Highways in New Jersey

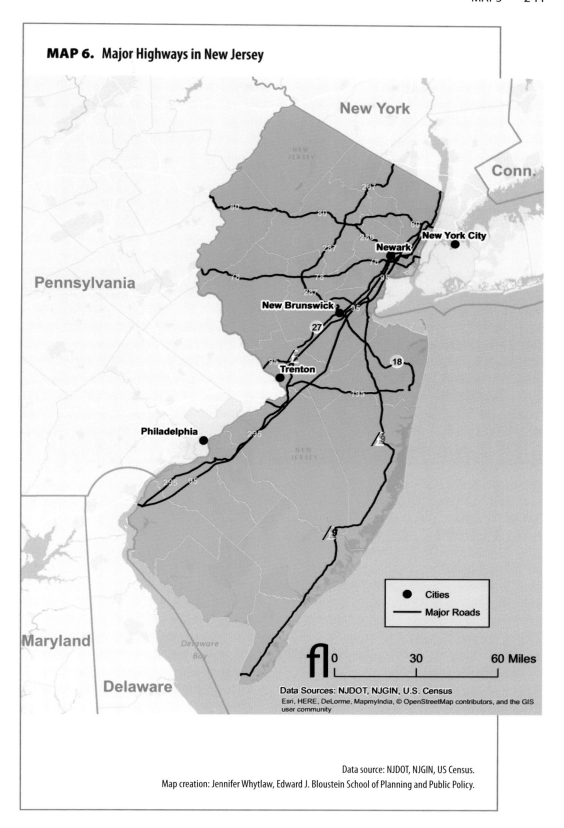

Data source: NJDOT, NJGIN, US Census.
Map creation: Jennifer Whytlaw, Edward J. Bloustein School of Planning and Public Policy.

MAP 7. New Brunswick and Surrounding Communities

Data source: NJGIN.
Map creation: Jennifer Whytlaw, Edward J. Bloustein School of Planning and Public Policy.

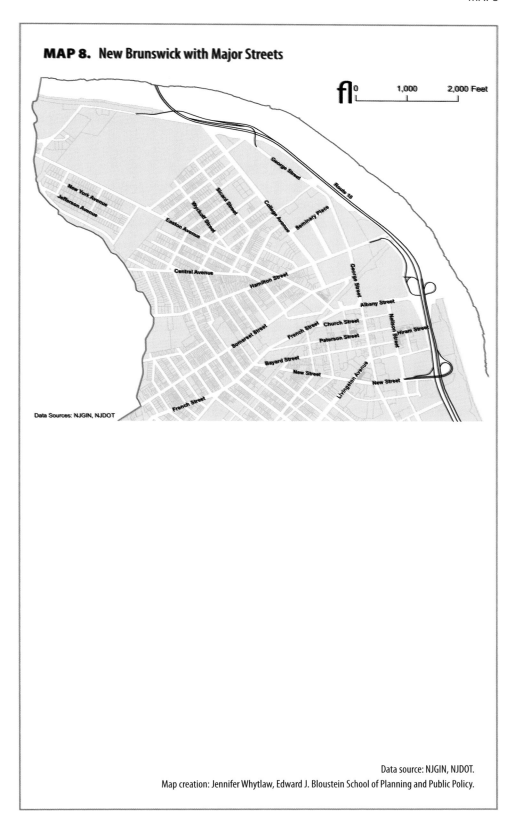

MAP 8. New Brunswick with Major Streets

0 1,000 2,000 Feet

George Street

Route 18

Richard Street

New York Avenue

College Avenue

Jefferson Avenue

Wycoff Street

Seminary Place

Easton Avenue

Central Avenue

Hamilton Street

George Street

Albany Street

Church Street

Neilson Street

Somerset Street

French Street

Hiram Street

Paterson Street

Bayard Street

New Street

Livingston Avenue

New Street

French Street

Data Sources: NJGIN, NJDOT

Data source: NJGIN, NJDOT.
Map creation: Jennifer Whytlaw, Edward J. Bloustein School of Planning and Public Policy.

MAP 9. Rutgers–New Brunswick Campuses

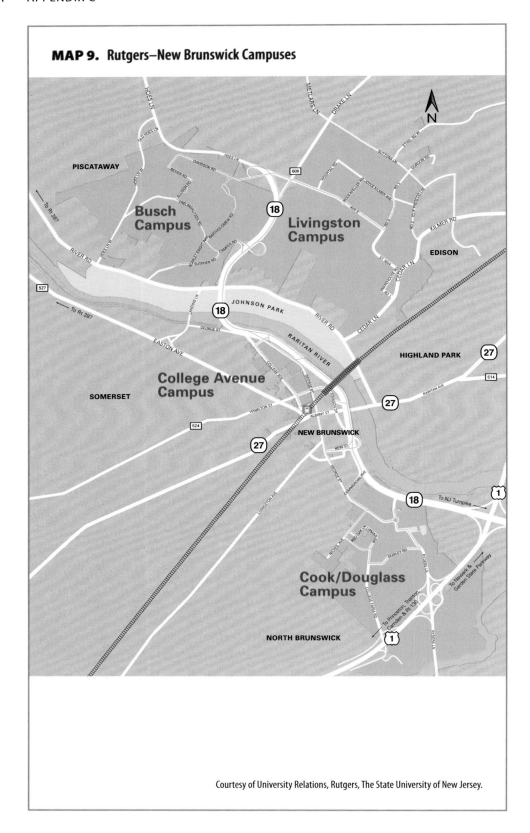

NOTES

Chapter 1 The Economy of New Brunswick

1 Only the original power plant of Johnson & Johnson's manufacturing complex remains, just in front of Johnson Hall, the neo-Georgian Johnson & Johnson structure facing Route 18 just west of the Northeast Corridor rail bridge. It now serves as a museum of historical Johnson & Johnson products.

2 The barracks was located at the northwestern corner of the intersection of Paterson Street and George Street. Based on historical sketches, the New Brunswick barracks was very similar in design to the Old Barracks in Trenton, which is the oldest surviving building in the United States specifically constructed to quarter military personnel. It has been preserved as a historical museum.

3 "New Brunswick soon became one of the great agricultural depots of the Colony. Every stream that could turn a wheel had its mill. Warehouses and inns were erected, and the river front was lined with vessels" (Federal Writers' Project 1939, 300).

4 The displacement of land-based highways and turnpikes by the first railroads at the beginning of the nineteenth century would come full cycle in the mid-twentieth century, when ever-expanding highways undermined the railroads.

5 Most of the transactions took place in Hiram Market, the early commercial heart of the city. Today, it is the site of upscale townhouses.

6 The most significant product for New Brunswick was sterile surgical dressings. For a history of the Johnson & Johnson Company and its almost accidental location in the city, see chapter 129 of the blog maintained by Margaret Gurowitz, the company's chief historian, at http://www.kilmerhouse.com/.

7 Longer belts used in power transmission were far less efficient than short ones; thus, spreading out production processes horizontally was inhibited. With the advent of electric motors, this constraint was removed. Today, the most efficient horizontal layout of production processes determines the basic footprint/floor plate of factory structures.

8 This railroad was established in 1888, running from South Amboy to railroad yards in New Brunswick, which were completed in 1891. It facilitated the further decentralization of manufacturing into North Brunswick and Milltown. In 1898, the National Musical String Company opened a manufacturing facility along the railroad in North Brunswick, just outside New Brunswick. In Milltown, the Willis W. Russell Card Company opened a factory in 1906; today that is a residential condominium complex. The Michelin Tire Company factory followed in 1907.

9 Production in New Brunswick ceased in the mid-1970s; the former factory currently houses Saint Mary's Apartments, a residential complex.

10 For entertaining chapters from the history of Johnson & Johnson, see the blog maintained by Margaret Gurowitz, the company's chief historian, at http://www.kilmerhouse.com/.

11 John W. Mettler had an influential role in town planning in New Jersey. During the
Great Depression, Franklin Roosevelt's Resettlement Administration created the
Greenbelt Town Program to build planned communities close to employment centers
and surrounded by preserved green space and agricultural lands. Three of four
model towns were built: Greenbelt, Maryland (outside Washington, DC); Greenhills,
Ohio (outside Cincinnati); and Greendale, Wisconsin (outside Milwaukee). A fourth
greenbelt town, Greenbrook, was to be located between New Brunswick (a major
employment center) and Bound Brook (a minor employment center). The site included
Mettler's East Millstone estate, which had been in his family since 1689. He and four
other property owners brought a suit that essentially had the Greenbelt Town Program
declared unconstitutional. Although Greenbrook was never built, the Mettler estate
is now part of Colonial Park, a major facility in the Somerset County park system. See
Arnold 1971.

12 Little remains of this original commercial heart except the streets themselves—Neilson
Street, Hiram Street, Hiram Square, Dennis Street, and Richmond Street.

13 Early in the nineteenth century, it was known as Queen Street east of Albany Street, and
King Street to the west.

14 As the city grew, the natural expansion was to the south, away from the river.

15 The right-of-way of the Bound Brook line is still evident today between River Road and
Johnson Park in Piscataway.

16 The bank's building at the old location still stands opposite the Hyatt Regency hotel and
is the home of the Old Bay Restaurant.

17 It subsequently was known as the Roger Smith Hotel and, until the 1960s, was Middlesex
County's premier hostelry. Today's Heldrich Plaza is located at this exact location. See
"Woodrow Wilson Hotel," Rutgers University Community Repository, https://rucore.
libraries.rutgers.edu/rutgers-lib/31604/.

18 Charles Carpender partnered with Jacob Janeway in the successful wallpaper firm of
Janeway & Carpender (Jenkins et al. 2007). The Carpender House is now home to the
Rutgers University Inn and Conference Center.

19 In 1918, Congress created the United States Housing Corporation to provide housing for
war workers near industrial centers. It was incorporated as a unit of the U.S. Department
of Labor's Bureau of Industrial Housing and Transportation. New Brunswick's project
was originally planned to have 397 units of various types—detached, semidetached, and
row houses. The design was fairly sophisticated, reflecting the Garden City movement,
which was at the height of its influence. The New Brunswick project was planned as a
traditional English village with playgrounds, parks, a school, and stores. By 1919, only
192 units had been constructed, and the project was never completed. Eran Ben-Joseph,
"Workers' Paradise: The Forgotten Communities of World War I; New Brunswick,"
http://web.mit.edu/ebj/www/ww1/NewBrunswick.html.

20 They would remain the tallest private-sector rental-housing structures in New
Brunswick until the luxury nineteen-story Colony House (originally Buccleuch Park
Towers) was built in the early 1960s on the western edge of Buccleuch Park near the
intersection of George Street and Landing Lane. Its construction, along with a smaller
companion mid-rise rental building, covered over parts of Raritan Landing.

21 Beginning in 1913, Albany Street was included as a part of the Lincoln Highway, the
nation's first transcontinental highway. Richard F. Weingroff, "The Lincoln Highway,"
http://www.fhwa.dot.gov/infrastructure/lincoln.cfm.

22 Permacel Tape was a new division of Johnson & Johnson, originally called the Revolite
Corporation, created in 1927. An outgrowth of the company's surgical tape business, the
unit was formed to create and market industrial adhesives and masking tapes. During
World War II, the North Brunswick plant invented duct tape for the U.S. Army, which
needed waterproof sealing tape for ammunition boxes. Soldiers began to call it "duck
tape," for its waterproof qualities. After the war, it acquired the name "duct tape" because
it was used to seal heating and air conditioning duct work during the postwar housing
boom (De Angelo 2007).

23 James W. Hughes, "One-Half Century of Housing Production in New Jersey 1940 to 1990," *Rutgers Regional Report,* issue paper number 1, December 1990. Technically, the unit numbers here are "dwelling units authorized by building permits."

24 Arnold Constable was a Manhattan retail emporium that began to open suburban branches in the 1950s. For the most part, it chose locations at the edge of central business districts. The New Brunswick store was an experiment in retail technology. It had parking on the roof for 200 cars, with elevator access to the main shopping level and the basement. It was the premier retail facility in Middlesex County when it opened. For a history of suburban department stores, see Longstreth 2010.

25 One parcel was developed at the northeast corner of New Street and George Street after the overpass was constructed. It was intended to be a Holiday Inn, but by the time it was completed (mid-1960s), the proliferation of motels outside of the city led to the decision to convert it to an office building. The six-story office structure, called Plaza I, struggled for many years to gain full occupancy. It still exists today (303 George Street).

26 The regional mall was a fully integrated development that competed in size with the traditional downtown or urban core. It could completely control the mix of anchor department stores and other retailers and restaurants. It also had consistent aesthetics and well-thought-out layouts to stimulate consumption.

27 Like Arnold Constable, Bamberger's first expanded from its flagship emporium (in Newark) to suburban downtowns. But it quickly and aggressively shifted strategies as regional malls proliferated.

28 The complete envelopment of New Brunswick by enclosed regional malls took place in 1988 with the opening of Bridgewater Commons, located in Bridgewater Township, approximately ten miles northwest of New Brunswick.

29 The Garden State Parkway, fully completed in 1956, is located approximately 6.5 miles northeast of New Brunswick.

30 The full name was the Penn Central Transportation Company. The two railroads were once strong rivals, but the Federal-Aid Highway Act of 1956—which authorized the building of the Interstate Highway System—helped to undermine the basic railroad business model.

31 Conrail, formed in 1976 through the merger of many financially troubled and bankrupt railroads, took over the commuter operations in the state under contract to the Commuter Operating Agency of the New Jersey Department of Transportation (NJDOT), which had been created in 1966. In 1983, New Jersey Transit (NJ Transit), founded in 1979 as an offspring of NJDOT, took over all of the former private rail lines that Conrail had acquired. Today, it is the largest statewide public transit system in the nation.

PHOTO ESSAY The Corner of Albany and George Streets

1 It was equivalent to the intersection of Broad Street and Market Street in Philadelphia and the intersection of Broad Street and Market Street in Newark, New Jersey. The latter, labeled Four Corners, was claimed to be the busiest traffic center in the world (Parsons 1928, 349).

Chapter 2 The People of New Brunswick

1 Not coincidentally, a history of the county surrounding New Brunswick is entitled *Middlesex County: Crossroads of History* (Karasik and Aschkenes 1999), and an immigration analysis of the county was titled *Crossroads of the World: New Americans in Middlesex County, New Jersey* (Mann 2011). In a larger context, New Jersey has been a cultural crossroads from its origins. According to cultural geographer Peter Wacker, "New Jersey was without question the most culturally diverse of the European North American colonies" (Wacker n.d., 199). A pamphlet for an exhibition at the Newark Public Library on "The People of New Jersey: Their Enduring Journey" noted that New Jersey is "often called the most diverse state in America" (Cummings 2004, 1).

2 Parent 1982, 125. New Brunswick residents who grew up in the city have frequently commented on its demographic diversity. See, for example, the oral interviews of Bennet Hoffman (by Diane Hoffman), Elizabeth Garlatti (by Peter Garlatti), Joan Suber (by John Lane), William Manley (by Kelly Manley), all dated October 5–6, 2007, and Marilyn Herod (by Daniel Littlewood), and available as streaming audio from the New Brunswick Free Public Library (http://nbfpl.org/story.html).

3 Between 1800 and 1900, the territorial size of the United States tripled, from under less million square miles to approximately three million square miles (Vanderbroucke 2008).

4 The increase in immigrants was a delayed event spawned by the Immigration and Nationality Act of 1965, which fundamentally changed the nation's immigration policies by phasing out the national origins quota system first instituted in 1921. The new policy helped generate another great immigration wave, but this time it was dominated by flows from Asia and Latin America. See the more detailed discussion later in this chapter.

5 For a historical review, see Gibson and Lennon 1999. For a contemporary snapshot, see Grieco, Acosta et al. 2012.

6 Coverage of all of the many groups residing in New Brunswick over time is beyond the scope of this book. The Greek, Polish, and Jewish communities, as well as Asians, are omitted. The following sections are indebted to Patt 1982.

7 Some have argued that Ireland experienced fewer deaths and more emigration than is commonly claimed; see, for instance, Nusteling 2009.

8 Cecilia Clafen, oral history interview, October 5–6, 2007, by Daniel Littlewood, New Brunswick Free Public Library (http://nbfpl.org/story.html).

9 Joseph Homoki, oral history interview, October 5–6, 2007, by Rose Gorman, New Brunswick Free Public Library (http://nbfpl.org/story.html).

10 http://hstrial-pfazekaz.homestead.com/index.html. Accessed May 21, 2015.

11 As of the 1990 census, the New Brunswick numbers (and percentage of total city population) by racial group included, in alphabetical order: 130 American Indian, Eskimo, Aleut (0.3%); 1,634 Asian (3.9%); 12,337 black (29.6%); 17 Pacific Islander (0.0%); 23,929 white (57.4%); and 3,664 (8.8%) "other races." The racial categories changed after the 2000 census. As of the 2010 census, the New Brunswick number (and percentage of total city population) by racial group included, in alphabetical order: 498 American Indian (0.9%); 4,195 Asian (7.6%); 8,852 black alone (16.0%); 19 Native Hawaiian/Pacific Islander (0.0%); 25,071 white alone (45.4%); 14,122 (25.6%) "some other race"; and 2,424 (4.4%) "mixed race."

12 It should be noted that in 2010, 10,301 Hispanics identified as "white alone," and 1,109 identified as "black or African American alone." So, although the growth in the Hispanic population that identifies as a race other than black or white alone results in a smaller share of the total population that is white or black, Hispanics also contribute to the absolute number of both these racial groups.

13 Marilyn Herod, oral history interview, October 5–6, 2007, by Daniel Littlewood, New Brunswick Free Public Library (www.nbfpl.org/story.html). Interestingly, Herod spoke about slavery and soul food, based on research she had conducted in New Brunswick. See also the interviews cited in note 2.

14 S. Douglass Greenberg, Princeton University lecturer and historian. Quotation contained in New Brunswick Free Public Library Vertical File on "Slavery in New Brunswick." See also "An Intimate View of New Brunswick in Year 1792," *Home News Tribune*, March 27, 1927.

15 Alice Jennings Archibald, oral history interview, March 14, 1996, by G. Kurt Piehler and Eve Snyder, Rutgers Oral History Archive (http://oralhistory.rutgers.edu/interviewees/750-archibald-alice-jennings). Accessed May 6, 2015. Page numbers of the transcript are provided parenthetically in the text.

16 http://www.olmtcarmelonline.com/english.html.

17 "Our History," https://prab.org, accessed May 27, 2015.

18 Mariam Merced, director of the Robert Wood Johnson University Hospital's Community Health Promotion Program, oral history interview for the project "Mapping New Bruns-

wick Memories," initiated by Andrew Urban, assistant professor in the American Studies and History departments at Rutgers University, and Chris Rzigalinski of American Studies and English departments at Rutgers University (http://mappingnewbrunswickmemories.org/exhibits). See Lin Lan, "Faculty, Students Create Digital History of New Brunswick," *Daily Targum*, December 3, 2014, http://www.dailytargum.com/article/2014/12/faculty-students-create-digital-history-of-new-brunswick.

19 "Hispanic or Latino by Type: 2010," U.S. Bureau of the Census, American FactFinder, factfinder.census.gov.

20 Rebecca Escobar, oral history interview, http://mappingnewbrunswickmemories.org/exhibits. See also "Hispanic or Latino by Type: 2010."

21 *Facts about New Brunswick, New Jersey, as an Industrial Center* (pamphlet, n.d.), 75. "New Brunswick: A City of Industry and an Education Center" (ca.1925–30), cited in Zeitz 1998, 6; "1946 City Report and Planning Assessment," cited in Zeitz 1998, 12.

22 On the Map Application, U.S. Census Bureau, Center for Economic Studies, http://onthemap.ces.census.gov.

23 Joan Suber, oral history interview, October 5–6, 2007, by John Lane, New Brunswick Free Public Library (http://www.nbfpl.org/story.html). See also the interviews cited in note 2.

24 Employment, Hours and Earnings from the Current Employment Statistics Survey, U.S. Department of Labor, Bureau of Labor Statistics.

25 "Leather Firm among Oldest Concerns in New Brunswick?" *Home News* January 19, 1970.

26 Dick Costello, photo captions, *Home News*, February 2, 1975.

27 The same study found that the twenty central cities examined lost an average of about one-fifth of their manufacturing jobs between 1970 and 1975 alone (Black 1978, 18).

28 Poverty is measured in different demographic metrics: families, family heads, unrelated individuals, persons, and households. The person's poverty rate is reported here in this paragraph.

Chapter 3 The National Context of Urban Revitalization

1 This section is extracted from Listokin 1991.

2 http://www.whitehouse.gov/thepress_office/Remarks-by-the-President-at-urban-and-metropolitan-roundtable/.

Chapter 4 New Brunswick Transformation

1 Dorothea Berkhout and David Listokin of the Edward J. Bloustein School of Planning and Public Policy at Rutgers University conducted twenty-four oral history interviews. These are cited as: interviewee name, interview, and page number of transcript, and short biographical sketches are included in appendix A. Four additional sources of oral history interviews are used and cited in this book. Whenever any of these additional oral histories or interviews are referred to in the monograph, the specific source and full bibliographic citation is indicated:

1. Oral histories of fourteen New Brunswick residents conducted by the nonprofit group StoryCorps on October 5 and 6, 2007, available at the New Brunswick Free Public Library website.

2. Rutgers Oral History Archives—a Rutgers University History Department Affiliated Center—started in 1994. Several are with New Brunswick residents.

3. "Mapping New Jersey Memories" was initiated by the George Street Playhouse in collaboration with Rutgers University American studies and history faculty members Andrew Urban and Chris Rzigalinski.

4. Interviews of New Brunswick residents conducted by the Rutgers Eagleton Institute of Politics, Center for Urban Interest Polling in ongoing surveys commissioned by New Brunswick Tomorrow.

2 In an interesting footnote to history, Cornelius Vanderbilt and his wife owned and operated the Bellona Hotel, located on Burnet Street, and this hotel and associated shipping activities in New Brunswick contributed to the start of his ultimate great fortune (*San Francisco Call* 1901).

3 While separate from J&J, Robert Wood Johnson Foundation supported the New Brunswick Redevelopment. For example, it gave a $1 million grant to New Brunswick Development Corporation from 1984 to 1986 to develop a revitalization program for New Brunswick.

PHOTO ESSAY **The Transformation of Seminary Hill**

1 It was also called the Theological Seminary of the Reformed Church of America, New Brunswick, N.J.

Chapter 5 New Brunswick Transformation

1 Descriptions of the Providence Square and Livingston Manor developments are adapted from project descriptions from DEVCO and Pennrose Properties.

Chapter 6 Looking to the Past and Future of New Brunswick and National Urban Revitalization

1 This section on urban renewal/urban redevelopment is adapted from Burchell et al. 2000.

2 State aid is granted according to complex formulas. Depending on the aid formula, community profile, and project scale, redevelopment with a PILOT may or may not reduce state aid.

3 This review of the historic preservation history in the Unites States is adapted from Listokin et al. 1998.

4 The following quantitative analysis and interpretation of the NBT/Eagleton survey data was done by Marc Weiner and Orin Puniello of the Edward J. Bloustein School of Planning and Public Policy.

5 Wilson 1968. For one contemporary update on the urban situation as examined earlier by Wilson, see Inman 2009.

REFERENCES

NOTE: Interviews cited in the text with name, interview, and page number refer to transcripts of interviews conducted by the authors and are grouped in Appendix A. All other interview citations are included in this list of references.

300th Anniversary Committee, 1982. *The Tercentennial Lectures, New Brunswick, New Jersey.* New Brunswick: City of New Brunswick.

Abravanel, Martin D., Nancy M. Pindus, and Brett Theodos. 2011. "What Makes for a Smart Community or Economic Development Subsidy? A Program Evaluation Perspective." *Smart Subsidy for Community Development.* Urban Institute, July.

Abt Associates Inc. 2003. *Exploring the Impacts of the HOPE VI Program on Surrounding Neighborhoods.* Cambridge, MA: Abt.

———. 2009. *Evaluation of the Low-Income Housing Tax Credit.* Cambridge, MA: Abt.

Advisory Committee on Government Housing Policies and Programs. 1953. *Slum Preservation through Conservation and Rehabilitation: Study Presented to the Sub-committee on Urban Redevelopment, Rehabilitation, and Conservation, Advisory Committee on Government Housing Policies and Programs.* Washington, DC: Housing Home Finance Agency and Home Loan Bank Board.

American City Corporation. 1975a. *New Brunswick Tomorrow.* Columbia, MD. American City Corporation.

———. 1975b. *Trends, Issues and Priorities in the Revitalization of New Brunswick, New Jersey.* Columbia, MD: American City Corporation.

American Hospital Directory. 2015. "Saint Peter's University Hospital." http://www.ahd.com/free_profile.php?hcfa_id=822908ee73dfb2aef927282ab1f2bbf3&ek=d929d370f9a3d23e1c0c18f659236021.

Anderson, Martin. 1964. *The Federal Bulldozer.* Cambridge, MA: MIT Press.

Arnold, Joseph L. 1971. *The New Deal in the Suburbs: A History of the Greenbelt Town Program 1935–1954.* Columbus: Ohio State University Press.

Attrino, Anthony. 2014. "John J. Heldrich, Former Top Executive at Johnson & Johnson and Civic Leader Dies at 88." NJ.com. October 28.

"Bardin Ruling on Route 18 Shift Awaited." 1975. *New York Times,* April 6.

Barnes, William. 2005. "Beyond Federal Urban Policy." *Urban Affairs Review* 40 (5): 575–589.

Barrett, Bill. 1970. "Pollution Could Affect Students' Health." *Daily Targum,* November 14, 1.

Beauregard, Robert. 2003. *Voices of Decline: The Postwar Fate of U.S. Cities.* Rev. ed. New York: Routledge.

Becker, C. J., S. A. Grossman, and B. Dos Santos. 2011. "Business Improvement Districts: Census and National Survey." Institute of Business District Management, School of Public Affairs and Administration, Rutgers University, Newark, NJ. Report for International Downtown Association. Washington, DC.

Bhutta, Neil. 2009. "GSE Activity and Mortgage Supply in Lower-Income and Minority Neigh-
 borhoods: The Effect of the Affordable Housing Goals." Finance and Economic Discussion
 Series, Divisions of Research & Statistics and Monetary Affairs. Washington, DC: Federal
 Reserve Board, March.

Black, J. Thomas. 1978. *The Changing Economic Role of Central Cities*. Washington, DC: Urban
 Land Institute.

Bloom, Nicholas Dagen. 2004. *Merchant of Illusion: James Rouse, American Salesman of the
 Businessman's Utopia*. Columbus: Ohio State University Press.

Borbely, James A. 2009. Oral History Interview, March 27, by Shaun Illingworth and Jordan
 Richman, Rutgers Oral History Archives. http://oralhistory.rutgers.edu/alphabetical-
 index/31-interviewees/820-borbely-james-a.

Boyle, Sheila Tully, and Andrew Bunie. 2002. "Paul Robeson: Rutgers Phenomenon, 1915–1919."
 In *Paul Robeson: Essays on His Life and Legacy*, edited by Joseph Dornison and William
 Pencak. New York: Guilford Press. 31–64.

Bradshaw, Jennifer. 2015. "Black History Month in New Brunswick: Mayor Aldrage B. Cooper,
 Jr." http://thecityofnewbrunswick.org/blog/2015/02/25/black-history-month-in-new-
 brunswick-mayor-aldrage-b-cooper-jr/.

Brennan, Katie. 2010. "Civic League of Greater New Brunswick: An Evolution of Success."
 Community Development Case Study, Edward J. Bloustein School of Planning and Public
 Policy.

Brown, Anna. 2014. "The U.S. Hispanic Population Has Increased Sixfold since 1970." Pew
 Research Center. http://www.pewresearch.org/fact-tank/2014/02/26/the-u-s-hispanic-
 population-has-increased-sixfold-since-1970/.

Burchell, Robert W., David Listokin, and Catherine Galley. 2000. "Smart Growth: More Than a
 Ghost of Urban Policy Past, Less Than a Bold New Horizon." *Housing Policy Debate* 11 (4):
 821–879.

"Busing Becomes a Campaign Issue." 1973. *New York Times*, April 5.

Byrne, Margaret. 1982. "The Irish Community." In *The Tercentennial Lectures, New Brunswick,
 New Jersey*, edited by Ruth Patt, 60–66. New Brunswick: City of New Brunswick.

Cahill, James. 2014. "Letter from Mayor Cahill." In "New Brunswick Redeveloping the Urban
 Experience," a supplement to *NJBIZ 2014*, 4.

Caro, Robert. 1976. *The Power Broker: Robert Moses and the Fall of New York*. New York: Knopf.

Cassity, Pratt. 1996. *Maintaining Community Character: How to Establish a Local Historic
 District*. National Trust for Historic Preservation Information Series. Washington, DC:
 National Trust for Historic Preservation.

Cisneros, Henry G., and Lora Engdahl, eds. 2009. *From Despair to Hope: Hope VI and the New
 Promise of Public Housing in America's Cities*. Washington, DC: Brookings Institution.

City of New Brunswick, N.J.: Its History, Its Homes, Its Industries. 1909. Reprint, New Brunswick,
 NJ: Clark's Bookstore, 1979.

Clarke, Sarah. 2010. Executive Vice President, DEVCO,. Interview by David Listokin and Katie
 Brennan of Rutgers University. November 9.

Coakley, John W. 2014. *New Brunswick Theological Seminary: An Illustrated History, 1784–
 2014*. Grand Rapids, MI: William B. Eerdmans.

Cohen, David Steven. 2006. "The Lenape Village at Waterloo." Trenton: NNJ Public Television
 and New Jersey Historical Commission. http://www.nj.gov/state/historical/pdf/lenape-
 guide.pdf.

Cohn, D'Vera. 2010. "Race and the Census: The 'Negro' Controversy." Pew Research Center,
 Social and Demographic Trends. http://www.pewsocialtrends.org/2010/01/21/race-and-
 the-census-the-"negro" -controversy/.

———. 2014. "Millions of Americans Changed Their Racial or Ethnic Identity from One
 Census to Another." Pew Research Center, Social and Demographic Trends. http://www
 .pewresearch.org/fact-tank/2014/05/05/millions-of-americans-changed-their-racial-or-
 ethnic-identity-from-one-census-to-the-next/.

Collins, William, and Katherine Shester. 2011. "Slum Clearance and Urban Renewal in the
 United States." National Bureau of Economic Research, working papers 17458, September.

———. 2013. "Slum Clearance and Urban Renewal in the United States." *American Economic Journal: Applied Economics* 5 (1): 239–273.

Colon, Otilio. 1982. "A Brief History of the Hispanic Community in New Brunswick, 1948–1980." Prepared for *Tercentennial Lectures, New Brunswick, New Jersey*, edited by Ruth Patt, 57–59. New Brunswick: City of New Brunswick.

Community-Wealth 2012. "Overview: Community Development Corporations (CDCs)." http://www.commonunity-wealth.org/strategies/panel/cdcs/index.html.

Company Spotlight. 2015. "Johnson & Johnson." http://www.companyspotlight.com/JNJ/company-people.

Conte, Michaelangelo. 2014. "Plans to Dissolve the Autonomous Jersey City Parking Authority on Hold." http://www.nj.com/hudson/index.ssf/2014/02/plan_to_dissolve_the_autonomous_jersey_city_parking_authority_on_hold.html.

Cooke, Annmarie. 1981. "12 Illegal Aliens Face Deportation." *Home News*, July 14.

Cooley, Henry. 1896. *A Study of Slavery in New Jersey*. Baltimore, MD: Johns Hopkins University Press.

Corté, Carlos E., ed. 2013. *Multicultural America: A Multimedia Encyclopedia*. 4 vols. Los Angeles: Sage Publications.

Council of Development Finance Agencies and the International Council of Shopping Centers, 2007. "Tax Increment Finance Best Practices Reference Guide." http://www.icsc.org/government/CDFA.pdf.

Cox, Rachel S. 1997. *Design Review in Historic Districts*. National Trust for Historic Preservation Information Series. Washington, DC: National Trust for Historic Preservation.

Cressie, Noel. 1988. "Estimating Census Undercount at National and Subnational Levels." In *Fourth Annual Research Conference Proceedings*, 123–150. Washington, DC: Bureau of the Census.

Cross, Dorothy. 1965. *New Jersey's Indians*. Trenton: New Jersey State Museum.

Cummings, Charles F. 2004. *The People of New Jersey: Their Enduring Journey*. Exhibition catalog. Newark: Newark Public Library. Available at http://www.npl.org/Pages/ProgramsExhibits/Exhibits/transcatalog.pdf.

Danter Company. 2012. "Statistical Overview of LIHTC Program 1987 to 2008." http://www.danter.com/taxcredits.stats.htm.

De Angelo, Walter A. 2007. *The History Buff's Guide to Middlesex County*. New Brunswick, NJ: Middlesex County Board of Freeholders. June. http://www.co.middlesex.nj.us/Government/Departments/BDE/Documents/history_buffs_guide.pdf.

Democracy Collaborative. 2012. "Overview: Community Development Corporations (CDCs)." Community-Wealth.org, a project of the Democracy Collaborative. http://community-wealth.org/strategies/panel/cdcs/index.html.

Donnelly, Jim. 2011. "The Irish Famine." http://www.bbc.co.uk/history/british/victorians/famine_01.shtml.

Dowd, Gregory Evans. 1992. *The Indians of New Jersey*. Trenton: New Jersey Historical Commission.

Duerksen, Christopher J., ed. 1983. *A Handbook on Historic Preservation Law*. Washington, DC: Conservation Foundation and the National Center for Preservation Law.

Duffy, Jennifer. 2014. *Who's Your Paddy: Racist Expectations and the Struggle for Irish-American Identity*. New York: New York University Press.

Eavis, Peter. 2012. "Obama Faces Tough Choices on Housing in 2nd Term." *New York Times*, November 9.

Ehrenhalt, Alan. 2012. *The Great Inversion and the Future of the American City*. New York: Knopf.

Enterprise Community Partners, Inc. 2012. "About Us: Innovating in Communities." Enterprise. http://www.enterprisecommunity.com/about/history/about-our-founders. Accessed November 16, 2012.

Federal Writers' Project of the Works Progress Administration for the State of New Jersey. 1939. *New Jersey: A Guide to Its Present and Past*. New York: Viking.

Fefferman, Hilbert. 1966. *Hearings before the Subcommittee on Executive Reorganization of the*

Committee on Government Operations. U.S. Senate, 89th Cong., 2nd sess. Washington, DC: Government Printing Office.

Finkelman, Paul. 1992. "State Constitutional Protections of Liberty and the Antebellum New Jersey Supreme Court: Chief Justice Hornblower and the Fugitive Slave Law." *Rutgers Law Journal* 23 (4): 753–787.

Fitzpatrick, Michael S. 2000. "Note: A Disaster in Every Generation: An Analysis of HOPE VI: HUD's Newest Big Budget Development Plan." *Georgetown Journal on Poverty Law & Policy* 7, no. 2 (Summer).

Foster, R. F. *Modern Ireland 1600–1972.* New York: Penguin, 1989.

Foundation Center. 2015. "Top 100 U.S. Foundations by Asset Size." http://foundationcenter.org/findfunders/topfunders/top100assets.html.

Fowler, John M. 1976. "Federal Historic Preservation Law: National Historic Preservation Act, Executive Order 11693, and Other Recent Developments in Federal Law." *Wake Forest Law Review* 12 (1): 31.

Fox, Connor. 2010. Development Associate, DEVCO. Interview by David Listokin and Katie Brennan of Rutgers University. November 1.

Freemark, Yonah, and Lawrence J. Vale. 2012. "Illogical Housing Act." *New York Times,* October 31.

"Fresh Grocer Supermarket Opens in New Brunswick, Addressing 'Food Desert' Challenge." 2012. *NJBIZ,* November 9. http://www.njbiz.com/article/2012/20121109/NJBIZ01/121109865/Fresh-G.

Gabe, Thomas. 2015. *Poverty in the United States: 2013.* Report RL33069. Washington, DC: Congressional Research Service. https://www.fas.org/sgp/crs/misc/RL33069.pdf.

Gallagher, Leigh. 2013. *The End of the Suburbs: Where the American Dream Is Moving.* New York: Portfolio/Penguin.

Galster, George. 2014. *Driving Detroit: The Quest for Respect in the Motor City.* Philadelphia: University of Pennsylvania Press.

Gans, Herbert. 1965. *The Urban Villagers: Groups and Class in the Life of Italian-Americans.* New York: Free Press.

Garmm, Carl. H. 1938. *The Germans in New Brunswick, New Jersey . . . 1838 to 1888.* Cleveland: Central Publishing House.

Gibson, Campbell. N.d. "American Demographic History Chartbook: 1790 to 2010." www.demographicchartbook.com.

Gibson, Campbell, and Emily Lennon. 1999. "Historical Census Statistics on the Foreign-Born Population of the United States: 1850–1990." Population Division, working paper no. 29. Washington, DC: Population Division, U.S. Bureau of the Census. http://www.census.gov/population/www/documentation/twps0081/twps0081.html.

Glaeser, Edward. 2011. *Triumph of the City: How Our Greatest Invention Makes Us Richer, Smarter, Greener, Healthier, and Happier.* New York: Penguin.

Goldberger, Paul. 1996. "James W. Rouse, 81, Dies: Socially Conscious Developer Built New Towns and Malls." *New York Times,* April 10.

Golway, Terry. 2005. "Jersey: How One Man Helped Revive New Brunswick." *New York Times,* November 13.

Gombach Group. 2013. "Livingston Avenue Historic District." http://www.livingplaces.com/NJ/Middlesex_County/New_Brunswick_City/Livingston_Avenue_Historic_District.html.

Gotham, Kevin Fox. 2001. "Urban Redevelopment, Past and Present." *Critical Perspectives on Urban Redevelopment* 6:1–31.

Gratz, Roberta Brandes. 1994. *The Living City: How America's Cities Are Being Revitalized by Thinking Small in a Big Way.* Washington, DC: National Trust for Historic Preservation.

Greiff, Constance M. 1971. *Lost America: From the Atlantic to the Mississippi.* Princeton, NJ: Pyne.

Grieco, Elizabeth M., Yesenia D. Acosta, G. Patricia de la Cruz, Christine Gambino, Thomas Gryn, Luke J. Larsen, Edward N. Trevelyan, and Nathan P. Walters. 2012. "The Foreign Born Population in the United States." American Community Survey Reports (ACS-19). Washington, DC: U.S. Census Bureau. https://www.census.gov/prod/2012pubs/acs-19.pdf.

Grieco, Elizabeth M., Edward Trevelyan, Luke Larsen, Yesenia D. Acosta, Christine Gambino, Patricia de la Cruz, Tom Gryn, and Nathan Walters. 2012. *The Size, Place of Birth, and Geographic Distribution of the Foreign-Born Population in the United States: 1960 to 2010.* Population Division, working paper no. 96. Washington, DC: U.S. Census Bureau. https://www.census.gov/population/foreign/files/WorkingPaper96.pdf.

Guidette, Christopher. 1981a. "The J&J Land Buy, Part 1: Massive 8-Block Purchase Completed in 8-Year Span." *Home News*, March 29, A1, D1.

———. 1981b. "The J&J Land Buy, Part 2: Corporate Home Hiked Tax Values." *Home News*, March 30, 1, 10.

Gurowitz, Margaret. 2006–2008. "Kilmer House: The Story of Johnson & Johnson and Its People." http://www.kilmerhouse.com.

Harris, Donna Ann. 2009. "Making Affordable Housing in Historic Places." Report prepared by Heritage Consulting for Preservation New Jersey, Inc. http://www.preservationnj.org/site/ExpEng/images/images/pdfs/PNJ_AffordableHousing.pdf. Accessed June 16, 2015.

Heldrich, John. 1988. "Remarks—Akron Roundtable." Akron, Ohio, August 18.

Herod, Marilyn. 2007. Oral history interview October 5–6, 2007, by Daniel Littlewood. New Brunswick Free Public Library, Historical Archives, New Brunswick Stories. www.nbfpl.org/story.html.

Hill, N. Salomon. 1942. "The Negro in New Brunswick as Revealed by a Study of One Hundred Families." MA thesis, Drew Theological Seminary, Madison, NJ.

Historic Design Associates. 1979. *Architectural-Historic Survey: Pursuant to Section 106 National Historic Preservation Act of 1966 for a Proposed Downtown Hotel in New Brunswick, New Jersey.* Cornwall-on-Hudson, NY: Historic Design Associates, May 11.

Hodges, Graham Russell. 1999. *Root and Branch: African Americans in New York and East Jersey, 1613–1863.* Chapel Hill: University of North Carolina Press.

Hoffman, Barnett. 2007. Oral history interview October 5—6, 2007, by Diane Hoffman. New Brunswick Free Public Library, Historical Archives, New Brunswick Stories. www.nbfpl.org/story.html.

Holcomb, Briavel. N.d. *The Changing Landscape of New Brunswick.* http://oldnewbrunswick.rutgers.edu/. Accessed June, 16 2015.

Hoppenfeld, Morton. 1967. "A Sketch of the Planning-Building Process for Columbia, Maryland." *Journal of the American Institute of Planners* 33 (6): 398–409.

Hosmer, Charles B. 1965. *Presence of the Past: A History of the Preservation Movement in the United States before Williamsburg.* New York: Putnam.

Housing Act. 1937. Public Law 83–560.

Housing Act. 1949, Title I. Public Law 83–560.

Housing Act. 1961. Public Law 70.

Housing Act. 1965. Section 101 Rent Supplement, Public Law 89–117.

Housing Act. 1968. Public Law 90–448.

Housing and Home Finance Agency. 1964. *Chronology of Major Federal Actions Affecting Housing and Community Development.* Washington, DC: Government Printing Office.

Howard, Clifford. 1988. "New Brunswick Tomorrow: The Start of Urban Renewal." *Targum*, April 20.

Hughes, James W., and Joseph J. Seneca. 2012. *The Evolving Rental Housing Market in New Jersey: Retrospective and Prospective.* Rutgers Regional Report, issue paper no. 32, November.

———. 2015. *New Jersey's Postsuburban Economy.* New Brunswick, NJ: Rutgers University Press.

"I. M. Pei Proposes a Rebirth for New Brunswick." 1976. *New York Times*, May 26.

Inman, Robert, ed. 2009. *Making Cities Work: Prospects and Policies for Urban America.* Princeton, NJ: Princeton University Press.

Institute for Domestic and International Affairs, Inc. 2009. "New Brunswick City Council, Urban Redevelopment." Rutgers Model Congress 2009, Director: Charlie Kratovil.

Jacobs, Barry G., Kenneth R. Harney, Charles l. Edson, and Bruce S. Lane. 1982. *Guide to Federal Housing Programs.* Washington, DC: Bureau of National Affairs.

Jacobs, Jane. 1961. *The Death and Life of Great American Cities*. New York: Random House.

Jenkins, Reese V., Bonita Craft Grant, Morris Kafka, and Peg Byrne. 2007. *Industrial New Brunswick and Area, 1811–2007: A Self-Guided Automobile Tour*. New Brunswick, NJ: Rutgers University.

Joint Center for Housing Studies of Harvard University. 2012. *State of the Nation's Housing 2012*. Cambridge, MA.

Kafka, Morris. 2014. Conversation with David Listokin. Edward J. Bloustein School of Planning and Public Policy at Rutgers, The State University of New Jersey, May 20.

Karasik, Gary. 1986. *New Brunswick & Middlesex County: The Hub and the Wheel*. Northridge, CA: Windsor Publications.

Karasik, Gary, and Anna Aschkenes. 1999. *Middlesex County: Crossroads of History*. Sun Valley, CA: American Historical Press.

Kerner Commission. 1988. *The 1968 Report of the National Advisory Commission on Civil Disorders*. With a preface by Fred R. Harris and a new introduction by Tom Wicker. New York: Pantheon.

Khavkine, Richard . 2008a. "Mexican President to Visit New Brunswick." *Home News*, September 20.

———. 2008b. "City Shuts Down Mexican Consulate." *Home News*, October 10.

Kingsley, Thomas, Margery Turner, Susan Popkin, and Martin Abravanel. 2004a. *What Next for Distressed Public Housing?* Washington, DC: Urban Institute, June.

Kingsley, Thomas, Martin Abravanel, Mary Cunningham, Jeremy Gustafson, Arthur Naparstek, and Margery Turner 2004b. *Lessons from HOPE VI for the Future of Public Housing*. Washington, DC: Urban Institute.

Klein, Alvin. 1999. "IN PERSON: The Road to the Tony's." *New York Times*, June 6.

Kocieniewski, David. 2006a. "Ex-New Jersey Lawmaker Given 3 Years Over Payoffs." *New York Times*, December 20.

———. 2006b. "In New Jersey, Party Bosses Meld Politics and Business." *New York Times*, January 1.

Koebel, C. Theodore. 1996. "Urban Redevelopment, Displacement and the Future of the American City." Center for Housing Research, Virginia Polytechnic Institute and State University, April 15.

Koppel, Nathan. 2014. "San Antonio Weighs Annexation Plan." *Wall Street Journal*, December 21. http://www.wsj.com/articles/san-antonio-weighs-annexation-plan-1419205551.

Kratovil, Charles. 2014a. "Fresh Grocer Owes $784,754 in Back Rent, May Abandon Store." *New Brunswick Today*, February 26.

———. 2014b. "Owing $1 Million to NBPA, New Brunswick Fresh Grocer Closes after Just 18 Months in Business." *New Brunswick Today*, May 14.

Laky, Reverend S. 1921. "What the Hungarian People in This City Have Done to Help Develop New Brunswick." *New Brunswick Sunday Times*, April 24.

Lan, Lin. 2014. "Mayor Cahill Addresses RUSA on City's Plans for the Future." *Daily Targum*, October 2. 1.

Landis, John D., and Kirk McClure. 2010. "Rethinking Federal Housing Policy." *Journal of the American Planning Association* 76 (3): 319–348.

Lang, Brian, and Eugene Kim. 2012. "Expanding New Jersey's Supermarkets." Report of the New Jersey Marketing Task Force.

Lawlor, Julia. 2010. "No More Barges But Plenty of Beauty." *New York Times*, July 29. http://www.nytimes.com/2010/07/30/nyregion/30canal.html?pagewanted=all&_r=1.

Ledesman, Ann. 1976. "City Park May Foster Unity." *Home News*, June 25.

Lei, Jonathan, and Andrew Seidman. 2014. "Private Sector Fix Eyed for A.C." *Philly.com*, November 30.

Lipson, Noel. 1967. "A City Sat on the Brink of Terror." *Daily Home News*, July 5.

Listokin, Barbara Cyviner. 1976. *The Architectural History of New Brunswick, 1681–1900*. New Brunswick, NJ: Rutgers University Art Gallery.

Listokin, David. 1985. *Living Cities*. New York: Priority.

———. 1991. "Federal Housing Policy and Preservation: Historical Evolution, Patterns, and Implications." *Housing Policy Debate* 2 (2): 157–185.

———. 2007. "The Property Tax and Housing Affordability." Study conducted by the Rutgers University Center for Urban Policy Research for the National Association of Realtors National Center for Real Estate Research.

Listokin, David, and Katie Brennan. 2011. "'Smart' School Construction Strategies: The Potential of Public-Private Partnerships." Study conducted by the Center for Urban Policy Research for the Fund for New Jersey, September.

Listokin, David, Michael L. Lahr, and Charles Heydt. 2012. *Third Annual Report on the Economic Impact of the Federal Historic Tax Credit.* Center for Urban Policy Research (CUPR), New Brunswick, NJ, July.

Listokin, David, Barbara Listokin, and Michael Lahr. 1998. "The Contributions of Historic Preservation to Housing and Economic Development." *Housing Policy Debate* 9 (3): 433–434.

Listokin, David, Elvin Wyly, Larry Keating, Kristopher Rengert, and Barbara Listokin. 2000. *Making New Mortgage Markets: Case Studies of Institutions, Home Buyers, and Communities.* Fannie Mae Foundation, Washington, DC: September.

———. 2011. *New Brunswick City Market–Special Improvement District (SID).* New Brunswick Redevelopment Studio, December.

Listokin, David, Elvin K. Wyly, Brian Schmitt, and Ioan Voicu. 2002. *The Potential and Limitations of Mortgage Innovation in Fostering Homeownerships in the United States.* Fannie Mae Foundation, Washington, DC, June.

Local Initiatives Support Corporation [LISC]. 2012. "By the Numbers." http://lisc.org/section/aboutus/numbers.

Longstreth, Richard. 2010. *The American Department Store Transformed, 1920–1960.* New Haven, CT: Yale University Press.

Lurie, Maxine, ed. 2010. *A New Jersey Anthology.* 2nd ed. New Brunswick, NJ: Rutgers University Press.

Malinconico, Joe. 2011. "The Legacy of HOPE VI in New Brunswick." *New Brunswick Patch*, July 15. http://newbrunswick.patch.com/articles/the-legacy-of-hope-vi-in-new-brunswick.

Mallach, Alan, and Laura Brachman. 2013. *Regenerating America's Legacy Cities.* Cambridge, MA: Lincoln Institute of Land Policy.

Mann, Anastasia. 2011. *Crossroads of the World: New Americans in Middlesex County, New Jersey.* New Brunswick: Eagleton Institute of Politics, Rutgers University.

Manvel, Allen D. 1968. *Local Land and Building Regulation: How Many Agencies? What Practices? How Much Personnel?* Washington, DC: U.S. Government Printing Office.

Martin, Antoinette. 2011. " In New Brunswick, a Mixed-Use Project Is Bustling." *New York Times*, February 11.

Marx, Paul. 2008. *Jim Rouse, Capitalist/Idealist.* Lanham, MD: University Press of America.

Masso, Anthony D. 1989. "Historic Hiram Market: Decade Update." Master's thesis, Mason Gross School of the Arts, Rutgers University.

Maugham, Elisabeth. 1982. "The German Community." In *The Tercentennial Lectures, New Brunswick, New Jersey,* edited by Ruth Patt, 50–56. New Brunswick: City of New Brunswick.

Meck, Stuart Terry Moore, and James Ebenhoh. 2006. *An Economic Development Toolbox: Strategies and Methods,* Planning Advisory Service Report No. 541. Chicago: American Planning Association.

Meriam-Webster Dictionary. S.v. "average." http://www.meriam-webster.com/dictionary/average.

Millennial Housing Commission. 2002. *Meeting Our Nation's Housing Challenges: Report of the Bipartisan Millennial Housing Commission. Submitted to United States House of Representatives and United States Senate pursuant to Section 206(6) of Public Law 106–74 as Amended.* Washington, DC, May 30.

Molinaro Associates, Inc. 1993. "The New Brunswick Revitalization Process." A Report to the City of New Brunswick and New Brunswick Tomorrow, June.

Molnar, August. 1982. "The Hungarian Community." In *The Tercentennial Lectures, New Brunswick, New Jersey,* edited by Ruth Patt, 83–91. New Brunswick: City of New Brunswick.

Monzingo, Louise A. 2011. *Pastoral Capitalism, A History of Suburban Corporate Landscapes.* Cambridge, MA: MIT Press.

Moskowitz, Harvey, Carl Lindbloom, David Listokin, Richard Preiss, and Dwight Merriam, 2015. *The Complete Illustrated Book of Development Definitions*. New Brunswick, NJ: Transaction Publishers.

Moynihan, Daniel Patrick, ed. 1970. *Toward a National Urban Policy*. New York: Basic Books.

Mullin, Stephen P. 2002. "Public-Private Partnerships and State and Local Economic Development: Leveraging Private Investment." *Reviews of Economic Development Literature and Practice* 16 (August): 1–38.

Muñoz, Daniel. 2014. "DEVCO Releases New Design for Potential Skyscrapers to Replace Abandoned Ferren Mall." *New Brunswick Today*, December 3.

Murtagh, William J. 1988. *Keeping Time: The History and Theory of Preservation in America*. Pittstown, NJ: Main Street.

Nanticoke Lenni-Lenape. 2007. "The Nanticoke Lenni-Lenape: An American Indian Tribe." http://www.nanticoke-lenape.info/index.htm.

Nathan, Richard P., and Jerry A. Webman, 1980. *The Urban Development Action Grant Program: Papers and Conference Proceedings on Its First Two Years of Operation*. Princeton, NJ: Princeton Urban and Regional Research Center.

Nathanson, Charles C. (Charles C. Nathanson and Associates), and Vivian D. Lerner (Elbasani/ Logan/Severin/ Freeman). 1975. "A New Approach to Land Disposition and Development." Report prepared under a demonstration grant from the New Jersey Department of Community Affairs to the Housing Authority, City of New Brunswick, December.

National Advisory Commission on Civil Disorders [The Kerner Commission]. 1968. *Report of the National Advisory Commission on Civil Disorders*. New York: Bantam Books.

National Association of Home Builders [NAHB]. 1986. *Low- and Moderate-Income Housing: Progress, Problems, and Prospects*. Washington, DC: NAHB.

National Commission on Severely Distressed Public Housing. 1992. *The Final Report*. Washington, DC: National Commission on Severely Distressed Public Housing.

National Commission on Urban Problems. 1969. *Building the American City*. New York: Praeger.

National Low Income Housing Coalition. 2012. "Public Housing." http://nlihc.org/issues/public-housing.

Nelson, William. 2013. *The Indians of New Jersey*. 1894. Reprint, London: Forgotten Books.

Nenno, Mary K. 1998. "New Directions for Federally Assisted Housing: An Agenda for the Department of Housing and Urban Development." In *New Directions in Urban Public Housing*, edited by David P. Varady, Wolfgang F. E. Preiser, and Francis P. Russell, 205–225. New Brunswick, NJ: Rutgers University, Center for Urban Policy Research.

New Brunswick Arts Development Commission. 1982. *A Cultural Center for New Brunswick*. Rutgers University Office of Physical and Capital Planning. June.

New Brunswick. City of New Brunswick Parking Authority. 2013. "Financial Statements and Required Supplementary Information." http://njnbpa.org/userfiles/files/NBPA%20-%20 12–31–2013%20Final%20Bound.pdf.

"New Brunswick Revitalization Program" Phase Two. April 1, 1975–March 31, 1976.

"New Brunswick Shuts Schools: Unable to Get Liability Insurance." 1969. *New York Times*, September 24.

New Brunswick Sunday Times. 1926. From vertical file, New Brunswick Library, May 30.

———. 1951. From vertical file, New Brunswick Library, May 27.

New Brunswick Tomorrow. 1977. "What Is NBT?" New Brunswick, NJ.

———. 1979. Annual Report.

"New Brunswick Tomorrow: Turning the City Around." 1979 (special edition, *New Jersey Business*).

New Jersey Future. 2003. "Lower George Street Redevelopment Strategy." http://www.njfuture. org/smart-growth-101/smart-growth-awards/2003-award/new-brunswick/.

———. 2012. "Vanguard of New Brunswick's Transit-Oriented Revitalization." http://www .njfuture.org/smart-growth-101/smart-growth-awards/2012-smart-growth-award-winner/2012-sga-gateway-transit-village/.

New Jersey Superior Court Appellate Division. 1994. *Davidson Bros. v. D. Katz & Sons*. 274 N.J. Super. 159 (1994), 643 A. 2d 642.

New Jersey Sustainable State Institute. 2008. "Municipal Revitalization Index Update and Ranking." May.

New Jersey Transit and Rutgers University. 2013. "New Brunswick Launches Wellness Plaza." *NJTOD—The Home of NJ's Transit Friendly Newsletter,* October 27.

New Jersey Trial Court. 1990. *Davidson Bros., Inc. v. D. Katz & Sons, Inc.* 121 N.J. 196, 579 A. 2d 288.

New York City Landmarks Preservation Commission. 2014. "About the Landmarks Preservation Commission." http://www.nyc.gov/html/lpc/html/about/about.shtml. Accessed April 23, 2014.

"The Next Innovation Center: The Hub at New Brunswick Station." 2014. In *New Brunswick: Redeveloping the Urban Experience.* Somerset, NJ: *NJBIZ.*

NJBIZ. "The Visionary: Omar Boraie Has Seen the Potential of New Brunswick for Four Decades." 2014. In New Brunswick: Redeveloping the Urban Experience, 7–9. Somerset, NJ: NJBI (special edition of NJBIZ).

Nusteling, Hubert P. H. 2009."How Many Irish Famine Deaths? Toward Coherence of the Evidence." *Historical Methods* 42 (2): 57–80.

Obama, Barack, and Joseph Biden. 2008. "Creating Urban Prosperity." White paper, Washington, DC, September 21.

Paladino, Christopher. 2014. Lecture to Urban Redevelopment class. Edward J. Bloustein School of Planning and Public Policy at Rutgers, The State University of New Jersey, December 3.

Pane, Remigio. 1982. "The Italian Community." In *The Tercentennial Lectures, New Brunswick, New Jersey*, edited by Ruth Patt, 92–102. New Brunswick: City of New Brunswick.

Parent, Louis. 1982. "The Smokestacks of New Brunswick: Its Industries." In *The Tercentennial Lectures, New Brunswick, New Jersey*, edited by Ruth Patt, 120–125. New Brunswick: City of New Brunswick.

Parsons, Floyd W., ed. 1928. *New Jersey: Life, Industries and Resources of a Great State.* Newark: New Jersey State Chamber of Commerce.

Patt, Ruth, ed. 1982. *The Tercentennial Lectures, New Brunswick, New Jersey.* New Brunswick: City of New Brunswick.

Pei, I. M. & Partners. 1976. Downtown Renewal Plan. Prepared for New Brunswick Tomorrow.

Pennrose Properties. 2012. Information on Providence Square and Livingston Manor projects provided by Timothy Henkel of Pennrose to David Listokin of Rutgers University.

Peterson, Sarah. 2014. "Tax Increment Financing: Tweaking TIF for the 21st Century." *Urban Land.* June 9. http://urbanland.uli.org/economy-markets-trends/tax-increment-financing-tweaking-tif-21st-century/.

Planning for New Brunswick's Central City. 1958.

President's Commission on Housing. 1982. *The Report of the President's Commission on Housing.* Washington, DC: US Government Printing Office.

President's Committee on Urban Housing. 1968. *The Report of the President's Committee on Urban Housing: A Decent Home.* Washington, DC: Government Printing Office.

Prior, James T. 1988. "New Brunswick Focuses on Improved Quality of Life." *New Jersey Business*, April.

Quinn, Dermot. 2004. *The Irish in New Jersey: Four Centuries of American Life.* New Brunswick, NJ: Rutgers University Press.

Rabinowitz, Richard, and Charles Kratovil. 2013. "End of Era: Ferren Deck Closes, Retail Businesses Survive." *New Brunswick Today*, January 14.

Rae, Douglas. 2003. *City: Urbanism and Its End.* New Haven, CT: Yale University Press.

Rasmussen, Chris. 2014. "'A Web of Tension': The 1967 Protests in New Brunswick, New Jersey." *Journal of Urban History* 40 (1): 137–157.

Rastogi, Sonya, Tallese Johnson, Elizabeth Hoeffel, and Malcolm Drewery. 2011. "The Black Population 2010." U.S. Census Bureau, 2010 Census Briefs. https://www.census.gov/prod/cen2010/briefs/c2010br-06.pdf.

Reed, Ingrid. 1989. "The Life and Death of UDAG: An Assessment Based on Eight Projects in Five New Jersey Cities." *Publius: The Journal of Federalism.* 19, no. 3 (Summer): 93–109.

Report of the National Housing Task Force. 1988, *A Decent Place to Live.* Washington, DC, March.

Reuschke, Darja. 2001. "Public-Private Partnerships in Urban Development in the United States." Network of European and US Regional and Urban Studies Program (NEURUS), University of California, Irvine.

Rich, Michael J. 1992. "UDAG, Economic Development, and the Death and Life of American Cities." *Economic Development Quarterly* 6, no. 2 (May).

Robert Wood Johnson University Hospital. "About Robert Wood Johnson University Hospital." http://www.rwjuh.edu/rwjuh/about.aspx.

Rojas, Maria. 1981a. "Hispanic Festival Rings with Pride." *Home News*, August 30.

———. 1981b. "Starting Over: Getting Settled in New Life No Simple Task for Cuban Refugees." *Home News*, October 16.

Ross, Bill. 1974. "J&J's New Brunswick Tract." *New York Times*, July 14.

Rouse Corporation. 1968. "Annual Report." May 31.

Rutgers University. 2014–2015 Fact Book. http://www.rutgers.edu/about/facts-figures.

Rutgers University. Center for Government Services. 2013. *Legislative District Data Book.*

Rutgers University. Eagleton Institute of Politics. N.d. "The Wood Lawn Mansion." http://www.eagleton.rutgers.edu/about/woodlawn.php.

Rutgers University. Eagleton Institute of Politics, Center for Public Interest Polling. 1985. "Images III: A Report on the Quality of Life in New Jersey."

———. 2000. "Residents' Views on 25 Years of Revitalization in New Brunswick."

———. 2008. "Results of Eagleton Survey of New Brunswick." Study and Survey for New Brunswick Tomorrow.

Rutgers University. Edward J. Bloustein School of Planning and Public Policy. Community Development Studio. 2004. "New Community Corporation."

Rutgers University. 2015. Office of Institutional Research.

Sanchez, Eladio, and Edwin Gutierrez. 1982. "The Hispanic Community." In *The Tercentennial Lectures, New Brunswick, New Jersey*, edited by Ruth Patt, 57–59. New Brunswick: City of New Brunswick.

San Francisco Call. 1901. "Vanderbilt Fortune Began in This Hotel," February 8. California Digital Newspaper Collection. http://cdnc.ucr.edu/cgi-bin/cdnc?a=d&d=SFC19010208.2.60.

Santos, Jorge. 2010. *New Brunswick Tomorrow Community Development Case Study.* New Brunswick, NJ: Edward J. Bloustein School of Planning and Public Policy. http://rwv.rutgers.edu/wp-content/uploads/2013/08/NewBrunswickTomorrow.pdf.

Schechter, Judy H. 2011. "An Empirical Evaluation of the Model Cities Program." Thesis, University of Michigan, March.

Schkrutz, Eric. 2011. "Urban Development in the City of the Traveler and Why It May Never Resolve Its Identity Crisis." Honors thesis, Rutgers History Department, April 1.

Schlegel, Jeff. 1995. " Developing with Abandon: An Empty Building Can Be Good Fodder for Adaptive Reuse." *Chicago Tribune*, September 24.

Schwartz, Alex F. 2010. *Housing Policy in the United States.* New York: Routledge.

Scott, Charles. 1996. *Historic Preservation: A Historic Preservation Perspective.* Trenton: New Jersey Department of Environmental Protection, Historic Preservation Office. http://www.nj.gov/dep/hpo/hpo_article.pdf.

Scott, Mel. 1969. *American City Planning: Since 1890.* Berkeley: University of California Press.

Segal, David. 2013. "A Missionary's Quest to Remake Motor City." *New York Times*, April 13.

Sellars, Richard B. 1974. Meeting notes. Office of Chairman of the Board, Johnson and Johnson. June 28.

Serrill, Ted. 1980. "New Brunswick—Ken Jennings Looks at the City's Past." *Home News*, January 27.

Shaw, Douglas. 1994. *Immigration and Ethnicity in New Jersey History.* Trenton: New Jersey Historical Commission.

Silver, Hilary. 2010. "Obama's Urban Policy: A Symposium." *City and Community* 9 (1): 3–12.

Singer, Lawrence E., and Elizabeth Johnson Lantz. 1999. "The Coming Millennium: Enduring Issues Confronting Catholic Health Care." *Health Law Commons* 8 (1): 1–32.

Skerry, Peter. 2000. *Counting on the Census? Race, Group Identity, and the Evasion of Politics.* Washington, DC: Brookings Institution.

Slesinski, Jason J. 2014. *Along the Raritan River: South Amboy to New Brunswick*. Charleston, SC: Arcadia Publishing.

Stewart, Vivian. 1982. "The Black Community." In *The Tercentennial Lectures, New Brunswick, New Jersey*, edited by Ruth Patt, 77–82. New Brunswick: City of New Brunswick.

Stipe, Robert E., and Antoinette J. Lee, eds. 1987. *The American Mosaic: Preserving a Nation's Heritage*. Washington, DC: U.S. Committee, International Council of Monuments and Sites.

Stowe, Stacey. 2003. "Latest Merger Makes It Clearer Than Ever: Hartford Is No Longer the Insurance Capital." *New York Times*, November 21.

Strange, John H. 1972. "Citizen Participation in Community Action and Model Cities Programs." *Public Administration Review* 32 (October): 655–669.

Struyk, Raymond J., Margery A. Turner, and Makiko Ueno. *Future U.S. Housing Policy*. Washington, DC: Urban Institute Press, 1988.

Suber, Jean. 2007. Oral history interview October 5–6, 2007, by John Lane. New Brunswick Free public Library, Historical Archives, New Brunswick Stories. www.nbfpl.org/story.html.

Swan, Herbert S. 1925. *The New Brunswick Plan*. New Brunswick, NJ: City Planning Commission.

Tamari, Jonathan. 2004. "Video to Recall City's Past." *Home News Tribune*, October 11, 1.

Tarbous, Ken. 2005. "New Brunswick Oks Gateway-Area Step." *Home News Tribune*, July 22.

Tax Foundation. N.d. "State and Local Property Tax Collections per Capita by State 2006–2010." http://taxfoundation.org/article/state-and-local-property-tax-collection.

Teaford, Jon C. 2006. *The Metropolitan Revolution: The Rise of Post-Urban America*. New York: Columbia University Press.

Turner, Margery. 2009. "HOPE VI, Neighborhood Recovery, and the Health of Cities." In *From Despair to Hope: HOPE VI and the New Promise of Public Housing in America's Cities*, edited by Henry Cisneros and Lora Engdahl, 169–190. Washington DC: Brookings Institution Press.

———. 2010. "New Life for US Housing and Urban Policy." *City and Community* 9, no. 1 (March): 32–40.

Urban Land Institute. 2005. *Principles for Successful Public/Private Partnerships*. Washington, DC:

U.S. Congress. House. Select Committee on Hunger. 1987. *Obtaining Food: Shopping Constraints on the Poor*. 100th Congress, 1st session. Committee Print.

U.S. Congressional Budget Office. 1978. *Barriers to Urban Economic Development*, May.

U.S. Department of Agriculture. Agriculture Marketing Service. 2015. "Food Deserts." http://apps.ams.usda.gov/fooddeserts/fooddeserts.aspx.

U.S. Department of Commerce, United State Census Bureau. 2010. State & Local Government Finances.

U.S. Department of Housing and Urban Development. 1974. *Housing in the Seventies, A Report of the National Housing Policy Review*. Washington, DC: HUD-0000968.

———. 1996. "Building Public-Private Partnerships to Develop Affordable Housing," May.

———. 2007. "HOPE VI Program Authority and Funding History." March.

U.S. Department of the Treasury. 2015. "New Markets Tax Credit Program, Overview." Community Development Financial Institutions Fund. http://www.cdfifund.gov/what_we_do/programs_id.asp?programID=5. Accessed June 15, 2015.

Vanderbroucke, Guillaume. 2008. "The U.S. Westward Expansion." *International Economic Review* 49 (1): 81–110.

Van Dyke, Rachel. 2000. *To Read My Heart: The Journal of Rachel Van Dyke, 1810–1811*. Edited by Lucia McMahon and Deborah Schriver. Philadelphia: University of Pennsylvania Press.

Wacker, Peter. N.d. "New Jersey's Cultural Resources: A.D. 1660–1810." http://www.nj.gov/dep/hpo/1identify/pg_199_NJCulturalResourc1660_1810Wacker.pdf.

Wall, John P. 1931. *The Chronicles of New Brunswick, New Jersey 1667–1931*. Sinclair, NJ: Thatcher-Anderson.

Wall Street Journal. "Johnson & Johnson." http://quotes.wsj.com/JNJ.

Walsh, Albert A. 1986. "Housing Assistance for Lower-Income Families: Evolution." In *Housing and Community Development—A 50-Year Perspective*, edited by Mary Nenno, 42. Washington, DC: National Association of Housing and redevelopment Officials [NAHRO].

Webman, Jerry A. 1981. "UDAG: Targeting Urban Economic Development." *Political Science Quarterly* 96, no.2 (Summer).

Wheaton, William. 1949. "The Housing Act of 1949." *Journal of the American Institute of Planners* 15:36–41.

Whitehill, Walter Muir. 1966. "Promoted to Glory." In *With Heritage So Rich*. Washington, DC: National Trust for Historic Preservation.

Whitfield-Spinner, Linda. 2011. "A History of Medicine and the Establishment of Medical Institutions in Middlesex County, New Jersey, That Transformed Patient and Doctor Relationships during the Early Twentieth Century." PhD diss., Casperson School of Graduate Studies, Drew University.

Wilson, James Q., ed. 1968. *The Metropolitan Enigma: Inquiries into the Nature and Dimensions of America's Urban Crisis.* Cambridge MA: Harvard University Press.

Wong, Frank. 2007. "The Politics of Greenways and Trails: The Raritan River Trail." PowerPoint presented at Transaction 2007 Conference, Atlantic City, NJ, April 11.

Wright, Giles R. 1989. *Afro-Americans in New Jersey: A Short History*. Trenton: New Jersey Historical Commission. http://www.njstatelib.org/research_library/new_jersey_resources/digital_collection/afro-americans/.

Wu, Sen-Yuan. 2011. "People from Many Nations form New Jersey's Hispanic Population." *NJ Labor Market News*, issue 14. lwd.dol.state.nj.us/labor/lpa/pub/lmv/lmv_14.pdf.

Yamin, Rebecca. 2011. *Rediscovering Raritan Landing: An Adventure in New Jersey Archaeology.* Trenton: New Jersey Department of Transportation.

Yamin, Rebecca, and Tony Masso. 1996. "The River, the Dutch, the District, and the Corporate Giant: New Brunswick and the Past." *New Jersey History* 114, no. 3–4 (February): 11–31.

Yeske, Susan Sprague. 2009. "Cooking Fresh: The Frog and The Peach, New Brunswick." *edible Jersey* (Winter). http://www.frogandpeach.com/mydocuments/ej_winter09_p28.pdf.

Zeitz, John. 1998. "Urban History Overview: A Report on New Brunswick's Post-War Industrial and Economic History." Report prepared for the New Brunswick Development Corporation, August.

Zelinsky, Wilbur. 1973. *The Cultural Geography of the United States*. Englewood Cliffs, NJ: Prentice-Hall.

Zukin, Cliff, Theresa Thonhauser, and Josh Applebaum. 2007. "New Jersey: A Statewide View of Diversity." Study conducted by Bloustein Center for Survey Research, Edward J. Bloustein School of Planning and Public Policy, for American Conference on Diversity. September.

INDEX

Page numbers in italics refer to illustrations. The letter *f* following a page number denotes a figure; the letter *m* a map; the letter *t* a table, the letter *n* or *nn* notes.

102, 104; city commission, 59; City Council, 47, 59, 101–102, 232; City Hall, 30, 60, 132, *132*, 134; and civil disorders, 1, 63, 87–91; and community action programs, 73; Council of Churches, 102; as county seat, 20, 26, 30, 39, 86, *133*, 134, *135*, 210, 214, 216, 218; decline of, 26, 30–32, *31*, 61–63, 63t, 85–87, 90, 105, 129; Department of Public Safety, 60; formal charter of (1730), 5; and gaming-based funds, 82; as Health Care City, 2, 166–169; and Hispanics, 54t, 55f, 55t, 56, 59–61; Historic Board, 187; Housing and Development Authority, 142; Housing Authority (NBHA), 60, 90, 124–127, 175; as Hub City, 2, 86, 93, 188; and immigrants, 43f, 44–50; incorpora-tion of (1730), 42; major streets of, 243m; median household income, 62; Municipal Courts, 234; and 100 percent location, 27, 32; Parking Authority (NBPA), 172, 175–177, 215–216, 218, 230, 232; Planning Board, 102; planning commission (1925), 108; Police Department, 59–60, 234; political stability of, 214–215, 218–219; population trends, 35–40, 37t, 38t; Public Safety Building, 111t, 113m, 114m, *133*, 134; and racial/ethnic groups, 50–61, 51f, 51t, 52t, 54t, 55t, 248n2; Redevelopment Agency, 124; riverfront, 93–94, *94*, 209, 232; and Route 27 corridor revitalization, 233; school district, 87–88, 128; and slavery, 42, 56–57; three hundredth anniversary of, 230; transformation of, 85–117; and urban economic history, 61–63, 63t, 65–66, *66*, 70, 72–73, 76–78, 81–83; and urban EZs (UEZs), 76; Welfare Department, 60. *See also* CBD (central business district); downtown New Brunswick
New Brunswick African Association, 57
New Brunswick Child Care Consortium, 231
New Brunswick City Hospital, 16, 166. *See also* John Wells Memorial Hospital; Robert Wood Johnson University Hospital (RWJUH)
New Brunswick Cultural Center. *See* Cultural Center (NBCC)
New Brunswick Cultural Center Corporation, 230–231
New Brunswick Directory, 49
New Brunswick Foundation, 166
New Brunswick Health Sciences Technology High School, 167
New Brunswick High School (NBHS), 117, 123, 128–129, 178, 232–233, 235; and black high school graduates, 57–58; boycott of, 88; changes in, 87–88, 221; and Puerto Rican high school graduates, 60; and redevelopment phases, 112t
New Brunswick Historical Association, 172
New Brunswick Italian Club, 50
New Brunswick Opera House, 16, 27
New Brunswick Oral History Interviews (2009–2015), 223–228
New Brunswick Patch, 126
New Brunswick Plan (1925), 108

"The New Brunswick Revitalization Process" (Molinaro Associates), 104
New Brunswick Savings Bank, 14, 217
New Brunswick Sunday Times, 93–94
New Brunswick Theological Seminary, 118–122, *119, 120*, 121f, *122*, 236, 250n1; and redevelopment phases, 112t, 113m, 114m, 117
New Brunswick Times, 57
"New Brunswick Voices" (Eagleton Institute), 202–203
New Brunswick Wellness Plaza. *See* Wellness Plaza (NBWP)
New Deal, 67
New Frontier, 71
New Jersey, 19, 21–22, 90–91, 238m; and ACC revitalization study (1975), 101; Big Six communities, 188–195, 188t, 189t, 190t, 191t, 193t, 194t; and blacks, 36, 52t, 53f, 54–56; and building permits, 192–194, 193t, 194t; commissioner of labor and industry, 95; and Cultural Center (NBCC), 158, 161, 163; as cultural crossroads, 247n1; Department of Community Affairs (DCA), 138; Department of Education, 128; Department of Human Services, 232; Department of Transportation (NJDOT), 115, 172, 216, 229, 247n31; Economic Development Authority (EDA), 138; economic geography of, 26; EPTR (equalized property tax rate), 190–192, 194–195; Food Access Initiative, 175; and food deserts, 174–177; and Gateway Transit Village, 171–174; Governor's Fund, 138; Green Acres money, 158, 214, 232; highway department, 20; and Hispanics, 55f, 55t, 56; Housing and Mortgage Finance Agency, 206; and immigrants, 43–45, 43f; lack of funding from, 168, 235; and Lower George Street, 138; LPCs (local preservation commissions), 187; Meadowlands, 221–222; *Mount Laurel* decisions, 75, 126, 152; Open Space funds, 176; PILOTs (property payment in lieu of taxes), 82, 184–185; population trends, 21, 35–40, 37t, 38t; and racial/ethnic groups, 50–56, 51f, 51t, 52t, 55t; RCAs (Regional Contribution Agreements), 75, 126, 152; Redevelopment Authority (NJRA), 138; and Route 18 extension and bridge, 94–96, 96t, 115; SDA (School Development Authority), 128–129; special needs school districts, 128; State Arts Council, 161; state highway system, 20, 22, 24–25, 241m; State Historic Preserva-tion Office (SHPO), 145, 173, 186; subsidies from, 138, 158, 161, 171–172, 175, 178, 184–185, 214, 232, 235; and suburbanization, 21–22, 91–92; success of urban revitalization, 205–207, 205f, 215; Superior Court, 174–175; Supreme Court, 75, 126, 191; and tax burden, 190–192, 191t, 194; TODs (transit-oriented development) tax credits, 82, 171–174; UDAGs (Urban Development Action Grants), 141, 143; and urban economic history, 62, 74–76, 82–83; Urban Enterprise Zones, 85;

ABOUT THE AUTHORS

DAVID LISTOKIN is a professor at the Edward J. Bloustein School of Planning and Public Policy at Rutgers, The State University of New Jersey, where he has served as graduate and doctoral program director. He has long been associated with Bloustein's Center for Urban Policy Research (CUPR) and is editor of the CUPR Series at Transaction. Professor Listokin has a PhD in urban planning from Rutgers University and is the author of numerous monographs and articles on historic preservation, development impact assessment, land use and housing, and public finance. He has lectured at Cornell and Harvard Universities and the University of Naples.

DOROTHEA BERKHOUT is the associate dean of the Edward J. Bloustein School of Planning and Public Policy at Rutgers, The State University of New Jersey. She has a PhD in comparative literature, an MA in French language and literature (Ohio University), and a BA from the University of Southern California. Born in Paterson, New Jersey, and currently a resident of and member of several boards in New Brunswick, Berkhout has had a longtime interest in urban redevelopment.

JAMES W. HUGHES is Distinguished Professor and dean of the Edward J. Bloustein School of Planning and Public Policy at Rutgers, The State University of New Jersey. He is the director of the Rutgers Regional Report, which has produced over forty major economic, demographic, and real estate studies on New Jersey and the broader metropolitan region. Among his recent awards are the 2014 Distinguished Service Award of the New Jersey State League of Municipalities, the Rutgers School of Engineering 2014 Medal of Excellence, the Warren Hill Award of the New Jersey Bankers Association, Rutgers's Richard P. McCormick Award for Excellence in Alumni Leadership, the Distinguished Service Award of the New Jersey Chapter of the American Planning Association, and the Rutgers Presidential Award for Distinguished Public Service.